A Polish Doctor in the Nazi Camps

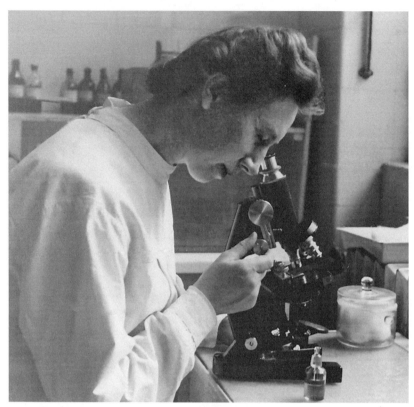

Jadzia at work in the dispensary; Höchst, October 1949.

A Polish Doctor in the Nazi Camps

My Mother's Memories of Imprisonment,
Immigration, and a Life Remade

❦

Barbara Rylko-Bauer

To Martha —
a lover of history.
Best wishes
Barbara Rylko-Bauer
15. X. 2014

UNIVERSITY OF OKLAHOMA PRESS : NORMAN

The epigraph for this book is from "The Turn of the Century," in Wisława Szymborska, *Miracle Fair: Selected Poems of Wisława Szymborska*, translated by Joanna Trzeciak. Copyright © 2001 by Joanna Trzeciak. Used by permission of W. W. Norton & Company, Inc.

Library of Congress Cataloging-in-Publication Data
Rylko-Bauer, Barbara, author.
A Polish doctor in the Nazi camps : my mother's memories of imprisonment, immigration, and a life remade / Barbara Rylko-Bauer.
 pages cm
Includes bibliographical references and index.
ISBN 978-0-8061-4431-3 (hardcover : alk. paper)
1. Rylko, Jadzia, 1910–2010. 2. Physicians—Poland—Biography. 3. World War, 1939–1945—Medical care—Poland. 4. Neusalz (Concentration camp). 5. World War, 1939–1945—Personal narratives, Polish. 6. Poland—Biography. I. Title.
R538.R95A3 2014
610'.92—dc23
[B]
2013022396

The paper in this book meets the guidelines for permanence and durability of the Committee on Production Guidelines for Book Longevity of the Council on Library Resources, Inc. ∞

To Jadzia's grandson
John Michael Rylko Bauer

❦

It was supposed to be better than the rest, our twentieth century.

.

Fear was to leave the mountains and valleys.
The truth was supposed to finish before the lie.

Certain misfortunes
were never to happen again
such as war and hunger and so forth.

.

God was at last to believe in man:
good and strong.
But good and strong
are still two different people.

How to live—someone asked me in a letter,
someone I had wanted
to ask the same thing.

Again and as always,
and as seen above
there are no questions more urgent
than the naïve ones.

—WISŁAWA SZYMBORSKA, "The Turn of the Century"

Contents

𝒦

Illustrations

✌

Unless otherwise noted, all photographs are in the family collection of Barbara Rylko-Bauer.

Photographs

Maps

Acknowledgments

∂

THE PROJECT OF DOCUMENTING my mother's life began thirteen years ago. But its incubation started much earlier, so the list of people to whom I owe a debt of gratitude is quite long. Topping that list are three physicians who deserve my deepest thanks: my mother, Jadwiga Lenartowicz Rylko, for the gift of her story and for her love; my husband, Daniel Bauer, for his constant encouragement, loving patience, and insightful comments; and my friend Paul Farmer, who from the beginning believed in this "ethnography of rediscovery," and challenged me to think beyond the story.

For years before this project began, a core group of friends—fellow anthropologists—saw the significance of this story, trusted in my ability to tell it, and repeatedly urged me to document my mother's experiences: Barbara Herr Harthorn, Mary Howard, Catherine Kingfisher, Barbara Rose Johnston, Ann Millard, Susan Stonich, Linda Whiteford, John van Willigen, and two who died in their prime, Elizabeth Adelski and Gay Becker.

I also wish to thank other colleagues—all dear friends—who patiently listened to my endless accounts of the project, provided insights on methods and relevant topics, participated in seminars or sessions that helped shape my thinking, or read and commented on different versions of the book. Especially important were Erika Bourguignon, Janet Brashler, Rose-Marie Chierici, Mary Howard, Linda Whiteford, and my collaborator, Alisse Waterston, who helped hone my sensibilities regarding the Jewish experience of the war and its aftermath during our long conversations about parents, Poland, history, and memory. Others who belong on this list include Philippe Bourgois, Ted

Edwards, Gelya Frank, Kris Heggenhougen, Carolyn Nordstrom, Jim Quesada, Robert Rubinstein, Merrill Singer, and Athena McLean, who with Annette Leibing invited Alisse and me to contribute a chapter to their edited volume on the "shadow" side of fieldwork. I also appreciate Virginia Dominguez's support, while editor of *American Ethnologist*, for the article Alisse and I co-authored on our family narratives, and for placing the photographs of our parents on the cover of the journal— thus honoring their stories and the histories they represented.

There were also local friends, non-anthropologists, who supported and cheered me on over this long research and writing process. I especially wish to thank Lucy Alt and Nancy Hejna (my walking partners), Carol Greenburg and Chantal Milligan (who are like sisters to me), Lori Hough (who, as an artist, understood my creative struggles) and Urszula Kassel (who helped me with Polish translations). In addition, I benefited from the friendship and insights of Marianne Dunn, Father Jim Chelich, Virginia Slaight, and the women in my decade-long book club (the "Winers") who were with me on the evening my mother died—Nancy Benzer, Judy Fanjoy, Beth Gumina, Sandy Haverkamp, Rebecca Kalinowski, Pat Marks, Alice O'Donnell, Iris Postma, Mary Richardson, Mary Thompson, Shirley Workman, and Mary Taber (who photographed my mother and me several times over the years).

In Poland, I had the good fortune to meet several people who helped me with my research for this book. Tomasz Andrzejewski, director of the Nowa Sól Regional Museum, provided me with valuable primary and secondary historical sources and graciously hosted my visit to the city in 2011. Curators of the Museum of Independence Traditions in Łódź, Maria Głowacka and Małgorzata Lechowicz, were equally helpful, giving me a tour of the museum, answering numerous questions, connecting me with specific individuals, and directing me to useful sources regarding the women's prison where my mother was initially held after her arrest. I am very grateful to them for incorporating her story into the museum exhibit about the Nazi era. I also received assistance from staff at the National Archives and the Janusz Korczak Hospital in Łódź; from the directors of the Warsaw and the Łódź branches of the Institute

for National Remembrance—Jerzy Eisler and Marek Drużka; and from Elżbieta Marciniak, director of the Dean's office at the Medical University in Poznań, who shared priceless materials relating to my mother's medical education. Finally, these successful trips to Poland would not have been possible without the assistance and kindness of my family in Warsaw and Łódź, who welcomed me into their homes, fed me fabulous food, drove me around, and took care of me in many ways.

Many other people contributed to the research or the book: Krista Hegburg and other staff at the United States Holocaust Memorial Museum; Chris Kochansky and Kate Whelan, who provided early editing; Elizabeth Hadas, who did the final copyediting; and Lisa Kaufman and Peter Osnos, who steered me in the right direction. I especially wish to thank Gretchen Schafft and Dorota Glowacka for their very detailed and useful reviews of the manuscript; Gerry Krieg for his wonderful maps; Ellis White for his photo wizardry; Kathleen Kelly, Alice Stanton, Steven B. Baker, and the rest of the wonderful staff at the University of Oklahoma Press; and most of all Jane Kepp, whose exemplary editing skills helped shape the final version of this book.

My hope is that this book about the past will stimulate readers to think of how we can shape a better future. I dedicate it, with the future in mind, to my son, John, and offer it in memory of my mother and all the women who shared the experiences described in this narrative of her century-long life.

A Polish Doctor in the
Nazi Camps

Prologue

It had been a busy day, so many patients to see, and I had a lot on my mind. Even though I was exhausted, I couldn't fall asleep. I kept thinking about the events of recent weeks and every once in a while would turn on the light to glance at my watch. Sometime after midnight, I finally drifted off.

In what seemed just a few minutes later, I was abruptly awakened by loud knocking and shouts outside my door. I sat up, heart racing, unable for a moment to move or think.

More shouts.

More pounding.

In the middle of the night, this could only mean trouble.

I hurriedly got out of bed, threw on my robe, and rushed to the door. As I reached for the knob, I paused. I had been dreading this moment ever since I found out that Witold, a member of our radio listening group, had been arrested. The Nazis had made it a crime for Poles to own or even listen to a radio, but we were so hungry for news about the war that we took risks.

Over the past few weeks, we had been worrying that Witold would break down under Nazi interrogation and tell everything he knew. How many days would go by before the Gestapo, the state secret police, paid each of us a visit?

I had good reason to worry. Since the Germans had occupied my hometown, Łódź, in September 1939, two of my sisters had been arrested, and one of them was languishing in a concentration camp.

I was petrified. But if I tried to hide, the Gestapo would punish my parents instead. I couldn't have that on my conscience.

Bracing myself, I opened the door, determined not to show how frightened I was. Several men armed with revolvers brushed aside my protests as they brusquely entered the apartment. One of them, who spoke Polish, ordered me to get dressed quickly. I shoved my hands into the pockets of my robe to steady them.

"Why are you here? Where are you taking me? What have I done?"

His only response was to order me to be quiet while the other two searched the small apartment that also served as my medical office. When I started to speak again, he cut me off with a warning to ask no more questions, just to get dressed. "There's no sense in protesting, because we know everything. You might as well come along without an argument."

For a moment, anger overcame my fear, and I demanded that he turn away while I dress. But he refused to let me out of his sight. So I took off my pajamas and put on a slip and dress, stockings, shoes, and then my warm fur-lined coat, a hat, and a pair of gloves. I tried to think of what else I should take . . . Toothbrush? Comb? Money? Documents?

I picked up my purse just as the man grabbed my arm. He hustled me out of the apartment and shoved me into the back seat of a dark car. As I sat there waiting, stunned and shaking, I tried to calm myself by thinking, with a bit of chagrin, that at least now I'd get a break from seeing patients night and day.

I glanced out the window just as the other two men, done with their rummaging, left the building. I couldn't imagine what they had expected to find. As we drove off, I glanced back once more at the building where I had worked and lived for three and a half years. I hoped to God I would soon return.

~

From what my mother told me about the early hours of January 13, 1944, this is how I imagine what she must have thought and felt in the moment her life changed forever.

1

Telling My Mother's Story

༕

W‍HEN THE GESTAPO CAME FOR MY MOTHER on that freezing January night, she was a thirty-three-year-old physician working in Łódź, the city in central Poland where she had been born on October 1, 1910. Her parents had christened her Jadwiga Helena Lenartowicz, although family and friends always called her Jadzia (pronounced Yah'-jah).

Following her arrest, she successively became a concentration camp prisoner, a slave doctor in the vast economy of forced labor that fueled the Nazi war machine, a survivor of a forty-two-day death march, a refugee, a displaced person, a wife and mother, an immigrant, and, finally, a citizen of a new country, the United States. In the course of this journey, she encountered cruelty, violence, and indifference, as well as generosity, courage, and compassion. She discovered hidden strength within herself that, along with large doses of good luck, enabled her to persevere. My mother never again saw the apartment from which the Gestapo took her, or any of her belongings. Twenty-three years would pass before she was able to return to her native city, walk its streets, and visit with family and friends who had survived the war.

The United States became her new home, one that offered freedom and security but also denied her the opportunity to continue practicing as a physician. Medicine was a defining theme in my mother's life. She took great pride in her profession and believed that her skills and medical practice had repeatedly saved her life during the war years. The loss of her profession was something she regretted to the day she died at the age of one hundred.

For many years I knew only bits and pieces of my mother's story. My parents and their friends, most of whom also were postwar immigrants to the United States, preferred not to dwell on the years immediately surrounding World War II. They tended to talk about Polish life before the war, about whatever current political crisis was brewing in Communist-ruled Poland, and about what the local Polish-American community could do to influence those events.

With the passage of time, I became more aware of how different my background was from that of most of my friends and classmates. Born in Germany, I was a naturalized citizen. I grew up in an ethnic enclave that was part of the larger Polish-American community of Detroit, I was fluent in Polish, and none of my extended family lived in the United States; they were all in Europe. When friends asked how this had happened, I would tell them about my father, Władysław Rylko, who had been a colonel in the Polish army and spent most of World War II in a German prisoner-of-war camp. He met and married my mother after the war, when they were refugees living in Germany. And I would tell them about my mother, who had been imprisoned in three different German concentration camps. "But you're Catholic, not Jewish, right?" they would ask. "So why would your mom be in a concentration camp?" People still ask me this question today.

History books, documentary movies, and museum exhibits amply document that from 1933 to 1945 the Nazi regime under Adolf Hitler made Jews their primary target of persecution and, ultimately, extermination through the systematic, state-sponsored program that we have come to know as the Final Solution. Hitler's aim was to kill all the Jews of Europe, and he nearly succeeded, annihilating whole Jewish communities and murdering approximately six million Jews.

But the Nazis despised other groups as well. They saw Roma and Sinti (peoples popularly but inaccurately referred to as Gypsies), along with homosexuals, people with mental and physical disabilities, and people of Slavic descent, as racially inferior and thus expendable, to be imprisoned, worked to death, or killed outright. The Nazis envisioned

the Poles, in particular, as a potential slave population in the projected thousand-year reign of the Third Reich.

And everywhere, the Nazis either executed or deported to a labor or concentration camp anyone, of any nationality or religion, who dared to criticize, oppose, or resist the regime. That was why the Gestapo arrested my mother. She had broken the law forbidding Poles to own or listen to a radio, so she was an enemy of the state who might be working for the resistance in other ways, too.

During the twelve years in which they held power, the Nazis built a massive system of more than forty thousand prisons, ghettos, killing centers, brothels, and numerous types of camps where they detained, persecuted, exploited, and murdered millions of people considered enemies of Germany. In the fifteen months between the day of her arrest and the day she regained her freedom, my mother moved through eight incarceration sites—a prison, three concentration camps, and four slave labor camps. Once in the Nazi camp system, she became, like many other inmates, a small, disposable piece in the economy of forced labor that built Germany's infrastructure and produced its war materiel.

~

It took me years to get around to asking my mother questions about her past, even though friends and colleagues repeatedly urged me to record her story. I talked about starting such a project but procrastinated while concentrating on my own marriage, motherhood, and my career as an anthropologist. I ignored the imperative of time—my mother was strong, vibrant, and healthy, and I assumed she would be around for many more years. Then one day in 2000, while attending a conference, I got together with a former professor of mine for a glass of wine. When he discovered that I still had not begun talking to my mother, who by then was eighty-nine, he looked me in the eye and said bluntly, "At this rate, your mother will die before you even get started." Within a few weeks I sat down with her for our first interview.

My mother, however, was ambivalent about the project and questioned its relevance. "My life has not been all that interesting or special," she said. Perhaps this was a reflection of the conscious decision she and my father made upon immigrating to the United States in 1950—to put the past behind them and look only to the future.

"Anyway," she continued, "this is old history. So much has already been written about all this." She was right that a great deal has been said and written about World War II and the Holocaust, in published memoirs, testimonies, interviews, scholarly books and articles, films, even in graphic novels. But for events of such enormity, how much is enough? Can too much ever be written about them if we are to learn from the past?

"Besides," I said, "your story—the story of a young, female, Polish Catholic physician forced to work as a prisoner-doctor in Jewish women's slave labor camps—would add new details, new angles, to the existing literature, however large it is." For example, her experiences offer a glimpse into the role played by medicine in the labor camps, where the Nazis wanted inmates kept just barely healthy enough to work but where the imprisoned doctors and nurses could sometimes use their skills to resist brutality and offer hope.

"This is why it's important to document your experiences," I urged my mother. I tried to convince her that each person's account contributes a unique perspective and helps to enrich and personalize what we know about that terrible time. Her wartime story, I said, offered an unusual opportunity to describe the Polish Christian experience of World War II without ignoring the targeted persecution of Polish Jews, thus linking (in the words of the Polish poet Antoni Słonimski) "two peoples fed from the same suffering."

All too often, in both historical studies and memoirs of World War II, the experiences of Polish gentiles and Polish Jews are presented as separate and very different events. Some Christian Poles believe that their suffering during the German occupation has been overshadowed by the attention paid to the Jewish Holocaust. Jews, meanwhile, understandably feel betrayed by what happened to them in Nazi-occupied

Poland, a country where Jews had lived since the late twelfth century. Many Jews see Christian Poles primarily through the lens of collaboration—as informers, opportunists, facilitators, or, at best, bystanders in the Nazis' brutality against the Jews. Many also assume, erroneously, that the Nazis situated some of their concentration camps and all their killing centers (Auschwitz-Birkenau, Bełżec, Treblinka, Chełmno, Sobibor, and Majdanek) on Polish territory because they could count on Polish support.

In reality, as the Polish-born Jewish writer Eva Hoffman observes, Poland was "the site of two catastrophes. One was the Nazi war of conquest against the Polish nation and the policy of widespread murder and eventual enslavement of the Poles. The other was the campaign of extermination directed against all Jews of Europe, but executed mostly on Polish territory." My mother's story links those two catastrophes in a remarkable way while respecting without diminishing either tragedy.

~

Reluctantly, my mother agreed that there might be some value in letting me record her story for others to read. On April 10, 2000, we held our first formal taping session as we sat at my dining room table, looking at old snapshots from her time in Germany just after the war. At first she felt nervous about the tape recorder, but soon she forgot it was there. Her photos all resided in old shoe boxes, in no particular order, for my mother had neither time, patience, nor inclination to create neat, themed albums. I would pick a photo, she would look at it and identify the people and setting, and then she would start reminiscing, elaborating on some event associated with the picture. Often the image would trigger a much earlier memory. I was amazed at her ability to recall classmates, street names, and stories about colleagues or relatives. In this simple, unthreatening way, we began the project of documenting my mother's life. It turned out to be a fortunate strategy, for a few years later macular degeneration robbed her of vision to the point that she could no longer see the photos clearly.

Between May and August 2000 we taped a dozen interviews, each of which I transcribed right away. We held additional taping sessions over the next few years, the last one in February 2005, when my mother was ninety-four. We had many informal, unrecorded conversations, too, which I reconstructed and wrote up as notes later the same day. We always talked in Polish, and I translated both the interviews and my notes into English. I soon realized that in translating my mother's story, I was beginning to make it my own, for translating intrinsically transforms the speaker's words as the translator makes choices about how to render words and phrases.

Our interactions usually took place at my mother's dining room table, often over a cup of Earl Grey tea and a plate of freshly baked chocolate chip cookies. Topics also came up during telephone conversations and as we drove places. My husband and I often took my mother along when we vacationed at our cabin on Lake Michigan, in the northern woods of the Upper Peninsula. She loved going there and would take long walks on the sandy beach, enjoying the crunch of zebra mussel shells under her feet, the sound of waves washing ashore, and the sight of swooping seagulls and Canada geese swimming by. She spent hours with our son, John, when he was younger, and late in the afternoon would start preparing dinner, enveloping the cabin in smells of stuffed cabbage leaves, meatballs in mushroom sauce, or Cornish hens with her special stuffing.

Some of our most intense discussions took place at the cabin. Once, I went up alone with my mother for about a week. Several times every day I asked her questions, following up on points from previous taped interviews. One afternoon she helped me construct a genealogical tree, in the process telling brief anecdotes about each family member. Another evening we looked at a map of Łódź to find places from her childhood—no easy task, for some street names had changed since the prewar era. Then late at night, once she was asleep, I would watch a segment of Claude Lanzmann's epic documentary about the Holocaust, *Shoah*, and worry about the deeply buried memories I was bringing back to the surface.

Indeed, there were times when the remembering and recounting clearly distressed my mother. "Enough!" she would say. "Let's not talk anymore, because then I don't sleep at nights, thinking of all this." She would remind me that the past still had the power to torment and haunt: "What happened in the camps has branded me to this day."

Overall, she had a remarkable memory for someone her age, but her narrative was largely a string of anecdotes, told repeatedly and with minimal drama, emotion, or embellishment. In the journal I kept during this time, I often remarked on the matter-of-fact way my mother spoke about frightening and even horrific events. She tended to keep her emotions in check, but I knew that later, by herself, she cried and grieved, for she would sometimes tell me. Just like her, I usually kept my emotions under control during our interviews. Then late at night, as I sat at the computer transcribing a taped conversation or writing up notes I had jotted on a scrap of paper, painful feelings would rise to the surface and the tears would flow.

I wondered whether my mother's favored anecdotes served as safe signposts for her travels into the past. She seemed to delight in sharing humorous moments from her university years and satisfying recollections of her medical work. There were also memories that clearly touched deep emotions. Focusing on familiar anecdotes might have been my mother's way of salving the wounds I was reopening as I explored her past. She rarely dwelt on the horrific, but when she did describe certain traumatic events in detail, such as her initiation into the concentration camp system and her experiences on the death march, I could hear the anger or indignation in her voice. I could see the anguish in her eyes. And I wondered whether those events and their associated emotions were seared into her memory so deeply that she could not delete them.

As my mother slowly revealed some of the painful events of her war experience, I discovered, in hindsight, another reason I had delayed so long in pursuing her story. I still recall the moment when she mentioned, during one of our interview sessions, that she had not been beaten when the Gestapo interrogated her after her arrest. I was

overcome by a wave of relief. The significance of her statement sank in later that evening as I typed up my notes. I realized I had been dreading precisely such a moment. How could I listen to my mother tell me she had been tortured? Or humiliated? How could I bear to hear her describe the brutality against others that she had witnessed? I had been terrified that I might learn things that would break a daughter's heart.

At one point I stopped formally interviewing my mother, because I was stirring up too many painful memories. I worried that I was causing her harm by pursuing her story. Was it worth the anguish? What were the risks of dredging up past history and reopening old wounds?

Interestingly, during this fairly long period when we did no formal work, my mother voluntarily brought up vignettes from the past, even traumatic ones. She seemed to have a growing need to talk, but she wanted to do so on her own terms. I wondered whether our collaboration might be helping my once fiercely independent mother deal with her increasing reliance on me. I was now making her appointments, taking her shopping, doing her taxes, and, when she stopped driving at the age of ninety-five, accompanying her to Sunday mass. In return, she could still cook me occasional meals, bake chocolate chip cookies, and, crucially, answer my endless questions and put up with my tape-recording.

From the start, the facets of my mother's story relating to health and medicine intrigued me, partly because I am a medical anthropologist. I study the social and cultural factors that affect people in sickness and health and shape their health care delivery systems. I peppered my mother with questions about medical school, about what it was like to be a female doctor in the 1930s and 1940s, about what cases she had treated in the camps, and so on. Often, she did not have the answers I wanted and quickly became impatient.

"Stop badgering me with all these questions. It's been over sixty years since this all happened!" she exclaimed more than once. "How do you expect me to remember everything?" On one occasion, she added, "You should have started doing this years earlier. Then I could have told you so much more."

Our discussions ranged over much of the first fifty years of her life, but our primary focus was on the war years and the early postwar period. Considering my mother's advanced age and the passage of time, it was hardly surprising that gaps appeared in her recollections, despite the precision of much of her memory. For example, when I pressed her for details about the routines of daily life in the slave labor camps, she responded irritably, "I don't remember . . . I just did what had to be done." She tended to recall unique events, such as the stemming of an epidemic and people's gestures of solidarity and kindness.

Several times during the first months of our conversations, my mother expressed concern that others would learn about aspects of her life, even seemingly innocuous ones, that she would rather keep private. She showed reluctance to provide many details. Although she was willing to talk to me and clearly took pleasure from the attention I gave her and from our spending more time together, she resisted my efforts to turn the endeavor into a formal research project, as the anthropologist in me wanted to do.

Some of our sessions went smoothly, but at other times I showed up at her doorstep with tape recorder, legal pad, and pen in hand, only to be told to "put those things away!" Sometimes my mother controlled the process through silence and humor. I recall sitting at my kitchen table, ready to record an anecdote about how she had helped rescue a close friend from Nazi deportation, a story with some heroic dimensions. She refused, issuing an emphatic "No!" as she flashed an impish grin and stuck out her tongue. She did not like being portrayed as a heroine, nor did she want to have the story formally recorded, making it a part of the anthropologist's project. Some weeks later, when she was good and ready, she finally told me the story, while I took copious notes.

⁓

As my written notes and interview transcriptions piled up, I struggled with how to tell my mother's story. One of the biggest decisions I faced was whether to approach the project as an anthropologist or as a daughter. My collecting of information for the book—taping interviews, taking

notes, and, from fairly early on, studying World War II history and examining documents from the war years in archives—was certainly guided by my academic training, as was the way I organized all my information. At times I thought of the project as a kind of intimate "salvage archaeology," a last-minute rescue of precious knowledge of the past.

But just as strong as my anthropological training was my emotional response as a daughter learning about her mother's life. Because my mother had lost so much, I valued every item saved by family and friends and later given to her. Personal documents, photographs, letters, an autograph book—these were tangible links to the past, a window into my mother's life. My father, before his untimely death in 1969, had saved a number of things from his and my mother's life in postwar Germany and their immigrant years in the United States. More than once, I have sent him a silent "Thank you!" for not throwing away old identification cards, tax forms, receipts, bank statements, newspaper articles, photographs, and drafts of letters. These became invaluable resources for me, especially because my interviews with my mother focused mainly on the years before and during the war and less on her later life.

It was not until I was well into writing this book that I realized that the story could not end with liberation from the Nazi camps. Displacement and migration were critical parts of the war's aftermath. I wanted to describe my parents' struggles—first in postwar Germany and later as immigrants in the United States—to rebuild their lives after enduring such violence and losing everything.

I treated all the material I gathered just as I would in any anthropological project, organizing family documents, cataloguing photographs, coding the interviews (meaning that I sorted the information according to relevant topics), and doing content analysis (looking for themes that emerged from my mother's narrative). When I actually began writing, however, I found that my identity as a social scientist conflicted with my identity as a daughter who had emotions and subjective views of the kind of person my mother was. Over time, I recognized that both perspectives could shape the project, in different ways.

As the anthropologist who happened to be documenting her mother's life, I used parts of her story to explore larger social issues and academic topics: the political economy of Nazi slave labor; the use and abuse of medicine in the camps; resilience and survival; the complexities of Polish Christian and Polish Jewish understandings of the past; the paradoxes of the U.S. immigrant experience; and the relationship of memory to history. My colleague Alisse Waterston, working on a comparable project concerning her family history, and I have called this approach *intimate ethnography*. The anthropologist uses personal family material—embedded in specific historical and social contexts— to understand traumatic history and situate memories and experiences within larger social forces such as wars, exile, and displacement. This approach also crosscuts the established anthropological genres of life history and historical ethnography.

I spent a great deal of time researching the history surrounding my mother's story. In both primary and secondary historical sources I found information that corroborated, fleshed out, or clarified statements she made and events she mentioned. For example, she had heard that her former church, the Assumption of the Blessed Virgin Mary—situated in the midst of the fenced Jewish ghetto and off limits to gentiles—became a Nazi warehouse during the war. In several books about the German occupation of Łódź, I found photographs of mounds of feather and down bedding piled up in the church against a backdrop of religious murals. Confiscated from deported Jews, the bedding was sorted and stored there before being shipped to Germany. The parish rectory, across the street, served in the 1940s as a post of the Kriminalpolizei (referred to as the Kripo), the German police who patrolled and terrorized the Jewish residents of the surrounding Łódź ghetto. Several years later, during a visit to Łódź, I stood in front of that church and read the plaque now hanging on an outside wall, which proclaimed in English (as well as Polish, Yiddish, and Hebrew): "St. Mary's Parish Church. Between 1940 and 1944, by order of the German occupying authorities, it was a sorting station and a depot for robbed Jewish property."

In 2011, I visited the site of the slave labor camp in the formerly German city of Neusalz where my mother had served as prisoner-doctor. When the Allies redrew Poland's boundaries near the end of World War II, Neusalz became the Polish city of Nowa Sól. Accompanied by the director of the regional museum, Dr. Tomasz Andrzejewski, I visited the factory of the textile firm Gruschwitz, where the Jewish women whom my mother treated had worked. Although the buildings are now in ruins—the firm a victim of Poland's entry into the global economy—I got a sense of how large an industrial complex this had been. The site of the slave labor camp is now the sports field of a high school across the street from the former entrance to the factory complex, and a plaque commemorating the women of the camp hangs on an outside school wall. Andrzejewski shared with me important documents—old postcards, photographs, and a film made by the firm in the early 1940s—that helped me understand the difficult work the women had been forced to do, something my mother could not have told me, for she was not allowed to leave the camp.

Additional historical sources that helped augment my mother's story were memoirs and testimonies by other women who described the time they spent in the same prisons and camps that my mother endured. Documents that I acquired from archives in Poland and Germany stunned me with the personal details that officials had written down about my mother. The prison entry book, yellowed with age but remarkably preserved, which I could barely believe I was holding in my hands at the Łódź branch of the National Archives, confirmed my mother's recollection that she had been arrested around two o'clock in the morning—it was 2:20 A.M., to be precise, but a day earlier than she remembered.

As I began writing this book, I also started presenting papers at academic conferences and publishing essays about my mother's story in scholarly books and journals. She read some of the articles and was generally pleased with them. By then she had come around to seeing the project as a validation of her history, acknowledging, "I suppose I did have a rich and full life, after all." She even chided me now and then

when I spent time on other pursuits, such as shopping. "Shouldn't you be working on the book?" she would ask.

For her, the importance of telling her life story was "so that history does not keep repeating itself, to *ludobójstwo*, this mass killing of people." My challenge, as her chronicler, was to find an effective way of harnessing the power of her story. As my mother so aptly pointed out, "Unless you go through these kinds of experiences yourself, you can listen, someone can tell you all about it, but you have no idea what it is like. You can't even imagine."

Yet I did try my best to imagine what it was like. In 2005 and 2011, I traveled to Poland to see firsthand the places that had been important in my mother's life and dig through wartime records and archives. During those stays in Łódź, I visited the prison where my mother languished for weeks before being transported to a concentration camp. I wandered the streets of the former Łódź ghetto, past my mother's church with its three tall spires overlooking the old neighborhood where she had grown up, and past my grandparents' prewar apartment, situated amid the traces of Jewish ghetto life and death—now commemorated by a scattering of small plaques. Ultimately, I wrote this book from the perspective of a daughter who secondarily happens to be an anthropologist. The foray into my mother's past has been a very personal journey, through which I have rediscovered my own past as well as hers.

My mother tended not to be very analytical or reflective when telling me about her life, and her accounts were often fragmentary. Various versions of anecdotes might contain different bits and pieces, but they matched in the details. To structure this book around my mother's voice, I pulled these versions together into a coherent narrative, and as a result many of the quotations from our interviews and conversations are actually composites of various retellings of a particular event. The words are my mother's; she just didn't necessarily say them all at one time.

I, in turn, shaped the meaning of the narrative by embedding it in its historical context—the Nazi occupation of Poland, Hitler's

exploitation of millions of prisoners as slave laborers, the uncertainty and chaos of postwar Germany, and the challenges of immigrant life in the United States. In the process of adding to my mother's story, to paraphrase the anthropologist Barbara Myerhoff, a "third voice" emerges, the voice of the collaboration between my mother and me as both daughter and anthropologist. What follows is our joint account of Jadzia Lenartowicz Rylko's century-long life.

A Young Doctor in Occupied Łódź

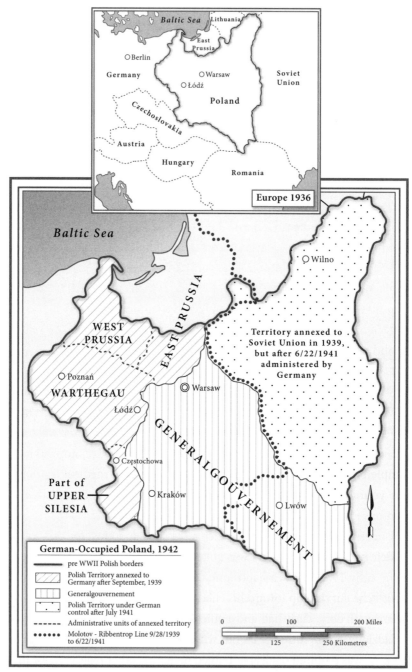

Baltic Sea · Lithuania
East Prussia
○ Berlin
Germany
○ Warsaw
○ Łódź
Poland
Soviet Union
Czechoslovakia
Austria
Hungary
Romania

Europe 1936

Baltic Sea

○ Wilno

WEST PRUSSIA

EAST PRUSSIA

Territory annexed to
Soviet Union in 1939,
but after 6/22/1941
administered by
Germany

○ Poznań
WARTHEGAU
Łódź ○

GENERALGOUVERNEMENT

○ Częstochowa

Part of
UPPER
SILESIA

○ Kraków

○ Lwów

⊙ Warsaw

German-Occupied Poland, 1942

——— pre WWII Polish borders

▨ Polish Territory annexed to
 Germany after September, 1939

▥ Generalgouvernement

▦ Polish Territory under German
 control after July 1941

– – – Administrative units of annexed territory

●●●●● Molotov - Ribbentrop Line 9/28/1939
 to 6/22/1941

0 100 200 Miles

0 125 250 Kilometres

Independent Poland, 1936, and German-occupied Poland, 1942. Map by Gerry Krieg.

2

Becoming a Doctor

☙

IN 1910, THE YEAR JADZIA WAS BORN, Poland as a nation-state did not exist.

During the sixteenth century and the first half of the seventeenth, Polish kings ruled over a large, ethnically and religiously diverse region known as the Polish-Lithuanian Commonwealth. By the end of the eighteenth century, a weakened Poland had been erased from the map of Europe, its vast territories partitioned and annexed by powerful neighbors—Austria, Prussia, and Russia. For the next 125 years, Poland would be a "nation without a state," until negotiations at the end of World War I redrew borders and created a new Poland.

When Jadzia's parents met in the early 1900s, the city of Łódź and its surrounding region were still under Russian control. Jadzia's grandfather Leonard Gąsiorek worked as a doctor in the nearby town of Brzeziny, and he agreed to take on as apprentice a young man who had completed his formal education but needed practical medical training. The young practitioner, Stanisław Lenartowicz, fell in love with his mentor's lovely daughter Helena, and soon they married.

I never knew Stanisław and Helena, my grandparents, for they died in their native Poland when I was quite young. Studio photographs taken in the early 1900s show a handsome couple, both trim, Stanisław with a moustache curving up toward his cheekbones in the fashion of the times, Helena with dark, curly hair and a quiet kind of beauty.

Jadzia was only three years old when World War I began, in August 1914. As was required of all able-bodied men, her father registered for the draft. Because of his medical skills, the Russian army took him immediately and sent him off to the front.

For the next four years, Poles found themselves caught in the middle of the horrific conflict. The three nations that had ruled the former Polish territories for more than a hundred years were now at war with one another, and millions of Polish men were conscripted into the three armies. Much of the fighting on the eastern front took place in Polish territory, bringing many civilian casualties, the seizure of food and livestock, and the destruction of roads, bridges, even entire villages. Nearly a million refugees fled their homes.

A major offensive, the Battle of Łódź, raged during November and December 1914, not far from the city. Even the *New York Times* noted the fierceness of the combat with a December headline stating, "Big Losses in Lodz Battle—German Casualties Given as 160,000 and Russian 120,000." In 1915, the German army captured Łódź itself.

Throughout this time of war and political chaos, Helena Lenartowicz somehow managed to feed and care for her four young daughters. Besides Jadzia, the second child, there were Marysia, the oldest—five years old at the start of the war; Zosia, age two; and Basia, in the cradle. As young as Jadzia was at the time, many years later she could still recall how difficult those years were and how often her family went hungry:

"Since my father was in the army, my mother could count on a small pension. But she had to stand in line for hours to get bread and flour. So our Uncle Zenek, who had quit his studies when the university was closed at the start of the war, would come over to watch us while she was gone. I remember that he would cook us noodles. And when they were made with the darker rye flour, he would try to cheer us up by announcing, 'Today we're having noodles made with chocolate!'"

Along with the daily struggles of running a household and feeding a young family, Jadzia's mother had to live with worry about the fate of her husband. "For a while," Jadzia remembered, "everyone thought my father had died somewhere on the eastern front. He was gone for four long years. But my mother refused to accept that he was dead and was convinced he would return. One day, my sisters and I were playing in the yard when suddenly we saw this strange man with a long beard walking toward us, wearing a heavy sheepskin coat and leaning on a

cane. He called out to us, but we became frightened and ran away—not realizing that our father had finally come home."

~

The end of World War I marked the beginning of the Second Polish Commonwealth. Emerging from 125 years of neglect, subjugation, and wartime destruction, the new Polish state had an underdeveloped, mostly rural economy, with more than 70 percent of the population living in the countryside. Poverty was widespread in both rural areas and the newly expanding cities. The nation faced endless challenges in building up its economy, political structure, and systems of education and public health while integrating the diverse mix of people, traditions, lifestyles, and institutions that had evolved over 125 years of Russian, Prussian, and Austrian rule.

Despite the war's end, border disputes continued. From 1918 until 1922, Poland was involved in six concurrent conflicts, the most important of them with Soviet Russia. Not until 1922 were the nation's borders finalized. On the domestic front, there were many political factions holding widely differing views on Poland's future. The assassination of the first elected president in 1922, two days after his inauguration, boded ill for establishing a stable constitutional government. Four years later, a coup d'état brought Józef Piłsudski, the charismatic military leader who had helped bring about Poland's independence and who served as Chief of State until 1922, back to power as head of the Sanacja regime, which he helped create. He ruled as a popular dictator until his death in 1935.

The rise of nationalism in Poland was reflected in the evolving debate about national identity and the role and status of minorities. Self-identified ethnic Poles made up only two-thirds of the population; the rest included large communities of Jews, Byelorussians, Ukrainians, and Germans. There was a struggle between two alternative visions for the independent Polish state. The first was pluralist and inclusive—a nation of multiple identities united by shared history and values, where loyalty to the state was considered more important than nationality. This perspective was identified with Piłsudski and his supporters and it served to

temper, at least for a while, currents of anti-Semitism. The other vision was defined by nationalistic exclusion—a Poland for ethnic, Roman Catholic Poles in which minorities would have minimal involvement in Polish society, especially Jews, who were seen as dominating political and economic life. This perspective was associated with Piłsudski's rival, Roman Dmowski, and the Endecja movement. The economic depression of the 1930s brought further social and political instability. After Piłsudski's death, Christian-Jewish relations deteriorated, with a rise in overt anti-Semitism, protectionist anti-Jewish policies, and calls for restricting participation of Jews in public life.

~

Jadzia's family seems to have been relatively untouched by the postwar turmoil—at least, my mother never said much about political events during her childhood. Once her father readjusted to civilian life, his medical practice began to flourish, and the Lenartowicz family prospered. A fifth daughter, Halina, was born in 1920. The family lived in a three-bedroom apartment in a part of Łódź known as Bałuty. This was a largely working-class borough, poor and underdeveloped, with a mixture of Jewish and gentile families. When it was incorporated into the city after the war, new construction and renovations began. The apartment building where Jadzia lived had running water and, on the ground floor, a communal toilet for residents.

Jadzia's family was fortunate, for there was always plenty of fresh food—milk, eggs, fruits, and vegetables brought in from the small country estate they owned. Helena came from a well-to-do family and had received a generous dowry, which was invested in this farm, about five miles from the center of the city. A caretaker and his wife tended the chickens and livestock, the small orchard, and the fields where they grew berries, vegetables, and grains. Jadzia recalled that despite a level of economic comfort, her mother worked hard: "She would put up jars and jars of preserves made from plums and cherries, as well as the strawberries, currants, and gooseberries that grew there. And she would can all kinds of vegetables, so we could eat well in the winter."

My mother often mentioned to me the summers spent at the country estate, smiling broadly at her fond memories of playing on haystacks with children from nearby farms and sitting on the edge of the well-stocked fish pond, soaking her feet: "Sometimes I'd wade into the deeper water, and Mama would yell out, 'Jadzia! Don't do that!' But I didn't listen. I was stubborn and tended to do whatever I wanted. I also loved climbing high up in the cherry tree, where I would sit for hours stuffing myself with sweet white cherries."

Jadzia's father stayed behind in the city to care for patients, joining the family on weekends. He liked to hunt, and Helena was an excellent cook, so occasionally the family ate partridge in cream sauce and other country delicacies: "My father also caught many rabbits. My mother used to grind the meat into a delicious pâté, while the pelts were sent off to be worked into warm rabbit-fur collars that went on the winter coats my sisters and I wore."

Jadzia had only eight photographs from the first two decades of her life, sent to her by family members after World War II. One of these was from the early school years; she is wearing her school uniform, and it looks as if her light chestnut brown hair is plaited into a braid wound around her head. Another photo, taken in the country sometime in her

The Lenartowicz sisters: Halina, Jadzia, Zosia, Basia, Marysia; Łódź, 1929.

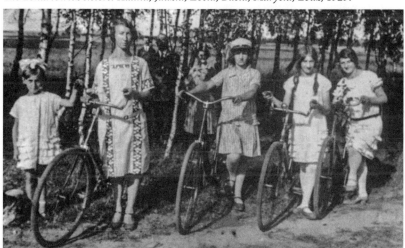

later teens, shows all five daughters posing in front of a grove of birch trees, all but the youngest holding a bicycle. Jadzia stands out, for she is the tallest. Already, her streak of independence is expressing itself. In this picture, she no longer wears a braid. Having decided that a shorter style was more fashionable, she had bobbed her hair without asking her parents' permission.

~

My grandmother had no formal education, nor did she work outside the home. In her day, women from prosperous Polish Catholic families were taught domestic skills—how to run a household, how to raise children, how to be a good and industrious wife. It was the sons whom families sent away to school. Jadzia's parents, however, were determined that circumstances would be different for their daughters. They initially sent each of them for eight years to a private girls school, where they studied Polish and either French or Latin, as well as math, chemistry, history, art, and "handiwork"—sewing and embroidery.

One of Jadzia's closest friends at the *gimnazjum,* the Polish equivalent of American high school, was a young woman named Irka Bolinska. In the fall of 1930, after completing high school and each receiving her certificate of matriculation (*matura*), these two ambitious young women set off for the university in the city of Poznań with the goal of studying medicine together. At the time, Łódź had no medical school. Poznań lay about 125 miles to the west, easily accessible by train, and both students had relatives living there.

Jadzia was following in her father's footsteps—sort of. Her education reflected the modern times in which she lived. Her father had received no university-based medical training, which in eastern Europe at the turn of the century was reserved for the select few. Instead, he had trained as a feldsher (*felczer,* in Polish), which was the Russian version of what we now call a physician's assistant. Feldshers usually received two years of specialized training after completing their basic education and were versed in public health and disease prevention, general medicine, pediatrics, obstetrics, and minor surgery. Many parts of Poland, both rural and

urban, were medically underserved, and feldshers such as Jadzia's father for decades played an important role in local health care, often practicing independently and referring only difficult cases to university-trained physicians.

During a trip to Poland that I took with my mother in 2001, I acquired my grandfather's feldsher certificate, dated June 3, 1909. We were visiting my mother's last remaining sister, Basia, who still lived in the by-now heavily weathered house on the country estate just outside Łódź. After we ate a light lunch, she pulled out several old photographs and documents. The certificate was still in remarkably good condition, if a bit frayed at the edges. Attached to the bottom corner was a photograph of my young grandfather, partly obscured by a cracked red wax seal. Written in beautiful Russian script, the ink aged to a dark brown, the document evoked an aura of old-fashioned officialdom: "Stanisław Augustin Lenartowicz . . . possesses the necessary theoretical and practical skills and preparation to practice as a feldsher."

To help finance their daughters' further studies, Jadzia's parents sold several parcels of land from the country estate. Eventually, two other siblings would join Jadzia in Poznań—her older sister, Marysia, who went on to study horticulture, and the younger Zosia, who became a pharmacist. Halina was never much interested in school and married at a fairly young age, and Basia took classes locally in household management.

~

"The student years—those were the best years of my life!" My mother had just finished relating, at times with delight, some anecdotes from the six years she spent in medical school. In these stories, I glimpse a witty and adventuresome young woman, but also one determined to succeed.

"We had to study a lot, and sometimes it was hard. But we also had time to be carefree, do silly things, to enjoy ourselves. During the first year, we studied skeletal anatomy, a course with lots of memorization and many exams. One day, my friends and I borrowed a skull from the lab and took it home to prepare for an upcoming test. In the evening, when we were done, we lit a small candle in the skull, stuck it in the

bedroom window, and peeked through the curtains to see what kind of reaction this would bring. The neighbors across the way were very upset! But when you're young, you play all kinds of pranks. You can't just be serious all the time."

Nevertheless, much was expected from this new generation—in the case of Jadzia and her friends, studying at a university established just eleven years earlier. They were being trained as the future leaders—in politics, education, law, agriculture, medicine, and fine arts—of a newly independent nation, eager to retake its place in the world. With Jadzia and her peers assembled in the university's auditorium on a Sunday in October, the rector opened the 1930–31 academic year by welcoming the new and returning students and reminding them of their obligation to their nation: "You came here seeking knowledge. That is your first responsibility—to educate yourselves. Not just your mind, but also your will and your heart, to nurture that which is most important in a person and most necessary to the nation—character."

Polish society was changing rapidly, especially in the urban areas. In Helena Lenartowicz's generation, girls seldom had the opportunity for higher education, but by the time her daughter was a young adult, women in Poland were pursuing all sorts of careers and professions. The field of medicine in the 1930s remained primarily a male domain, but that, too, was changing. Jadzia believed that her entering class of 150 included about 25 women, and the proportion increased with subsequent classes. Available statistics show that women made up about 23 percent of the medical school student body at the University of Poznań during Jadzia's last four academic years. The proportion was even larger for the mathematics-biology division (ranging between 38 and 40 percent women) and pharmacy studies (54 to 60 percent women).

My mother had about a dozen photos from her medical school years, given to her by Irka or by family during visits to Poland in the 1970s. Two were taken during the second year of study, in the gross anatomy lab, where sessions were conducted in small groups of a

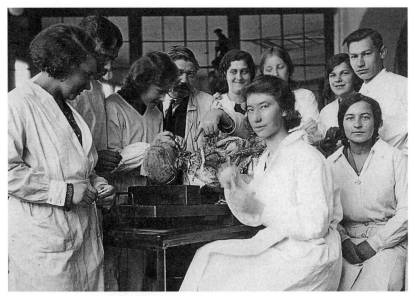

Gross anatomy class, Jadzia (front center); Poznań, 1931.

dozen or so. They show my mother and some of her colleagues, male and female, standing around a partially dissected cadaver. The image of these young women, dressed in white lab coats, clearly confident and comfortable, underscores for me that they were trailblazers.

The medical school curriculum that my mother recalled was daunting even by today's standards. In addition to anatomy, the first year included classes in organic and inorganic chemistry, higher physics, zoology (with a focus on human parasites), embryology, histology, physiology, and the history of medicine. Students had to pass frequent exams before advancing to the next section. Many of the courses extended into the second year, and new ones were added, such as general biology, biochemistry, anthropology, anthropometry, and gross anatomy.

Several years after I interviewed my mother about her medical school experiences, I discovered the course catalogs of the University of Poznań for 1930 to 1936 on the Internet, part of holdings of the Digital Library of Wielkopolska in Poznań. As I looked through the requirements for each of the six years in the department of medicine, I

was awed by how rigorous and wide-ranging the curriculum was and amazed that my mother so accurately remembered the courses she took, more than sixty years after the fact. My admiration grew even greater when, during my 2011 visit to Poznań, I acquired my mother's medical school records, which miraculously had survived both the war and the intervening decades.

~

During their first two years of medical school, Jadzia and her friend Irka lived with Irka's aunt, Mrs. Bolinska, who let out rooms to students because her husband was ill and unable to work. The price for room and board was reasonable, and Jadzia's parents were relieved that the young ladies were under Mrs. Bolinska's watchful eye. Several years later, Jadzia and Irka would rebel and move out so that they could have more freedom, renting a room together in an apartment building that "just by chance" was across the street from a cabaret.

Although medical school demanded hard work and long hours of study, there was also time for friendships and socializing. My mother had a small leather-bound autograph album, a gift from her older sister, Marysia. The album was missing for many years, but in 2003, one of her nieces in Poland found it deep in the back of a drawer and mailed it to us. Although its cover was well worn, the pages were barely yellowed. Among the poems, adages, and drawings inscribed by high school and university classmates was the following sentiment penned by Irka in May 1931, as the students neared the end of their first year of medical studies. Translated from the Polish, it is dedicated to "my companion in our first steps at Poznań University":

> *All earthly things seem uncertain,*
> *For time pulls everything asunder,*
> *One thing, however, remains certain—*
> *True friendship's bonds last forever.*

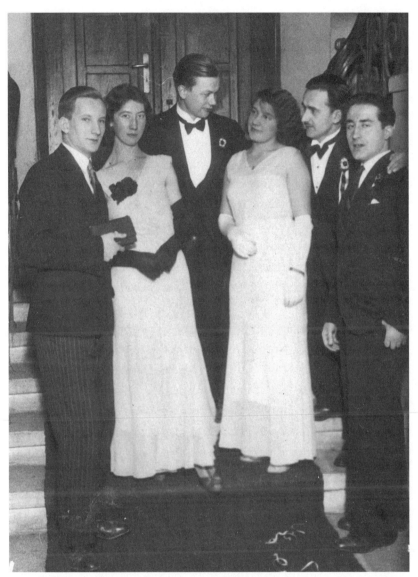

Jadzia and friends at the medical school ball; Poznań, 1933.

In another of my mother's university-era photographs, she poses with several friends, all in formal attire, ready to attend the medical students' ball. During Carnival (*Karnawał*), the period between New Year's Day and the start of the Lenten season, many of the schools held

dances and parties. The festivities often continued well into the night, with just enough time afterward to rush home, change clothes, and make it to the morning lecture.

As I look back on our conversations, I realize that my mother rarely talked about romance or her feelings toward male colleagues. For my part, there was so much I wanted to learn about her first four decades—much of it unfamiliar to me and, once the war began, filled with drama and tragedy—that I did not probe the more personal aspects of her young life. Discussions about close relationships focused mostly on her female colleagues. But from the anecdotes she shared, it was clear that she enjoyed a brisk social life filled with group activities.

I did ask my mother about the ball she attended during her first year of studies and wondered who accompanied her as an escort. Did she have a steady young man by then? She shook her head and started to laugh.

"It wasn't like when you were in school. We didn't go on dates. We all went as a group. We had male friends, and they would come by to pick us up. Mama was visiting from Łódź and accompanied us to this first ball. We all sat at a large table and many young men would come over to talk with us, in part because Mama offered them wine. Then they would bow and ask one of us for a dance. These were our colleagues from medical school, so we knew them. I recall one in particular who invited me to dance. He had long legs and took these giant strides. We were dancing the tango, and since I was quite a bit shorter, he was dragging me behind him! We flew around that ballroom, and afterward, my friends and I laughed about my 'great partner.' I certainly didn't dance with him again!"

When my cousin Ewa visited from Warsaw in 2008, she brought a CD collection of recordings by one of Poland's most popular singers of the 1930s, Mieczysław Fogg, in the hope that my mother might recall with pleasure some of the tangos and waltzes of her youth. My mother was then ninety-seven, and hearing and memory loss prevented her from recognizing the music. But whenever I listen to Fogg's rich baritone, I am transported to that past and can almost see the young stu-

dents dancing the night away, Jadzia looking lovely and elegant in her first formal dress.

"It was a beautiful celadon green, similar to the color of celery," she told me. "Later, when I had worn it a few times and it became less fashionable, I sold it to Józia, the young girl who worked for Mrs. Bolinska, cleaning and helping in the kitchen. Józia would also wash our clothes. When I think back on it, she had to work quite hard, and we really weren't very kind to her. We tended to tease her."

Józia came from the countryside and, not surprisingly, looked up to these fashionable, sophisticated young women and wanted to be like them. Jadzia and her friends, for their part, were often short of spending money and viewed Józia, who earned a wage, as a potential source of cash.

"Józia was going home for the holidays, so we told her, 'Come, we have a stylish dress for you.' Of course, she was heavier and shorter than I, so this dress didn't quite fit, but we hitched it up at the waist, telling her that this was the current fashion. We convinced her to buy it. 'It hangs so nicely on you, Józia. You'll cause a furor in the whole countryside.' And she did."

Jadzia and her friends sometimes attended the opera, which was situated close to the medical school. A member of their circle was enrolled in the school of fine arts and could get free tickets, usually in the uppermost balcony. Far below, on the main floor, sat the well-heeled elites. On one such occasion, the young "ladies" yielded to temptation and sneaked in some overripe tomatoes. At an opportune moment during the performance, under cover of darkness, they let the tomatoes fly. A scene ensued as ushers ran up and down the aisles trying to find the culprits while Jadzia and her girlfriends sat quietly, looking demure and innocent. My mother loved telling this anecdote and would admit, with an impish grin, that this was not a "nice" thing to do. Then she would assure me that most of her other pranks and adventures were quite harmless.

There were also more serious activities. The politics of the time spilled over into university life. The rise of ethnonationalism triggered anti-Jewish actions and policies at various institutions of higher learning

in Poland. These included efforts at restricting Jewish enrollment and isolating Jewish students—the most egregious being the introduction of segregated seating, known as "ghetto benches." Since I was unaware of these events at the time when I was interviewing my mother, they never came up during our various discussions.

Jadzia did remember the parliamentary elections of November 1930, and since women had received full suffrage in Poland in 1918, she was able to participate: "We were all Piłsudskowscy [for Piłsudski]. Even though we were students, we had the right to vote, so we worked on this campaign. We had gotten placards urging people to vote for Piłsudski's government, and late at night we ran over to the men's dormitory to put them up. Most of them were nationalists and supported the opposition, Dmowski's party, Endecja. When the fellows saw the placards they began to yell at us. We ran away because we were afraid that they might beat us up.

"On the day of the election, we couldn't wait to find out who won. So at two in the morning, we quietly arose from bed, propped open the door, and sneaked out; we didn't want Irka's aunt, Mrs. Bolinska, to hear us leaving. We ran over to the campaign headquarters, and soon after we got there news came that Piłsudski had won a majority. How we celebrated! We all had a toast, a glass of vodka, and then we snuck back home."

During summer breaks, Jadzia took tutoring jobs to earn extra spending money and, in later years, volunteered with her friend Irka at a local hospital to gain clinical experience. But she also had time to vacation with her university friends at the beaches of the Baltic Sea. They would rent a room in a private home or stay at a *pensjonat*, a boardinghouse that provided meals. Small traveling carnivals would visit these resort towns, and many other students were vacationing there as well. In the evening, someone would bring a gramophone out to the beach, wind it up, and put on records that the young people would dance to late into the night. Several photos from one such trip in 1935 show Jadzia with a sailor's cap perched jauntily on her head, posing at the oceanfront with Irka and another close friend.

Jadzia had grown into an attractive young woman with a lively sense of humor. Her blue-gray almond-shaped eyes gave her an exotic air. Not surprisingly, she had many admirers among her university colleagues. I got a hint of this from her autograph album, which contains bouquets of roses and other colorful flowers sketched by male classmates. She also had a sense of style in the way she dressed and carried herself, something she retained throughout her life. In the sixty years I knew her, she never neglected herself. She had an understated elegance, an eye for classic fashion even when money was scarce, and she wore hats well. Presentation of self was clearly important to her,

Jadzia (right), sister Marysia (left) and their mother; Poznań, 1934.

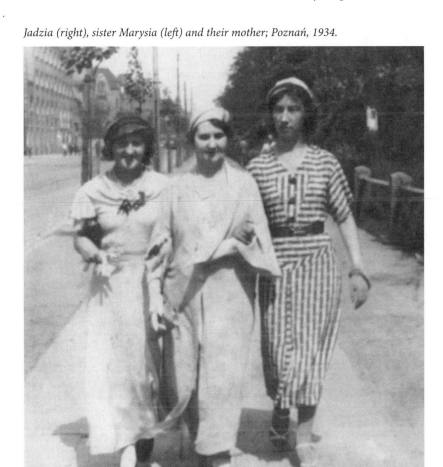

and several photographs showing her out and about in Poznań reveal that she learned this early in life.

In one picture, taken on a mid-September day in 1935, Jadzia, elegantly dressed in a long wool skirt and three-quarter-length light-colored coat with matching hat, is strolling down the street arm in arm with her father, who had come to Poznań to see how his daughters were faring at the university. Another photograph was taken the year before, in May. Jadzia is walking with her sister Marysia and their mother along the street bordering the famous Poznań fairgrounds. The two sisters sent the picture to their mother, with a dedication written on the back, as a memento of her visit to Poznań, and Jadzia acquired it decades later during one of her visits to Poland. A small, framed copy of this photo sat on her nightstand during the last five years of her life, when she took great comfort from having her beloved mother close by.

The Maharajah and "his" retinue; Poznań, 1930.

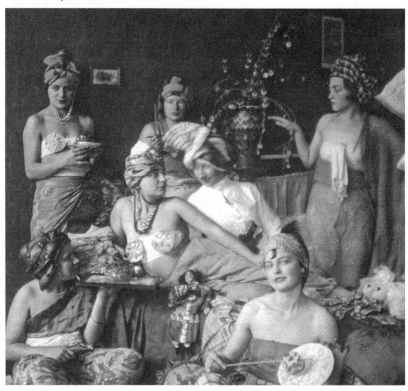

The most interesting photograph from my mother's university years was taken in October 1930. During that first year of her studies, seven young women lived in the Bolinska household. In addition to Jadzia and Irka, they were Mrs. Bolinska's own daughters, Helena and Irena; her goddaughter, Halina Czerejska; and two sisters, Jadwiga and Halina Stankiewicz.

We see seven young, attractive women, full of joie de vivre, posing for the camera, playing out a charade with an East Asian theme. And what a scene!

The participants must have had fun trying to get this tableau right. Clearly paying attention to details, they created inventive costumes and props with materials at hand. Penciled on the back of the picture are the words, "The maharajah with wife and loyal subjects." In the center of the photo, a turbaned prince, pistol tucked in "his" sash, reclines on a divan with "his" wife, surrounded by the attentive retinue. The maharajah is my mother.

This is my favorite of all my mother's photographs. I can feel the tongue-in-cheek mood. I glimpse smiles playing on the lips and in the eyes of several of the women and can easily imagine the laughter that must have erupted as soon as the shutter clicked.

In 1930, each of these young women enjoyed a life filled with challenge and promise: they were friends, all enrolled at university, anticipating new opportunities and bright futures. Helena Bolinska was studying art and had a lively imagination. My mother thought the idea for the charade probably originated with her. Irena Bolinska and Jadwiga Stankiewicz were studying economics. Halina Czerejska wanted to be a chemist. And the other three, Halina Stankiewicz, Jadzia, and her close friend Irka, were going to be physicians.

World War II altered the course of life for these women and prematurely ended the lives of two of them, as I learned one evening when I went to my mother's apartment with a special gift. I had had this photograph restored, and my mother was delighted when I gave her the

framed eight-by-ten enlargement, printed in sepia tones that highlighted the photo's age and exotic tone.

As we sat drinking Earl Grey tea, my mother began to reminisce about each of the women in the photo, at times getting a bit emotional as she pondered their varied fates. These were women with whom she had shared her first two years of university life. Even at the age of ninety-two, her memory of those past years remained remarkably sharp.

Helena Bolinska, my mother knew, survived the war and eventually moved to Warsaw, where she married a pediatrician by the name of Witold Gloksin. She became an accomplished artist, taking part in the juried Warsaw 1966 Festival of Fine Art and other exhibitions. When I accompanied my parents on their first postwar visit to Poland, in 1967, I met Helena and remember eating strawberries with cream in her Warsaw apartment and looking at many of the paintings she had on display. During my mother's subsequent visits to Poland, she bought a number of Helena's oils and watercolors that portrayed well-known Polish landmarks and landscape scenes. These graced the walls of her apartment, and several hang in my home as well.

Helena's sister, Irena Bolinska, was the only one of the seven who did not complete her studies at the university. During a visit to an aunt in Wilno (or Vilnius, in what was then far northeastern Poland), Irena met and fell in love with a Russian aristocrat whose family had fled to Wilno after the Russian revolution. The couple married and had a son before the war broke out. My mother and her friends called Irena's husband "Georgie"; she thought his name might have been Georgy Afanasyev.

According to my mother, when the Soviets invaded Poland in mid-September 1939 and occupied Wilno, they executed Georgy because of his aristocratic background. Broken-hearted, Irena returned to stay with her sister. Her tragedy was compounded when she was diagnosed with a brain tumor. After surgery, she was sent to recuperate at the psychiatric hospital. My mother thought the Nazis "took everyone from this hospital and sent them away, probably to be killed." And so," my mother concluded, "she perished."

Halina Czerejska finished her studies in chemistry and married just before the war. My mother lost track of her and did not know whether or not she survived those times.

Jadwiga Stankiewicz got her degree in economics. When the war broke out, she fled with her fiancé to England, where they married. She tried to convince her sister, now a physician, to leave with them, but her sister refused, saying, "Poland needs us here." Jadwiga and her husband eventually immigrated to the United States and settled in California. My mother stayed in regular contact with her, by phone and mail. In a final Christmas note sent in December 1996, just a few months before she died, Jadwiga wrote: "You will probably be the last and only one of us remaining. I am very sick. It's good that you are wearing the little medal." The previous year, she had sent my mother a small holy medal blessed by the Polish pope. My mother cherished the medal as a memento of their friendship and always wore it on a thin silver chain around her neck.

Jadwiga's sister, Halina, would have been wise to flee to England. Instead, she died needlessly in the early days of the war. She was engaged to another physician and living in Warsaw, training to be a dermatologist. The Germans already occupied parts of the city but continued to bomb it. One day, as Halina stood by a hospital window, a German guard thought she was sending signals to planes overhead and fatally shot her.

My mother's closest relationship was with Irka Bolinska, who survived the war despite some brushes with danger. Their friendship remained strong after the war, even though they lived an ocean apart. They corresponded regularly and never forgot to exchange greetings on their respective *imieniny*, or name days. In the Polish Catholic calendar, each saint has a feast day, and a person's name day is the feast day of his or her patron saint—in Jadzia's case, St. Jadwiga. This is a more important day of celebration in Polish culture than a person's birthday. When my mother traveled to Poland, she always visited Irka, and many of the photographs from my mother's university days—including the one of the maharajah and loyal subjects—came from her.

Sometime in the 1990s, when Irka was seriously ill, she urged my mother to come for another visit so they could see each other one last time.

Unfortunately, this was impossible. The last letter my mother got from her friend ended: "If you don't receive a card from me on your imieniny, you will know that I am no longer alive." There was no greeting that year.

As she finished reminiscing about her former university colleagues, my mother paused, then smiled and pointed to the maharajah in the framed photo: "And then, there's Jadzia. And we both know what happened to her."

She became very still and her eyes brimmed over with tears:

"All of them, my friends, my classmates, my sisters, they're all gone now. I'm the only one left." Then, in a gesture so characteristic of my mother, she clenched her fist to calm herself. After a few seconds, she continued: "You know, those university years were some of the best years of my life. That's why I'm so glad I have this photo to remind me of those good times."

Much later that evening, when I returned to my own home, I took my copy of the photograph down from the shelf. Gazing at it, I thought about the threads of those stories, the ways in which war shaped the life trajectories of those beautiful and intelligent women, so full of promise on that October day in 1930. And I thought especially about my mother, the "maharajah." Knowing even a little about what lay ahead for each of the women in the photograph imbued the image with poignant meaning—which is why I value this photograph above all the others my mother gave me.

~

Jadzia's last three years at university focused on the clinical areas of medicine and culminated, in the sixth year, with final examinations covering many subjects—internal medicine, surgery, dermatology, otolaryngology and ophthalmology, psychiatry, neurology, gynecology, pediatrics, and legal medicine. A passing grade in each was a prerequisite for the diploma, and the whole examining process took about six months.

Jadzia did well in everything but gynecology. The professor was demanding and unsympathetic, at times even vulgar, and not particularly popular. Jadzia failed the test on the clinical aspects of gynecology and

obstetrics. This posed a problem for her, because it happened to be her last exam before the end of the term and the start of the Christmas holidays. Waiting until the next term to retake the test meant paying more tuition and delaying the start of her internship training. Bearing in mind her colleagues' warnings that this professor was known to slam the door in students' faces, she went to see him, planting her foot firmly inside his door so he would have to hear her out. She asked to take the exam again, before the end of the term, on the grounds that this was the only grade preventing her from getting the medical diploma. He relented. Jadzia retook the test and passed.

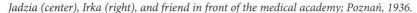

Jadzia (center), Irka (right), and friend in front of the medical academy; Poznań, 1936.

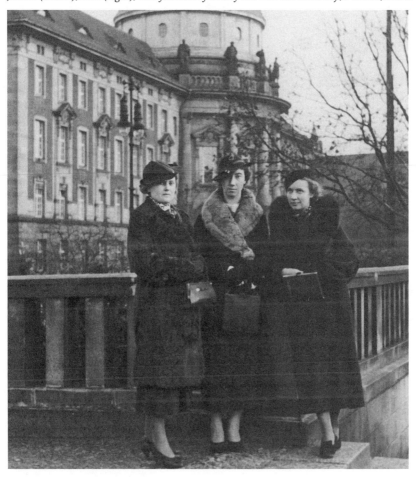

The last photo from this time of her life, taken to commemorate the completion of her studies, is dated October 1936. Jadzia, Irka, and another friend, all fashionably dressed in furs and high heels, lean against a granite railing in the park across the street from the medical school. They no longer look like students; these are mature, poised women, ready to take on the world. It must be late in October, because the leaves have fallen off the trees. Visible in the background are the façade and great dome of the Collegium Medicum, where they had spent so much of their young adult lives.

It had taken Jadzia six years—"the best years of my life"—but in December 1936 she made her final train trip from Poznań back home to Łódź, as Dr. Jadwiga Lenartowicz.

Anna Maria Hospital

๛

THE NEWLY MINTED DR. LENARTOWICZ began her year-long internship early in 1937, working three months at a time in hospitals throughout Łódź, first in surgery, then internal medicine, obstetrics and gynecology, and finally pediatrics. It was a demanding but exciting time to be a young physician in Poland as the republic modernized its underdeveloped health care system—a legacy of 125 years of foreign occupation followed by destruction during World War I.

In 1920, a majority of Polish households had neither safe running water nor sewage disposal, and about a third of the population was seriously undernourished. Infectious diseases, especially diphtheria and scarlet fever, killed many young children, and even in 1935 the infant mortality rate, 140 deaths of infants under one year of age per 1,000 live births, was about three times higher than that in western Europe. Diseases of special concern for people of all ages included tuberculosis, smallpox, typhoid fever, typhus, cholera, and dysentery, although vaccination programs and improvements in public health and sanitation had helped lower the overall death rate by 1938.

Rural areas, where more than two-thirds of Poland's population lived, were especially underserved in health care, but larger towns and cities had their own problems. Łódź in the 1820s was just a small town of 800 residents, but by the late nineteenth century it had become one of the fastest-growing cities in Europe, thanks to its expanding textile, chemical, and metal industries. Multitudes flocked to Łódź from both the Polish countryside and other parts of Europe, searching for work, so that by 1910 it was a densely populated urban area of 512,000. The

city's nickname was the "Promised Land," a sobriquet reflected in a novel of the same name, *Ziemia Obiecana*, written in 1898 by the Nobel laureate Władysław Reymont—one of Jadzia's favorite authors—about life in Łódź during the Industrial Revolution. That Łódź was a hotbed of worker protests and strikes—the first workers' political party in the Polish territories, Proletariat, was established there—attests to the fact that for many, the promised land never materialized.

By the late 1930s, Łódź had grown to more than 650,000 residents. This rapid expansion brought with it industrial pollution, lack of adequate housing, problems with public sanitation, and poor access to health care. During the 1920s and 1930s, public health efforts aimed at testing water and food safety, tracking the incidence of diseases, organizing mass immunization campaigns, and constructing sewage systems and safer wells had helped reduce some serious diseases. Tuberculosis and typhoid fever, however, linked as they were to poverty and its associated conditions—malnutrition, poor sanitation, and poor housing—remained serious scourges. The long workdays imposed by many factories, unhealthy work settings including dangerous machinery and exposure to dust and chemicals, and crowded living conditions exacerbated the health problems of workers and their families. The need for physicians and dentists in Łódź was acute.

Indeed, the whole country urgently needed health care personnel, since some 4,000 doctors from the Polish territories had died during World War I. Poland had just five medical schools and in 1933 there were only 10,644 physicians for more than 32 million people. By 1938 the number had risen to 13,000, but the ratio was still low—about 37 physicians per 100,000 people, in comparison with countries such as France (65) and Czechoslovakia (74).

Serious discussion about establishing a medical academy in Łódź began in the 1930s. Academic courses were scheduled to begin in October 1940, but the start of World War II derailed those plans, although they continued to evolve clandestinely. Soon after the war's end, the Faculties of Medicine, Dentistry, and Pharmacy were estab-

lished within the University of Łódź, with the respected Anna Maria Hospital for Children serving as a base for teaching and training medical students as well as postgraduates in pediatrics.

Jadzia would have benefited from these changes. She was planning a combined private and hospital-based practice after completing her residency training and even thought of eventually doing doctoral studies. In the late 1930s, Jadzia's future seemed filled with opportunities.

～

For the final three months of her year's internship, Jadzia transferred to the Anna Maria Hospital to do a pediatric elective and stayed on for specialized residency training in pediatrics. Her father and the hospital's director, Dr. Tadeusz Mogilnicki, knew each other through patients whom her father had referred there. My mother noted, with a smile, that "Dr. Mogilnicki used to call my father a 'tailor of daughters' because there were five of us and no sons."

By the time she started her postgraduate medical training in Łódź, the Anna Maria Hospital was a well-established and prestigious institution, having expanded from an initial 60 beds in 1905 to 350. Even though it was not then associated with a medical school, the hospital was considered innovative and on a par with the best university-based pediatric clinics in Europe. As early as 1908, the first pediatric section of the Polish Medical Society was established at the hospital, and later the first Polish pediatric journal.

Not surprisingly, the Anna Maria Hospital attracted highly respected specialists with its first-rate teaching, research, and training program. Many of the hospital's physicians were also active in public health and welfare projects focused on the needs of children, such as preventing and treating tuberculosis and reducing the high death rate for very young infants.

The hospital's dozen or so red brick buildings, known as pavilions, were built in a neo-Gothic style, with arched windows and doorways and decorative brickwork along the rooflines. Their layout—each build-

ing set 50 to 250 feet apart from the others—was unique in Poland at the time. Having evolved in major European cities during the nineteenth century, the design was believed to minimize the spread of infectious diseases between pavilions. In keeping with the popular notion that fresh air and a natural environment promoted health and healing, the hospital grounds were planted with trees and shrubs, creating an inviting, parklike setting.

Each pavilion was devoted to a different pediatric specialty or illness—for example, one to internal medicine and another to neonatal care. One building held a surgery that included an orthopedic ward, and one offered exam rooms for eye, ear, nose, and throat problems. Four pavilions housed patients with infectious diseases, reflecting the fact that these were the predominant causes of illness and death in children before the ready availability of antibiotics. One building was exclusively for diphtheria, another for scarlet fever, and a third for tuberculosis, perhaps the most serious infectious disease of the time. The second floor of the TB pavilion opened onto a large terrace where children with the disease could sit outside and take "sunshine baths."

The last pavilion, built in 1938, after Jadzia had begun her residency program at the hospital, specialized in the isolation of children sick with other contagious diseases. It had a unique centrally located observation area, structured so that staff could treat a variety of illnesses separately but simultaneously. This layout made a lasting impression on Jadzia.

"Along the inside walls there were separate wards, isolated one from the other. Children lying in each specific ward had the same contagious disease, be it dysentery, measles, typhus, or polio. Each ward had its separate door. You would first enter a small foyer where you would change, taking off the white coat you generally wore, to put on a special gown, along with mask and white booties. Only then could you enter that ward to visit the patients. Each of the wards had a large window facing into the central room of the pavilion, where the nurses sat and observed all the children. This way, they were right there when the children needed help. And the parents could come and visit their child

without having direct contact. I really thought this was a good system, and it kept diseases from spreading to others in the hospital."

During her internship, whenever Jadzia was not required to be on call in the hospital, she lived with her parents. While she had been attending medical school in Poznań, her family had moved into a larger apartment on Zawiszy Czarnego Street, still in the old Bałuty neighborhood. It was newly furnished with a comfortable sofa, a beautiful dining room set, a Persian rug, and lace curtains imported from France. Four of the rooms served as living quarters, and the other three formed her father's medical office. One was a waiting room for patients, the second served as the examining room, and the third room was to be Jadzia's office after she finished her training—or so her father envisioned. Jadzia, it seems, had other plans: "I would never have agreed to living at home and working with my father! I wanted to have my own private practice and my own life."

After finishing her internship, Jadzia moved from her parents' apartment into the quarters provided at the hospital for resident physicians. "When I first started, there were three other women doctors doing their residency. We all got to know each other well because, as a house doctor [*lekarz miejscowy*], you had to live in the hospital. Along with me, there was Marysia Wichura, Janka Więckowska, and another doctor, named Marta Cebrzyńska. She left after a year, and Irka Kraj came to take her place. Several of us were from the University of Poznań, and we really worked well together, cooperating, helping each other."

The first floor of the main administration building held an ambulatory clinic, the admissions office, and an area for medical records. The house doctors, along with other staff, lived on the second floor. "As part of the residency, we got room and board. There was a bedroom for each of us and a common kitchen and dining area. I had a small electric burner in my room, so I could make myself some coffee or tea. We shared the services of a maid—she would wash things for us and clean our rooms. In addition, I got a stipend of five hundred złoty [the Polish currency] a month."

The only personal item that has survived from this time in my mother's life is her small bankbook from the Polish national bank, the PKO. One of her sisters managed to save it as a memento of those prewar years. Jadzia's monthly stipend was sufficient to take care of her needs, with some to spare for savings. The account was opened on August 29, 1938 and the final deposit was made about a year later, just before war broke out.

～

My mother recalled her years at the Anna Maria Hospital with great fondness. Undoubtedly, there were bad days, long hours, moments of frustration, and times of crisis, but those were not the days she remembered. Several female physicians were on staff at the hospital, and they served as valuable mentors for the young women who, as house doctors, were just entering clinical practice.

"Each of us was assigned to a different service at the hospital. You would spend three months on internal medicine, then three months working with newborns, then another three months on the scarlet fever service, and so forth. Each service had its chief [*ordynator*], under whom you worked, making rounds, taking notes, getting lab results, writing orders, learning procedures, attending autopsies. I would sit up late into the night, filling out charts, describing the care given to patients, and so on. We would also alternate being on call twenty-four hours at a time for any emergencies that came in."

With increasing experience, Jadzia gradually took on greater responsibilities for patient care: "Dr. Anna Margolis, a pulmonary specialist, was the chief of the tuberculosis service, a very pleasant woman who taught me a lot. When she went on vacation, several months before the war began, she put me in charge. We had a lot of children sick with TB, and I would perform the artificial pneumothorax [*odma*], a standard procedure where you inject air into the space between the lung and the chest wall to create pressure and thus keep the infection from spreading into other parts of the lung."

In the 1930s, many children were hospitalized with infectious diseases for which there were no vaccines; antibiotics were in the early stages of development. For diseases such as diphtheria, doctors used specially prepared serums with antibodies (antiserums), along with antibacterial agents—the prototypes of modern chemotherapeutics and antibiotics—such as Septazine and Prontosil. "Still . . ." my mother paused, then held up her hand as if to emphasize a point, "it's a terrible disease, and sometimes the medicine would not be enough. A child with diphtheria would start to asphyxiate, gasping for air, and everyone would drop whatever they were doing and come running to put in a tracheal tube. We were all trained to do this, but the nurse who worked on that ward was the best, and we learned a lot from her."

Dysentery, which caused bloody diarrhea and resulted from poor hygiene and contaminated food and water, was also prevalent and kept Jadzia busy during her residency: "This was highly infectious, and the children had to be kept strictly isolated. There was an epidemic in Łódź just before the war started, and even my mother got it. She was staying out in the country at the time, and she had to be brought back to the apartment in town. She got medicine, and several times after work Marysia Wichura and I would go there to give her glucose shots to help keep her nourished. We had passes, as physicians, that allowed us to break the strict curfew, but to be safe, we'd spend the night in the apartment and leave early in the morning so as to make it back in time for work at 8 A.M. at the hospital. The epidemic was soon over, and my mother recovered fine."

Of all the physicians on staff at the Anna Maria Hospital, the one for whom my mother clearly had special respect was Dr. Matylda Tomaszewska, the chief of pediatric surgery: "She was an excellent surgeon, with such small, delicate hands, and especially skilled at doing repairs on children with cleft palates. She was also very elegant, always well dressed. After assisting her with an operation, you would get invited to her room for tea and sandwiches. Her husband was an orthopedic surgeon and worked mainly at another hospital but would

come to ours for consultations. He was also president of the Łódź District Chamber of Medicine, where all physicians were registered. They were both highly skilled surgeons and made a handsome couple."

No photographs of my mother exist from this period, but she possessed several documents, acquired soon after the war through the efforts of her sister Marysia, that corroborate her recollections of postgraduate training. One of these, dated January 27, 1948, and signed by Dr. Antoni Tomaszewski, her mentor's husband, attests that Jadwiga Lenartowicz was registered in the 1938 Physician Yearbook of the Polish Commonwealth as a certified physician (under column number 893) and was a member of the Łódź Chamber of Medicine until September 1, 1939.

The conversations I had with my mother about her experiences at the Anna Maria Hospital, unlike her stories of her six years in medical school, were not peppered with anecdotes about pranks and jokes. By 1939 she had matured and, with the heavy responsibilities of residency training and patient care, had little time for frivolity. Concerns about European politics and the growing aggression of neighboring Germany weighed heavily on everyone's mind. As tensions and fears increased throughout Europe during the summer of 1939, the hospital and its staff began to prepare for the contingencies of war.

~

In early August, Jadzia took advantage of her scheduled vacation time to unwind in the Tatry Mountains of southern Poland, near the picturesque resort town of Zakopane. "I actually stayed in Poronin, a smaller village nearby," she remembered, "because I could rent rooms there much cheaper. I would walk down to Zakopane, where there was a wonderful café, and just sit, relax, drink coffee, and enjoy their delicious cakes. Early August was a busy time there."

This tranquil scene belied the growing apprehension in Europe generally and in Poland particularly. Everywhere people sensed that events were bringing the continent ever closer to conflict. During Jadzia's stay

in the mountains, she recalled seeing military preparations going on in the area—Zakopane lay close to the Slovak border, and what was then Czechoslovakia was already firmly in German control. After a few days, she decided to cut her vacation short.

Upon returning to work, she found the Anna Maria Hospital in the midst of implementing its contingency plans. Hospital beds would have to be made available for the wounded, staff would need to be ready for crises, and someone would have to organize a response in case of attack, as well as address rumors and concerns. The director of the hospital, Dr. Mogilnicki, chose Jadzia for this last assignment.

High on the list of concerns was the question of how to deal with a chemical attack. After all, chemical warfare had been used during World War I, and the Germans had surely developed more sophisticated technologies since then. The hospital sent Jadzia to a special course on how to prepare for and handle such an eventuality.

"I learned how to use a gas mask. We were supposed to wear them around our necks all the time and put them on whenever we heard planes overhead. Now I realize what nonsense that was! I also got these boots that laced up to my knees. And so I went all around the hospital with this mask and in these boots like an idiot, telling everyone one what to do in case of attack. But I'm sure that if such an attack had actually happened, we all would have died anyway."

She was also in charge of investigating rumors. The hospital's administration assumed that in times of such uncertainty, people would panic. For example, the Germans were sending high-altitude reconnaissance flights over Poland during August, and people worried that overhead planes were actually enemy aircraft coming in to drop bombs. Once, the maintenance man came running up to Jadzia, convinced he had uncovered a spy:

"He was sure he had seen the engineer in charge of the boiler room waving his arms and signaling to planes overhead. The engineer, an older man, had worked at the hospital for quite a long time, but he happened to be of German descent and so was viewed with suspicion."

Some staff members suggested that he should be punished or dismissed from his job, and Jadzia had the task of calming their irrational fears and quelling the wild rumor.

As August drew to an end, preparations continued at the hospital. Dr. Mogilnicki, the director, was a captain in the army reserves, so he left to help organize battlefield hospitals. In his absence, he appointed the pediatric surgeon whom Jadzia so admired, Matylda Tomaszewska, as interim director.

My mother could not remember much about local reaction in Łódź to the historical events leading up to the war, nor what happened there during the first few weeks of September. Events unfolded quickly, and she was preoccupied with her usual workload along with the defense preparations going on in the hospital. Because she also roomed there, she had neither time nor opportunity to observe what went on in other parts of the city or even to keep in close touch with her family.

A young Jewish resident of Łódź, Dawid Sierakowiak, just fifteen when Germany invaded Poland but a keen observer, kept a diary that was discovered soon after the war's end and published many years later. His description of the last week in August mentions the rapid preparations for defense of the city.

"Mobilization! A great many neighbors have been called. . . . The requisitioning of carts and horses continues. . . . I read President Kwapiński's [mayor of Łódź in 1939] appeal for volunteers to dig anti-aircraft trenches. . . . At six o'clock in the morning, I went with Father to dig trenches using shovels provided by the municipal government. . . . Fifty thousand people dug in Łódź yesterday! As of today a night home-defense alert service was established. (We sleep in our clothes)."

In the entry for Wednesday, August 30, Sierakowiak noted that a general mobilization had been issued, and reservists up to the age of forty were being asked to report for duty.

It was around this time that Jadzia's mother came down with dysentery: "I had gotten a phone call about the fact that she was sick and was returning from the summer house in the country. I went over to the apartment on Zawiszy Street to see how I could help my mother, but

she had not yet arrived. Instead, I found the cleaning lady and her son there, and to my surprise, he was wearing a pair of my father's shoes! When I asked her why, she answered that my father wouldn't need them because he had gone off to war."

Jadzia was stunned: "This was the first time I heard anything about this! I knew that a general call had gone out for all able-bodied men to come to the defense of the capital, Warsaw. But I didn't know that my father—at the not-so-young age of fifty-nine—had gone to volunteer. He returned safely several weeks later, with a wounded foot for his effort."

4

Doctoring in Litzmannstadt

𝒫

GERMANY INVADED POLAND on the first day of September 1939. Seventeen days later the Soviet Union attacked from the east, in accordance with a secret treaty, the Ribbentrop-Molotov Pact, which the two nations had signed in August. Warsaw, the capital city, saw fierce fighting, but most of the country fell quickly. By the end of September the conquest of Poland was essentially complete.

Germany had commenced its final planning for the invasion as early as March 1939, when Adolf Hitler instructed his commander in chief to attack Poland so mercilessly that the nation would be politically irrelevant for decades. The Nazis' stated reason for the invasion had to do with territorial disputes and concerns about the treatment of the large German ethnic minority living within Polish borders. As German forces began attacking Polish defenses on the Baltic Sea coast and along Poland's western borders in the early hours of September 1, Hitler made a proclamation to the German army in which he falsely blamed Poland for the start of hostilities:

"Germans in Poland are persecuted with bloody terror and driven from their houses. A series of violations of the frontier, intolerable to a great Power, prove that Poland is no longer willing to respect the frontier of the Reich. In order to put an end to this lunacy, I have no other choice than to meet force with force from now on. The German Army will fight the battle for the honour and the vital rights of reborn Germany with hard determination. . . . Long live our people and our Reich!"

In reality, the invasion of Poland was a land grab. As a first step toward Hitler's vision of the thousand-year Reich, it was meant to

establish what the Germans called Lebensraum, or living space, by expanding into eastern Europe.

German mechanized warfare, especially armored tank assaults supported by heavy aerial bombing and artillery shelling, quickly overwhelmed Polish defenses. This approach to warfare became known as blitzkrieg, or lightning war. The Nazis coupled it with vicious suppression of any resistance. They saw the murder of Polish civilians as a justifiable part of the military operation.

Warsaw, a main target of the blitzkrieg, suffered enormous loss of life and destruction of property, but Jadzia's home city, Łódź, was largely spared. Some fierce battles took place nearby, especially during the Polish army's counteroffensive along the Bzura River, but the fighting stayed well north of the city, and Łódź suffered only minimal bombing. Still, there were victims in those first few days of war, including children. My mother remembered one case in particular.

"A young boy arrived on a stretcher with his shoulder badly torn, and for some reason, Dr. Tomaszewska was unavailable. Another house officer, Marysia Wichura, and I were on the surgery service at that time and we tried our best to repair the boy's wound with the help of Mrs. Paula, the surgical nurse on duty. This was the first time we operated alone, without supervision. But we managed to stitch up the muscles, connect the blood vessels, and I'm sure the boy did fine."

As it became clear that Polish defenses were being overwhelmed, panic and confusion spread among the residents of Łódź, fed by conflicting news reports and rumors. People knew the German army would march into the city at any moment. Many wondered whether to stay or to pack necessities and leave. But where would they go if they fled? How would they reunite with their families? Where could they remain out of harm's way?

Jadzia's close friend from medical school, Irka Bolinska, was now engaged, and her fiancé had already crossed into another part of Poland. She was trying to find a way to join him. Other former classmates stopped by the hospital to say goodbye to Jadzia. Most of her immediate family chose not to leave Łódź. Her younger sister Zosia,

however, lived in the city of Lublin, where her husband worked as an engineer in an airplane factory. When the war broke out, the owners moved the factory to France via a southern route that circumvented Germany by going through Romania and then west. Zosia and her husband followed but had to stop early in their trip when Zosia, pregnant with their first child, went into labor and gave birth prematurely in a small town in Romania. Mother and baby were too weak to continue the journey, so the family stayed in Romania throughout the war and for decades afterward, living in the capital city, Brasov.

For the residents of Łódź, the terrible waiting ended all too soon. On Friday, September 8, 1939, Dawid Sierakowiak noted in his diary, "Łódź is occupied! The beginning of the day was calm, too calm. . . . Then all of a sudden the terrifying news: Łódź has been surrendered! German patrols on Piotrkowska Street. Fear, surprise. . . . Surrendered without a fight? . . . Mr. Grabiński [a neighbor] comes back from downtown and tells how the local Germans greeted their countrymen. The Grand Hotel, where the General Staff is expected to stay, is bedecked with garlands of flowers; civilians—boys, girls—jump into the passing military cars with happy cries of '*Heil Hitler!*'"

By the end of September, Poland's two-decade existence as an independent state was over. Again the nation was occupied as Germany and the Soviet Union split Polish territory according to their August pact. Although Jadzia's story concerns the German occupation of Poland, the Soviets were equally capable of terror and brutality, as symbolized by the now infamous Katyń Forest Massacre, which took place near the Russian city of Smolensk. The Soviets captured an estimated twenty-two thousand Polish officers, soldiers, and other prisoners in late September 1939, and months later members of the Soviet secret service, the NKVD, murdered them all and buried the bodies in mass graves. Among the victims was Dr. Mogilnicki, the director of Jadzia's Anna Maria Hospital.

For decades the Soviet government denied responsibility for the massacre, forbade public discussion of it, and placed the blame on Nazi Germany. But in postwar Communist Poland, the tragedy was

one of the war's open secrets, something people knew about—because it had touched so many families—but could not publicly acknowledge. My mother had long been aware of the true story, and I grew up with this knowledge, for my mother's cousin Nina also lost her husband there. Mieczysław Rybus had been a physician in Łódź and, like Dr. Mogilnicki, joined the army when Germany and Russia attacked Poland in 1939.

~

The German army quickly consolidated control over its part of Poland and divided the territory into several regions. Łódź found itself in the newly created province of Warthegau (also known as Wartheland), which the Nazis annexed to the Reich along with other western regions as part of greater Germany. In effect, Łódź became a German city. The remaining, unannexed occupied territories, including Warsaw, were placed under civilian German rule within an administrative unit that was designated Generalgouvernement. Poland disappeared as a geopolitical entity, at least from German-made maps.

The Nazis had formulated a ruthless plan, named Operation Tannenberg, for using mass murder to pacify and demoralize a conquered Poland. They slated entire sectors of Polish society, especially the well educated, for "liquidation"—professors, teachers, intellectuals, political figures, nobility, Catholic clergy, leaders in the medical and legal professions, and many other people viewed as potentially able to mobilize popular resistance against German rule. By December 1939, just three months after the invasion, more than fifty thousand Polish civilians had been murdered, of whom at least seven thousand were Jews. In Łódź alone the Nazis arrested several thousand citizens and executed a large number of them by early November. At the end of the war, Poland had lost, through mass executions, deportations, and deaths in concentration camps, about 15 percent of its teachers, 18 percent of its Catholic priests, 45 percent of all doctors, 50 percent of all engineers, and 57 percent of all lawyers.

From the start, Hitler's goal was not only to establish a German empire in eastern Europe but also to implement the Nazis' racist ideol-

ogy, which declared the Germanic "Aryan race" to be the master race, biologically and culturally superior to all others. This thinking translated into a desire to "cleanse" any newly acquired German territory of all peoples whom the Nazis defined as racially, ethnically, biologically, or culturally inferior—Jews, first and foremost, but also ethnic Poles. Years later the Polish poet and Nobel laureate Czesław Miłosz captured the Nazi view of occupied Poland in *Miłosz's ABC's*: "Anus Mundi. The cloaca of the world. A certain German wrote down that definition of Poland in 1942." Miłosz added, "I spent the war years there and afterward, for years, I attempted to understand what it means to bear such an experience inside oneself."

As the historian Israel Gutman wrote, not only did Germany intend to eliminate the Jews from its Polish territories, but "the Polish population was to be thinned out and subjected to a regime of political and sociocultural repression," which began almost immediately with the issuing of decrees. All Poles between the ages of sixteen (later lowered to fourteen) and sixty were required to work, often in menial jobs regardless of their previous positions. Workers had to pay extra taxes. Working papers—*Arbeitskarte*—served as personal identification.

The Nazis operated four main prisons in Łódź, including one for women at 13 Gdańska Street—a place Jadzia would come to know all too well four years later—as well as custody centers, jails, and transit camps. Especially dreaded was Gestapo headquarters on Anstadta Street, in a building formerly home to a Jewish middle school, where brutal interrogations took place. Altogether, some twenty-four places of incarceration lay scattered throughout the city and surrounding region. My mother recalled: "You knew someone was in real trouble when you found out they had been taken to Anstadta. Life was dangerous. There were roundups on the street, at railroad stations, in the marketplace, all the time. The Nazis would suddenly show up, arrest everyone in sight, and ship off the able-bodied to forced labor, either somewhere in the city or off to Germany." Random violence and rule by terror became the norm.

The German authorities viewed Poland as a gigantic labor camp. According to Hitler's own directive, the standard of living was to be kept low: "[Poland] is of use to us only as a reservoir of labour." During the course of the war, the Nazis deported an estimated 1.7 million Polish citizens for forced labor in Germany, where they worked under difficult conditions for lower wages and longer hours than their German counterparts. They received poor food and primitive, cramped housing, often in barracks. Out of their meager paychecks came a special "Polish contribution" tax of 15 percent. During their off time, the workers had little freedom of movement and could not use public facilities. They had to wear a badge—the letter P—at all times and were prohibited from contact with Germans, except in the workplace.

The German economy and war effort depended heavily on foreign forced laborers—civilians taken from Poland, the Soviet Union, France, and other occupied territories, as well as Polish, French, and Soviet prisoners of war. At one point in wartime Germany, foreign laborers made up roughly one-fourth of all registered workers in agriculture, industry (especially armaments), mining, railroads, construction, and even domestic service. Many of the forced workers were housed in cramped quarters in miserable labor camps—perhaps more than twenty thousand of them scattered throughout the Reich in cities and rural areas.

In Łódź alone, the Nazi's Office of Employment, the *Arbeitsamt,* sent more than a hundred thousand Poles to forced labor in the Reich by mid-1942. My mother described the atmosphere of fearful wariness that permeated the city:

"You never knew when something could happen. You had to look out for yourself. I had a twenty-four-hour pass because I was a physician. Nevertheless, when I was out very late, well after curfew, seeing a housebound patient, I would sometimes spend the night with a trusted friend just so I wouldn't take risks."

The Nazis also tried to break down Polish society by undermining its values and curtailing people's social, cultural, and religious activities. Especially in the territories incorporated into the Reich,

the Germans closed most churches, monasteries, and charitable organizations. They saw the Catholic Church as a particularly dangerous supporter of the opposition and symbol of Polish nationalism. In November 1941, the Nazis arrested many priests throughout the annexed territories, including 352 from the Łódź region, most of whom were deported to the Dachau concentration camp.

The Nazis prohibited Poles from visiting libraries, museums, cinemas, and theaters. Signs stating *Für Polen verboten!* (Poles Not Allowed!) and *Nur für Deutsche* (Only for Germans) appeared everywhere. Entertainment for Poles was limited largely to cabarets and pornography, and Poles were forbidden to own all sorts of items, such as bicycles, cameras, radios, leather briefcases, telephones, and gramophones.

I could hear the frustration in my mother's voice as she recalled what daily life was like under the occupation: "You didn't move around a lot. You felt like you were caged. There wasn't much to do socially, since Poles couldn't go to theaters or cafes. There were no movies or concerts for Poles. The regular schools were closed down, but secret schools did exist. You couldn't own a radio or listen to one. And we had to ride in the back section of streetcars."

The Nazi administration closed all secondary schools and universities and allowed Polish children to attend elementary school only up to the fourth grade. In a secret memorandum issued on May 25, 1940, Heinrich Himmler, commander of the German security forces, commented: "The sole goal of this schooling is to teach them simple arithmetic, nothing above the number 500; writing one's name; and the doctrine that it is divine law to obey the Germans. . . . I do not think that reading is desirable." The remaining population of occupied Poland—those neither deported nor killed outright—would consist of "laborers without leaders" and would "furnish Germany annually with migrant workers and labor for special tasks (roads, quarries, construction of buildings)."

German became the official language in the territories annexed to the Reich. Public use of Polish was banned. All store signs in Polish, even Polish names of products sold in shops, had to be removed. Signs,

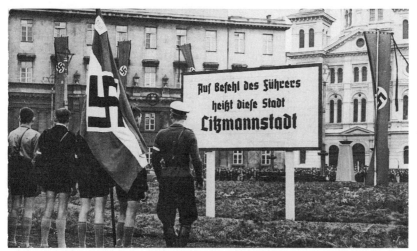

Official sign announcing: "By order of the Führer, this city is called Litzmannstadt;"
Łódź, 1940. Courtesy of Muzeum Miasta Łodzi (Museum of the City of Łódź), ref. no. I-1273.

advertisements, and announcements could be in German only. As a physician, Jadzia had to interact with various officials, so she quickly acquired a working knowledge of German, which would become vital for her in the later years of the war.

In January 1940, all the city streets, parks, and squares received new German names. The main thoroughfare, Piotrkowska Street, became Adolf Hitlerstrasse and the city's Freedom Plaza, ironically, became Deutschland Platz. The street where Jadzia's parents lived, Zawiszy, was renamed Inselstrasse. On April 11, Łódź officially became Litzmannstadt, named after General Karl von Litzmann, who had captured the city from the Russians during World War I.

Part of the Nazis' plan to Germanize the city involved deporting some forty thousand Polish residents by March 1940, sending most of them to the Generalgouvernement. In their stead came Germans from the Reich and ethnic Germans from central and eastern Europe. Another part involved identifying Aryan-appearing Poles, especially children, who were deemed racially acceptable for Germanization. The Łódź public health department, led by SS-man Herbert Grohmann, subjected tens of thousands of Łódź residents to racial examinations.

The Nazis also viewed the disabled and mentally ill as "unworthy of life," and at the start of the war, in both Germany and Poland, implemented a program of "euthanasia" known by the code name "T4." My mother recalled that this happened at the hospital for psychiatric and nervous disorders in Kochanówka, on the outskirts of Łódź: "When the Germans came, they removed everyone from this hospital and took them somewhere, to be destroyed."

Recent studies indicate that between March 13 and March 28, 1940, 550 patients were forcibly taken from the Kochanówka hospital and killed by gassing in mobile vans—a method later applied on a much larger scale to murder Jews and Roma at the Chełmno death camp. A year later, another 290 current and former patients were killed. Similar actions were taken against psychiatric patients in surrounding communities, as well as those in the Jewish hospital on Wesoła Street, which by then was part of the Łódź ghetto.

～

As the Nazis settled into their occupation of Łódź, they dismissed many Polish citizens from their jobs. Administrative, professional, and skilled positions went either to Germans or to people who were considered Volksdeutsche—ethnic Germans born and living outside Germany. The Nazis considered the Volksdeutsche potentially supportive of the regime, even though they were not (nor would they become) citizens of the Reich.

The Nazis encouraged—and in many cases coerced—Polish citizens of even distant German ancestry to register on the Deutsche Volksliste, the official list of people classified as Volksdeutsche. Poles living in territories annexed to the Reich who had even tenuous German family connections, such as through marriage, found themselves strongly encouraged or even forced, under threat of deportation, to join—as long as they were not descended from Jews, Roma, or Sinti (another Romani people). The Nazis' aim was to ensure widespread support for the Reich among the resident population, increase the pool of men who could be conscripted into the German army, and identify "racially

appropriate" populations that could settle the conquered eastern lands. With the latter aim in mind, they created categories of "Germanness" within the Volksliste, with each group receiving a different colored identity card. They even invented a category for Poles whose physical appearance made them appear "racially German."

People listed as Volksdeutsche were exempt from the 15 percent tax imposed on Poles. They enjoyed greater security and had access to more goods, larger rations, and better jobs. In many cases they also received property—furniture, clothing, apartments, shops, even farmsteads—confiscated from Jewish and non-German Poles.

Many Poles accepted Volksdeutsche status, although this did not necessarily mean that they agreed with Nazi policies; some of them acted out of fear or opportunism. Sometimes members of the Polish resistance who had, say, a German grandparent would sign the Volksliste in the hope of obtaining useful sensitive information. One daring example was Halina Kłąb, a young woman from Łódź who later wrote about her experiences under her married name, Szwarc. As a Volksdeutsche, she was able to spy for the resistance movement in both Poland and Germany.

The existence of the Volksliste presented a dilemma for thoughtful Poles with clear German ties. If you signed, other Poles might condemn you as a traitor. If you refused to sign, the Nazi authorities might label you a traitor against the Reich, and you could lose everything—your job, your status, your freedom. Prominent Poles of German descent who openly criticized Nazi policies took especially great risks.

Several staff members at the Anna Maria Hospital, where Jadzia worked, had German backgrounds, among them the administrative secretary, Gertrude Walman, and the head nurse, Maria Teichman. Both women refused to register as Volksdeutsche and were dismissed from their hospital posts. The same was true for one of the infectious disease doctors, Ludwig Gundlach, who was active in the emerging underground resistance movement. He lost his job, endured repeated harassment and interrogation by the Gestapo, and died of a heart attack in early 1941.

People at every level of society felt the effects of the occupation, directly or indirectly. Early on, Jadzia's father, Stanisław, had to stop practicing as a feldsher for a time. My mother recollected hearing about an incident in which her father challenged the authorities—perhaps over the loss of his former apartment, the family's possessions, and much of their country estate—and he may even have been jailed briefly. Eventually, he was able to resume his medical work, as is revealed by several war-era documents, written in German, that Jadzia's older sister, Marysia, managed to preserve. One permit—torn and yellowed with age, dated July 1, 1943—authorizes him to work as a feldsher in private practice inside the city of Litzmannstadt. The other is an identity pass (*Sperrstundenausweis*) similar to the kind that Jadzia had, allowing him unrestricted movement during curfew hours so that he could visit the sick.

Early in the occupation of Łódź, the German authorities began to take control of public and social institutions, including hospitals. By January 1940, Jadzia's place of work had been renamed the Anne-Marie Kinderkrankenhaus, signaling sweeping changes ahead. German policy

Identity pass issued to Jadzia's father, Stanisław Lenartowicz; Łódź, February 23, 1943.

decreed that Poles were unfit to hold important positions such as hospital physician or administrator. One by one, the authorities removed the Polish staff from the hospital. According to my mother, "They were so well organized, the Germans, you just can't imagine. There were students, Polish but of German descent, who were at the medical school in Poznań with me, several years before the war. No one [in those student years] thought these people were in contact with Berlin. They studied medicine, spoke Polish perfectly, were born in Poland. But all this was prearranged."

When I first heard my mother make this comment, I dismissed it. To think that the Germans had planned well in advance to replace ethnic Polish physicians with doctors of German descent sounded paranoid to me. But when I later read historical accounts of the period leading up to World War II, her statement seemed more believable.

As early as 1936 the Nazis were compiling names of tens of thousands of Polish Christians and Jews whom they considered "anti-German." Later, the Nazi "special operations" killing units, the *Einsatzgruppen*, used this list, known as the *Sonderfahndungslisten*, for targeting individuals and groups. Several organizations, such as the Volksdeutsche Mittelstelle, or Ethnic Germans Welfare Office, were also set up in the 1930s with the purpose of disseminating propaganda beyond Germany and recruiting ethnic Germans who lived elsewhere. In preparing for the invasion of Poland, the Nazis identified places with large German ethnic minorities, such as Poznań, so that sympathetic Volksdeutsche could be used as informers against local Poles. There were also plans to employ such people in auxiliary police and security forces and eventually in professional and administrative positions.

At the Anna Maria Hospital, German and Volksdeutsche personnel, some of whom came from other occupied territories, replaced the Polish medical staff. My mother recalled that an Estonian surgeon was assigned to replace Matylda Tomaszewska, Jadzia's mentor, who was serving then as both chief of surgery and interim director of the hospital:

"This Estonian was quite a heavy man, and he had a habit of marching through the swinging double doors not caring who was behind

him. You had to watch out, or the doors would hit you in the face. I remember Dr. Tomaszewska wishing me good luck as she left and saying that she did not envy my working with him. He had a lot of trouble with one of the first cases that he did after coming to the hospital. Marysia Wichura and I were assisting him on an appendectomy. He searched and searched for the appendix but couldn't find it. He was getting quite anxious and explained to both of us that he was out of practice. The Germans had promised him a good position when they recruited him. But first, he had to spend six months in a transit camp. When a surgeon goes for so long without practicing, it's very hard to start back again. Eventually, he found the inflamed appendix, removed it, and left us to sew the young boy back up."

Jadzia was well into the third and final year of her pediatric residency when she lost her position at the hospital. An official document, written in Polish by the hospital's director, confirms that "Dr. Jadwiga Lenartowicz worked in the Anna Maria Hospital in Łódź as a house doctor from January 1, 1938, to May 31, 1940. On May 31 she was dismissed from the hospital by the occupying forces because she was a Pole."

Jadzia was surprised when she recognized her replacement: "A former medical school colleague from Poznań, Polish but of German descent, came to take my place. We were in the same class, and I remember him as a stout fellow who would walk around carrying this thick walking stick and singing German songs."

Jadzia was relatively fortunate, though, for she was able to continue working as a physician, albeit a general practitioner for the social insurance system. Many leading physicians, including those who were Jewish, either disappeared or were killed in the early months of the occupation. She remembered hearing later that several of her medical school professors from Poznań had been arrested: "The Germans wanted to get rid of the intellectuals, who might cause them problems, who would resist more forcefully than the average person."

When Jadzia went to the Łódź District Chamber of Medicine (*Izba Lekarska*) to register for her new position, she got another dose of the new reality: "As I entered the office, I was shocked to discover that the

former director [Dr. Antoni Tomaszewski], a distinguished surgeon and husband of my mentor, had been dismissed. In his place they had put a young doctor, another colleague of mine from medical school who was also of German descent. He was as inexperienced as I, and yet here he was in this position of responsibility!"

My mother's voice took on a defiant tone as she continued: "I told him that I had been released from the Anna Maria Hospital and that I wanted to continue to work with children. His response was that this was not possible. Instead, I had to take the position assigned to me as a general practitioner in an ambulatory clinic. Well, I hardly knew anything about taking care of adults, so I protested and refused to accept the position. I wanted to work in a hospital.

"He was taken aback and then became angry, saying, 'Oh, you won't take it? Well, then, we'll send you off with nothing but your stethoscope to the Generalgouvernement region.'"

My mother shrugged her shoulders: "Well, I had no choice. What was I going to do, away from family and friends, with just a stethoscope? So I had to agree. I moved into the small apartment on Nowopolska Street that had served as my father's medical office for a short time after my parents were forced out of their former apartment. They had recently made yet another move, this time to the outskirts of Łódź, to our country home. The Nazis had confiscated most of the property there, giving it to a German neighbor, leaving them just the house and a small plot of land. And so I remained in that apartment on Nowopolska Street. This is where I lived and where I saw patients until the day of my arrest."

~

Jadzia was responsible for a sector in the northeastern part of Łódź, and all patients living there who were registered with the social insurance system through their place of work were supposed to come to her for care. "The employer would deduct money from the workers' salaries," my mother explained. "They, in turn, would not have to pay for medical office visits or hospital stays. The doctors who saw these patients

worked for the social insurance system and were paid quite poorly. People could only visit the doctor assigned to their neighborhood or region. If someone wanted to see me from another part of the city, they had to come as a privately paying patient.

"At the beginning, it was really terrible for me because I had specialized in the diseases of children and didn't know much about adult sicknesses, what doses of medicine to give, and so on. I had to figure this out as I went along. Since I was assigned to work for the social insurance system, I could only prescribe what was on the set medications list. Any patient who wanted something different—a better or more expensive medicine—had to pay for it out of pocket."

Jadzia's apartment, which served as both home and office, consisted of three rooms. Patients entered from the street into a large waiting area, which was unheated: "I did have a small stove in my examining room that I would heat with coal. Since people had to get undressed, I kept this room warm. But not the waiting room, which had been converted from a store. In the winter, I could hear the patients stamping their feet as they sat waiting to be seen. From there, a door led into the smaller room that served as the office and exam room. It was furnished with my father's couch, on which patients could lie down, as well as a desk, chair, and small hand autoclave for sterilizing syringes and needles. Beyond that was another, smaller room, where I lived and slept."

A patient would come with a problem and be seen without charge. Jadzia would then fill out a card, noting the date, symptoms, diagnosis, and prescribed treatment. Everything had to be documented:

"Near the end of a designated time period—I think it was every three months—I would send these cards off. I think they went to Berlin, to the Ministry of Health, because Łódź belonged to the Reich. At least, that's where my payment came from. The money was sent to the German Dresdner Bank, where I had an account."

Łódź suffered a shortage of physicians. It had perhaps 115 for almost 370,000 residents still living freely in the city. This shortage was the result of the earlier Nazi persecution of prominent physicians and the loss of Jewish doctors who were now imprisoned in the closed ghetto.

The ratio of German doctors to the German population of Łódź was three times greater, but German doctors were generally not allowed to treat Poles. Not surprisingly, Jadzia worked long hours seeing patients for a great range of health problems. Some of them came with negligible complaints, probably, she suspected, because the care was free. She admitted there were times when she had had enough:

"Occasionally, when I was tired of all those hours of sitting, seeing so many patients that I could barely talk anymore, I would just leave. There were two doors to my apartment, the one from the front, which led to the waiting room, and another one leading from my personal room out the back, where you would walk through the garden. So I would finish seeing the last patient, call Mrs. Kałuża, the woman who lived next door, and she would go out to tell the others that the office was closed, that I'd had to leave on an emergency."

Part of Jadzia's medical practice involved making home visits to patients who were bedridden. Usually she took a streetcar, but if she was called out at night after curfew, which ran from 8:00 P.M. to 5:00 A.M., she often had to walk. Streetcars didn't run then, and carriages were hard to find:

"If the patient lived out in the country, I might get a ride in a wagon. Many who lived outside the city did not work formally, so they weren't registered with the social insurance system. But they had at least a plot of land, and I would get paid with a chicken, or eggs, or potatoes. I would give this food to Mrs. Kałuża—she would make a nice dinner for us all! She and her husband lived in a small wooden house off the same courtyard as I did. Before the war, they owned a large house on one of the major streets in Łódź, and her husband worked as a clerk in the treasury department. But when the Germans came, he lost both their home and his job."

Jadzia was fond of the Kałużas: "They were very good people and helped me out a lot. I would give Mrs. Kałuża my ration cards and she would take care of all the shopping. When she'd tell the butcher that she was buying 'for the doctor,' he would give her a bit more than was allotted. I also shared my extra potatoes and coal, which I stored in a cellar

just outside. The potatoes were from my parents. Coal was rationed, of course, but I had a cousin who was married to a German. Since he was a Volksdeutsche, he was allowed to keep his coal business and always delivered more than I was officially supposed to get. I had no stove, so Mrs. Kałuża would cook for me, and I often ate with them."

From time to time, patients came with the hope of getting excused from work. Jadzia had to be careful. The punishment for providing a false or illegitimate excuse was severe, as she soon learned when she received an official notice from the Gestapo warning her that if she gave out any more illegal work releases, she would be arrested.

Jadzia heard that one of her neighbors had been detained, and that was how she figured out what had happened. A few days before, this man had come to her office doubled over in pain, complaining that his back hurt so much that he could not do his job. She signed a form releasing him from work for a week.

After all those years, my mother was still indignant at the thought of what happened next: "Do you know why he wanted this work release? So he could go into the countryside and buy pork illegally to sell in town on the black market! Our ration cards only allowed us a small amount of meat per week, and it was hard to find good meat in the city. So people would buy it from farmers and smuggle the meat under their clothing. You could make good money on the sly, but if you got caught, you would be sent to prison. Well, they caught this neighbor trying to smuggle pork wrapped around his belly. And he had my work release in his pocket! You can imagine how angry I was! He took advantage of me, knowing full well that I could get into serious trouble if he was caught. But some people didn't bother to think about this. They thought only of themselves, of how they could earn some extra money."

Daily life was hard for most Poles, especially when food rationing began in January 1940. As my mother explained: "Everything was rationed. Coal, meat, sugar, butter, eggs, other food, as well as cloth-ing, shoes, and soap. Things like chocolate were only for the privileged. Everything was for the Germans or for those on the Volksliste. And so

people did things illegally, on the sly, or *na lewo*, as we say in Polish. Well . . . life was very difficult then."

People tried to improve their lot in many forbidden ways—by bribing, smuggling, bartering, selling goods on the black market, providing clandestine services such as teaching older students, forging identity papers and ration cards, stealing ("a bit here, a bit there") from their place of work—all of which the German authorities considered equally illegal. Many goods, services, and activities—whether economic, political, religious, social, or cultural—that had been features of daily Polish life were now forbidden to Poles. And people caught in such actions or with such goods were viewed as opposing the German regime and punished accordingly.

On one level, the Germans were succeeding in their goal of undermining the social and moral order of Polish society, by creating conditions that fostered the informal illegal economy. But the situation was not that simple. Outlawed behavior might feel wrong yet at the same time represent an act of resistance, both to the person engaged in such behavior and to others. The Polish word *zorganizować,* used during the occupation and into the Communist era, captures the creativity people employed to get things done despite legal and bureaucratic restrictions. The word's literal translation—to organize, to fix, or to take care of—does not capture its nuanced meaning, for such "organizing" involved, at the least, some bending of rules, some exchange of favors. In Nazi-occupied Poland, nearly everyone took part in such activities to one degree or another. People were always on the lookout for ways to "organize" whatever they could (*zorganizować co się da*).

Everyone understood the need to make do, the need to survive. But this did not necessarily translate into "anything goes." Tolerance depended on who the victim was. People who stole from their Polish neighbors, knowingly put someone in danger, or benefited by betraying someone incurred disapproval and could even be viewed as traitors. In Jadzia's eyes, the neighbor who had duped her into giving him a false work release deserved condemnation. Unfortunately,

ethnic Poles' disapproval of bad behavior did not necessarily apply if the victim was Jewish. Deprivation and existing anti-Semitism, fanned by Nazi propaganda, led some gentile Poles to betray Jews or exploit their desperate situation and led many others to overlook such heinous behavior.

And if a Pole did something at the expense of the Germans—for example, stole paper and pencils from the German office she worked in or smuggled bits of sugar or bacon or bread from the Volksdeutsche-owned shop where she served customers—the act met with approval. Poles saw actions that deceived or swindled Germans, thwarted Nazi policies, or, better yet, undermined the occupation not merely as necessary for survival but as acts of resistance and patriotism.

～

In the course of making home visits, Jadzia saw all sorts of patients, including some who were miserably poor. War and occupation had left both town and countryside impoverished and reduced many people to menial jobs that were very poorly paid. For some, alcohol provided a temporary escape from uncertainty and despair.

My mother still recalled one case clearly: "I was called out one day to a home on the outskirts of Łódź because the daughter was bleeding badly. The family was living in a small, run-down house, with five children sleeping on the straw-covered floor. At first I was angry because it turned out to be an unnecessary house call. The girl was just having a very heavy menstrual period." As she continued the anecdote, my mother's voice became anguished:

"Then I took a closer look at the other children. I was appalled at how thin they were, with visible signs of rickets. One child had a skull that was so soft—it was horrible! You could tell the father drank. I was so upset by all this—by the neglect, by the fact that they had so many children amid the poverty. So I wrote out a prescription for treating the rickets and gave the father money to buy the medicine. And warned him that I would be back to make sure he had done this and to check on the children."

Another time, a local peasant drove his horse and wagon into town to ask for Jadzia's help because his two daughters were ill: "I agreed to return with him. When I examined the girls, I could see immediately that they had typhus. You were supposed to report such cases to the authorities, but the father begged me not to tell the Germans, because he feared that his daughters would be taken away, never to be seen again. There were two kinds of typhus; one was really contagious and caused epidemics, and the other was abdominal [murine] typhus. The two girls had the second type, and they were lying in a separate part of the house. I told the parents how to care for them, to feed them a very light diet, such as gruel, that was easy on the intestines. I also left them some money and they gave me a fresh chicken in exchange. I broke the rules and did not report these cases. By some miracle these two young girls survived and recovered."

Jadzia also made house calls to patients who paid her privately: "This helped to sustain me, because the social insurance practice didn't pay very well." Several of the families were Volksdeutsche and technically not supposed to visit Polish doctors, but they happened to be former patients of her father's. Some came to her when their children were ill. The purse that Jadzia took with her on the night of her arrest had been a gift from just such a family, Polish but of German descent:

"We had always gone to their shop to buy shoes, so the owner knew my size. He gave me the purse and matching shoes because I cared for his children without charging him money. It was a lovely purse, made of brown lizard skin.

"Then there was another family who ran a shop selling liquor and wine—it had, of course, been confiscated by the Nazi authorities from some unfortunate Jewish family. They would call me whenever one of their young daughters was sick. In exchange, the owner would give me a package with things that otherwise I could not have bought, like chocolate, sweets. I always got a bottle of vermouth, too. I would take all this to my own family."

The extra money Jadzia earned by seeing private patients enabled her to purchase needed supplies for her parents and sisters in the country, who largely depended on her:

"There was a cousin, Maryla, who had a source for extra ration cards. She would sell them on the black market and thus make some money on the side. I would buy the cards from her and take them to a butcher she knew, on Nawrot Street. Of course he, too, had to be paid extra. So all my money would quickly get spent. But at least I would get meat and good sausage.

"On Saturday, after I was done seeing patients, I would get away and visit my parents and bring them all this food. The streetcar did not go out that far, and so I had to walk some distance, in the winter sometimes in snow up to my knees! Later, my friends would scold me and ask if I was crazy, to go walking like that and so late in the day. But because I had a twenty-four-hour pass, I had the right to go wherever and whenever I was needed. If I was stopped, I would just say that I had been to see a patient and would show my pass. I didn't worry too much about being out in the evening (late at night was another matter). Anyway, I didn't have much choice."

5

The Shadow of the Ghetto
℘

IN EARLY FEBRUARY 1940, Jadzia's parents suddenly received an order to vacate their apartment on Zawiszy Street, in the partly Jewish neighborhood of Bałuty. The Nazis were about to turn the area into a ghetto—an urban concentration and slave labor camp where all the Jews of Łódź would be confined.

The Nazis' long-term policy was to make all German territories *Judenrein*, or cleansed of Jews. Obsessed with *Blutreinheit*, or blood purity, they viewed Jews as a contaminating and subhuman race. The initial plan was to kill some Jews and expel all others from the regions controlled by the Reich. But even in 1933, the Jews of Europe numbered about 9.5 million. As Germany invaded and defeated one country after another, it quickly became impossible simply to deport all Jews out of the conquered territories. In any case, other countries, such as the United States, were unwilling to accept large influxes of Jewish immigrants. The Nazis decided instead to deal with what they called the "Jewish problem" by concentrating Jews in enclosed ghettos—a step toward what became the Final Solution, total extermination.

At the outbreak of the war, Christian Poles made up about 55 percent of Łódź's population of some 665,000, and ethnic Germans about 10 percent. The city was also home to the second largest Jewish settlement in Poland, numbering about 223,000 persons, or 34 percent of the population. The Nazis targeted this community in an especially brutal, immediate, and sustained way.

During the first four months of occupation, the German authorities repeatedly issued decrees aimed at curtailing the daily lives of Jews and

their freedom of movement and at undermining the economy of the Jewish community. As early as October 20, 1939, the young chronicler Dawid Sierakowiak noted in his diary, "They have issued an order forbidding Jews to trade manufactured goods, leather, and textiles. Jews are forbidden to buy anything, and they can sell only to Christians. . . . It forces thousands of Jewish families into ruin."

The Nazis blocked Jewish bank accounts, pillaged and confiscated Jewish homes and businesses, removed Jewish lawyers, teachers, artists, and doctors from their jobs, forbade Jewish bakers to bake anything but bread, and instituted Jewish forced labor. The list of restrictions was long and kept getting longer.

To facilitate the targeting of Jews and to separate them from the rest of Łódź society, the Nazis first required that their stores prominently display signs indicating the owner's ethnicity. Then, in November 1939, they ordered all Jews, under penalty of death, to wear a yellow armband. Later, they changed the identifying badge to a yellow Star of David worn on the chest and back. Between November 11 and 15, the Germans destroyed the four great synagogues in the city.

On December 10, a secret order was issued creating a ghetto in the northern part of the city. Two months later, on February 8, 1940, a public decree "regarding the residence of Jews" made this official. The decree stated, among other things:

"In order to concentrate all Jews residing in the city of Łódź in one separate quarter, a residential area will be established in the part of the city northward from Deutschland Square. . . . All Volksdeutschen [ethnic Germans] and Poles still residing in that area must leave it by 29 February 1940, together with their families, furniture, work equipment, and all other portable property. The Volksdeutschen in question will be assigned appropriate apartments within the city of Łódź. . . . The Poles will be assigned residences in another part of the city. . . . These regulations will also state which objects the particular group will be permitted to take with them during the relocation."

To make room for all the Jews being herded into the ghetto, Jadzia's parents and their non-Jewish neighbors received orders to leave their

apartment on short notice. Jadzia was still working at the hospital at the time, but she recalled that events happened so swiftly that her parents hardly had time to gather their belongings and move:

"My parents got assigned a much smaller apartment on Nowopolska Street. Luckily, my father was able to rent space farther down the street, which became a small, three-room medical office, the one I eventually moved into once I was dismissed from the hospital. This had been a store that the Germans closed down, so there was a basement, where supplies and surplus goods used to be kept. My parents transported whatever they could from their previous home with a horse-drawn wagon, but it had to be done quickly. It was all unanticipated, so I'm sure there were many items left behind. The new leather couch went into the examining room, and they placed their remaining belongings—which they later lost when I got arrested—in the basement. And so people who once were well-off now became paupers.

"I seem to recall someone telling me that at the end of the war, my parents were informed that some of their belongings—maybe a chest or another piece of furniture—from that apartment on Zawiszy Street had survived those years and times and would they like it back. My mother absolutely refused, saying that she could not have anything in her house that came from a place—the ghetto—where people were made to suffer so much."

~

By April 30, 1940, the Nazis had forced all the Jews who had not fled or been deported from Łódź into the ghetto, which they then sealed off from the rest of the city. The ghetto essentially became a huge slave labor camp where Jews were made to produce goods to meet Germany's wartime needs, especially textiles for German army uniforms. At one point, 90 percent of the remaining Jewish population worked in ninety-six workshops and small factories located inside the ghetto, generating huge profits for their Nazi masters. Jewish workers made uniforms, coats, jackets, caps, shoes, straw boots (used over regular boots as insulation for winter battle on the Russian front), and knapsacks for the military

and the police. Almost half of ghetto production, however, went to fill orders from German department stores and private firms for clothing, fine lingerie, footwear, handbags, textiles, furniture, lamps, and similar items. These jobs were ghetto residents' only livelihood, and once the Nazis implemented their plans for exterminating the Jews, work became the only way to avoid deportation to the death camps.

Because of overcrowding and poor sanitary facilities, living conditions in the ghetto immediately deteriorated. Approximately 164,000 people were packed into 1.59 square miles; a year later, in 1941, the area was reduced to 1.47 square miles. Infectious diseases such as typhus fever, dysentery, and tuberculosis rapidly emerged, as did heart problems, probably due in part to the exhausting struggle for survival and the constant fear. The ghetto eventually held not only the Jews of Łódź but also Jews deported from other parts of western Europe—a total of about 200,000 residents during its five-year existence. About five thousand Roma were confined in a separate camp adjacent to the ghetto.

In 1942 the Łódź ghetto became a point of deportation to the Chełmno death camp, which the Nazis established about forty-five miles from Łódź. From January to September that year, 72,745 Jews and 4,300 Roma were murdered at Chełmno by gassing. Guards herded the victims into large panel trucks, which were then sealed and pumped full of carbon monoxide gas from the truck's exhaust pipe. In mid-1944, the Nazis decided to liquidate the ghetto and sent most of the remaining Jews to their deaths, either at Chełmno (7,196 people) or Auschwitz (about 70,000 people). In all, they murdered an estimated 145,000 Jews from the Łódź ghetto.

But the ghetto itself was a place of death. An estimated 43,700 people perished there from physical abuse, malnutrition and starvation, appalling working conditions, disease, and despair. Dawid Sierakowiak, the young diarist, was among them, barely nineteen when he died in August 1943 of "ghetto disease"—a deadly combination of tuberculosis, starvation, and exhaustion. The final entry in his diary, made on April 15, 1943, anticipates the end: "There is really no way out of this for us."

Jadzia's parents stayed only a few months in their new, small apartment before moving again, this time to their country home just outside Łódź. Jadzia, fortunately, was able to take over the space on Nowopolska Street that her father had rented for his medical practice, and it served as her combined living and office quarters after her dismissal from the Anna Maria Hospital.

Looking at a current city map of Łódź, I was surprised to see that Nowopolska Street, where my mother lived and worked from mid-1940 until the night of her arrest, was a relatively short street that backed right up to the old Jewish cemetery, one boundary of the Łódź ghetto. I wondered whether my mother had known what was going on so close to where she lived. "Yes, this was near the ghetto," she said when I asked. "But I lived at the other end, so not right by the boundary. And I didn't understand then all that was happening inside."

This puzzled me—that someone, anyone, could have lived in Łódź during those terrible times and been unaware of the suffering taking place inside the ghetto. Then I realized that I was looking back on events from the safe distance of more than sixty years. For Poles lucky enough to have lived on the "right" side of the ghetto boundary, reality was defined by their own daily uncertainty, their efforts to survive and stay out of trouble in the face of ever-present violence.

As my mother put it, "You didn't go looking for the ghetto. You knew where it was, you knew it existed, but that was all. There was a fence around it, and by the entrance there were German guards, and they controlled who could come in and who could come out. Plus, you didn't have time. You were busy trying to get through each day. Anyway, you weren't allowed to come close to it."

She remembered correctly. Historical sources verify that the Łódź ghetto was one of the most tightly sealed and guarded of all the ghettos the Nazis set up in Poland, making escape almost impossible. Fences and barbed-wire entanglements marked the boundary. A strip of no-man's-land, closely monitored, surrounded the fence, and outsid-

ers were forbidden to approach it. The Warsaw ghetto, the largest in Poland, was even more enclosed, but residents on both sides of the barbed-wire-topped brick wall found ways to smuggle goods and occasionally people in and out.

I have thought a great deal about the juxtaposition of my mother's life in wartime Łódź and the existence of the ghetto. I admit that my mother's general unawareness bothers me. I want her to have been outraged, to have somehow protested or resisted. But I dare not judge her, for I cannot say I would have acted any differently. Few of us are principled or brave enough to speak out against injustices we see in our own communities, and how much harder, how much more dangerous it was to confront or defy Nazi policies. Yet some did have the courage to do so, and part of me wishes, perhaps naively, that my mother had been one of them.

I have also thought about the filters of perception and memory. We inevitably have only a limited view of things that are going on around us, and this view is colored by our personal biases, immediate circumstances, and what those in power encourage or allow us to know and see. It is difficult to say why we remember some events or persons and either suppress or forget others. That my mother recalled little about the ghetto after sixty years does not necessarily mean she was unaware then, on some level, of what the Jews were suffering. Rumors surely circulated; word surely got out. I also do not know the extent to which my mother interacted socially with Jewish Poles, although she certainly knew some families, and at least three of her teachers at the hospital were Jewish doctors for whom she had great regard.

As I talked with my mother about this past, I shared some of the knowledge I was garnering from my reading. I brought over a copy of *The Chronicle of the Łódź Ghetto*, and together we looked at the ghetto map. We were excited to find the street that her parents had lived on, even though it was mislabeled "Zawiska Czarny." She was struck by the size of the ghetto and by some of the buildings it incorporated, such as the church of her youth. She remembered that the Nazis had closed the church down and turned it into "some sort of ware-

house." I pointed out the two photos in the book showing bedding stacked inside the church, which confirmed her memory. She read excerpts from the book over the next few days, and upon returning it, remarked: "You knew the ghetto was there . . . and yet you didn't know. I am amazed that the Germans transported people from towns all over Poland into the ghetto."

Sometime later, I loaned her a book, written in Polish, of recollections by survivors of the Warsaw Ghetto. Once again, her reaction was one of amazement and dismay: "I'm learning things I never knew about. I had no idea how terribly the Jews were treated in the ghettos." The realization that she had not understood what was going on at the time upset her tremendously: "They simply left people there to die. . . . Why did they have to do this, any of this?"

~

My mother still remembered three of the Polish staff physicians at the Anna Maria Hospital who were Jewish—Dr. Henryka Frenkel, chief of internal medicine and the neonatal section, her coworker Dr. Sima Mandels, and Dr. Anna Margolis, director of radiology and chief of the tuberculosis service. Because Jews were singled out from the start of the Nazi occupation, all three of these physicians probably lost their posts by early November 1939, although my mother did not specifically recall such events. These accomplished women were influential in my mother's evolution as a young physician, and she mentioned their names repeatedly during our conversations and interviews. They were her respected mentors, and I felt compelled to find out what had happened to them in the wake of the Nazi occupation.

My mother did not know the fates of Drs. Mandels and Margolis, but she never forgot the tragic story of Dr. Frenkel, who had worked at the Anna Maria Hospital since 1916. Frenkel had studied philosophy at the University of Geneva at the turn of the century and then completed her medical studies in Zurich and Berlin, receiving her doctorate in medicine in 1907. She eventually moved to Łódź. By the time my mother knew her, she was a highly regarded physician and

clinical scholar, having published some forty medical articles before the war. She must have been a remarkable role model for my mother, who recalled that "she was excellent, with an international reputation as a newborn specialist." Frenkel was also deeply involved in public health initiatives to combat tuberculosis and helped establish a unit in the hospital for children under the age of two, at a time when infant mortality in Łódź was alarmingly high.

Frenkel was widowed, but my mother remembered talk of a husband, so perhaps she had remarried. She had two children from her first marriage, who would have been in their teens when my mother began working at the hospital. My mother's voice became tinged with sadness when she related what happened in the fall of 1939: "Sometime around the start of World War II, Dr. Frenkel's husband and son fled to England while it was still possible. The plan was for her and her teenage daughter to join them later. But this didn't happen. Dr. Frenkel wanted to stay at the hospital until the end, and by then they couldn't get out of Poland. As the persecution of Jews escalated, she was driven to despair and committed suicide, along with her daughter." Frenkel died in December 1939 and was buried along with her daughter, Janina, in the Jewish cemetery in Łódź.

I know the least about the life of Dr. Mandels. Like all Jews living in Łódź, she was forced to move into the ghetto, where she continued her work on behalf of children's welfare and consulted in several of the ghetto hospitals. She most likely died in 1944, either in the ghetto itself or in Auschwitz, after the ghetto was liquidated.

Dr. Margolis survived. She had worked at the Anna Maria Hospital for twenty years before the war. Her husband, Dr. Aleksander Margolis, was a highly regarded internist and director of the Municipal General Hospital in Radogoszcz, in the northern part of the city, as well as a city councilman and prominent member of the Jewish socialist organization, the Bund.

In late autumn of 1939, the Nazis began rounding up prominent citizens, both Jews and gentiles—religious, social, and political leaders, as well as professionals. Aleksander Margolis was part of a group

of several thousand arrested in early November and executed by the Gestapo. With her husband gone and rumors circulating of further actions against the Jewish population, Anna Margolis decided to send her two children to stay with a relative in Warsaw and later joined them there.

Soon, along with other Jews in the city, they were relocated to the Warsaw ghetto. There, Margolis managed to enroll her teenage daughter, Alina, in the Jewish School of Nursing, and she herself worked in one of the ghetto's hospitals. In this way they were able to avoid the initial selections for transport to the Treblinka death camp, which began in the Warsaw ghetto in 1942. By early 1943, when it was evident that all ghetto residents were slated for extermination, Margolis managed to send her children out and then escape herself to the "Aryan side." There, she was secretly sheltered by non-Jewish friends.

Margolis's son survived the war posing as a Christian child, living in an orphanage. The daughter, Alina, also passing as "Aryan," became a courier for the Jewish underground resistance movement, playing a critical role in the bold rescue of survivors of the Warsaw ghetto uprising, including one of its heroes and leaders, Marek Edelman, whom she later married.

After the war, Alina and Marek both studied medicine and eventually moved to Łódź. She worked at one of the pediatric clinics of the medical academy, located in the former Anna Maria Hospital, until the "March events of 1968," when she left the country in the wake of anti-Zionist purges instigated by the Polish Communist Party. She eventually settled in Paris, where she became a highly regarded humanitarian.

Alina's mother, Anna Margolis, also returned to Łódź after the war. She served as a professor of pediatrics at the university and director of the TB sanatorium for children, situated north of the city. She devoted the rest of her life, until her death in 1987, to the study and treatment of tuberculosis in children, training many physicians in physiotherapy and publishing scores of academic articles in this area.

If Jadzia had been able to remain in Łódź throughout the war, she would have completed her residency training once peace was restored.

Most likely, she would have continued her postdoctoral studies at the newly established medical academy in Łódź and flourished in her chosen profession as a pediatrician. She might well have ended up a colleague of both Anna Margolis and her daughter, Alina Margolis-Edelman.

6

Resistance and Rescue

ᴀ

ALMOST IMMEDIATELY AFTER POLAND'S DEFEAT, a resistance move-
ment began to take shape. By the end of 1939, a network of under-
ground organizations was already in place throughout the country.
Several were relatively small groups, notably the Communist-organized
People's Army and the right-wing National Armed Forces. But the main
military component of resistance against the occupying forces was the
Home Army, or Armia Krajowa, commonly referred to as the AK. By
mid-1944 the AK had nearly four hundred thousand members. Despite
being poorly armed, the Polish resistance became the largest and most
effective movement of its kind in war-torn Europe. It operated clandes-
tine educational and cultural activities, ran a successful underground
press, and conducted a far-reaching campaign of intelligence gathering
and sabotage against the Nazis.

I knew that my mother's older sister, Marysia, had been involved in
the AK. Family members talked about it during our visits to Poland,
and my mother at times related some of her sister's exploits. But when
I asked her for details, she would shrug and claim not to know much
about what Marysia had been up to: "I didn't have time for this kind
of stuff. I was busy working to earn money to support the family." She
had been the only family member steadily employed during the war, so
she did what she could to help her parents, her three sisters (other than
Zosia, who had left Poland), and occasionally two older aunts who had
lost their home and possessions when the Germans seized their house
for use as administrative offices.

One day, while looking through boxes of mementos, I came across a dark red AK identity card with my mother's name on it. Issued in Łódź, post facto, on August 15, 1981, it stated that Jadwiga Lenartowicz was entitled to wear the insignia of an AK soldier from the Łódź district, an area known during the war by the code name "Barka." When I asked my mother about this, she dismissed its importance, saying that Marysia had obtained the card for her during one of her visits to Poland. But when pressed further, she acknowledged that from time to time during the war, she had treated sick or wounded AK members. She was viewed as a "safe" doctor, and people trying to avoid official attention would come to her after hours, entering by the back door of her apartment.

Although my mother did not elaborate, I can imagine several ways in which a doctor might have aided the underground movement without being directly involved. Young members were recruited to help prepare for a future uprising against the Germans, stockpiling first aid supplies, creating manuals for the care of wounded soldiers, and teaching basic first aid practices. I never thought to ask my mother whether she had taken part in such activities, but it is not inconceivable that she did.

Everyone working with the underground had a code name, and according to the identity card, Jadzia's was Jagoda. The name translates as Blueberry, perhaps referring to her blue-gray eyes or, more likely, playing on a diminutive of her name, Jaga. Her sister Marysia had a more dramatic pseudonym, undoubtedly a reflection of both her personality and the extent of her work in the resistance. She was known as Huragan, or Hurricane.

My Aunt Marysia died several years before I became interested in my family history, so I never had a chance to hear her story firsthand. On a visit to Poland after her death, however, family members gave me some written eyewitness accounts that attest to Marysia's involvement in many resistance actions, perhaps even helping Polish prisoners of war to escape. Some of the testimonials were written by colleagues in support of claims Marysia filed sometime after the war in an effort to garner a pension based on her wartime activities.

It appears that during the early months of the occupation, captured, wounded Polish soldiers were treated at a number of hospitals in Łódź and allowed to recover before being deported to POW camps in Germany. I suspect that hospitals were similarly used in many cities and towns throughout Poland. My father, for example, a Polish lieutenant colonel at the start of the war, was captured by the Germans in late September 1939 while serving as commander of the 23rd Light Artillery Regiment of the Polish army. He spent the first four months of the Nazi occupation at the Red Cross Hospital for Prisoners of War in Kraków, in southern Poland, where his regiment had been fighting. Afterward, he was sent to a POW camp in Germany, where he remained until April 29, 1945. My parents met after the war.

Conditions in such hospitals, whether in Łódź or elsewhere, were far from ideal. The Polish soldiers received poor rations and too little care. Marysia and countless others served as liaisons between these convalescing soldiers and various organizations and individual citizens who wanted to help. Many people brought needed supplies, such as medicines, bandages, bedding, clothing, food, and books; others offered care and companionship to boost the wounded soldiers' morale. My mother remarked on how committed her sister was to this cause:

"Marysia would go around and talk neighbors into donating food. Others would cook meals and bring them to the soldiers. My own parents had provisions stocked away for the coming winter. They had this small room where they kept potatoes, fruit preserves, and vegetables that my mother had canned. Marysia carted all this away. I came home once for a visit and found the shelves almost bare."

For the most part, the German authorities, preoccupied with consolidating their rule, neither encouraged nor prohibited these efforts on behalf of the POWs. Still, resistance operatives tried to stay under the radar. Sometimes they were able to help POW officers, once sufficiently recovered, escape from the hospitals. They also prepared and mailed food packages after the recovered soldiers were sent off to POW camps—an illegal action, for such packages were only supposed to come from family members. When Marysia did this, she would

claim to be a soldier's fiancée. At times she recruited her younger sister Basia to help. And eventually, their work came to the attention of the German authorities.

~

On May 8, 1942, the Gestapo arrested Marysia and Basia. At first they incarcerated them in the Police Prison for Women on Gdańska Street in Łódź. Soon afterward, Jadzia, too, came under Gestapo surveillance, simply because she was their sister. The police brought her in for lengthy questioning, but she managed to convince them that she was too busy taking care of patients to notice what her sisters were involved in or to take part in any underground organization.

Nevertheless, suspicions had been aroused, and Jadzia soon noticed that one of her Gestapo interrogators was following her. He even sat in her waiting room a few times while she was seeing patients. This unnerved but also irritated her. "What is this?" she wondered. "What does he want? Why is he running after me like this?"

One day, she finally had enough and decided to shake him. This was a story my mother told repeatedly, with great relish and delight:

"Here's what I did. I was waiting to catch a streetcar, on my way to visit a patient—actually, it was a cousin of mine whose little girl, Hanka, was sick and I was going to see her after my office hours. I was walking along Konstantynowska Street, and every once in a while, I'd stop for a moment in front of a shop window, pretending to look at the display. But I was actually waiting to see if this fellow would pass on by. I could see him in the reflection of the glass, could see that he was following me. So I continued to walk slowly, pretending I was just shopping.

"I looked into another shop window—he was still there. After a few minutes, I again stopped in front of yet another display, but at the same time, I was keeping my eye out for the streetcar. I could see that the Gestapo agent was still in the distance, walking in my direction.

"So I'm thinking to myself, how to lose him? And then I noticed the streetcar approaching. It came to a stop. And just as it began to

leave, I jumped on. The streetcar drove away, leaving my 'shadow' standing in the street!"

To the family's distress, Marysia was held in the women's prison for about four months, undergoing repeated interrogations. Then the Gestapo transferred her to the Auschwitz-Birkenau concentration camp, where she was registered on September 4, 1942, as a Polish political prisoner.

My mother knew little about Marysia's experiences in Auschwitz, except that at one point she was very ill with typhus and almost died. "We never really talked, during my later visits to Poland, about what we went through in the camps," she said. Nor did she recall when the family finally learned that Marysia had been sent to Auschwitz. But eventually, they began to receive mail from her. I have in my possession one letter, written in 1944, which Marysia's grandnephew gave me during the trip I took with my mother to Poland in the summer of 2001. The letter is handwritten in German, as was required of all correspondence sent by prisoners in Nazi camps.

Every time I take this letter out of the archival sleeve in which I store it for safekeeping, I recall the day I had it translated. I had just finished eating dinner at my cousin Ewa's home on the outskirts of Warsaw, during that trip in 2001. Ewa is a distant cousin, genealogically speaking, but as family, we are close. Her deceased grandmother, whom I always called Aunt Nina, was a dear friend of my mother's.

It was a classic Polish Sunday dinner, which always included soup, this time a rich *rosół*, a beef-based broth with noodles. Following the soup came breaded pork cutlets, boiled potatoes tossed with butter and dill weed, a tomato and onion salad, cauliflower smothered in sautéed breadcrumbs, and, at the end, fresh strawberries with cream. Present, besides my mother and me, were my cousin Ewa, her husband, their two college-age daughters, and the paternal grandparents, Mr. and Mrs. Biernat. As we all relaxed after the meal, I pulled out several old documents I had received the week before while visiting other family in Łódź.

One of the documents was my grandfather's feldsher certificate from 1909. Mrs. Biernat, who for many years had taught Russian at

the high school level, sat down at one end of the room and began to translate the certificate with the help of one of her granddaughters, Agnieszka. My mother and Ewa sat on the couch looking at an old photograph album, with Day, the family dachsund, lying at their feet.

The rest of us gathered at the dining room table, Mr. Biernat looking over our shoulders at Marysia's letter—a torn, stained, yellowing piece of paper that had originated in a place synonymous, to this day, with unspeakable evil and suffering. As he and his granddaughter Ewunia dictated the translation from German to Polish, I carefully wrote it down in my notebook. I find this scene so memorable because of the way I felt at that moment—so connected to both intimate family history and history writ large. Adding to the poignancy was that Agnieszka and I had taken a day trip to Auschwitz earlier in the week.

The letter is written in pencil on the official form that prisoners were required to use. It is dated October 1, 1944, two years into Marysia's imprisonment there. In the box marked *Absender* (sender's address) is written, using her formal name, "Maria Lenartowicz Nr. 18995 Block H Frauenlager—Auschwitz O/S."

The salutation reads, "My dearest parents and Jadzia." Clearly, Marysia did not know that by this time Jadzia, too, was a concentration camp prisoner. She asks: "What is Jadzia doing, has she already forgotten about me?" Near the end of the letter, she addresses her sister again: "My dear Jadzia, on your name day [October 15] may the Blessed Mother . . . give you health and a long life."

Marysia thanks her parents for a letter and package she has received but asks why they do not answer her questions or write more about themselves. She, in turn, says little about herself, except that she is "so sad and lonely, like a tree out in the desert." She refers to people whose names my mother did not recognize, even to Babcia, or Grandmother, although none of Jadzia's grandparents was alive at the time. We wondered whether these might have been pseudonyms or coded messages—a common way for prisoners to communicate with family and friends. Unsurprisingly, considering that such letters

were censored, Marysia says nothing about her situation, how she is doing, or what life is like in Auschwitz on October 1, 1944.

～

A different fate awaited my Aunt Basia after her arrest that day in May 1942. Formally named Bronisława, she was twenty-eight years old, a pretty woman with blue eyes and curly, dark blond hair. Her stay in the women's prison on Gdańska Street was shorter than Marysia's. According to official records, her case was transferred on June 15 to the Office of Employment, suggesting that she was to be deported for forced labor. As Jadzia described it:

"This was not to be a usual kind of labor. Basia was taken from the jail and sent to an *obóz rasowy*, or race camp, that the Germans had opened near us, I think on Brzezińska Street. They set up this special camp for women who had Aryan features, who were blond, blue-eyed, and healthy. This was to be part of the effort to improve the German race. The women were treated well there, well fed. Just before the transport was to leave for Germany, each woman got a pass to go home and say goodbye to her family."

Without documentation, I cannot say definitively that Basia was destined for a breeding program in Germany. But a *Rassenlager*, or Nazi race camp, was indeed located in the former Observantine Monastery in Łódź, at 73 Spórna Street, which intersects Brzezińska Street. This was where rounded-up non-Jewish individuals and families awaited racial examinations to determine their suitability for Germanization. In particular, the Nazis took children with "Aryan" features such as blond hair and blue or green eyes from orphanages, foster families, and refugee camps to centers like the one on Spórna Street for racial testing. Those selected were then sent to Germany for adoption by German families or to camps for further Germanization and schooling. The Germans "processed" an estimated ten thousand Polish children in Łódź alone and, between 1939 and 1945, kidnapped as many as two hundred thousand children throughout occupied Poland.

As early as December 1935, Heinrich Himmler set up a related program called *Lebensborn,* or "Source of Life." Grounded in eugenics and the Nazi philosophy of racial purity, this program encouraged Nazi officers to father children with "Aryan" women, who would then be cared for and would give birth in special Lebensborn homes throughout Germany and, later during the war, in Norway and several other countries.

This plan for increasing the so-called Aryan population was part of the Nazis' effort to reverse Germany's declining birth rate. As the war progressed, the program also became viewed as a means of replacing Germany's war casualties and providing a "racially suitable" population for the eventual "Aryanization" of captured eastern territories such as Poland. In 1942 Hitler expanded the Lebensborn program to include "racially fit" non-German women, and soldiers were even encouraged to fraternize with such women in the countries where they were stationed.

Jadzia learned of her younger sister's apparently intended fate purely by chance: "A certain Volksdeutsche who used to be a patient of mine and who worked at this race camp as a secretary contacted me. He had noticed on the list of women that one of them had the same last name as I did. He came to me and asked, 'Do you have a sister, Bronisława Lenartowicz?' I said yes and asked why he wanted to know.

"He told me what was in store for Basia. Then he said, 'I want to help. I'm in charge of giving out and collecting back the passes these women will get so they can go home one last time. When your sister leaves in a few days, I'll destroy all her papers here in the office. You must take her away somewhere to keep her safe. But this means that she won't have identity papers. If she's caught on the street, she will be arrested.'"

Family members frantically worked out a plan for a successful rescue. On the day Basia was released to bid farewell to her parents, Jadzia picked her up in a horsedrawn carriage driven by a man she trusted, who often took her on house calls to bedridden patients. Accompanying them was Nina, my cousin Ewa's grandmother, a gutsy woman who was involved with the underground resistance.

Jadzia's twenty-four-hour pass, the one that allowed her to move around after curfew, gave the travelers a small measure of security in an otherwise extremely risky venture. Jadzia and Nina first took Basia to stay with one of Nina's aunts who lived in town. Several days later, she was driven to another aunt's home in the country, quite a distance from Łódź. There she remained for several months, until the Gestapo began to requisition properties in that area.

"So then," Jadzia recalled, "she had to move again. In actuality, she didn't exist, since all her identity papers had been destroyed and she could not receive ration cards. She had to stay hidden." My mother often wondered about the psychological effect this situation had on her younger sister—the desperate need for anonymity, the total dependency, the constant fear of discovery.

"Basia eventually hid in the home of our parents for the remainder of the war—in the small country house on the outskirts of Łódź. None of the neighbors or friends could know. When someone was supposed to come over for a visit, she would go and hide in the basement. For three years, she lived under this threat. If the Germans had caught her, they probably would have killed her."

The story of Basia's rescue captured my imagination from the moment I heard it, years ago. I recall a relative telling it matter-of-factly, with few details, during one of my visits to Poland. In my mind, it became an exciting drama, a cloak-and-dagger affair. I pictured Jadzia and Nina hurtling down backcountry roads with the younger sister curled up under a blanket, trembling with terror that at any moment the carriage would be stopped and the rescue plot revealed.

Nowadays, the story's appeal for me rests not in its heroic aspects but in the way it underscores the risks ordinary people took while trying to live day to day in the face of oppression and danger. Those who were unwilling to collaborate fully with the Nazis enjoyed neither security nor well-being. Some Poles benefited from the misfortune of others, but most struggled daily to overlook the shocking, terrifying brutality going on all around them, feeling helpless against adversity or ambivalent in the face of injustice. I am sure my mother was no different.

Yet ordinary people can show extraordinary courage, compassion, and inventiveness in the face of danger or impending tragedy. My mother and her cousin had good reason to risk their lives to save her sister from deportation or worse. But the carriage driver and the Volksdeutsche clerk who worked in the camp risked their lives simply to help another human being and her family. Jadzia made no mention of having paid either of them for their efforts. Her larger story of the war is peppered with examples of small and large acts of kindness by others—friends, family, Volksdeutsche acquaintances, and, later, fellow prisoners and strangers—humane acts that made an important difference in her daily life, helped her cope with danger and stress, and sometimes even saved her life.

I am sure that my mother, too, made a difference in other people's lives, but she rarely shared those stories with me. She probably did not even remember the events, for often it is the recipient of such acts of kindness who understands what danger was averted, what suffering was relieved, and at what possible cost, and therefore never forgets.

I do know, however, of one other instance in which Jadzia put her own safety at risk to help someone dear to her.

⌒

Jadzia's close friend Irka Bolinska, with whom she had gone to medical school, had been engaged to a young lawyer, Tolek Kularski, a fellow student at the university in Poznań. The war interrupted their marriage plans. My mother's voice always took on an affectionate tone when she talked about Irka:

"When the war broke out, Tolek left Łódź and went to stay with his parents in nearby Piotrków, and occasionally he'd come back to visit. But I think the Germans began to round up young people there, deporting them to forced labor camps. So Tolek managed to escape to the city of Częstochowa, which lay just across the border in the Generalgouvernement sector."

To travel legally from Łódź, in the annexed region of Warthegau— now officially a part of Germany—to the Generalgouvernement region

of occupied Poland, a person needed an official pass. But in the early months of the war, the boundaries were not so rigorously patrolled, and it was possible to sneak across the "green border"—places that offered the cover of woods, ravines, or overgrown fields.

Irka lived with her widowed mother in an apartment shared by her sister, Janka, and Janka's husband. He had some kind of international passport that allowed the family more freedom of movement than was afforded to most Polish residents of Łódź. Irka also had an older brother, Bolek, a lawyer who had helped to support her during medical school. Bolek was married to a woman of German descent who came from a wealthy factory-owning family. When the Nazis took over, the wife was given management of a confiscated Jewish textile store. Jadzia got to know Irka's family well and from time to time went to the mother's apartment for dinner, because she had no means to cook for herself and no time, since she often worked long hours.

Jadzia learned that the family had found someone willing to smuggle Irka across the border so that she could join her fiancé. Such crossings, usually conducted at night, were perilous, but with an experienced, well-paid guide, one stood a good chance of success. So Irka set out, taking with her many belongings, including family photos and her wedding dress and veil. Unfortunately, a local German who informally patrolled the border caught the group accompanying the smuggler. The German lived nearby and had converted part of his house into a holding cell where he kept illegal travelers until the German authorities came to get them.

Luckily, the group's escort managed to escape and was able to inform Irka's family that she was being held in this temporary jail. The family quickly found another escort, who promised to get her over the border safely. He knew that this "jailer" could be bribed and was able to negotiate with him.

"Irka's family agreed to pay this German in return for letting her go, and they also promised to bring him enough fabric for two suits, as well as other goods. He would take care of the formalities so there would be no trace of her capture." Irka's brother and his wife had the resources to

provide the money and the material. Jadzia agreed to help collect Irka and bring her home safely, until she could make a second attempt.

"On the day when Irka was supposed to be released, I accompanied her sister, Janka, when she went to pick her up. We had hired a trusted carriage driver. The German jailer had told us that we had to do this in such a way that no one would notice anything unusual was going on. The carriage was to wait at a distance, and Irka would just be walking along the street. And that was exactly how it happened. But Irka had to leave all her belongings behind, so as not to attract attention as she strolled down the street in the early morning."

The two women picked her up and immediately drove away. A short time later, Irka did cross the border successfully. She was reunited with her fiancé, and they married and remained in Częstochowa for the remainder of the war.

Years later, I had a chance to meet Irka Bolinska—now Dr. Kularska—and to lunch with her and my mother at her home. I was only twenty then and not particularly interested in the stories the two close friends must have shared as they sat drinking tea and eating sandwiches. By the time I did begin paying attention to these past events, thirty years later, Irka had died.

Once, as I listened to my mother retell her stories, I commented on her courage and the risks she took in rescuing her sister Basia and her friend Irka. My mother seemed taken aback:

"What courage? You didn't think about it," she said. "You simply did what had to be done. Things were risky for everyone in those days. I suppose, if caught, we would have been arrested, maybe sent to some concentration camp, or even shot in the head. . . . But you didn't think about the consequences, about the danger, when you were young. You focused on how to resolve bad situations and on how to survive."

7

Women's Prison on Gdańska Street

≈

AMONG THE MANY RESTRICTIONS the Nazis placed on Polish citizens was the prohibition against owning or listening to a radio—an offense punishable by arrest and deportation. But people's desire to know what was going on in the outside world and to hear a version of events that was not Nazi dictated led many, including my mother, to take such risks.

Jadzia had a colleague, Johanna Cudnowska, who worked as a nurse-masseuse at the Anna Maria Hospital, giving massages to children while they recovered from surgery. Mrs. Cudnowska was of Finnish descent, a widow in her mid-fifties whom Jadzia described as friendly, outgoing, and an elegant hostess. Because Finland allied itself to Germany throughout much of World War II, the Nazis perceived Finns more favorably than most other nationalities, and Cudnowska fared better than her Polish neighbors. She was allowed to stay in her apartment, received more generous ration cards, and had permission to own a radio.

From time to time, a small group would gather in the evening at Johanna Cudnowska's to socialize, and sometimes they ended up listening to British radio broadcasts, hoping for uplifting news. The apartment was a spacious one, as my mother recalled, not far from the center of town, with a bedroom, kitchen, two other rooms, and a large dining area. Sitting around the dining table, the friends would listen to the radio with a blanket over their heads to help muffle the sound. Besides Jadzia, her friend Janina Raburska often showed up with her husband, and occasionally a young lawyer, Witold Bukowiecki, joined them, with his fiancée, Maria Bartoszewska. Maria's family had owned a pharmacy in Łódź since the 1890s, and although the Germans seized

it after 1939, she was allowed to continue working there as a pharmacist. From time to time, Maria brought her widowed mother along to the gatherings. My mother described the scene.

"We would sit at Cudnowska's all night long and into the early hours of the morning, because the curfew began at nine in the evening. You didn't dare go out after nine, because if you got caught without a pass, you could get arrested and deported. I did have a twenty-four-hour pass, but I would stay with the others. Then, early in the morning, I would leave. Since the streetcars were not running at such an early hour, I would walk across town all the way home. It was safer to be out after dawn than very late at night. We didn't meet on a regular basis, just once in a while, when one had had enough of the Germans, of the Gestapo."

These gatherings turned out to be more dangerous than Jadzia realized. In December 1943 she learned from one of her colleagues that Witold Bukowiecki had been detained. Soon afterward, his fiancée and her mother were also arrested.

In Nazi-occupied Łódź, arrests were daily occurrences, sometimes for no apparent reason. Perhaps you were in the wrong place at the wrong time, you knew someone who was suspected by the Gestapo, you were spotted in suspicious circumstances, or your name happened to be mentioned, even innocently, during an interrogation. The Gestapo, the Nazi secret police, cast its net widely.

After an arrest, one could only wait and see what happened—and hope there had been some mistake. Over the next few weeks, Jadzia wondered what had gone wrong. Did someone become suspicious of the gatherings at Johanna's apartment and report them to the Gestapo? Did a neighbor hear the radio? As days went by, she and the others became increasingly anxious, concerned about the repeated interrogations to which their colleagues were being subjected at Gestapo headquarters on Anstadta Street. Would Witold break down under Nazi questioning? Would the Gestapo soon be paying each of them a visit?

The Gestapo made their sweep in the early morning hours of January 13, 1944. First to be arrested was the Raburski couple—at ten min-

utes to one, according to Gestapo records that survived the war. An hour later, they came for Johanna Cudnowska. Jadzia was the last to be arrested, at 2:20 A.M. She learned these details two months later when she met up with the other women of the group and Janina Raburska told her what had happened on that fateful night. Upon arriving at the Raburskis' home, the Gestapo announced, "And now we're going to visit Dr. Lenartowicz."

~

On the night of her arrest, Jadzia was taken to the same women's prison, at 13 Gdańska Street, where her sisters Marysia and Basia had been held twenty months earlier. She was registered, briefly questioned, and searched. The Gestapo confiscated her personal belongings, with one fortunate exception: "They let me keep my warm coat. I had bought it before the war. It was made of light gray wool and lined with soft brown fur. That was a lifesaver. But I had to hand over everything else—my purse, my jewelry, my documents."

Jadzia had a large sum of money in her purse—eight hundred German marks—which almost got her into serious trouble during her interrogation. The Gestapo insisted the money was proof of her involvement in resistance activities. She argued that she had a legitimate reason to have so much cash with her—she had just been paid, and leaving the money in her apartment seemed unsafe: "Luckily, I was able to convince them that this money was payment for my work as a physician."

After being registered, Jadzia was taken down a narrow corridor lined with heavy, dark wooden doors, all barred and locked. Each door had a small screened opening with a sliding cover, through which a guard could look into the cell. The guard stopped in front of one of the doors. It looked impenetrable. As the guard pulled out a long heavy key and unlocked the door, Jadzia felt a wave of fear and anxiety, followed by dismay as she barely made out, in the dim light from the corridor, the dozen or so women already packed tight into the small space. Even sixty years later, those feelings returned and her voice trembled as she described the scene in front of her that night:

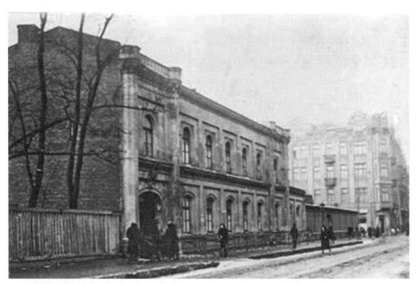

The prison at 13 Gdańska Street; Łódź, 1930s. Courtesy of Archiwum Akt Nowych (Central Archives of Modern Records).

"The women all lay there on the floor on straw covered with blankets, lay there lined up like herring in a tin can. There was also a platform of wooden boards. I climbed up onto this bench so I wouldn't be squeezed in with all the others. What I didn't realize then was that they were huddled together to stay warm. Thankfully, I still had my fur-lined coat that I had brought from home. So I laid this coat down on the hard wood and tried to fall asleep."

On average, the Gdańska Street prison housed between 200 and 250 women a day, although in the last year of the war the number increased to between 300 and 350. Some of the women were held for alleged crimes such as theft, but most of them, like Jadzia, were political prisoners. The Nazis suspected them of belonging to the resistance, listening to radio broadcasts, aiding sabotage, or displaying hostility toward the Nazi authorities.

At Gdańska Street, a detainee found herself in one of twenty-four cells. Two were comparatively large and held as many as sixty women at a time. The rest, like Jadzia's, averaged about one hundred square feet each (roughly seven by fourteen feet). The guards typically jammed

eight to ten women into the smaller cells. Because the sleeping bench my mother mentioned could accommodate only two, the rest of the prisoners slept on the rotting floorboards.

A separate cell called the *Krankenzelle* housed severely ill prisoners, who received sporadic visits from an outside nurse or doctor. Other prisoners avoided the Krankenzelle if possible, because they mistrusted the medical care and took what measures they could to avoid contagion. In a cellar off the main entrance to the prison lay two punishment cells, called *Dunkelzelle*, each about the size of a small closet—cold, dark, and dank, with hardly room for a person to curl up in, let alone stretch out.

⁓

During a trip to Poland in 2005, I set out one drizzly day to find 13 Gdańska Street. I was curious to see the site where my mother's ordeal began. And I was on a mission. My mother had never tried to locate this building during her visits to postwar Poland; her sisters had discouraged her from doing so. During our conversations, however, she revealed that she regretted this now. So I had a compelling reason for insisting that my Łódź cousins let me go off by myself on what they thought was probably a wild goose chase.

I came upon Gdańska Street easily, in the heart of the older part of the city. The busy road was lined with apartment buildings and shop fronts, interesting architecturally but, on this gloomy day, looking drab and worn, in need of a fresh coat of paint.

Standing on the corner, I noticed an official-looking building of faded yellow stucco, several stories tall, just across the street. As I approached it, I saw that this was, indeed, number 13.

A small plaque told me that Józef Piłsudski, the revered World War I hero and leader of interwar independent Poland, had been jailed here in 1900. I felt growing excitement as I realized I had found the actual prison. I waited for traffic to pass and stepped back across the street to shoot some photographs. That was when I noticed a larger, dark plaque at the other end of the building. I crossed the street again and went to

inspect it. At the very top, dramatically depicted in relief, appeared a pair of shackled hands, the left one clenched in a fist, the right with two fingers raised in the sign of victory. I read the text in Polish: "This structure, the oldest political prison in our city, was erected in 1885 by the tsarist authorities for the purposes of suppressing revolutionary efforts on the part of the working class of Łódź." Then my eye caught a sentence farther down the plaque: "Within these walls sat our mothers and sisters, awaiting a terrible death in the hands of Hitler's torturers."

I stood there for several minutes, trying to take it all in, trying to imagine my mother locked up behind these thick stone walls. Then I noticed a more modern sign off to the side. This 120-year-old site of oppression and incarceration turned out now to be the Łódź Museum of Independence Traditions.

I entered the museum, and the staff member who took my ticket asked what had what brought me there. I replied that I was the daughter of a former inmate. Word must have spread quickly, because as I began to look around at the historical exhibits, someone came to invite me upstairs to meet two of the curators. After introductions and offers of tea, we sat down and I began to talk about my mother's experiences. I had barely spoken her name when one of the curators interrupted: "You don't mean Dr. Lenartowicz?"

I nearly fell off my chair!

"Yes," I answered, "but how did you know she was a physician?"

As it happened, another former prisoner, Zofia Goclik, had shared some recollections of her time in the prison with one of the museum's curators, and she had mentioned my mother by name. Mrs. Goclik was from Pabienice, a town about ten miles from Łódź.

Later that evening, while at dinner at my cousin's house, I received a phone call from this curator. She had managed to contact Zofia Goclik and gave me her address. I was leaving Łódź the next morning and could not, to my disappointment, meet Mrs. Goclik in person, but I began corresponding with her soon after I returned from Poland. Because she was elderly by this time, with health and vision problems, she dictated her letters to her daughter. She found it upsetting to talk

about the war years, as she noted in her first letter to me, dated March 3, 2006: "I still recall and relive all that happened then, but largely in my heart." She eventually shared some of her story so that I would understand why she remembered my mother after all those years. In a letter dated February 26, 2007, she wrote:

"I was arrested on January 31, 1944, because I harbored members of the AK resistance organization in my home . . . my husband and I were the first ones of this group arrested. . . . The interrogations and investigations were torture. In May, my husband was deported to the Gross-Rosen concentration camp, and then to the Mittelbau camp, where he worked on the production of airplanes. After my interrogation, I was sent to the prison in Łódź, where I stayed with your mother, who was such a wonderful and generous person. She sustained us with hopeful words. She was the only one among us thirteen prisoners [cellmates] who had a higher education. Once, when we succeeded in bribing the head guard to let your mother visit the cell for seriously sick prisoners, she managed to smuggle back some medicine for us. I had left my eight-month-old daughter with my neighbors, along with my thirteen-year-old sister, who was orphaned, since our parents were no longer alive. I had been breastfeeding my daughter, so you can only imagine how much pain I was in. Your mother cared for me. She was our guardian angel."

Zofia, only twenty, was still lactating, and in pain because she had no means of relieving the buildup of breast milk. Soon she developed a breast infection with painful abscesses. The prisoners received no basic medical care, so Jadzia helped her by creating a poultice from rags, probably ripped off some dress hem, that were soaked in urine. Several published accounts of former inmates' recollections also mention prisoners using their own urine to help cleanse wounds, including those resulting from beatings during interrogations.

Jadzia's efforts to aid and comfort her fellow prisoners were not unique. Former inmates whose stories have appeared in Polish periodicals talk about the way class, age, and status differences became irrelevant as the women united in the face of a common enemy, their

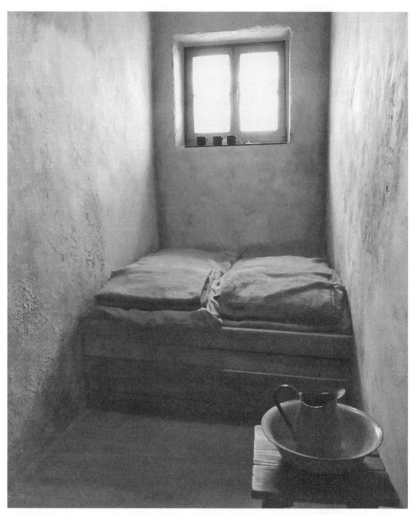

Exhibit of cell from the women's prison, Muzeum Tradycji Niepodległościowych (Museum of Independence Traditions); Łódź, 2011. Photograph by Barbara Rylko-Bauer.

German captors. Skilled prisoners would organize activities such as poetry readings and sing-alongs to bolster morale in their cells. The older among them often took on maternal roles, helping to care for younger inmates. And women expressed their affection by creating small trinkets for one another out of tiny swatches of material, felt, paper, string, even bits of rolled-up dried bread. Some of these artifacts survived the war and are on exhibit in the current museum.

The solidarity among the women prisoners was especially evident in their support of one another before interrogations. Veterans coached newcomers on the tricks the Gestapo used in order to gain information, explaining what to expect so that the uninitiated could brace themselves for the worst. Wearing thick, warm clothing, for example, provided comfort and confidence and lessened the pain when the Gestapo resorted to beating. Each prisoner faced her captors knowing that her cellmates were thinking of her and praying for her. Those who returned beaten and sore received care from their fellow prisoners. Often, the inmates reserved the wooden sleeping bench in the cell—the one Jadzia had lain down on during her first night in the prison—for those who were sick or recovering from a beating. The friendships these women forged helped them survive the abuse, hunger, squalid living conditions, and fear that defined their daily lives in prison.

~

On the heels of my 2005 visit to the Museum of Independence Traditions, the curator sent me a copy of an unpublished memoir by Barbara Cygańska Wiland, a former inmate who had been arrested on the same night as my mother. Wiland had appended to her well-crafted story letters written to her family just before she was to be transferred to a concentration camp. In one letter, she mentioned my mother by name: "Many women signed the [transport] list with me. We'll be leaving together, intelligent individuals sharing common cause. Dr. Lenartowicz is with me as well." Only twenty-three at the time, the young prisoner was trying to reassure her family so they would not worry about her pending transfer. Wiland's memoir gave me a better sense of what life was like in that prison on Gdańska Street. More important, it suggested additional reasons for Jadzia's arrest.

Barbara Cygańska was training to be a schoolteacher when the war interrupted her studies. As the Germans tightened their grip on Polish society and closed Polish schools, she grew increasingly frustrated. Having returned to Łódź illegally to be with her family, she lacked a legitimate identity card and so could not find a paying job. She stayed

home, watching her dreams fade, feeling powerless as she saw Polish children around her being denied an education. Finally, she decided to hold clandestine classes, first for her younger sister and a friend, then for others living in her neighborhood. Soon she had about twenty pupils at various grade levels.

But Cygańska desperately wanted to do more. She eventually succeeded in getting a falsified ID card, found work in a tailoring shop, and in mid-1942 joined the AK resistance movement, working on first-aid preparations in the event of an uprising. She was part of a five-member "conspiracy cell" whose leader was a young lawyer in his early thirties—the very same Witold Bukowiecki who later joined Jadzia in listening to the radio.

Cygańska wrote, in Polish: "In the final months of 1943, a markedly increasing sense of terror permeates Łódź, the underground continues to suffer losses, and we feel that danger seems to be closing in on us. . . . I don't remember the exact date . . . most likely in December of that year, we found out that Witold Bukowiecki had been arrested. After a few days, the same fate met those close to him." Others higher up in the AK assured Cygańska and her colleagues that Witold "was strong" and would never betray them.

Their well-meant reassurance was wrong. During the early hours of January 13, 1944, three men from the Gestapo came to the Cygańska family's apartment, ransacked it, and took her away to 13 Gdańska Street. She was placed in cell number 6 and five days later underwent questioning at Gestapo headquarters about her relationship to Witold. She resolved to tell the Gestapo nothing of consequence and denied knowing anyone by that name, even when they insisted that Witold had told them about his meetings with her. And she stuck to her story, refusing to incriminate others despite being brutally beaten. Then something dawned on her: "During undoubtedly very difficult questioning and even torture, [Witold] probably tossed my name out to the Gestapo, assuming that as a very junior member, I knew almost no one in the resistance movement and thus would not do them much harm. What he did not realize was that I would be forced to reveal the name

of the person who recruited me—Krysia—and Krysia, when arrested, would similarly be forced to betray others."

It seems likely that a desperate Bukowiecki also gave the names of those who met at Johanna Cudnowska's to listen secretly to radio broadcasts, thinking that such minimally useful information might deflect the Gestapo's attention from serious resistance activities and from important members of his underground group. He might not have realized that mere association with him placed Jadzia and the others at risk. Or he might have felt that this was the cost of protecting the larger resistance network.

In the days following the arrests of the radio group, the Gestapo interrogated each of its members. Every morning around eight o'clock, the *suka*, or "bitch"—prison slang for the paddy wagon—took designated prisoners "to Anstadta," site of Gestapo headquarters. Prisoners often returned bruised and bloodied. Jadzia heard from someone else that Maria Bartoszewska, the young pharmacist engaged to Witold Bukowiecki, had been roughed up badly. A fellow prisoner had seen her, black and blue, being carried on a stretcher down the hall to another cell. Then one morning Jadzia heard her own name called out for the trip in the suka to Gestapo headquarters.

As my mother started to tell me what happened, I braced myself, expecting the worst. I was surprised when instead she said: "But they didn't beat me or kick me. I wasn't tortured. They just came, took me in for questioning, and then returned me to my cell."

During Jadzia's interrogation, she had little choice but to admit that she had repeatedly listened to foreign broadcasts on the radio. The authorities already seemed to have all this information. And she clearly could shed no further light on the activities of Witold Bukowiecki, for she was not part of his underground network. Perhaps the Gestapo sensed that she was telling the truth. As the questioning came to an end, the Gestapo officer startled her by making an offer:

"He told me that if I accepted the Volksliste, the charges against me would be dropped. I would be able to have everything the Germans now had, and things would be much better for me. I think they needed

doctors. But at the same time, they had to arrest me and punish me since I had been caught listening to the radio, right? So he offered me this proposition."

I remember saying to my mother, "But you aren't German. How could you be put on the Volksliste?" I did not understand then that the Nazis adapted this category to suit their purposes. I also wondered whether they might have viewed my mother as a potential source of useful information, because she saw so many people in her capacity as a physician.

"Of course I wasn't German," my mother replied impatiently. "But there were Germans in the family. I had a distant cousin from my father's side who married a German, and he was a Volksdeutscher. They had a large business selling coal." I remembered her mentioning this before. "The coal was rationed, of course, and especially for Poles, but he was the one who always brought me more than my allotment, for free.

"So this Gestapo officer tried to convince me to accept the Volksliste. But I refused. I looked straight at him and said, 'I'm sorry, but no, I cannot. I am not a German. I am a Pole.'"

~

Jadzia remained in the jail on Gdańska Street for about nine weeks. "Remember," my mother asked me once, "how when I was first arrested, I said that at least now I'd get a break from seeing patients night and day, I'll finally have some rest from all this? Well! I had no idea what it was really going to be like . . . that I would be 'resting' for so long."

Gdańska Street was a transitory prison, holding women while the Nazi authorities examined their cases. Some remained for just a few days; others were subjected to repeated interrogations and were held longer when the Gestapo anticipated new developments. Stays averaged two to three months, but occasional cases dragged on for more than a year. A few women were lucky enough to be released, but the majority were sent on to other prisons, forced labor camps, or concentration camps. Altogether, an estimated fourteen thousand women passed through this prison during the Nazi occupation.

Conditions in the prison were squalid. Twice each day, morning and evening, female guards led the prisoners out to the bathroom, one cell at a time, and stood watch as they used a row of open toilets. In between toileting times, the inmates had to use a large barrel that stood in the corner of the cell, something everyone avoided as much as possible. Ventilation in the cells was poor, with the heavy doors kept locked and only a small, barred window high on the back wall.

The prisoners received no showers or any other adequate means of washing up. Not surprisingly, they endured lice, fleas, and cockroaches. My mother choked up whenever the subject of lice arose: "The lice were horrible! It all comes back to me, how awful they were, hanging from your hair. It's indescribable. When you don't change your clothes and you can't wash your hair. . . . There were these dense combs that the women would use to pull out the lice and kill them. But still there were lice."

According to published recollections by other Gdańska Street prisoners, families were allowed to bring inmates packages of clean laundry once a week—rare moments of relief from the otherwise unrelenting dirt and stench. The prisoners handed over their soiled clothes to a guard, who passed them on to the family members waiting outside. Guards kept the women under strict observation, so they could not easily communicate with fellow prisoners in other cells, but families smuggled in bits of newspaper and brief notes by sewing them into hems or pockets. They might conceal tablets of medicine and vitamins by wrapping them in bits of cloth and sewing them as decorative buttons on the laundered blouses and dresses. My mother must have received packages or clean clothing from her family, but when I asked her about this, she no longer remembered.

The prisoners suffered from the unsanitary conditions and overcrowding, and many fell ill with fevers, pneumonia, diarrhea, heart problems, and depression. Compounding their deprivation was poor nutrition and a lack of exercise. The Gdańska Street building was U-shaped, surrounding a small courtyard, and guards sometimes took women whose cases were nearly resolved for short walks. Most of the

women, however, got little or no exercise. Some of the long-term prisoners who were recruited to peel potatoes in the kitchen or to clean the corridors, the toilet area, or the guards' quarters gained a little ability to move about the prison, and hence an opportunity to share information and news they picked up along the way. But they were closely guarded, and it took skill and great care to not get caught.

The prison had its own kitchen, staffed mainly by Germans. The food was bad. The daily routine for prisoners began with a roll call at six A.M., followed by a meager breakfast of dark, heavy bread and something that passed for coffee. The staff doled out one loaf of bread per day for every eight prisoners. At noon the women received the universal staple of Nazi prison cuisine: a bowl of watered-down soup made with carrots, beets, or turnips, sometimes featuring a few bits of horsemeat. Supper, at seven in the evening, mimicked breakfast. The food was unappetizing and of minimal caloric value. Not surprisingly, Jadzia, already slender, found herself quickly losing weight.

The guards were mainly German or of German descent, and some of them, according to published recollections of former inmates, were crude, abusive, even sadistic. The inmates gave their guards nicknames that reflected their physical appearance or personality—Red Mouse, Duck, Achtung, Bombardier. The crueler guards earned more vulgar sobriquets.

Not all the guards were so bad. As luck had it, one of the female guards, a Volksdeutsche from Łódź, recognized Jadzia, who had once treated the woman's sister's children. This guard willingly helped Jadzia from time to time by hiding extra food for her in the furnace that heated her cell, which was probably lit only for short spells on the coldest of days. As the museum curator pointed out to me, the prison officials would not have squandered scarce coal keeping the prisoners warm.

Each pair of adjacent cells shared one of these tall, black, circular furnaces, half of which projected into each room through their common wall. The furnace stood in a front corner of the cell and had two inch holes along the top and the bottom through which heat ema-

nated. A small black metal door opened into the corridor outside, and through this exterior door, the prison custodian fed the furnace with coal and lit it.

At mealtime, the prisoners would come out, one cell at a time, and walk down the corridor to where a large kettle of soup or coffee was set up. The sympathetic guard would signal Jadzia to leave her cell last, by saying that "something was wrong with the furnace." Following the others, Jadzia would hastily open the small black door outside her cell, there to find some wrapped food hidden in the cooler section of the furnace, where ashes were stored. She recalled getting a pork sandwich once—a real treat, because meat was not on the jail menu. This was just one among many instances in which my mother's profession—being a physician and having treated many patients— helped her survive hazardous times.

﹏

Near the end of Jadzia's stay in the jail, she developed diarrhea and cramps, probably from some spoiled prison food. She also learned that she was going to be transferred, along with a large group of other women, to a concentration camp called Ravensbrück, just north of Berlin. About a week before the scheduled departure, a doctor visited the jail to examine the prisoners. He, too, happened to be a Volksdeutsche known to Jadzia, for he practiced from a medical office in central Łódź. She expressed her anxiety to him. How would she tolerate the trip, and what would happen if she arrived sick at the concentration camp? But the doctor was unable to help her—he had orders to follow. He could not hold her back. Sick or not, she would have to go with the others when the time came to leave.

Jadzia had reason to worry, for the first days and weeks in concentration camps were times of heightened danger and vulnerability. Postwar memoirs and recollections by survivors of camps such as Ravensbrück and Auschwitz attest to the large number of women who died soon after arriving, from the combined effects of shock, hunger, weakness, disease, and physical trauma.

As the day of departure drew near, Jadzia became increasingly apprehensive. Her ailment was not getting better. The sympathetic guard asked whether she could bring something to help Jadzia recover. Medicine, of course, was unavailable, but my mother remembered a common home remedy:

"I asked her for some vermouth [to settle the intestines] and for charcoal tablets [to absorb gas]. From somewhere, somehow, she was able to get this for me. Two small bottles, placed into that stove. Perhaps she got them from my family. This really helped me, and the diarrhea got better. Since that time," my mother said with a smile, "I've made sure I always have vermouth in the house."

Before leaving, the women were taken to a small washroom at the far end of the prison for a shower. Despite the lukewarm water, they felt wonderful, finally getting clean after so many weeks—even if their clothes remained infested with lice. My mother could not remember precisely, but she thought the women left Łódź sometime in the evening and traveled all night: "There was quite a large group of us, but I can't really say how many. After all, I wasn't feeling too well after spending so many weeks in jail."

It was actually three in the morning on March 16, 1944, when the transport left the prison on Gdańska Street. I learned this detail when I discovered the Gestapo prison registry book—*Gefangenen Buch B*, listing women arrested between June 17, 1943, and January 24, 1944—at the Łódź branch of Poland's National Archives during a visit to my mother's native city in September 2011. The entries, handwritten in blue ink, are difficult to decipher, partly because they use an old form of German script. But the last names and birthdates of each woman prisoner are easily read.

The archives also safeguard a catalog of transport lists for 1943–44 naming women sent from 13 Gdańska Street to other places of incarceration. Among the lists is a three-page document, this time typewritten but supplemented with penciled notations, identifying the women who left the prison before dawn on that day in March, bound for Ravensbrück. Among the more than seventy names on the list is that of Jadwiga

Lenartowicz. Her acquaintance Barbara Cygańska, the memoirist, was supposed to have been on the transport as well, but her name is crossed off. At the last moment, she was summoned to yet another interrogation, and by the time she returned to her cell, the transport had left. She would remain at Gdańska Street for the duration of the war.

My mother did not mention to me how the group got to the train station in Łódź—perhaps in a series of vans. But she was sure the

List of female prisoners transported from the prison at 13 Gdańska Street to the Ravensbrück concentration camp, including Jadzia's name (third from bottom); Łódź, March 16, 1944. Courtesy of Archiwum Państwowe w Łodzi (National Archives, Łódź branch), from the file "Penal Institutions of Łódź, 1939–1945."

women made the rest of their trip in a regular passenger train—"not the closed ones used for pigs or cattle that I've since read about"—and that there were benches to sit on.

"We were accompanied by armed guards, and the windows were covered up to prevent anyone from looking in or seeing out. As I sat on that train, I couldn't help wondering just where we were going. I didn't really know much since they never told you anything of significance. It was a relief to be out of that jail, to be able to stretch my legs, to see something other than the four walls of a cell. But I was also very anxious and afraid. I remember having this sinking feeling that I was traveling into the unknown."

Part II

In the Camps

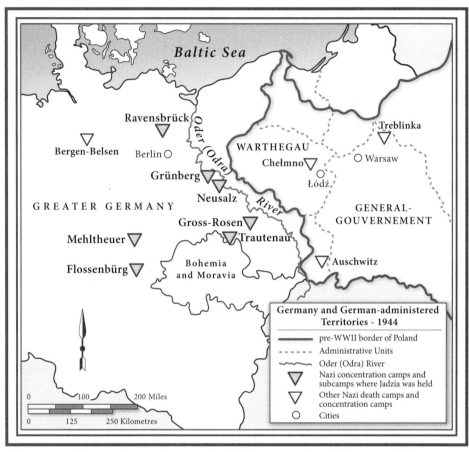

Nazi concentration camps and subcamps where Jadzia was imprisoned, Germany, 1944.
Map by Gerry Krieg.

8

"Treated Like an Animal"

⤳

UNTIL LATE 1938, Ravensbrück was just a small village in the Mecklenburg lake district of northern Germany, a picturesque and popular summer resort region. The official German tourism Web site describes this large area of rivers and lakes as a region of fairytale castles and palaces, villages tucked among Ice Age hills, medieval ports, and magnificent natural scenery—a tourist's paradise.

The village sat on the banks of Schwedt Lake, just across from the medieval town of Fürstenburg. Despite its apparent seclusion, the village was easily accessible by rail from several nearby cities, notably Oranienburg and Berlin, some thirty and fifty-five miles to the south, respectively. At Oranienburg the Nazis had already built a men's concentration camp—Sachsenhausen, one of the main headquarters of the *Schutzstaffel,* or SS, the powerful, elite, Nazi Party police. A system of canals, constructed years before, connected the many lakes of the region with the Havel River, which meant that heavy machinery and other goods and supplies could be readily transported in and out by barge. All these factors influenced the Nazis' choice of Ravensbrück as the site for their largest women's concentration camp.

Construction of the camp began in November 1938, and six months later, Ravensbrück officially opened with the transport of 867 women prisoners from the Lichtenburg concentration camp in Saxony. Those women, in turn, were forced to work on further expansions. By 1940 the camp had twenty barracks, each designed to hold 200 women. Twelve larger barracks, added two years later, brought the camp's capacity to about 8,000 prisoners. But even these expansions failed to keep up with

the continual influx of prisoners transported from all over Europe. By the end of 1942 the inmate population was already at twice the camp's capacity—15,000 women. Every year the overcrowding grew worse.

The Nazis designed Ravensbrück and their other concentration camps originally as places of imprisonment and punishment. This purpose changed in the third year of the war as Germany experienced mounting military costs, shortages of workers (most able-bodied males had been drafted), and a growing need for weapons, uniforms, and other military supplies. In response to these problems, the Nazi leadership began viewing the concentration camps not only as prisons but also as sources of cheap labor.

In September 1942, the Nazi leadership instituted a policy meant to maximize the exploitation of foreign prisoners as labor while minimizing the cost of their upkeep. Termed *Vernichtung durch Arbeit*—literally, "to be destroyed through work"—this plan made concentration camp prisoners, especially Jews, Russians, Poles, and other Slavs, equivalent merely to raw material to be used up and discarded. Put simply, inmates were now slave laborers, to be worked to death in quarries and coal mines, in weapons production and other war-related industries, and in building roads, factories, and railroads. Unlike the forced laborers shipped off to Germany from Poland and other countries earlier in the war, slave laborers received no pay and had little freedom of movement, if any. Usually their living and working conditions were brutal—inadequate food and clothing, crowded sleeping quarters, minimal or no health care, difficult manual labor, abusive overseers, and exposure to severe weather.

Earlier that same year, the Nazis had formalized their Final Solution for exterminating the Jews of Europe. These two policies—death by labor and the outright killing of Jews—together fed the Nazis' goal of eliminating "undesirable" populations from Germany and its occupied territories. Mass murder was thus integrated into the regime's larger vision of territorial expansion and economic development for Germany.

The camps figured prominently in the economic plans of private firms as well as the military and other government agencies. Private companies paid the SS for the use of prisoners, and nearly every major German

company took advantage of the ready supply of cheap labor. Plant managers worked closely with concentration camp commanders, who often provided the firms with staff, guards, and administrators. The firms, in turn, were responsible for housing and feeding the workers, but the drive for profits and even more cheap labor led most of them to spend the bare minimum. Except in the case of skilled workers needed for high-priority production of military equipment, companies showed little concern over the extreme death rates in the camps attributable to exhaustion, starvation, and exposure. New replacements could always be had.

In Ravensbrück, a new commandant, Fritz Suhren, assumed leadership of the camp in 1942 and put into full practice the policy of extermination through work. His camp became a key center of the widespread Nazi slave-labor system. By 1944, the staff at Ravensbrück were administering seventy subcamps scattered throughout Germany. Women prisoners worked as slave laborers not only for the SS but also for many civilian German companies, primarily in military-related production.

Similar situations existed throughout Germany and the occupied territories. All the major concentration camps administered large networks of subcamps, exploiting several million prisoners over the course of the war. This exploitation was no state secret. It took place openly, with prisoners often working alongside German civilians, all of them supervised by German foremen and managers. As the historian Ulrich Herbert commented, "Foreign forced labor was . . . on the Germans' very doorsteps, around the corner, and down the street."

During the final year of the war, overcrowding in Ravensbrück became unmanageable, in part because prisoners were being continually transferred from concentration camps in the east, such as Auschwitz, that the Nazis were evacuating as Allied troops advanced into Poland. The prisoner population at the start of 1944 was an estimated 17,300, and by January of the next year it was more than 45,000. The number of prisoners in many of the barracks was three or four times what was originally intended, leading to deplorable living conditions and a dramatic rise in the death rate from hunger, exposure, and diseases, such as typhus and tuberculosis. For 1944, the camp's hospital records—in which deaths

were often underreported—noted 116 deaths in January; by December, the monthly number was 727. Many sick or weak women were killed by being shot, given the barbiturate Luminal or a lethal injection, or, after a rudimentary gas chamber was installed in early 1945, gassed to death.

By the time the war was over, an estimated 132,000 women and children of various nationalities and religious persuasions had passed through the gates of Ravensbrück. One of the women was my mother.

~

In 2005, while visiting Washington, D.C., I examined some archives housed in the United States Holocaust Memorial Museum. I already knew basic details about my mother's time at Ravensbrück because in 1950 she had received a "Certificate of Incarceration" from the International Tracing Service (headquartered in Arolsen, Germany) confirming that "Jadwiga Lenartowicz entered Concentration Camp Ravensbrück as prisoner no. 32220, on 17th March 1944, coming from Litzmannstadt [Łódź]."

The Holocaust Museum archives hold microfilm reels pertaining to various concentration camps, and among these are reels dealing specifically with Ravensbrück. One of these, reel 22, contains transport lists of incoming prisoners for the first five months of 1944.

I felt both excitement and apprehension as I placed the reel onto the spool and began to unwind the film, unsure what I would discover. It was immediately clear that what had been photographed was a series of record books, with successive pages of typed daily transport lists of women arriving at the camp from distant places, starting with January 1, 1944.

I turned the reel slowly, awed and appalled at the endless lists of names. Midway through the reel, I came upon a transport list of prisoners arriving from Litzmannstadt—on March 17. I was dismayed because the image was heavily blurred, but I could make out enough to tell that it spelled out seventy-six names. As I strained to read them, I suddenly spotted my mother's name, followed by her date of birth, the designation "*polit.*" (political prisoner), her assigned prisoner number, and her nationality (*Polin*, or Polish).

My first feeling was one of shock. The room was warm but I felt cold. I am still surprised that I did not start crying right there in the library; that came later, once I returned to my hotel room. Here was evidence! Not that I had ever doubted my mother, or the records she had acquired. But seeing her name on a list that someone had typed in a room in some building on the grounds of the Ravensbrück camp made her story real for me in a new way. I could almost visualize her standing in front of the German clerk who took down her information, typing it into the record, and, in that instant, officially transforming her into prisoner number 32220.

The record I discovered in the Holocaust Museum's archives also answered one of my questions: What happened to my mother's colleagues who were arrested on the same night as she? It turned out that they were also part of this transport. There were their names: Maria Bartoszewska, number 32180; her sixty-one-year-old mother, number 32179; Johanna Cudnowska, number 32185; and Janina Raburska, number 32229.

~

The distance between Łódź and Ravensbrück, via Berlin, is about three hundred miles. According to the historian Jack Morrison, prisoners usually arrived at the Fürstenberg railroad station at night. They were met by SS men and female guards with dogs, who escorted them along the two-mile march to the camp. In the daytime, the approach to the camp presented a deceptively pleasant scene, with views of homes (where SS officers lived) and the lake beyond them. Then came the camp entrance. A photograph from 1941 shows a large double iron gate, perhaps twelve feet tall, wide enough to admit a truck or a column of prisoners, and surrounding walls twelve to fifteen feet high topped with barbed wire.

My mother remembered little about the trip from the women's prison on Gdańska Street—only that it was night when her group arrived at Ravensbrück. She was sure that her train did not pull up at the town's railway station, for the women did not have to march any distance to get to the camp. What she did remember was that "a large,

heavy gate opened wide. The train drove past it and came to a stop. We were in the camp." Site maps of Ravensbrück show railroad tracks running alongside with a separate railroad station only a short distance from the main entrance.

The entire group was taken to a huge washroom, where the women spent the rest of the night trying to sleep on the hard linoleum floor, not knowing what they would face the next day. My mother's recollections of being registered as a prisoner at Ravensbrück were painful for her to share and painful for me to hear. I struggled with the recognition that I was delving into memories that she had purposely hidden in the recesses of her mind. Was it really such a good idea, reopening these old wounds? This was one event that my mother did remember vividly, once I edged open the door to this past.

"In the morning, it all began. We were ordered to undress, leave all our belongings behind, and we took a shower with a tiny bit of soap, just enough to wash yourself. And then we walked naked into another room, where they were doing examinations. You were examined everywhere, to make sure that you weren't hiding gold or valuables on your body. They looked in your mouth, your vagina, even in your rectum. Can you imagine? Each of us had to go naked, one by one. The exams were done by German women prisoners assigned to this work, but under SS supervision. They checked us out and, when ordered, would cut off all your hair with clippers.

"Not everyone had their hair cut. I must have been singled out for punishment. My sister Zosia used to often remark on how beautiful my hair was—dark blond, thick, but soft and naturally wavy. When this German woman started on my hair with the clippers, I thought I would simply go crazy. She clipped my entire head, to the scalp.

"You know, this was the worst part for me, losing my hair. It was so degrading. I felt like I could just strike out, kick someone—but of course I didn't."

My mother paused to calm herself down. Her face was flushed, her eyes bright with tears. Sharing this ordeal with me was clearly difficult for her. I offered to stop, but she wanted to continue, so I asked

her, "Why were you singled out? Do you think they shaved your hair because you had lice? Did they shave you anywhere else?"

"No, Basiu, just on my head," she replied. (My mother always called me Basia, the Polish diminutive for Barbara, and because proper nouns are declined in Polish, she used the form Basiu when she addressed me.) "Maybe I did have lice, but then so did everyone else. After all, you didn't change your clothes regularly during that weeks-long stay at the jail in Łódź. You slept just as you were, and there were plenty of lice. But they didn't shave off Raburska's hair.

"I wasn't the only one, Basiu. Many women had their heads shaved, but not all. I think the SS did this, in part, to make things easier for themselves in the camp. But I also suspect that they shaved the heads of those whom the Gestapo identified as deserving more punishment."

It is clear from testimonies given after the war by survivors of Ravensbrück and other concentration camps that the initial examinations and the head shaving were deeply traumatic experiences for women, causing them distress, shame, anger, and despair. This initiation into an unimaginable world is captured exquisitely in the following excerpts from the compelling poem "Arrival (1942)," written by Polish inmate Maria Rutkowska while she was in Ravensbrück.

> *They robbed us entirely:*
> *Of clothing, of our only shirt,*
> *And deprived us of the right*
> *To our own body,*
>
>
>
> *We stood as helpless flock*
> *In a large hall,*
> *Like animals behind bars*
> *Put on show.*
>
> *Like a symbol of total suffering*
> *The shorn heads hang heavy,*
>
>

After this ordeal of being examined and shaved, Jadzia was officially registered as a new prisoner, a *Zugang*:

"So there you are, completely naked. And then they give you this prison uniform—we called it a *pasiak* in Polish. It was a light-gray dress with vertical navy blue stripes, long-sleeved and made out of some thin, coarse material. I also got a sleeveless undershirt and underpants that didn't fit me at all, made out of another coarse, cotton-like fabric. And finally, old socks with holes on the heels. And *trepy*, which were wooden clogs with a wedge-like heel, open in back and with canvas on top. They clothed us like beggars."

My mother might have lacked the poetic eloquence of Maria Rutkowska, but in her own way she conveyed the profound humiliation she felt. One day, just as I was leaving her apartment after an interview session, she stopped me and after a moment, said: "You know, Basiu, hunger didn't really bother me in the camps. I can tolerate hunger. But to be treated like an animal or worse and not as the human I am—this I could not bear."

It is impossible for me even to begin to imagine my mother's feelings on the day she officially entered the camp, but I have a photograph that brings me at least a small step closer to understanding. During my trip to Poland in 2001, when I acquired the letter written by my Aunt Marysia from Auschwitz, I also got a copy of the mug shot taken of my aunt when she was registered there, on November 5, 1942. Photographing new inmates was standard procedure in the concentration camps. One of the more compelling exhibits at the United States Holocaust Memorial Museum is a wall completely papered with such photographs. They come in sets of three frames, each a different pose, developed in a row. Together, they form a triptych.

The first frame is a profile shot showing my aunt's dark hair raggedly cut down to the scalp, the tracks of clippers making uneven trails across her head, tiny bits of hair sticking out in places. Her number, 18995, is displayed prominently at the bottom. The second frame is a full-face shot. She seems weary but also defiant as she gazes into the camera. In the final frame, she is looking off to the opposite side, and her head is

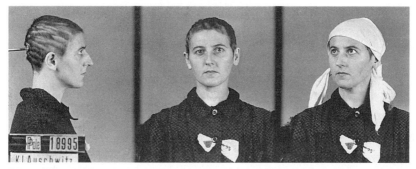

Maria (Marysia) Lenartowicz; 1942. Courtesy of the Archive of the Auschwitz-Birkenau State Museum.

covered with a light-colored kerchief, tied in the back. When I study this photo, I can almost visualize what my mother looked like on the day she officially entered Ravensbrück.

~

After Jadzia dressed in her prison garb, she was briefly interrogated: "There was this handsome SS woman who asked me more questions." My mother paused for a moment and then said, almost as an afterthought: "You know, all these SS women were so young and so attractive."

At the time, I did not think to ask my mother to elaborate on this comment. But it seems to reflect the jarring contrast between the Nazi women's outwardly pleasant appearance and their underlying capacity for brutality. SS women were trained to be harsh and abusive to prisoners. Their teachers inculcated in them the Nazi racist ideology that the women prisoners were less than human. Ravensbrück, indeed, served as the principal training center for female overseers (*Aufseherin*), or SS women, who then worked in camps throughout the Third Reich.

My mother continued her description of that first day in the camp: "Once the questioning was over, the SS woman turned to her companion and said in German that I was suspected of political resistance and of listening to the radio. Then she went to make a report to her superior." Because Jadzia had grown up in a city that had a large German population before the war and became a part

of the Reich during the war, she had learned to speak rudimentary German. This skill would prove useful in the coming months, because the SS staff in the camps gave all commands in German, and understanding them was critical to survival.

At Ravensbrück, as at other concentration camps, the SS sorted prisoners into categories, each designated by a different colored badge, an upside-down triangle known in German as a *Winkel*. Political prisoners wore red badges, and those labeled "criminals" green ones. Black badges went to "asocial" people—anyone who did not conform to Nazi dictates or racial and social norms. This diverse category included the Roma and Sinti ethnic groups as well as prostitutes and even poor women who were unable to hold jobs or had had extramarital affairs. Jews were often assigned to two categories and wore a yellow triangle superimposed by one of another color, forming a Star of David. Women who were Jehovah's Witnesses, an outlawed sect in Nazi Germany, were distinguished by a lavender badge.

Besides serving the Nazis' administrative purposes, these categories, together with the prisoners' numbers, acted to establish social status and shape relationships among the inmates. For example, if a prisoner had a low number, she obviously had been in the camp for a long time and knew how to survive. Such prisoners often received preferential treatment from SS personnel and sometimes respect from fellow prisoners. Asocials, on the other hand, often found themselves spurned by other prisoners. Political prisoners constituted the largest category. They tended to associate with others of their nationality, which was easily identified by an initial inside their red badge: P for Polish, B for Belgian, T for Czech, and so forth. Although my mother spent no more than six weeks at Ravensbrück—all of this time in the zugang barracks, she could still, after nearly sixty years, rattle off accurately all the categories and their respective badges.

The Nazis accused Jadzia of political actions against the Reich, so she had to wear a red badge with a large black P superimposed on it, identifying her as a Polish political prisoner. A patch displaying her assigned inmate number went on the upper left sleeve of her pasiak,

directly above her red badge. Jadzia was no longer a person with a name; she had become Ravensbrück prisoner 32220.

All concentration camp prisoners received a prison number upon entry. If they were later transferred to a different camp, they were assigned a new number. The tattooed number on the left forearm is one of the most widely recognized symbols of the Nazi prison system and of the Holocaust, so many people nowadays assume that all concentration camp inmates had such tattoos. In fact the Nazis used tattoos primarily at Auschwitz, starting in late 1941. Jadzia, thankfully, was spared this additional assault and humiliation.

From the beginning, camp officials at Ravensbrück worked on stripping newcomers of their identity. My mother recalled the female overseers telling the women, "You have no family. It's just you, and you are here." And they would often repeat, "You are nothing. You are just a number."

⌒

Because my mother expressed interest in learning what other survivors recalled about their experiences in the camps where she had been, I loaned her a memoir about Ravensbrück, a slim volume written by Geneviève de Gaulle Anthonioz—niece of General Charles de Gaulle—titled *The Dawn of Hope*. My mother stayed up reading late into the night. When I visited her the following day, she shared her impressions with me: "This author, she had it much worse than I did. She was locked up in a punishment cell and tortured. At least I was never tortured."

Then my mother paused, visibly upset, and her eyes filled with tears: "When I was reading this account, the memories flooded back. I said to myself, 'This is me! The shaved hair! The wooden clogs!' I saw it all again, right before my eyes. I'll never lose this image, these memories. And then, you know, I began to cry. I cried for quite a while. But then I pulled myself together. 'Enough!' I said. You know, Basiu, it took me a long while to fall asleep last night."

Again, I was racked with feelings of guilt and uncertainty about our project. What was I putting my mother through? And for what

reasons? Was my desire to document her story justifiable, in light of the consequences? Afterward, as we sipped tea and ate slices of her freshly baked lemon pound cake, I voiced my concerns. I asked how she felt and whether she thought we should continue our interviews and conversations about her painful past. I was reassured when she insisted that we forge ahead.

The violence Jadzia and her fellow prisoners endured—the nakedness, public exams and shaving, rags for clothes, inhuman living conditions, and heartless treatment—was not only physical violation but also psychological, emotional, and symbolic assault, aimed at destroying the women's sense of dignity, worth, identity, personhood. The loss of their hair—crudely clipped and shaved—reinforced the message: You are now powerless, sexless, featureless, and nameless, no longer a person.

Jadzia's experience of what she referred to as the "degradation of humanity" (*poniżenie człowieczeństwa*)—meaning not just what she herself went through at Ravensbrück but also what she saw all around her—became the standard by which she judged the rest of her concentration camp experiences.

9

Zugang *in Ravensbrück*

⁓

By the time Jadzia arrived at Ravensbrück, thirty-two women's barracks flanked the main street, the Lagerstrasse, leading to the roll-call square. Additional buildings housed the kitchens, the main showers, the infirmary, the punishment block, and administrative offices. Just outside the camp wall stood a crematorium, and in early 1945 the Nazis added a gas chamber. On the southern edge was a smaller camp for male prisoners, many of whom worked in nearby factories or on camp construction projects.

The women's barracks all had two identical wings, each with a sleeping area and a large dayroom where meals took place. The two wings were separated by the washroom, fitted with large sinks and toilets.

Just as they did at other concentration camps, SS officials supervised Ravensbrück and held ultimate authority and decision-making power. They placed much of the daily administration, however, in the hands of a hierarchy of prisoners to whom they assigned official tasks and responsibilities. In return, these appointed prisoners received certain privileges, which greatly increased their chances of survival.

At Ravensbrück, the highest position in the prisoner administration was that of the *Lagerälteste*, or camp senior. In addition, each *Block*, or barrack, had a block senior, the *Blockälteste*, who reported directly to her SS overseer. Responsible for maintaining discipline and order in her block, the block senior wielded considerable authority and acquired a separate room of her own. In turn, she appointed several prisoners to serve under her as room seniors (*Stubenälteste*). Because so many of the prisoners at Ravensbrück were from Poland—by one

estimate, about one-fourth of the prison population—and they occupied many of the positions of relative authority, inmates often used the Polish terms *blokowa* and *sztubowa* for the German *Blockälteste* and *Stubenälteste.*

The noted author and Auschwitz survivor Primo Levi once pointed out that "if one offers a position of privilege to a few individuals in a state of slavery, exacting in exchange the betrayal of a natural solidarity with their comrades, there will certainly be someone who will accept." The Nazis exploited such human tendencies, creating a system of governance in both concentration camps and Jewish ghettos that fed on manipulation, competition, fear, uncertainty, suspicion, and the ultimate drive to survive.

Considering the nature and purpose of the camps, prisoners who sought and accepted positions of privilege acquired an ambiguous status, for although they remained victims, they also became potential persecutors of fellow prisoners. Not all privileged prisoners abused their acquired status, but the tendency to do so—to exploit those over whom they had command—was strong. In camps such as Auschwitz, the SS masters even encouraged this dark side of human behavior by refusing to punish prisoner-officials who abused or even killed those under their charge.

～

When women first arrived in Ravensbrück, they were assigned to a transitional barrack known as the Zugang block. In camp parlance, *Zugang*—German for "access"—was the term used for new prisoners. There they stayed for a quarantine period ranging from two to four weeks, sometimes longer, to make sure they were not carrying highly contagious diseases such as active TB or typhus.

As the prisoners from Łódź headed toward the quarantine barrack, Jadzia caught up with Janina Raburska. They agreed to stick together and look out for each other.

"The room where prisoners slept had three levels of bunk beds, lots of them, lined up one right next to the other. These beds—we called

them *prycze* in Polish—were made of wood. There was some sort of mattress [probably sacking filled with straw] and blankets. There was also a pillow. I can't remember how many beds there were, just that there were many. We were allowed to pick out where we would sleep.

"I said to Raburska, 'Listen, let's go up to the third level so that no one bothers us, no one smells things up for us.' So we clambered up to the top. It was actually much better for us, being up there, with more fresh air. You weren't closed in, sandwiched between two beds. You had to climb up a small ladder to get to this third tier, but there was hardly anyone up on that level."

My mother never talked about the overcrowding in Ravensbrück, which was especially severe during the last year and a half of the war. Indeed, more than once she mentioned in passing that the sleeping quarters were not full when her group first entered the Zugang block. I found this surprising, considering that a transport of 958 French women had arrived in early February 1944, swelling the ranks of the new prisoners. My mother did meet a few of them in the washroom, but perhaps by the time she arrived, about six weeks after the French women, most of them had been transferred out of the Zugang block. Her transport group might just have been lucky enough to arrive at a rare moment between much larger transports, so that the quarantine barrack was uncrowded while the rest of the camp overflowed with prisoners.

My mother's memories of that first day in the camp remained vivid: "While Raburska and I were picking out which bunks to sleep in, we joked around that since I had my hair cut off and hers was spared, I would be her husband and she could be my wife. You know, you had to laugh once in a while to keep your sanity. What else could you do? At first, it was terrible to be without my hair, but I survived. We all got this scarf that we had to wear, a small square of rough cotton-like material that you could barely tie under your chin, so at least my head was covered."

Existence in the new quarters was primitive: "I think we slept in our clothes. I don't remember taking the pasiak off. Somehow I don't think I did, because it was so cold. There basically wasn't any heating."

"No heating in the barracks in mid-March?" I asked my mother, in surprise.

"Not really. There was a small coal stove, but it didn't do much good at all. Another thing—you slept with your clogs under your pillow, and anything else you had, like a sliver of soap. If you saved a bit of bread from that day, people would try to steal this at night. You had to hold onto this bread.

"Everyone was trying to survive, trying to not die. It was late winter, and I wondered how I would ever stay warm. This Mecklenburg region of Germany had such a bad climate in the winter and early spring, really cold and damp.

"Sometime later, I was able to get newspapers that I put under my thin dress as insulation, to help keep me warm, so I wouldn't get sick."

"Newspapers?" I asked incredulously. "You managed to get newspapers?"

"Yes," my mother chuckled at my surprise. "Yes, you could buy old newspapers from the more established prisoners. I don't remember what it cost me, what item I traded for them, but I must have sold something, probably my daily loaf of bread."

The stay in the quarantine block was a time of great uncertainty and vulnerability. Newcomers had to learn the rules and regulations of camp life quickly—how to make up their beds, how to address their superiors. They had to learn the daily routines and tricks of survival—how to guard their few possessions, how to avoid punishment, how to stay healthy in a place that was anything but healthful. And they had to figure out whom they could and could not trust among the more seasoned prisoners. This was made more difficult by the fact that new prisoners, because they were under quarantine, were forbidden to leave their barrack or visit other parts of the camp unless assigned to a job in the kitchen or the gardens. Normally, prisoners did not receive permanent work assignments until they rotated out of quarantine.

My mother vaguely recalled being sent off to work in some field a few weeks after arrival: "But just for a day, because I didn't know

anything about physical labor. After all, I had been a physician. I can't remember what it was that I had to do, but they didn't send me back out again to work in the fields after that."

In Jack Morrison's study of everyday life in Ravensbrück, he noted that the quarantine period was especially dangerous for women who entered the camp already sick, because they were unlikely to get medical care. Moreover, newly arrived prisoners, who were depressed, homesick, and confused, were in no position to develop the personal ties and support networks that could help the sick and the desperate. Many of the women, Morrison wrote, died within a few days of arriving at the camp.

Most of the women in the Zugang block at Ravensbrück, including my mother, did not understand at first what was happening to them, what their new imprisonment meant: "You were really kind of within yourself, trying to deal with the loss of your humanity," she said. They were stunned from so many losses—of home, family, friends, possessions, of a life left behind. My mother did not remember anyone dying in their barrack, although there must have been some deaths, but she was aware that many prisoners were sick:

"A lot of women were coughing or moaning, especially at night. I remember once a woman screaming. In such cases, the *ausjerka* [the Polish word for a female SS guard, from the German *Aufseherin*] would come to the barracks with this large black dog. I have no idea what happened to this particular poor woman, for there were several hundred of us in my block."

~

The daily routine of the camp began at four in the morning, when blaring sirens woke the prisoners. The room senior ran around the barrack yelling at the women to get up and shaking those who were slow. Some women hastily washed, others made up their beds, and eventually everyone gathered in the barrack's large dining area. According to my mother, this was when they received their daily ration of bread:

"For breakfast we had dark ersatz tea, made from some sort of herbs, and bread served with something, maybe marmalade, to spread

on it. Several long loaves, heavy like clay, would be set at the table. One of the women was assigned to cut up and distribute the loaves. All of us watched her like hawks, to make sure she divided them evenly. If she cut one portion a bit thicker, there would be an immediate outcry. Everyone was hungry. So each woman watched the slicing with ravenous eyes to ensure that she got what she deserved, and no less. You had to guard your ration and make it last throughout the day."

The women also gathered in the dining area for afternoon lunch and evening supper. According to my mother, the menu never varied: "We always had soup, sometimes with bits of meat in it, but it was watery and not very nutritious."

The soup was usually made with either cabbage or turnips. If the women were lucky, a few potatoes might be thrown in. The guards sent prisoners to the camp kitchen to bring back the soup in large metal kettles. My mother shook her head and grimaced as she described how awkward and heavy they were:

"I once had to help carry one of these kettles. I think it took three of us, they were so big. You could barely carry them, your hands ached so much. You had to go outside, and the kitchen was quite far away. The SS woman would accompany us, and you tried to be so careful. You didn't dare spill the soup or drop the kettle, for fear of being punished and going hungry."

The women would line up to have soup ladled into their bowls, and they ate it with bread left over from breakfast: "There was an older prisoner who worked in the kitchen, and she would serve us the soup. She was pretty honest, and if she liked you, she would stir the soup up with her large ladle and give you the thicker portion from the bottom of the kettle."

After their meager breakfast, the women hurried to line up for the roll call, called *Appel* in German. A siren blasted a warning, and all camp prisoners were expected to be present. The large Appel square lay at the end of the camp near the main entrance. First thing in the morning and again at the end of the day, the prisoners had to be accounted for. The roll call could last an hour or more while everyone stood at

attention. Although the main purpose was to make sure no one was missing, guards also used this daily ritual—which took place in all the concentration camps—to discipline, punish, and humiliate prisoners.

Roll call was a time of danger, often marked by selective acts of cruelty on the part of the SS guards. It was difficult, at first, to remember the multitude of camp regulations, and prisoners could be punished for breaking even minor ones, such as the rules against talking during roll call and stepping even slightly out of line. Punishments ranged from being forced to stand for a long time or being denied food and mail to being kicked and beaten, placed in solitary confinement, or sent to the punishment block, where overseers were especially brutal and prisoners were forced to do the worst jobs, such as cleaning the latrines.

It was also during roll call that the SS staff made "selections." Women considered healthy and strong might be assigned to a special work crew or chosen to leave and work at a subcamp elsewhere. Those deemed weak and useless might be sent to their deaths.

My mother's recollections of the daily roll-call ritual were clearly traumatic: "We would all line up in groups of five, straight, at attention. There were thousands of women standing out there during the Appel. Sometimes it would last for several hours. Rain would fall and you would get wet, your shoes, your dress. You were not allowed to step out of line. The SS women, or ausjerki, were dressed in long dark capes and pointed hats. They reminded us of crows, and so we called them *wrony*, in Polish. They would walk around with large black dogs on a leash. Everyone was terrified. We had heard that if you stepped out of line, the dog would attack you. And so everyone tried to stand still in straight, even lines. Not one step out, not even a centimeter."

The SS women used dogs not only during roll calls but also when they accompanied prisoners who worked outside the camp, in the fields or nearby factories. All prisoners shared the fear of dogs that my mother remembered, for dog bites were one of the most common reasons women prisoners were seen in the camp infirmary.

During the roll call, the block senior would count off each prisoner from her barrack—by number, not name—and then present a report

to the SS woman in charge. If anyone was missing, the others would be punished. My mother did not recall this ever happening during her short time at Ravensbrück, but stories circulated that when a prisoner tried to escape, the SS would count out ten women randomly from the roll call and shoot them. Such rumors were plausible and terrifying enough to keep the women in line.

In several concentration camps, roll call was also when SS personnel chose prisoners to serve as guinea pigs in medical experiments conducted by SS doctors working at the camps. Everyone has heard of the notorious Dr. Joseph Mengele of Auschwitz, but physicians conducted sadistic experiments in Ravensbrück as well, especially on Polish and French political prisoners and on Roma and Sinti. My mother mentioned seeing women limping around the camp whom others identified as former victims. Those who survived the agonizing experiments suffered horribly and were usually crippled. They were often protected by the other prisoners, who sympathetically referred to them as "rabbits" (*króliki* in Polish)—a reference to both their hobbling gait and its cause.

—

Life in Ravensbrück was a constant struggle for food, for medicine, for clothing and other scarce goods, for safer work assignments—in essence, for anything that might help one stay alive. Success in the struggle came partly from luck, from being in the right place at the right time. But friendships and relationships—knowing other prisoners who had access to valued goods or who might intervene on one's behalf—could also ease the deprivation. Jadzia learned the value of relationships early in her stay.

The block senior, or *blokowa*, of the quarantine barrack was a handsome young Polish woman who happened to be from Poznań, where Jadzia had studied medicine for six years. She organized the roll call, made work assignments, maintained discipline, and was accountable to the SS woman who was the block overseer. Jadzia considered the blokowa relatively compassionate, although she could be harsh at times. Even though she was in a position of authority, the blokowa was

responsible for all the prisoners in her barrack and thus risked punishment if the women she supervised misbehaved:

"The blokowa had to ensure that everyone acted properly. She would yell at us, and at times she had to hit those whom she was ordered to punish. Once, an acquaintance of mine from Łódź, Mrs. Bartoszewska, got slapped in the face by the blokowa because she had walked over the freshly washed floor. But no one ever treated me badly."

My mother's assessment of this blokowa and her actions was undoubtedly tempered by a remembered act of kindness the woman showed her sometime before Easter, which in 1944 fell on April 9, about three weeks after my mother arrived at Ravensbrück:

"The blokowa called me into her small room, located in the middle part of the barrack, and she said, 'I'd like you to have this loaf of bread.' I asked her why she was giving this to me, and she replied that she had gotten a package from Poland, and since she had enough food, she wasn't going to eat the bread. Of course she knew I had lived in her native city of Poznań for six years, so maybe she felt a bit closer to me."

But perhaps the woman had another reason for offering this valuable gift. From other accounts of life in Ravensbrück, it is clear that prisoner-officials like this Polish block senior had to perform a balancing act. They needed a minimal level of cooperation from the prisoners under their charge if they were to maintain order in the barracks, and order was what the SS overseers demanded. But order was also beneficial to the prisoners, for the SS women often meted out punishment to the entire group—such as all the residents of a block—for the transgressions of a single inmate. One way to achieve order, as many accounts from concentration and labor camps attest, was through intimidation and cruelty. An alternative was to reward a select number of prisoners, often members of the prisoner-official's own nationality, in exchange for their support and collaboration. It is difficult to tell whether this blokowa's gift of bread was a gesture of generosity and solidarity or an attempt to make Jadzia feel beholden.

Regardless of the reason behind her unusual gesture, the loaf of bread was a welcome gift, and Jadzia put it to good use in the prison's informal

economy, where "everything was traded," as Jack Morrison observed. "Everything had a price, and that price was calculated in units of bread rations, a unit being a prisoner's daily ration of bread or about 200 grams (7 ounces, not quite half a pound)." The traded goods might come from packages prisoners occasionally received, but more often they were stolen—from the kitchen, from the gardens, from sites of work, from wherever possible. Theft and barter were a way of life in the camps.

And barter was precisely what Jadzia did. She traded the extra loaf of bread for something she believed would help keep her healthy. "I exchanged it for a head of garlic. From the kitchens. There was always someone working there who could sneak things out. A loaf of bread for a head of garlic. It was good for the gums. So that your teeth didn't fall out completely. Many women got gingivitis because of poor nutrition. You didn't get enough to eat, not enough vitamins. I think I mashed this garlic and spread it on some bread."

⌒

My mother was awed by the many chance occurrences that altered her fate in the prison and in the camps. She even had a phrase for this: "fortune within misfortune," as when the guard at the prison on Gdańska Street smuggled the vermouth and charcoal tablets to her, helping cure her diarrhea just before her departure for Ravensbrück. I myself was impressed by my mother's determination in the face of great adversity not to give in but to do whatever she could to survive. This facet of her personality, this attitude, carried her through much in life. More than once I heard her say to herself, "Grit your teeth, Jadzia. Don't give in! [*Zaciśniej zęby, Jadziu. Nie daj się!*]"

A telling example of her determination was the personal regimen she followed in Ravensbrück. "The wake-up call came at 4 A.M. Everyone had to get up quickly and wash. What I would do . . . there were these huge sinks with faucets in the large washroom of our barracks, so large that you could sit in them, that even five people could have climbed in.

"Many women would only wash their face and hands. I would get up earlier, before everyone else, so no one would see me, and quickly

make my way to that washroom. I would strip naked and climb into the sink and wash my whole body under the freezing water, using the bit of soap they gave us. I can't remember how I dried myself off, but there must have been some sort of towel. I'm convinced that this is why I didn't get sick while I was there. I did this to get hardened, to toughen up. And then I'd return to the room to get ready for the Appel."

Jadzia's daily washing ritual took courage and certainly contributed to her psychological, if not also her physical, well-being in Ravensbrück. It was also a small act of resistance, a way to fight back against the dehumanization in the camp. She was exercising control over her own body and in this way asserting her humanity. But determination, will power, and a strong desire to survive were never enough. Luck was critical, especially when selections took place during roll call.

As the quarantine period drew to a close, the time came for the Zugang block inmates who had survived in relatively good health to be either reassigned to other barracks in the main camp and given jobs or transferred to work as slave laborers in one of Ravensbrück's many subcamps. One morning after roll call, guards ordered the prisoners to remain standing. As my mother recounted what happened next, she became visibly upset and her voice took on a harsh tone of outrage:

"This fat German officer had arrived at the camp to pick out women for work in some factory that made military equipment. First he looked you up and down, then he glanced into your mouth to see what your teeth and gums were like—I had all my teeth, healthy, with only one gold crown. And he looked at your hands to see if they were work-worn, which meant that you were used to physical labor. If you had nice hands, then you would get assigned the hardest work, because you clearly had had an easy life. That's what we figured out. My hands were soft and smooth. And then he made a mark on your forehead, like a "1," with some sort of crayon, meaning that you were selected for the transport. Even though I was so thin, they still wanted to send me off to work. When I look back on this, it's as if we were set out for sale!"

Jadzia was selected to join a transport of women being sent to Oranienburg, thirty miles to the south, where there were munitions and

airplane assembly factories, many of which employed female prisoners, including women from Ravensbrück. Jadzia did not know which factory her transport was destined for, but she remembered being told that it was dangerous work, almost a death sentence, because of the high risk of lead poisoning. All the selected women were sent to the infirmary, where they were ordered to strip and line up for a medical exam.

Some images are almost impossible to conjure up in the mind's eye. But in this case there was no need, for I came across a haunting drawing in Morrison's book about Ravensbrück that captured this moment. It was done by French artist and Ravensbrück prisoner Violette Lecoq, who was at the camp from October 1943 until April 1945. During her stay there, she made a series of more than thirty ink drawings, which she titled *Témoignages*, or *Evidence*. In a stark black-and-white drawing titled *Fit for Work*, the gaunt, naked women, tufts of hair sticking out from their recently shaved heads, await their turn. They stand in an endless line along the corridor outside the examining room while a fellow inmate is "inspected" by the camp medical staff. It took me a long time before I could look at this drawing without weeping, without picturing my own mother standing in that unending line.

Yet it was while waiting her turn in line that good luck and friendship benefited Jadzia again. The assistant to the German doctor in the "fit for work" exam that day happened to be a former medical school classmate of Jadzia's, a woman named Maria Adamska. She had been at Ravensbrück since August 1941, registered as prisoner number 6723. In the beginning Adamska was forced to help build new barracks, but later the SS put her skills as a physician to use in the camp infirmary, under the supervision of the German doctor in charge. Because of her position and seniority, Adamska was free to move about the camp. She was friendly with the Polish blokowa in the Zugang barrack—the woman who had given Jadzia the bread—and occasionally dropped by to visit her, ostensibly to offer medical advice, because the blokowa had urinary problems.

During one such visit, Adamska happened to run into Jadzia and recognized her instantly from their medical school days. Although they had

not been close colleagues in Poznań, under the current circumstances they soon became friends. Whenever Adamska paid a visit to the Zugang barrack, she sought out Jadzia and took time to talk with her.

On the day of the medical exam, Adamska was able to use her influence to help her friend avoid transport. My mother recalled: "When she saw me in this group, she immediately went to her supervisor and managed to convince him that since I was a fellow physician, he should pull me out of this large group by declaring that I was too sick to be sent to work in that factory. And so, thanks to her, I was not sent off to Oranienburg. He agreed and instead sent me back to the Zugang block."

～

Jadzia's reprieve was short-lived. A week or so later, another selection took place during the morning roll call: "As each number was called, the woman had to step out of line. We had no idea what this meant. We thought maybe something bad had happened. Maybe someone had gone missing or escaped. Or violated some major rule. Maybe they were randomly picking out eight or ten women to be shot so as to set an example for everyone else."

The SS woman in charge called out the numbers of a handful of women, including Jadzia's number, 32220.

10

The Camps of Gross-Rosen

❧

THE PRISONERS PULLED OUT of the roll-call line were ordered to follow the SS woman to the Ravensbrück camp office and wait outside. They stood huddled together in front of the office door, nervous and fearful, wondering why they had been selected. After a while, those who spoke Polish began to talk quietly among themselves:

"Who are you? Where are you from?"

"I'm Dąbrowska, a physician from Warsaw," one of them answered.

Another exclaimed, "I'm a physician, too. My name is Węgrzyńska. I'm also from Warsaw."

The oldest woman in the group said, "I'm Parczewska, a doctor from Poznań."

Then Jadzia added, "And I am Dr. Lenartowicz, from Łódź."

The other four prisoners, who were Czech and Russian, managed to communicate that they, too, were physicians. The women looked at one another, puzzled. They began to relax a little, thinking it unlikely that they had been selected randomly and even less likely that they were about to be lined up against a wall and shot. But why would the SS want eight women prisoners who were doctors?

After a long while, the SS woman reappeared at the door and ordered the group to come in. My mother recalled: "When we entered the office, we were told that we were being sent out as doctors to Jewish women's labor camps—even though none of us was Jewish. One of the office workers, a Polish prisoner, whispered to me, 'Listen, it will be an improvement for you. Each of you is being assigned to a

different labor camp. Conditions there are bound to be better than in the concentration camp here.'"

After filling out paperwork, the women were sent to take showers. They were then given new clothing—still the pasiak, or prison garb, but this time of much better quality: "It was like a suit, a dress with a longer jacket. And we got new socks, without holes in the heels, and new shoes. The shoes were still trepy, the wooden clogs, but better made, with laces on top. And each of us got a new flannel headscarf."

My mother paused and then added with a wry smile, "You see what elegant outfits we were given for our travel."

A day or so later, the physician prisoners left Ravensbrück on a train bound for Berlin, escorted by several SS women. This was a regular train, and many of those traveling on it were German soldiers, but Jadzia and her companions stayed in a separate compartment, forbidden to move about or talk to the other passengers. My mother still remembered what the war-ravaged capital looked like:

"When we got off in Berlin, we could see how much of the city had been destroyed from the bombings. There were ruins everywhere. This must have been sometime in early May of 1944, and we rejoiced in thinking that maybe soon the war would be over. And that God was punishing the Nazis for what they were doing to so many people."

~

In Berlin the women, still under SS guard, boarded another train, headed toward southeastern Germany. Their immediate destination was the Gross-Rosen concentration camp, situated about 185 miles southeast of Berlin near a small town of the same name. Today, after the postwar shift of national borders, the town lies in southwestern Poland and is called Rogożnica.

To understand why Jadzia and her fellow inmates were being transferred, it is helpful to know some of the history of the region in which Gross-Rosen and many of its satellite labor camps were located. Silesia, much of which at the time belonged to Germany, is renowned for its

abundant natural resources, especially coal and metallic ores such as copper and silver. The easternmost portion, especially rich in coal, had been transferred to Poland after World War I and was an industrial center with mines, smelting and chemical plants, and numerous factories. Because of its economic and military value, Germany annexed this territory to the Reich soon after the invasion of Poland and made it part of the administrative district known as Eastern Upper Silesia. It was also an area densely populated with Jewish settlements.

In other parts of occupied Poland, the Germans were quick to either deport local Jewish populations or segregate and isolate them inside ghettos, as they did in Łódź and Warsaw. In Silesia, however, the Nazis needed cheap labor to exploit this region's rich resources, and pragmatists in the leadership argued that at least a portion of the able-bodied captive Jewish population should be put to use.

This economic argument won out and delayed, for a while, the kinds of massive deportations and killings of Jews that would soon begin in other parts of Nazi-occupied Poland. In 1940 the Nazis instituted a system of Jewish forced labor throughout Silesia and the adjacent Sudetenland, which Germany had annexed from Czechoslovakia in 1938. To administer this labor scheme, they established a new SS economic agency, named after its director, Albrecht Schmelt, a Nazi officer personally appointed by SS chief Heinrich Himmler.

Schmelt's organization became highly profitable, initially using Jewish workers for major construction projects in the region. As its importance to the military increased, Schmelt brought in Jewish workers from an ever-larger radius, hiring them out for a fee to eager German owners of workshops, factories, and businesses in Silesia. Jews worked in both large and small enterprises, constructing roads, processing sugar, and manufacturing armaments, submarines, airplanes, munitions, freight cars, light bulbs, heavy machinery, and textiles. They lived in any of more than two hundred labor camps set up near the work sites and controlled by Organization Schmelt, where conditions ranged from difficult to inhumane, depending on the nature of the work and the attitude of the employer and the camp staff and guards.

For a while, the Jews of this region experienced slightly better living conditions than Jews elsewhere, but not for long. Even as Schmelt's empire expanded, the systematic killing of Jews was accelerating in other parts of occupied Poland. Eastern Upper Silesia was not spared, although the pace of extermination remained slower there. Starting in the spring of 1942, the Nazis liquidated most small Jewish communities in this district and sent their residents, especially those deemed "unproductive"—the sick and the disabled, the very young and the aged—to Auschwitz to be gassed. But unlike elsewhere in occupied Poland, some Silesian Jews survived these actions. For example, the Nazi authorities ordered more than fifty thousand Jews from the largest towns in the district to show up on August 12, 1942, at the sports stadium in the city of Sosnowiec. Those with valid work permits were allowed to return home. The others underwent a series of selections, whereby representatives of Organization Schmelt chose some nine thousand of the young and healthy to send to labor camps. Most of the remaining Jews were put on trains to Auschwitz.

In early 1943, more than fifty thousand Jewish prisoners considered necessary to the war economy were still "employed" through Organization Schmelt. More than half its labor camps housed exclusively women, many of them near textile plants where prisoners harvested cotton and flax, ginned and cleaned the cotton, made thread, wove cloth, and produced finished clothing.

There is no doubt that the Nazi plan included the eventual murder of all remaining Jews. The question was never *whether* this would happen, but merely how quickly. For Hitler and other high-level Nazi officials, wrote the historian Bella Gutterman, "seeing the camps as sources of prisoner labor was a secondary factor, which would merely be a phase in the extermination process."

Yet arguments arose repeatedly between Nazi pragmatists who were focused on the war effort and saw young, healthy Jews as a readily exploitable workforce and Nazi ideologues who considered the Final Solution more important. The tipping point in this debate was the Warsaw ghetto uprising of April 1943, in which Jewish insurgents attacked

the Nazis in a heroic and desperate effort to prevent the remaining ghetto residents from being sent to the Treblinka death camp. The Germans feared that the uprising would spark similar rebellions in other ghettos and in labor camps. But more important was the fact that the extensive employment of Jews, however profitable it might be for the SS, was impeding the completion of the Final Solution.

As a result, in late 1943 Heinrich Himmler decided to dismantle Organization Schmelt, close down most of the camps, and deport the Jews to Auschwitz. The liquidation lasted until the middle of 1944. The only Jewish labor camps that were spared were those located close to factories that produced armaments, munitions, and other critical military supplies. Some of these surviving camps were reassigned to the large subcamp system of Auschwitz.

By May 1944, when Jadzia's group arrived in Gross Rosen, the remaining twenty-eight Organization Schmelt camps had been reconfigured as Gross-Rosen satellite camps, under the direct control of the SS. Among them were a number of exclusively female camps that held a total of about 7,000 Jewish women, many of whom worked in adjacent textile factories. Jadzia and her fellow inmates were about to be assigned to work as prisoner-doctors in these camps.

When I talked with my mother about her experiences during this time, she often wondered why she and the other women had been pulled out of the Ravensbrück roll-call line and sent to work as doctors in the Gross-Rosen labor camps. She was unaware of the history of the Schmelt camps and so her explanation, over fifty years later, focused on the changing fortunes of war and the Nazis' desire to cover their tracks:

"Such German hypocrisy! The war was ending and the Nazis wanted to show that each camp was self-sufficient, that it had everything, a nurse, a doctor, and so on, that prisoners had health care. The Germans were afraid that once the war was over, they would be held accountable for all of this. So I think that's why the order came down to get prisoner-doctors into the camps."

My mother was right: the Germans were indeed intent upon hiding their long trail of murder, brutality, and exploitation. During the last

months of the war, faced with defeat and capture, they worked hard to destroy evidence—including, tragically, the people imprisoned in the camps, who could bear witness against them.

But the reason for installing physicians in slave labor camps at this late point in the war related not so much to the recognition of impending defeat but rather to the continuation of the German war effort. The remaining labor camps supported enterprises necessary for producing military supplies, which was the only reason these camps were not liquidated and the only reason the Jewish prisoners in them were still alive. And the Nazis' only reason for having medical care in the camps was to ensure that this essential work force stayed just healthy enough to be exploited to the fullest.

~

My mother was unsure exactly how her group traveled the couple of miles from the Gross-Rosen train station to the concentration camp. If the women arrived in daytime, they would have seen an imposing iron gate framed in granite, with a guardhouse above it and a wooden building on either side. At night, searchlights lit up the gate. Electrified barbed wire strung on evenly spaced concrete posts surrounded the camp.

In mid-1944 the main camp, which held male prisoners, acted as the administrative center of an industrial complex comprising about one hundred subcamps. The whole Gross-Rosen camp system controlled some eighty thousand prisoners at the time, 65 percent of whom were Jewish. Many of the prisoners worked in construction and weapons production, and inmates from the main camp also worked in a nearby SS-owned granite quarry. The work was exhausting and dangerous, the living quarters were overcrowded, and the guards and overseers starved and mistreated their prisoners.

My mother was still haunted by images from her brief stay at the main camp: "Gross-Rosen was a difficult, terrible camp, and the prisoners had to work the quarries. While we were there, we saw groups of men who were like walking skeletons. They were so thin, shuffling along with their hands up, carrying heavy stones, barely marching."

As my mother described this scene, she lifted her hands as if she herself were carrying the heavy stones, tears in her eyes:

"It was a horrible sight . . . one that I'll never forget." She took a moment to compose herself before resuming her story. "Since this was a camp for men, we couldn't stay in the barracks with them. Instead, the camp staff prepared a separate place for our little group."

Jadzia and her companions stayed in a coal bin that had been emptied, cleaned out, and furnished with wooden bunks and large covered barrels that served as their night latrines. As my mother observed, "Coal bins don't have windows," but this one did have a ceiling light. The bin was situated near the camp entrance, far away from the barracks where the male prisoners lived:

"There was a large washroom just across the way. The guard would lead us there and stand outside the door while we washed up under the showers. I think this was where they usually brought the newly arrived prisoners for their first shower. The water was heated on stoves using coal, which is why there were coal bins across the way. We would laugh about this sometimes . . . that we were living in a coal bin. An armed guard was posted in front of our 'lodgings' to make sure none of the men would try to talk to us. And, I suppose, so that none of us would try to escape. But where would you escape to, with electrified fences all around?"

The women were thin and malnourished after the sparse rations of bread and watery soup that were standard camp fare in Ravensbrück. Now that they had been designated as useful to the Nazis, their overseers wanted them to gain weight and strength. On their first day at Gross-Rosen, by order of the resident German doctor, male prisoners from the kitchen brought the women a huge kettle of pea soup made with bacon, along with tin bowls and spoons. My mother recalled how the initial pleasure of eating hearty food that had substance and taste soon gave way to misery:

"This was a lot of soup for us. It was very rich, and we ate too much of it too quickly. After having been on a steady diet of watery soup, we ended up getting very sick with stomach pains and diarrhea. Dr. Parczewska, who was around seventy and so the oldest in our group

and who spoke German very well, called out to the guard, 'We are sick. We need to see the doctor!'

"When the doctor came, we told him we were ill from eating too much pea soup with bacon. 'But what do you need?' he asked. He was young and perhaps didn't know how to treat such problems. We told him to bring us opium, charcoal, and something for the pain. Opium drops were used in those days to treat diarrhea, and the charcoal was for gas. And we also asked for *kleik*, oatmeal cooked in water, to eat."

Jadzia and her companions were sick for three days. But their self-prescribed treatment worked, and by the fourth day they felt better. From then on, the kitchen sent them a lighter soup for their meals. The German doctor also decided that they needed exercise and fresh air: "So they took us out onto a large sports field."

What my mother remembered as a sports field was, I discovered when I saw a layout of the camp in a Holocaust historical atlas, a parade ground just outside the main camp gate, not far from where the resident SS officers lived. Guards took Jadzia and her colleagues on daily walks around this ground. "There were two of them, with rifles, for us eight innocent, barely-able-to-lift-their-legs women. Can you imagine? We could barely walk . . . one, two, three, four . . . dragging our feet. They would lead us around this place several times and then we would head back into our coal bin, which had been aired out while we were gone."

The women stayed in the main Gross-Rosen camp for about ten days. On the eve of their departure, something happened that under-scored the degree to which their status had improved—from "less than human" to prisoners of some value. My mother remembered that the area where the SS officers lived, just outside the camp perimeter, included a canteen where the officers came to drink coffee and eat meals. The place even featured a small orchestra. "One of the SS officers invited us to this café. I think he was impressed by the fact that we were all physicians."

Much later, I wondered if the officer was more impressed by the fact that they were women. Since Gross-Rosen was an all male camp,

the company of even emaciated women prisoners might have been a welcome change. What my mother said next made this explanation more plausible.

"The orchestra was made up of prisoners who had to play. He asked them to perform some Polish music for us. I thought we would all start to cry, but it also made us angry. And then, if you can believe this, he offered us wine, raised his glass, and made a toast to our health. That was the last straw. The irony of all this was almost too much to bear. I closed my eyes and thought to myself, 'I will never accept wine from such hands.' All of us refused the wine, claiming that it would make us sick again. And this was partly true. We could barely drink tea, much less wine. He was clearly offended. But thankfully, he didn't do anything to us. Just had us taken back to our coal bin."

As my mother finished this anecdote, I asked her why she thought this SS officer made such a gesture. She replied:

"I really don't know. The Germans were already losing the war. Maybe he wasn't a hundred percent Nazi. Maybe he belonged to the SS because he had to, because otherwise they might have put *him* in a concentration camp." Then she chuckled, "So there he was, in a concentration camp after all.

"That's how they bid us farewell in Gross-Rosen."

~

The very next day, Jadzia and the other women of her group left Gross-Rosen, traveling by train, again under the watchful eye of SS women. This time, they headed north about eighty-five miles to the city of Grünberg, site of a Gross-Rosen labor subcamp. Today, this city lies in Poland and is called Zielona Góra, but before 1945 it was in eastern Germany. Textile weaving had been a major industry in Grünberg for several hundred years. Now one of the largest mills, the Deutsche Wollenwaren Manufaktur AG, was producing material for uniforms, army coats, parachutes, and blankets. Starting in February 1942, the factory began to replace its German workers with Jewish women prisoners sent there by Organization Schmelt, which set up a camp nearby to house

those unpaid workers. When the Nazi leadership dismantled the Organization Schmelt network in May 1944, they incorporated this camp into the Gross-Rosen system.

My mother thought that it was upon their arrival at Grünberg that the women in her group were assigned new identities, for they were now considered inmates of Gross-Rosen. Each concentration camp had its own bureaucracy, which meant that a transfer from Ravensbrück to Gross-Rosen required a new registration and a new prisoner number. Jadzia became prisoner number 32049.

Even though their stay in Grünberg was to be brief, the women had to work during the short time they were there. On the first day, Jadzia was assigned some tasks in the kitchen:

"I was sent to peel potatoes." My mother began to laugh as she related what happened. "My, I had a hard time with those potatoes. The supervisor asked me, 'What's wrong? Don't you know how to peel potatoes?' And I replied, 'No, I'm a doctor, not a potato peeler.' She was not pleased and retorted, 'Well, here you are a worker and not a doctor.' But on the next day, they sent me instead to the textile factory. Another supervisor sat me down, but I had no idea what to do. All around me, women were working at weaving, and he ordered me to do the same. 'But I don't know how to weave,' I replied. He showed me a little bit and then said, 'Do the best you can. Pretend to weave, because I'm responsible for you. There are SS guards in the factory, watching you, watching me, watching everyone.' And so I somehow tried to weave. Luckily, we didn't remain too long in that camp."

A few days later, Jadzia and her colleagues were given their new assignments. The two oldest, Dr. Parczewska and a Czech physician, were to stay at Grünberg; the remaining prisoner-doctors were to be dispersed among other Gross-Rosen labor camps. Yet again Jadzia boarded a train, this time headed back south, accompanied by one of the young Russian doctors and, of course, their ever-present SS escort. Their destination was Trautenau, now the Czech city of Trutnov, located in the annexed region of the Sudetenland, near the Czech-Polish border. This was an area with many industrial plants, including textile mills

that produced goods for the German army. It also housed an SS head-quarters for centralized supervision of all the camps in the area.

My mother did not recall the name of the slave labor camp near Trautenau to which the SS sent her. Five of the former Organization Schmelt camps lay in this area, adjacent to German-owned spinning mills where Jewish women prisoners worked. It seems likely to me that the SS would have assigned a prisoner-doctor to a camp with a relatively large inmate population, so I assume that my mother and her Russian colleague went either to Ober Altstadt, which held some 1,000 to 1,200 Jewish women, or to Parschnitz, which, during its four-year existence, housed between 600 and 2,000 Jewish female prisoners at a time.

My mother seemed to have a favorable impression of the living conditions at this camp compared with others she had seen. The prisoners had to do demanding work at nearby factories, but to my mother they appeared healthier and better nourished than their counterparts at previous camps. Many of them were young Jewish women from Sosnowiec so they all spoke Polish.

This camp, however, was not to be Jadzia's final destination. The Russian prisoner-doctor stayed there, but Jadzia was assigned to yet another slave labor camp. For some reason, however, delays arose, and she ended up staying in the Trautenau-area camp for about a month. Finally, an SS woman arrived to escort her on the last leg of her journey through the Gross-Rosen system.

In the meantime, Jadzia worked as a physician alongside the young Russian doctor: "This was probably a good thing, because she didn't seem to have much clinical or practical experience. She was a handsome woman, tall and a bit plump. She had just finished medical school when she was sent to the Russian front and there was captured by the Germans. Since she knew that I was only staying for a short while, she kept asking me how to treat various ailments. I didn't mind, and it helped pass the time."

My mother's recollections of her weeks in this camp were few, and they seemed benign in comparison with her accounts of the previous months following her arrest. When I first asked her to describe what

life was like at the camp in Trautenau, her reply took me aback: "It was actually very pleasant there."

I could not believe what I was hearing. I remembered my mother mentioning, in an earlier conversation, that the air there was fresh, the weather was getting warmer, and the camp atmosphere seemed calmer, less harsh than at Ravensbrück and the other places. Still, I could not fathom anyone describing a Nazi labor camp as "pleasant." Incredulous, I asked her just what she meant. She explained:

"Well, I was able to rest up there. The barracks were small, but with separate beds. I could take a walk around this recreation area from time to time. There was also a Jewish dentist. She had her office in a very small barrack. And I and the Russian doctor had a small place set aside to see patients together, for minor things, just exams, things like headaches, other aches and pains. Of course, it was a Nazi camp, and so SS women guarded and watched you. They would make checks during the night while we slept, so you couldn't close the doors. But at least I was doing something."

Later that evening, as I transcribed this taped conversation, I began to understand what my mother meant. Even when life is full of terror, uncertainty, and privation, not all suffering feels the same. Weeks earlier, when she and I were talking about Ravensbrück, she had made a statement that affected me profoundly and that I had since thought about repeatedly. This was her remark that although she tolerated hunger in the camp, she found being treated like an animal, not like a human, unbearable.

In comparison with what my mother had endured at Ravensbrück and with what she was yet to suffer before the war's end, the Trautenau camp seemed, in retrospect, "pleasant." She had her own bed, not one of a crowded set of bunks stacked three levels high. She had decent clothes—a two-piece suit, even if it was prison garb—with new socks and wooden shoes that fit. She had meaningful work. She was no longer just another despised and dispensable Polish prisoner but a human being who was accorded at least a small degree of value and dignity. She was a prisoner-*doctor*.

~

During her stay in the Trautenau camp, Jadzia had an encounter that underscored the Nazis' obsession with bureaucracy, documentation, and the appearance of legality. Not only did they issue laws, directives, and orders—those aimed against Jews alone numbered in the thousands, and implementing them created a mountain of paperwork—but they also formulated passes, letters, announcements, permits, certificates, ration cards, and tons of reports. Every organization under German control had to comply.

Jadzia's direct experience with the long reach of Nazi bureaucracy illustrates the lengths to which the Nazis went to maintain a fiction of legality and order. Each time my mother related this anecdote, it was with a sense of indignation but also amazement at its absurdity:

"One day, I was called into the camp office in Trautenau. It turns out I had a visitor, a Gestapo agent. At the time of my arrest, I had had a fair amount of cash with me, about eight hundred German marks, because I had just gotten my monthly salary. When I arrived at the women's prison on Gdańska Street, this money was confiscated, along with my purse, my watch, and my diamond ring. Later, I suppose, all my other possessions that were left behind in the apartment were also seized. In addition, I think I had about three thousand German marks in the Dresdner Bank in Łódź.

"Well, the Gestapo agent came to this camp three or four months after my arrest to get my signature on a document declaring that I was voluntarily giving up my claim to this money on behalf of the German Reich. Can you imagine?

"As if I had a choice to do anything but sign! I assume that he came from quite a distance just to have me sign this paper. I wanted to ask him, 'And what about my jewelry, what about my clothes and furniture, my photos, my books, my documents? What about my parents' belongings that were stored in the basement of my apartment?' They never asked if I would sign those away. They just took them!" Those goods, of course, would have been difficult to trace, so no official receipts were needed.

Through bureaucratic procedures like this one, policies and practices that would be considered abnormal, immoral, even criminal under other circumstances became "normal" under Nazi rule. The historian Raul Hilberg, who devoted much of his life to studying how the Nazis' massive bureaucracy functioned, observed that lists, tables, and reports, made out in a deliberate, standardized, matter-of-fact style, help mask the nature of what is being listed or documented. And such masking is especially evident "when accounts of drastic actions are summarized in lists." Among the Nazis' inventories of supplies purchased and ammunition transferred are also lists of arrests, of deportations, of categories of people killed in a particular place on a particular day.

All this bureaucracy and documentation gave individual people in the Nazi system, from major decision makers to minor clerks, a way to distance themselves from actions that caused great suffering and deprived innocent people of their possessions, their families, and their lives. One example is the way the Germans managed train time-tables. They treated trains carrying Jews to death camps like any other train commissioned for a group. Train departure schedules for death transports, Raul Hilberg pointed out, look similar to other schedules, except that the destinations are extermination centers such as Auschwitz and Treblinka. The SS paid the railroads a set rate, often using funds that came from confiscated Jewish property. The fee covered a one-way ticket—except for the guards, who had returns—with children charged half fare and those under four going for free.

At one point in the epic film *Shoah*, director Claude Lanzmann and historian Raul Hilberg have a conversation about the train schedules. Lanzmann asks whether the travel bureau that handled the scheduling of death camp transports also dealt with regular passengers. Hilberg responds:

"Absolutely . . . the official travel bureau. Mittel Europäisch Reisebüro would ship people to the gas chambers, or . . . vacationers to their favorite resort. And that was basically the same office and the same operation, the same procedure, the same billing. . . . As a matter of course, everybody would do that job as if it were the most normal thing to do."

The Nazi bureaucracy, with its categorizations, regulations, and identity cards, also aimed to prevent Jews and members of other ethnic and cultural groups deemed inferior from fraternizing with members of groups viewed as superior. This prohibition could be difficult to enforce in situations where mixed groups worked side by side.

The Jewish women from the Trautenau camp worked in several factories that also used male forced laborers from nearby camps. Technically, the men and women were to be kept separate, but in reality, they did sometimes have opportunities to meet. From time to time, romantic relationships developed. On the eve of Jadzia's departure from this camp, several women approached her asking for help:

"One of the Jewish prisoners had fallen in love with one of the male workers from the factory, and she was pregnant. They asked me to tell them what she could do. But I wasn't a gynecologist. I told them that I had nothing with which I could help her. She was afraid and wanted to end the pregnancy. I could understand this because the SS would probably send her to Auschwitz if they found out."

Surviving records from Gross-Rosen, as well as testimonies and memoirs by former women prisoners, reveal that those discovered to be pregnant were often shipped directly to Auschwitz. In the rare cases in which a woman was allowed to remain in a labor camp and bring her pregnancy to term, the newborn was usually taken from her and killed. In this case, as it turned out, there was little that Jadzia could have done:

"I had nothing, just aspirin and some minor first aid items. That was all. There was nothing I could do to help her, and to be honest, I was afraid myself. And then, on the very next day, two SS women dressed in their black capes—in Ravensbrück, we used to call them wrony, or crows—came for me, and we left by train.

"We were heading for the town of Neusalz, to the slave labor camp where I had been assigned. And so I left this young Jewish prisoner with the Russian doctor, who, unfortunately, had minimal clinical knowledge. I don't know what ended up happening to that poor young woman."

11

Neusalz Slave Labor Camp

𝓍

THE CITY OF NEUSALZ, now Nowa Sól in southwestern Poland, sat on the left bank of the Oder River, a major transport route through easternmost Germany to the Baltic Sea. The town got its name, meaning "new salt," because of the sea-salt refinery established there in the mid-sixteenth century. By the 1930s, Neusalz housed more than seventeen thousand residents and had become one of the busiest river ports in Silesia and an important regional industrial center, especially for smelting, metallurgy, and textile production. When Germany began preparing for war, the Nazi government saw Neusalz as a military asset because of its diverse industrial base and its strategic location on the Oder just fifty miles from the Polish border.

With the start of World War II, many of the factories in the city retooled to produce armaments, armor sheeting for tanks, ammunition barrels, and specialized glue for the aircraft industry. They even cast frameworks for German U-boats, which were then assembled at plants farther north along the Oder and tested in the gulf waters of the Baltic Sea. Neusalz had twenty-six metallurgical firms in 1939 which, despite being relatively small, would play an important role in war-related production. By 1943, as Allied bombing intensified, Germany had transferred many sectors of industry to small and medium-size firms scattered throughout the southeastern parts of the Reich, far from the reach of Allied airbases. All these firms needed plenty of labor.

During the war years, prisoner-of-war and forced labor camps and barracks dotted the city, set up by local companies eager to exploit cheap foreign labor, initially that of Polish prisoners and deported

civilians. Later, the Nazis brought in workers and POWs from the Soviet Union, Ukraine, Belgium, France, and Czechoslovakia. One of the largest factories in Neusalz belonged to the textile firm Gruschwitz Textilwerke A.G. More than thirty-five hundred workers produced parachute cords and linen, cotton, and hemp thread for the German military in Gruschwitz's industrial complex of eighty buildings. Only one-third of the workers were German civilian employees; the rest were forced and slave laborers from occupied countries. The firm had a favorable prewar record of concern for workers' welfare, providing child care facilities and recreational and educational opportunities for workers and their families. Its policy changed dramatically when the Nazis took over.

In November 1939, a transport of about one hundred Polish Christian women arrived to work for Gruschwitz. At first the company lodged them in one of its factory buildings. Later, as more forced laborers arrived, the firm moved the workers' camp across the street from the factory complex, to buildings that before the war had formed a Reichsarbeitsdienst (RAD) compound. The RAD was the German National Labor Service, compulsory for men between the ages of eighteen and twenty-five, who had to work for six months on agricultural,

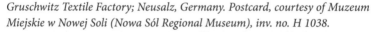

Gruschwitz Textile Factory; Neusalz, Germany. Postcard, courtesy of Muzeum Miejskie w Nowej Soli (Nowa Sól Regional Museum), inv. no. H 1038.

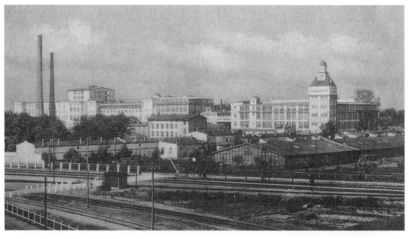

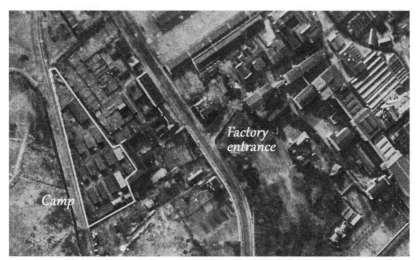

Close-up from a German aerial photo of Neusalz, showing the slave labor camp (left) and the Gruschwitz factory entrance (center) and complex (right); February 7, 1945. Courtesy of the Herder Institute map collection, Marburg, Germany.

construction, and military projects. When the war began, the RAD became an auxiliary of the armed forces, and its buildings became available for housing forced workers.

In 1942, Organization Schmelt sent a transport of Jewish women to work in the Gruschwitz factory in Neusalz. The firm set up barracks for them on the RAD compound's sports field, which it fenced off from the rest of the area and placed under heavy guard. A German aerial reconnaissance photograph taken on February 7, 1945, shows, on the far left, a triangular area of fourteen large buildings and several smaller ones that constituted the Jewish slave labor camp. Ten of the buildings appear similar in size and probably were the barracks where the women lived. The camp, largely invisible from the factory, was a completely separate organizational entity from the camp housing Polish Christian forced laborers in the adjacent RAD buildings.

In 2011, during a trip to Nowa Sól (the former Neusalz), I met one of the Polish forced workers, now eighty-five years old, who had lived in those buildings. She remembered that her group's outhouse backed right up against the rear of the slave labor camp, and when

the Polish women placed bricks next to the fence, they could peek into the Jewish camp.

The SS leaders must have considered the work done in this textile factory crucial to the war effort, for when they dismantled most of the Schmelt camps, they allowed the one in Neusalz to remain. Sometime in mid-1944, the SS annexed the camp to Gross-Rosen. Soon afterward, the inmates were subjected to a degrading inspection conducted by male SS officers from Gross-Rosen. The women were poked, prodded, and put through a series of exercises while naked. Those who passed inspection were assigned numbers and registered as prisoners of the Gross-Rosen concentration camp system. Those who did not pass were probably sent to Auschwitz.

By this time, the Jewish camp housed close to a thousand women. They came primarily from Poland and Hungary, and their ages reflected the Nazi policy of selecting only those deemed fit for work. The majority of them were between thirteen and forty-five, and almost half were twenty-one or younger. The women worked at the Gruschwitz factory and in its fields, planting and harvesting flax. For both the forced laborers (who received small wages) and the Jewish slave laborers (who didn't), the work was hard, the hours were long, and many workers were chronically exposed to dust, chemicals, and dyes. Processing flax to produce linen fibers to be spun into thread was complicated and hazardous. Many of the factory's machines were large, with complex, fast-moving parts, so workers risked serious accidents.

The factory owners housed and fed the foreign workers but did not treat them all equally. In testimony provided after the war, one Polish forced worker remarked that conditions for the Jews at Gruschwitz "were even worse than those faced by the Polish women, because they were made to do even more difficult physical labor. You could see from their outward appearance how exhausted they were, how weakened, and still they were forced to work."

The Jewish women received less food and harsher treatment, and were closely guarded while being escorted to and from the factory. They were forbidden to interact with the other workers, but some of

the Polish and German women surreptitiously shared food with them and even smuggled out of the factory letters that the Jewish women wrote to their families—courageous actions that would have been severely punished if discovered.

Such kindnesses became less possible, and living conditions became much worse for the Jewish women, once the SS took over the camp. Nevertheless, the women's skills, and therefore their lives, had some value in the eyes of their Nazi masters. Textile manufacturing required specialized training, especially for those who had to operate and service the heavy machinery used to gin cotton, process flax, and spin thread and yarn. So these Jewish women were permitted a slightly larger margin for survival—including care by a prisoner-doctor sent to Neusalz around June 1944.

⁓

Word spread throughout the camp that a Polish physician had just arrived: "They've sent us a goy [gentile]! Maybe things are going to improve . . . maybe the war is ending!"

Sadly, the war was far from over. In fact, the SS had sent Jadzia to the Neusalz camp precisely because the Nazis believed they could still turn the tide of war in their favor. Her job, from the perspective of the SS—although Jadzia did not perceive it this way—was to keep the Jewish women just healthy and fit enough to work for their German masters.

Jadzia had been traveling in the same striped prison suit she had received when she left Ravensbrück. Upon arriving in Neusalz, she noticed immediately that the prisoners were wearing civilian dress, and very few of them had shaved heads: "My hair, too, was starting to grow back. I had tufts sticking straight up for a while." A few days later, she was able to exchange her pasiak for some regular clothes, including a black skirt that came from the camp warehouse. Leather shoes, however, were a rare luxury, so she continued wearing wooden clogs like everyone else.

After being registered, Jadzia was taken to the small barrack where she would reside and work for the next eight months. Two Jewish women

who had been in Neusalz for a while were already living there, providing rudimentary health care, and she still remembered them clearly:

"One was Estera Bodner, a dentist originally from the Polish town of Oświęcim. Her sister was also in Neusalz and she worked in the factory. The other was a young Polish woman named Hania Priester, who was only twenty-one. She had received six weeks of basic nursing training from the SS. They were pleasant, and the three of us got along quite well."

According to my mother, the barrack consisted of two rooms, the smaller back one serving as sleeping quarters: "When I arrived, there were only two simple metal beds, with straw-filled mattresses, I think. That's what was often used in those days. When a third bed was added, they just barely fit. The other room served as a clinic where we saw patients. There was a table, which held an electric sterilizer and at which we also ate our meals."

In the earlier years of the camp, before the SS took it over, Estera and Hania had been the only sources of health care, although a German doctor occasionally came from outside the camp to examine the women. When Jadzia arrived, she began to treat patients almost immediately. Women would line up along the small road that passed by the door of the barrack and wait to be seen: "Estera would treat her patients in one spot, and I would examine my patients in another part of the same room. The women worked several shifts at the factory, so in a sense I was on twenty-four-hour duty. Those who were sick or wanted to get excused from work for the next day would stand in line once they returned from the factory."

As was the case throughout the Nazi concentration camp system, the Gross-Rosen subcamps had two overlapping organizational structures, that of the SS officials and that of the prisoner hierarchy. The SS commandant, or *Lagerführerin*, who administered the camp had ultimate authority and decision-making power. She was accountable to her superiors at Gross-Rosen headquarters, who visited the camps for periodic inspections. In Neusalz, the camp commandant at the time of Jadzia's arrival was an SS woman by the name of Elisabeth Gersch, known to the prisoners as Gerschowa—women's last names in Polish

are often given endings such as *owa* or *ówna*. She was a native of Polish Silesia and spoke Polish as well as German.

For the daily tasks of running the camp, the SS recruited prisoners. The most senior position among the prisoners was that of Lager-Älteste, a woman who was directly responsible to the camp commandant. My mother remembered well the prisoner who held this post in Neusalz: "She was the Jewish leader of all the Jewish prisoners—Mitzi Mehler, a tall, attractive young woman with beautiful blond hair." Mitzi was generally regarded as fair-minded and willing to look out for those who were young and vulnerable, but she could also mete out punishment when necessary. "She had an assistant named Cyli, who was a typist. Reports about everything had to be typed and sent to central headquarters. So the two of them worked in the camp office."

As in Ravensbrück, each barrack, or block, had a prisoner assigned as block senior, or blokowa. Other prisoners worked in the kitchen, performed clerical tasks in the camp office, or had duties such as laundering clothes, repairing shoes, cleaning barracks, and sweeping the grounds. In a small sewing room, three seamstresses worked full-time, among them the mother of Hania, the nurse. Throughout the camp's existence, prisoners also served as a kind of camp police, maintaining social order and enforcing camp regulations. Inmates with these sorts of assignments ranked above factory workers in the prisoner hierarchy, enjoyed slightly better living conditions, and had more access to food. Jadzia and her barrack mates, because they ran the infirmary, were part of this privileged group of prisoners.

According to other sources, when SS officials took over administration of the Neusalz camp, they replaced the civilian guards with specially trained German women loyal to the Nazi party, many of them former employees of the Gruschwitz factory. These recruits had been sent to the training center for SS women at Ravensbrück and upon their return became guards over the Jewish inmates. They kept close watch to prevent escapes as the prisoners walked to and from work and some of them brutalized the prisoners for the slightest infraction, using truncheons to beat them.

Guards watched the inmates closely inside the camp as well. According to my mother, "escape was impossible, because the camp was fenced," the fencing was reinforced with barbed wire, and the local Germans were likely to report any wandering Jewish women. However, other memoirs and testimonies by former Neusalz prisoners mention several escape attempts that took place before Jadzia's arrival, and one case where two women managed to flee in early 1944. To discourage further attempts, the SS man investigating the successful escape collectively punished about forty of the escapees' barrack mates by ordering their heads shaved. Later, another prisoner tried to escape in the darkness of early dawn while the women were being led to the factory, and upon capture, was publicly punished to set an example—shaved, beaten, tied up naked, and eventually taken away by the same SS man, most likely to Auschwitz. The concentration camp, with its gas chambers and crematoria, was the ultimate threat held over the heads of the prisoners.

◠

As camp doctor, Jadzia found herself in a situation different from that of most other inmates, who worked in the factory or out in the fields. She was largely confined to her barrack and prevented from wandering around the camp at will, but she did participate in much of the daily routine of camp life:

"Every morning began with the roll call, at seven o'clock, with all the women lining up outside. Mitzi would call out, '*Achtung!* [Attention!]' and then count each one of us and submit her report to the camp commander, Gerschowa. You had to stand still and straight, but this neither took as long nor was as strict as the roll call at Ravensbrück. For one thing, there were no SS women in black capes terrorizing the prisoners by walking around with dogs. When the roll call was over, everyone dispersed to their jobs while the three of us returned to our medical barrack."

Jadzia was also required to help occasionally with inspections of the prisoners' barracks: "I was surprised at how clean and neat they were. The barracks had two-tiered wooden bunk beds, quite a few crowded

in, but at least each woman had her own place to sleep. Before going off to work, they had to make their beds and sweep the floor. Everything had to be perfect, the beds made up army-style, the blankets just right. If the bed looked sloppy, everything would be thrown onto the floor, and the prisoner would have to make her bed up again."

The same was true for the small infirmary where Jadzia worked: "Someone from among the prisoners must have been assigned to keep the hospital clean. I don't remember after all these years. But Hania was responsible for the beds as part of her nursing duties."

For heat, each wooden barrack had a small coal-burning stove, which the women also used for cooking extra food they managed to get by barter or theft. Bathroom facilities occupied a different building. The women were permitted to shower with warm water about once a week, but Jadzia and her roommates had more flexibility: "There was a really large washroom where everyone came from their barracks at designated times. It wasn't always open. We went when the other prisoners were at work, so it wasn't crowded. On other days, I would wash up in the small infirmary, because there was a sink in there."

The kitchen was in a brick building and, according to my mother, was reasonably well equipped—considering that it was in a slave labor camp. Prisoners in white hats and aprons prepared and served the meals: "I would go in there from time to time and remember seeing these huge kettles used for cooking soup." Kitchen jobs were highly desirable because they gave access to extra food, which translated into the ability to grant favors to other prisoners and barter for other goods. But, as my mother commented, "They had to work hard in the kitchen, scrubbing vegetables, preparing food for so many people. It wasn't an easy life." Most of the prisoners ate in the dining area, but the medical personnel—Jadzia, Estera, and Hania—had to stay in their barrack.

The food was barely nourishing. My mother recalled that breakfast consisted of "ersatz coffee without sugar and a bit of bread. And you were sent off to work like this. The main meal was some sort of soup that had a few vegetables in it, accompanied by bread. The other women had to stand in a long line, each with her bowl, to get the soup.

But not us. Someone from the kitchen would bring the food to us. And since we were medical staff, we got two bowls of soup each. The other prisoners generally got only one bowl. I usually could just eat one serving, and even that didn't taste so good. But you ate out of necessity. I would give the second bowl to Hania, my young nurse, who was quite plump. She was always hungry."

Hunger is an ever-present theme in testimonies and memoirs of the Nazi camps, yet it was not something my mother dwelled on in her recollections. I asked her directly whether she felt hungry much of the time. "Surely this was not enough food to live on," I said, "these two bowls of watery soup with some bits of bread."

My mother agreed that what the prisoners experienced—especially those forced to do hard physical labor—was essentially slow starvation. She paused for a moment and then repeated a point she had made before: "I could go without much food. But the lack of freedom, the feeling of being locked up, that got to me. Sometimes at night, as I lay in bed thinking, I would hear the sounds of the nearby canal as it drained downhill toward the Oder. And I would start to cry. But never, never during the day. I'd cry for a while and then regain control over my emotions. 'Quiet down,' I'd say to myself, 'before they pack you off to Auschwitz.'"

~

Searching for background information about the Neusalz camp, I discovered several testimonies by Jewish women who had been imprisoned there. Reading them made me realize that my mother did not have a complete picture of camp life. As a prisoner-doctor, she enjoyed more privileges than most of the other inmates, but she was not allowed to roam the grounds or leave the camp, so she had no firsthand experience of the Gruschwitz factory, the kinds of work the other prisoners had to do, or their working conditions. The women's health problems gave her some idea, but they could be misleading, because Gruschwitz personnel dealt onsite with injuries and deaths that happened on the factory floor.

When we first started talking about Neusalz, the picture my mother painted seemed relatively benign. In comparison with the other camps where she had stayed, the women were healthier, the food was a bit better, and everyone had work to do. She personally witnessed little physical abuse. In reflecting on her time there, I think that my mother compared her stay in Neusalz favorably against her frightening detention in the Łódź jail and the dehumanization she endured and witnessed in Ravensbrück. For her, Neusalz was an interlude sandwiched between the horrors of Ravensbrück and, later, the nightmarish death march she barely survived. Small wonder that in talking about Neusalz, she sometimes commented, "It wasn't so bad."

"I wasn't beaten or kicked, and this helped me to endure, you know, to survive. While in Neusalz, I didn't feel worthless. Everybody worked. Whereas in the concentration camp, you basically felt like you were nothing. It was relatively calm there, in Neusalz. You didn't feel like you were being maltreated."

Then she paused and qualified her statement: "Well . . . that was true at least for the three of us, the medical staff. Of course, we had to stand at the roll calls, just like everyone else, whether it was warm or cold, sunshine or rain. We were also watched by the guards. On the other hand, it's true that we got more food and we didn't have to stand in line for it."

My mother was aware of her unique position as a prisoner-doctor. She repeatedly remarked, "My profession helped me a lot. It made things better for me in this labor camp. In fact, my profession saved me, for I might well not have survived if I had stayed in Ravensbrück or if I had been sent somewhere as just a regular prisoner."

Yet she also persistently pointed out the ways in which she identified with the other inmates: "You know, I never felt any different from the other women prisoners. Even though I wasn't Jewish, the women didn't treat me differently. Many of them spoke Polish, and I felt comfortable with them. But I wasn't able to wander around to all the barracks, and I never left the camp. We prisoners did have a bit more free time on Sundays and were allowed to take walks around

the grounds, so some of the young women would come to talk to me. But I don't remember their names anymore."

I believe my mother was sincere, but I also think she never truly understood the fundamental difference that set her apart from the other prisoners. It had little to do with her profession. Rather, in the racist universe created by the Nazis, the fact that she was not Jewish gave her a greater chance for survival.

Our conversations about life in Neusalz gained momentum after I introduced my mother to an unpublished memoir by a young Jewish woman named Aliza Lipszyc Besser, handwritten in the form of a diary in Polish soon after the war. While in the camps, she went by her first married name of Kokocinska; her husband had died in 1941 in the Warsaw ghetto. She met her second husband after the war.

My copy of the document came from the Yad Vashem Archives in Jerusalem. The script was difficult to decipher and strained my mother's aging eyes, so I typed out about one-third of the memoir, covering the months from October 1, 1943, to March 24, 1945. Besser was first sent to a labor camp associated with a branch of the Gruschwitz textile works in the town of Grünberg. When that factory shut down in November 1943, she and 119 other women were transferred to the camp in Neusalz.

One May afternoon in 2001, I brought the typed memoir over for my mother to see. After tea and a bite to eat—one always had to eat at my mother's—we sat down, side by side, at her dining room table. To my surprise, she began to read aloud. Luckily, I had my tape recorder with me, and she agreed to let me turn it on.

My mother was fascinated by the account and in the following weeks and months read aloud short segments totaling about seven hours of tape-recording, verbally annotating the text as she went along. Occasionally, when she came across an event that brought back painful memories, she choked up and had to stop and recover her composure. After reading the passage where Besser described how one group of women were collectively punished by having their heads shaved when two of their barrack mates escaped, my mother exclaimed, "They shaved my head in just the same way!"

Another time, she read Besser's description of an agonizing six-hour roll call on a freezing December Sunday that ended only when someone confessed to stealing a bottle of wine from the camp commandant's cache. Besser wrote: "It was terrible, we could barely catch our breath, our feet in the wooden clogs were stuck to the frozen ground, our hands numb from the cold."

Instantly, memories of roll calls in Ravensbrück brought tears to my mother's eyes, and she had to pause as she struggled to control her emotions. When anguish overwhelmed her, we would set aside the reading and go do something else, or have a cup of tea. But eventually, my mother would insist on returning to the memoir.

"I want to know all about this. I was there," she would say. She could envision herself in this narrative and was curious about what went on in parts of the camp with which she was unfamiliar. Accounts like Besser's opened a window onto events and circumstances my mother either could not recall or knew nothing about. They challenged some of her perceptions of life in Neusalz during her eight-month stay: "This is so interesting. There is so much that I wasn't aware of while I was there," she would remark. "After all . . . I was busy working as a doctor."

Besser did not mention my mother in her memoir. And with few exceptions, my mother did not remember the women by name. As she noted, "You didn't call people by their last name, just the first name. When I was seeing the women as patients, it was more formal, less personal." However, when I asked my mother to clarify this, she became impatient; this was yet another moment when her memory failed her. I now wish that I had pressed her on this point, for I wonder whether, when recording patient visits, my mother had to use a prisoner's number rather than her name. Such a practice, as well as the passage of time, would help explain why she did not recall the names of prisoners who came to see her.

My mother did remember that her records were officially scrutinized. A Nazi physician would occasionally inspect the camp, and as she recalled, "I would also be checked by this SS woman in a gray uniform, an attractive blond, but with a mean streak. She would arrive

from time to time. I would present the patients to her and the doctor, and they would determine whether these women truly needed to be in the infirmary rather than at work in the factory."

~

I learned from other sources that prisoners' living conditions were harsher than my mother's recollections suggested. The privileged jobs—working in the camp office, the kitchen, laundry, and sewing room, and the infirmary—afforded some protection as well as opportunities to obtain extra food. Most of the other prisoners worked long hours—conflicting accounts say that the factory ran either three eight-hour shifts or two twelve-hour shifts—and suffered small and large acts of cruelty inflicted by both the Jewish-prisoner camp police and the SS guards. And they often went hungry.

One short testimony, given to the Yad Vashem staff in Polish just after the end of the war by a former Neusalz prisoner named Anna Katz, echoes Aliza Besser's account, although Katz also commented, "Our living conditions were fairly good, since there were just 20 people to a room. Each had her own bed."

This reminded me of my mother's relative assessment. Like my mother, Katz was probably weighing life in Neusalz in relation to events that followed—a death march that in her case eventually took her to one of the worst concentration camps, Bergen-Belsen, where she spent the last weeks of the war.

Katz went on to say: "Sunday was a free day and we would sit around talking to each other and singing songs. A favorite song, composed by a woman in our group . . . told of our terrible misfortune." She also mentioned a camp guard who enthusiastically meted out punishments ordered by the commandant: "We would often get 25 lashes on our bare body." And she described the dangerous factory work:

"Some of the women [were] employed in the fields, planting and harvesting flax, while others worked inside the factory. My work was especially difficult and dangerous, because I would insert the fibers into the machine and I could easily have lost either a hand or fingers. I was

constantly breathing in the dust. . . . Most of the young women had lung problems due to all the dust at the factory. But we suffered the most from hunger. We only got 6 slices of bread and a half-liter of soup per day."

My mother grew distressed when she read this account while seated in my kitchen one morning. She was upset by her fellow prisoners' suffering and by her ignorance of it. At one point, she even started to cry: "These poor women, they did nothing wrong!" After a moment, she added: "I feel so badly about all that happened. But I didn't know about this. I didn't know that they were beaten."

My mother did not recall seeing the camp commandant kick or hit anyone during the roll call or women being made to run laps around the camp until they fell to the ground from exhaustion— punishments mentioned in Aliza Besser's account. It might be that these events occurred before Jadzia's arrival or at times when she was confined to her barrack, seeing patients. She had to report for the morning roll call, but probably not for the evening one. Because she had little freedom to socialize with other prisoners and did not live and work side by side with them, she was less aware than they of incidents that took place in the factory and in the camp. Or it might be that she had simply suppressed such painful memories.

Interestingly, the historian Bella Gutterman mentioned a documented case from October 1944 in which one of the camp's SS-trained German guards submitted a complaint to the commander of the main Gross-Rosen concentration camp. In the letter, she accused the Neusalz commandant, Gerschowa, of actually being too lenient— by SS standards. She claimed that Gerschowa failed to treat prisoners strictly enough and that she behaved inappropriately by wearing civilian dress, having prisoners mend her clothes, and spreading thick layers of butter on her bread. According to Gutterman, records show that Gerschowa was exonerated and the guard was dismissed from her post.

Like Anna Katz's testimony, Aliza Besser's memoir helps flesh out details not just about life in the Neusalz camp but also about work in the Gruschwitz textile factory. In addition to the Jewish women,

the company's work force consisted of forced laborers from Poland, France, Czechoslovakia, Ukraine, and elsewhere, as well as local German female employees. The Jews were distinguished from the rest by a large green-and-gray-striped patch sewn on the backs of their dresses, so that they could be easily spotted from a distance.

Working outside the camp had its advantages. Even though they toiled under the watchful eyes of SS-trained guards and factory foremen, the workers managed to surreptitiously share news from the outside world. In her memoir, Besser occasionally mentioned some turn of events that gave the Jewish women hope: "France has been liberated from the Germans. England and America are making progress. What joy it would be if one day we were to wake up and find the gates open. Able to go wherever we choose, able to search for our loved ones. To be free."

Even though the Jewish prisoners were forbidden to socialize inside the factory, they found ways of bartering with sympathetic co-workers, although this became more difficult after the SS took over the camp. The young women were resourceful in putting skills such as sewing to use and would repair clothes or make dresses for their German or Polish co-workers in exchange for packets of food. They were also adept at smuggling thread, wool, and other goods from the factory.

Again, my mother had no idea that this went on, and she was amazed at the women's ingenuity when she read the following account from Besser's memoir: "Some of the girls . . . would wear oversized panties with elastic at the leg, which allowed them to smuggle spools of multi-colored thread out of the factory. They would wind ten strands of thread together to make a thicker strand and use this to knit or crotchet all sorts of artistically done piecework. Beautiful sweaters, children's clothes, knee-high socks, etc. They would then barter these for bread that they got from either the German girls employed at the factory or from some of the privileged staff who worked at the camp."

~

The SS bureaucracy did not cut the women off from all communication with their families. My mother said, "I think we were allowed to write

once a month, although the letters were censored, of course." The prisoners could also receive letters and packages from time to time. My mother did not recall getting much mail, but it seems reasonable to assume that her parents wrote as often as they could. One package that came during her stay in Neusalz did make a lasting impression:

"In the late summer, my parents somehow heard that there was great hunger in our camp, that there was nothing to eat. And so my father sent me a huge basket of potatoes. I tell you, Basiu, I was amazed that these potatoes got to me. I had to give the potatoes to the kitchen, of course, but I had permission to have a small amount cooked up especially for me."

Not surprisingly, the prisoners dreamed of home and the food they used to eat—it helped them cope with the meager, monotonous camp diet, the constant hunger, and the losses they had endured. In his book on Ravensbrück, Jack Morrison mentioned that "women talked constantly of recipes and cooking; they dreamed of food. . . They kept secret journals of recipes and never tired of exchanging them."

Jadzia and her barrack mate Estera began to fantasize about what they could do with these potatoes: "Estera suggested that we make some *kopytka*"— a simple dumpling, basic Polish fare. "I asked Estera, 'How?' and her idea was to have the kitchen cook up some of the potatoes and mix in a bit of flour. And then we could make the kopytka and cook them here, in our barrack, on our burner."

While I was growing up in Detroit, kopytka usually appeared on the supper table the day after a celebration or big dinner, when my mother had plenty of leftover mashed potatoes. She would mix a good amount of flour, a bit of salt, and an egg into the potatoes and knead this mixture into a firm dough. Then she would take a handful, roll it out into a long rope about as thick as a finger, and diagonally slice off two-inch-long pieces. These she tossed into boiling water, to be served, when done, with gravy or drizzled with browned-in-butter breadcrumbs.

Jadzia and Estera decided to go ahead with their plan: "We knew some of the women who worked in the kitchen and asked them to help us. They could prepare the potatoes and add the flour but didn't

dare to make the kopytka or cook them, in case one of the SS women asked what they were doing. So when the guard stepped out of the kitchen, they quickly mixed in some flour with the cooked potatoes and brought them to our barrack.

"Here's what we did. We shaped the kopytka while the potatoes were warm. But we had to wait until night to cook them so we wouldn't get caught. We had this machine that was used for sterilizing syringes and instruments like scissors, forceps, dental equipment. Before going to bed, we filled the pot with water, put in the kopytka, and placed the electric burner with the pot under my bed so that if the SS woman came by at night to check up on us, she wouldn't see what we were doing. They made rounds regularly, you know, and though you could close your door, there were no locks. The guard could enter at any time.

"We were tired and, despite our best intentions, quickly fell asleep. I woke up to a strange feeling, wondering why my behind felt so warm. All of a sudden, I remembered. The kopytka! What a mess they made! They had cooked into a soupy mush and soon would have started to burn. It probably didn't help that we had left out the egg, but of course there were no eggs in the camp.

"We were so lucky that the guard didn't look in on us just then, because she might have smelled something and we surely would have been punished. Early the next morning, we threw out the kopytka and cleaned up the sterilizer. So you see, Basiu, I cooked kopytka in the slave labor camp. Later, the three of us—Hania, Estera, and I—had a good laugh about those kopytka."

Jadzia remembered one other package, this time sent to her by a Polish prisoner of war who corresponded with her youngest sister, Halina, who was living in Poland. One afternoon, Jadzia got a message to come to the commandant's office:

"This acquaintance of Halina's had included a note, stating that he had gotten this package from the Red Cross and wanted me to have it. He knew that what he sent was not in the best of shape, but at least it might help keep me warm. When I arrived at the office, the package

was lying opened." Packages were always delivered to the camp office, where the staff unwrapped and inspected them.

"The camp commandant, Gerschowa, told me to look inside. Basiu, when I saw what was in there, I couldn't help but laugh. This lieutenant had sent me a red carton of cigarettes and a pair of men's long woolen underwear that was torn in several places! I held up the underwear, and we both began to laugh. Well, he sent what he could.

"Gerschowa said, 'Take them if you want them, but the cigarettes stay with me.' You weren't allowed to smoke in the barracks, but she said that I could come to her office if I wanted to light up an occasional cigarette.

"When I returned to my barrack and Estera saw those old, torn long johns, she started to laugh so hard she had to sit down. All three of us had a good laugh. I mean, I would never wear such a thing. Or so I thought. But I kept them. Later, when the SS made us evacuate the camp in 1945 in the dead of winter, that pair of long underwear came in handy. I put them on even though they were torn, and they helped keep me warm during all those days that we marched."

～

As German war losses mounted, all sorts of resources became scarce, but especially food and coal. Aliza Besser wrote about the bitter weather in late December 1944. "It is terribly cold, temperatures are well below zero. We have no heat and our requests and complaints are for naught. None of the barracks has any coal." The women prisoners would double up in their beds, getting warmth from one another's bodies and the extra layers of blankets they would share. At least when they were at the factory, they could stay warm and even get washed up. And the work was easing, because the SS guards and factory foremen were preoccupied with the increasingly dismal news coming from the front. Germany was clearly losing, and they worried about what the future would bring.

December was an especially difficult month for Jadzia. Before the war, this would have been a time of celebration and family gatherings for

Catholic Poles. As Christmas of 1944 approached, the idea of spending it imprisoned and away from loved ones must have depressed her. But on Christmas Eve, she got a surprise:

"When I came to sit down for supper in our barrack, I discovered the table set and a wrapped package sitting next to my bowl of soup and bread. When I opened it, I found a beautiful short-sleeved sweater made of dark red wool, dark red like beets. Some of the Jewish girls I had befriended decided to make me a *Wigilia* [Polish for "Christmas Eve"]. They wanted me to feel better because it was Christmas. They had somehow managed to smuggle in the yarn, perhaps from some of the English or French prisoners who worked in the factory, and one of them had knitted it into this pretty sweater. This was so nice of them. I was really touched by the fact that they had thought of me." On this poignant note, Jadzia's first year of imprisonment drew to a close.

12

Slave Doctor

ONE DAY ABOUT MIDWAY through Jadzia's internment in Neusalz, a woman came to see her complaining of a sore throat and of feeling weak and feverish. She appeared seriously ill, so Jadzia admitted her into the camp infirmary, in a barrack nearby.

My mother's recounting of this incident happened to be the first time in our conversations about Neusalz that she had mentioned the infirmary, so I asked her to tell me more about it.

"It was small. I suppose you could call it a little hospital."

"How many beds did it have?" I asked.

"I can't remember. Maybe twenty, maybe thirty beds."

"How did it look?" I was curious about my mother's work as a labor-camp physician, so I peppered her with questions: "What kinds of medicine and supplies did you have? What sorts of problems did you treat?"

My mother replied impatiently, "How can I remember? It's been over sixty years since I was there!" Then she paused for a long moment. I could hear satisfaction creep into her voice, as she began to describe some of the work she did in the camp:

"I remember now. This little hospital was in a fairly long barrack. And there was a sink, a bathroom, and a small coal stove for heating. This is where I would put women who had a high fever, who were very sick and needed more attention." As my mother would soon discover, the woman she had just admitted needed attention urgently.

Jadzia began working almost immediately upon her arrival in Neusalz. Daily she confronted illnesses, diseases, and injuries for which she could offer little treatment. The women suffered from routine maladies such as colds, upset stomachs, diarrhea, and minor injuries, as well as ailments related to the deprivations of camp life and the stress of their work: ulcers, abscesses, sores, and respiratory problems caused by inhaling dust in the textile factory. Jadzia often felt unequipped to provide adequate care.

"You know, there was a shortage of everything because of the war. All the supplies were sent to the front for the German army. I had charcoal tablets [for diarrhea], aspirin, some antibacterial tablets, and a few other basic medicines. Bandages, of course, and sutures for sewing up cuts. That sort of thing. But you needed so much more. Somehow, I managed to get by with what little I had."

I asked my mother to describe what her workday was like. "Let me think for a moment," she said. "Well . . . the women would line up in a row outside the door to our barrack. The first time I saw this long line, I remember exclaiming, 'What's going on?'

"Hania and Estera had been in Neusalz for quite a while and knew most of the women. They warned me that some of them would try to take advantage of me, try to get out of work when they weren't really that sick. I suppose you couldn't blame them. But if this happened, the camp commandant would hold me responsible."

Jadzia had to weigh her medical judgment carefully, knowing that she was accountable to the SS. Someone from the main Gross-Rosen camp would periodically inspect the infirmary and Jadzia's patient records to make sure she was excusing women from work legitimately. All the subcamp offices had to submit weekly reports to Gross-Rosen detailing daily statistics such as the number of prisoners in the camp, the number working outside the camp (for example, in the factory or in the fields), the number working inside the camp (for example, in the kitchen, office, and laundry), and the number who were sick.

Because Jadzia was a newcomer, she agreed to let Hania, the nurse, continue to triage the women, something she had been doing throughout the months when the camp had no doctor. "Hania would do a preliminary check of those standing in line and decide who needed to be seen and who didn't, who seemed to be just looking to get out of work." But Jadzia worried at first about whether she could trust the young nurse's judgment:

"Her training wasn't that extensive; she just had a six-week course. I mean, how much can you learn in six weeks? Just basic things like bandaging, when to give out aspirin, minor stuff. Of course, she did have months of experience applying that basic knowledge, but let me tell you a story about something that happened soon after my arrival.

"One of the women got a severe stomachache and was very distended from gas. So I said, 'Listen, Hania. Why don't you give her an enema? That should relieve some of her pain.' Hania looked puzzled and asked how this was done. 'Well,' I said, 'you put water in. You lead it through a tube to the rectum. You do the enema so that stool and gas can come out.' I think I had her go do this in the infirmary. So she went to help this woman while I turned my attention to another patient.

"All of a sudden, I heard shouting and went running over there. The poor woman was yelling at the top of her lungs. I asked Hania, 'What are you doing?' And she replied that she was just doing what I had told her, putting the enema in so it could work, and she didn't know why the woman was screaming.

"Well, Basiu, I took a look and said, 'Hania, where are you putting it? It goes elsewhere, into the other hole!'

"Now, I can laugh about this, so many years later, but that poor patient! Hania had started to put the tube into the woman's vagina. So I showed her exactly how to give an enema, and it worked and the patient felt much better. It really wasn't Hania's fault. She was young, and she didn't have much training."

Still, Jadzia was just starting to familiarize herself with her new situation and felt she had no choice but to rely on Hania's judgment. "Hania's job probably made her unpopular with some of the women because she

helped decide who could see the doctor and who couldn't," my mother admitted. "But this needed to be done. I didn't know any of the women, or what they did, or the kinds of problems I would end up dealing with. And I didn't want to be seeing patients endlessly, day and night."

~

My mother's memories of the concentration camps revolved around anecdotes, and she was less likely to recall details of daily life than she was to remember people and incidents. When we discussed her work as a prisoner-doctor in Neusalz, she remembered particular cases, but many everyday mundane aspects of her practice—things like the average number of patients she saw each day, the range of health problems she dealt with, and the treatments she devised—had faded from her memory.

Aliza Besser's memoir helps augment my mother's recollections. She wrote about friends and co-workers who became seriously ill with tuberculosis, inflamed joints, and severe infections. Several of the women died. Besser came to Neusalz in late 1943, so some of the cases she mentions took place before my mother's arrival. For example, my mother recalled only one instance in which a patient died: "There may have been others, but I no longer remember."

The women in Neusalz, undernourished, overworked, and living in crowded quarters, were also exposed in the textile factory to chemicals, dust, and other hazards that posed serious health risks. Neusalz inmate Anna Katz mentioned in her testimony that many women suffered from lung problems. Even before the turn of the twentieth century, it was scientifically known that inhaling cotton, linen, and flax dust caused respiratory illness and, with protracted exposure, led to chronic diseases such as bronchitis and emphysema.

When I asked my mother about lung diseases, however, she could recall no cases of acute tuberculosis or serious respiratory illness. My first reaction was to think that many women afflicted with these maladies must have appeared at Jadzia's door but that she had simply forgotten. Later I realized that alternative explanations were possible. For

one, the factory had its own doctor, who might have handled acute TB cases, and such patients might well have been shipped out of the camp without my mother's ever knowing about them. For another, many of the prisoners had been working in the textile factory for several years without a camp physician; perhaps chronic coughing had become so ordinary for them that by the time a doctor arrived, they did not regard it as a reason to see her. Realistically, my mother could have done nothing for them anyway, since she had only a few basic medicines.

Aliza Besser remarked, too, that skin sores and carbuncles were common, and she herself suffered from them at one time. Carbuncles are painful local inflammations of the skin and deeper tissues caused by staphylococcal infections. As pus forms, the sores can develop into ulcerating abscesses and lead to destruction of tissue, with risk that bacteria in the blood (bacteremia) will spread the infection to other tissues and eventually cause death. My mother did recall seeing patients with skin problems, and one case in particular stood out:

"A woman from the camp came to see me because she had a carbuncle. It looked terrible. This was an ulcer that probably started at the skin but then went deep into the tissues of her leg. Oh, my gosh, Basiu. There was so much pus! It had to be surgically drained and I had never done this before. But I basically knew how it was done, and so I had to do it. The pus just flowed from her leg. It was terribly infected. So I cleaned the wound, bandaged it, and admitted her into the infirmary. This was in the pre-antibiotic era. Penicillin was not yet available, but there were some antimicrobial agents. One of these was an orange tablet called Prontosil that was often given to patients with pneumonia. So I treated her with these tablets."

While Jadzia's patient with the deep carbuncle was recuperating in the infirmary, a physician came to inspect the camp, accompanied by an SS woman. When the doctor entered Jadzia's barrack, she recognized him immediately: "He was from Poznań, where there was a large German population. We had been in the same class in medical school. When he saw me, he exclaimed, 'What! You're here?' And I answered, 'Yes, unfortunately, I am.'"

Jadzia and her old acquaintance began to converse softly in Polish: "He was asking me about the conditions in the camp and if there was anything I needed. I responded, 'Anything and everything.' And he promised to try and get some more supplies sent."

Suddenly, Jadzia's medical colleague noticed that the SS woman was approaching: "He walked over to the doorway of my barrack and declared loudly in German that we needed to 'move on to the *Krankenzimmer* [the infirmary] for the inspection.' Then he turned to me and whispered quickly, 'Don't speak Polish, only German now. Not a word in Polish, so she doesn't discover that you and I know each other.'

"The three of us walked over to the infirmary, where I presented the patients, including this woman who had the carbuncle, which by then was healing nicely. This doctor, my classmate, had to certify that all the patients were in the hospital for legitimate reasons, that they couldn't go to work in the factory."

"How did the visit turn out—did the doctor ever have more supplies sent?" I asked my mother.

"No. Nothing ever arrived, and I never saw him again. Some other doctor came on subsequent inspections, so I don't know what happened to him."

"And what became of the woman with the carbuncle?" I wondered. "Did she go back to work soon afterward?"

"Yes," Jadzia answered, "but it all ended sadly. The wound was not completely healed, and her leg was still hurting. But the camp officials decided that she was capable of returning to the factory. I couldn't keep her in the hospital any longer, not once she got the order to go back to work. A few days later, I found out that she had suddenly collapsed on the factory floor and died. She was probably forced back to work too soon and developed an embolus, a blood clot in her leg that loosened and traveled up to her brain."

～

This case of the woman with the carbuncle underscores how few medical supplies and how little professional authority Jadzia had. Many

times during our conversations, my mother would say, "I didn't feel much like a doctor because I didn't have many resources. It was more like first aid. But you did what you could with what you had."

Jadzia had been sent to Neusalz to keep the slave laborers at the Gruschwitz factory alive and healthy, but just barely. That was not, of course, how she viewed her work, but she was caught in the same vicious web as the other prisoners. She did what was expected of her, with scant resources. I do not think my mother ever understood the extent to which she was a cog in the machinery of exploitation that characterized the camps.

The noted author and Auschwitz survivor Primo Levi argued in *The Drowned and the Saved* that daily life for prisoners in German concentration and slave labor camps existed largely in a "gray zone," a morally ambiguous arena in which people's actions did not fall neatly into categories of good and bad. In the gray zone, everyone was complicit, to some degree, in searching for any way possible to survive.

Jadzia was caught in just such a gray zone, surviving by doing her job, even without the basic tools of her trade. My mother asserted that she was never forced to actively harm a patient, but routinely she was unable to provide the kind of care she knew people needed. Accounts from other Nazi camps document the overwhelming ethical dilemmas faced by prisoner-nurses and prisoner-doctors. Lacking adequate resources, they had to decide who would get treatment and who would not. Sometimes they actually helped patients die in order to spare them even worse fates. One non-Jewish physician who survived Auschwitz, Adelaide Hautval, observed years later, "Nobody could live during the nightmare years who in some instances was not forced to break the rules of traditional behavior. . . . All of us, including myself, were sometimes in situations in which we had to make abnormal decisions. The impossibility of living without 'dirty hands' belonged to that phenomenon."

An incident that arose in the first few weeks of Jadzia's stay in Neusalz shows how even simple acts, played out in the gray zone of Nazi camp life, could take on meanings not easily forgotten, not easily lived with in later years. This is the way my mother described what happened:

"One day Gerschowa, the German camp commander, came to me with a request. Could I remove a piece of glass that had been embedded in her finger for quite a while and caused her much discomfort? She had gone to another doctor, but he couldn't help her. Perhaps he was afraid to try because she was an SS woman. I thought to myself, 'What do I have to lose? It seems to be just under the skin.' So I agreed. I sterilized the scissors and scalpel, cleaned the area with iodine, made a shallow cut, grabbed the piece of glass with the forceps, and—poof!— quickly pulled it out and covered her finger with a sterile dressing. As she was leaving, she told me not to mention this incident."

For a long time, my mother would not let me share this anecdote with anyone, either. "Please don't write about this," she asked. "Who knows who will read about this? Who knows where it will go?" So many years gone by, and still she worried that others might condemn her for this moment when the patient-doctor relationship blurred the boundary between oppressor and victim. Similarly, the camp commander might have felt that she crossed an ideological line in getting help from a prisoner, an action her superiors would have frowned on. This was the only time any German camp functionary or guard ever came to my mother for care. Eventually, I was able to convince her of the value of the story and reassure her that others would not judge her.

I confess, however, to a persistent concern throughout the project of documenting my mother's life—the fear that I might stumble across some bit of information that would paint her in a bad light. As I searched for supportive materials, such as testimonies from other survivors of Neusalz, I could not help wondering what I might discover. At one point, I even gathered the courage to ask my mother outright whether she was ever made to do something that would harm a patient, such as give a lethal injection. Her answer was short but emphatic:

"No! I would never, ever, do such a thing."

But she must have faced situations in which she had to choose between her own welfare and that of someone else. Primo Levi remarked that the principal rule of survival in Auschwitz (and

undoubtedly in other Nazi camps) was "that you take care of yourself first of all." Another prisoner-doctor, Ella Lingens-Reiner, wrote in her memoir, *Prisoners of Fear,* "We camp prisoners had only one yardstick . . . whatever helped our survival was good, whatever threatened our survival was bad and to be avoided." Yet both of these Auschwitz survivors offer accounts in which prisoners had the moral courage to risk their survival to help others.

In the end, I am left with the realization that we cannot truly know how we ourselves would have behaved in those brutal settings and inhumane times, when fear was a constant companion and the margin for survival so very thin.

—

Even in the camps, medicine did, from time to time, mitigate suffering and offer hope and healing. Prisoner-doctors learned how to manipulate the Nazi bureaucracy to save at least a few lives—for example, by purposely misdiagnosing diseases that otherwise would condemn patients to deportation and death or by intervening on a fellow prisoner's behalf. The latter was precisely what saved Jadzia during her stay in Ravensbrück, when her former medical school classmate, Maria Adamska, convinced the SS doctor to designate Jadzia unfit for a dangerous transport.

At Neusalz, Jadzia herself was able to intervene and save the life of one fellow inmate who otherwise would have been sent to Auschwitz. This was an anecdote my mother told repeatedly, with pride and emotion. It clearly was one unique moment in Neusalz when she *did* feel like a physician who could make a difference. The patient was the woman mentioned earlier who came to the infirmary complaining of a sore throat and high fever. She was part of a group of 120 Hungarian Jews who had been transported from Auschwitz to Neusalz just a few months before Jadzia's arrival, to work in the textile factory.

Jadzia put the woman to bed. A day later, the patient felt even worse and had trouble swallowing. Upon taking a closer look at her throat, Jadzia became alarmed:

"Without any laboratory or microscopic testing, I knew immediately that she had diphtheria. I quickly reported the situation to the camp commandant and requested antitoxin serum, because that was how diphtheria was treated in those days. And strychnine for injections against paralysis."

I had heard of diphtheria antitoxin, which was a serum drawn from horses that had been injected with diphtheria toxin to produce the antitoxin that could neutralize this harmful substance that the bacteria released into the body. But I had never heard of medical uses for strychnine, so I asked my mother:

Oh, yes," she explained. "Strychnine was often used before the war as a stimulant for those who suffered from fatigue and for a lot of other problems, including complications from diphtherial infection."

The name of this deadly disease comes from the Greek word for leather, *diphthera,* and refers to its classic clinical feature, a leather-like membrane that forms on the tonsils and throat and in the nose. In severe cases, if untreated, this membrane can cause suffocation. The bacteria responsible for the disease release a toxin that can affect the heart and other organs, leading to potentially deadly complications. Timely treatment is critical. To make matters worse, diphtheria is highly contagious, spread by coughing and sneezing or by direct contact.

Jadzia faced the double task of treating the patient and preventing the disease from spreading rapidly throughout the camp. My mother's voice became animated as she continued the story:

"The commandant, Gerschowa, contacted the German doctor associated with the factory, and he came to see the patient. I remember that he was quite stout, with a large belly. He confirmed my diagnosis and took some samples. I, in turn, insisted that he get me some antitoxin serum."

In the meantime, something had to be done about isolating the sick woman and quarantining everyone who had been exposed to her. Adjacent to the barrack where Estera, Hania, and Jadzia lived was a small storage shed:

"They emptied it out and put in two beds, one for the patient with diphtheria and the other for her bunkmate, who lived in close contact

with her and had suspicious symptoms. This was convenient, because I could easily check up on them, see what they needed. Normally, when I saw patients, I just wore my usual clothes. I didn't have a white coat or apron, but in this case they furnished me with one, as well as gloves and a mask."

Because the sick woman had already spent several days in the infirmary, the other patients there were placed under quarantine as well, so that they could be observed during the ten-day incubation period. Even those who had recovered from whatever brought them to the infirmary had to remain there, because diphtheria was so contagious. No one, other than Jadzia and Hania, could enter the area during this time. Hania was moved into a small room off the infirmary so she could tend to the patients around the clock. She even slept there, and she wore a mask during the day. Jadzia chuckled as she recalled the nurse's reaction.

"Hania was so unhappy that she had to be confined and couldn't leave. 'Why me?' she asked. 'I feel like I'm in prison!'"—apparently said without irony. "And I replied that she was the nurse, and this was how it had to be. I certainly could not stay. I was the doctor and had to take care of others who were sick. No one from the kitchen could enter the infirmary, so Hania would meet them at the door and distribute the delivered food to all the patients. Only after the incubation period had passed could these other patients leave."

While waiting to hear back from the doctor about the antitoxin serum, Jadzia did what she could to help the woman: "In those days, we didn't have penicillin, but I did have those orange tablets, Prontosil. This was the best I had, so I gave them to her."

Jadzia waited and worried because she knew that medicine, especially antitoxin serum, was scarce and usually reserved for the German troops. She also recognized that this patient was now viewed as a threat to both the camp and the factory and as a useless, expendable burden. After all, Jews were being slaughtered simply for being Jews; would a Nazi doctor bother to save the life of a Hungarian Jew? Jadzia was counting on the Germans' desire to prevent an epidemic and to avoid

transporting an infectious patient more than two hundred miles back to Auschwitz to be gassed. A few days later, she had her answer:

"The German doctor kept his promise. I have to say that he truly treated me like a colleague rather than a prisoner. And he did take care of this. A few days later, he returned with the right dose of serum and even said that if I needed anything else, just to let him know, as one doctor to another."

Jadzia immediately began to give the patient a series of shots: "I did this slowly at first, to make sure she wasn't allergic to the serum. You give just a small amount in the buttocks and wait an hour. If there's no reaction, then you inject the rest."

Telling the story, my mother paused for a moment, then looked at me with a triumphant smile: "You see? I still remember. My memory is not so bad after all these years!"

The quarantine worked. No one else became infected, and the patient recovered. "Unfortunately, she got the antitoxin a bit late, so she was left with some paralysis of her palate, which made it hard for her to swallow. So I gave her injections of strychnine to ease the paralysis. And it helped in this case. As this Hungarian woman was leaving the infirmary, she thanked me and said, 'I'll never forget what you did for me.'"

⁓

One of the dangers mentioned in almost all the testimonies from Neusalz was the constant potential for accidents in the factory. Manufacturing textiles, whether from linen thread or cotton, meant working with machines that had sharp parts and ran at high speeds. The workers had to clean and oil parts, feed cotton into the machines, fix broken strands, and perform other risky tasks, all by hand. The machines were loud and generated a lot of heat—a blessing in winter, because the camp barracks were poorly heated, but a curse in summer, making it harder for the workers to stay alert.

Aliza Besser told of one sad factory accident in her memoir. A coworker lost part of her right hand while working at one of the machines. The unfortunate prisoner was sent directly to Auschwitz—"to the

ovens," Besser speculated. Another case mentioned in several testimonies involved a worker who died after being scalped when her long hair became caught in a machine. The factory managers had the scalp cleaned and dried and put it on display as a warning to other workers.

My mother remembered, in a general way, treating women who were injured during work, but she could recall few specific cases. It is possible that the factory doctor handled the urgent injuries. Only one incident remained vivid in her memory, partly because it happened right before her departure from Neusalz:

"One of the women broke her leg while at work, and I had to set the bone and put on a cast without the benefit of X-rays. I did have plaster and other supplies, so at least I was able to immobilize her leg. This happened shortly before the camp was closed down and we started on our march. We were all concerned about this woman, because she couldn't walk. So she was left behind. Maybe they sent her somewhere else or just left her in the abandoned camp. More likely, they killed her. The Nazis, you know, didn't fool around. I've often wondered what happened to her."

This accident occurred in the first week or so of 1945. Rumors were already flying around the camp that something big was about to happen, that perhaps the camp was going to be closed down. One rumor said that the camp was to be turned into a hospital for German soldiers. Some of the SS women had supposedly left for the main concentration camp at Gross-Rosen, so maybe the Neusalz prisoners were going to be transferred there. Or maybe elsewhere. Or could it be possible, remotely possible, that they might be set free? Change was in the air, but no one knew what it meant.

What the prisoners did know, from bits of information picked up at the factory, was that the tide of war had turned dramatically against Germany. First, in mid-January, came news that the Russian army had liberated Poland's capital, Warsaw. Aliza Besser wrote that the pace of work at the factory slowed during these weeks because the SS guards spent much of their time huddling together, discussing the turn of events. As she worked the machine right by the foreman's table, she

overheard several times that Allied armies were advancing rapidly and the Germans were in retreat: "The Russians are approaching the former Polish-German border with lightning speed. From the west, the American and British armies are liberating one country after another. France, Belgium, Holland, Italy are already in the hands of the Allies. Oh, just another day, just another week. . . ."

~

On January 19, 1945, the Soviet Red Army liberated Jadzia's beloved city of Łódź, although at least three months went by before she heard the news. Just a few days later, on January 24, another group of Soviet troops reached the Oder about fifty miles south of Neusalz and advanced northward along the river.

My mother remembered the final days in the camp: "We could clearly hear the sounds of battle on the other side of the Oder. We could tell that the Russians were drawing closer. We thought the war was coming to an end, and we were rejoicing, thinking that we would shortly be free. Of course the Russians, too, could be brutal. After the war, you heard stories of how they raped and murdered people when they entered some of the camps."

Unfortunately, liberation was not yet what awaited the women of Neusalz. The commanders of the Gross-Rosen subcamps had received orders to evacuate their prisoners—under no circumstances did the Nazi leadership want them to fall into the hands of the Allies and bear witness to Nazi atrocities. When Mitzi, the Jewish camp senior at Neusalz, learned of the plans to evacuate the camp, she opened the warehouse and started distributing all sorts of clothing, shoes, and blankets. My mother tried to recall what she was given in preparation for the evacuation. "I think that some days or weeks before we set out, a transport of clothes had arrived. I'm sure these were all items from women who had died, who had been gassed, maybe at Auschwitz. I remember getting some sort of dress, a winter coat, not too nice, whatever there was, and maybe a sweater. Probably socks and of course a

pair of trepy, those clogs that we all wore, that were covered with material. These lasted me only halfway through the march."

Daily routine broke down during those final days. Beds went unmade and floors unwashed, and no one came to inspect the barracks. A number of the SS women were summoned to the main Gross-Rosen camp. A few days later, the prisoners were told that the factory was "closed for repairs" and they would not be going to work for a few days. Soon they learned the truth—that on the very next morning they were to march out of the camp. My mother recalled that each woman received a ration of food to take with her:

"We got several loaves of bread, maybe some marmalade and packets of margarine. And some sort of backpack to carry these in. Each of us also had a blanket that we carried so we would have something to cover ourselves with at night."

Meagerly supplied, the women lined up early the next day—sometime in late January 1945. The sky was clear and sunny, but it was a bitterly cold morning. Guards divided the women into three groups of more than three hundred each. The first long line left the camp, walking five abreast and accompanied by SS women. My mother thought she went with the third group, headed by Mitzi. As this last group, which also included Estera and Hania, departed the Neusalz slave labor camp, no one knew where they were going. No one knew what lay ahead in the days and weeks to come.

13

Death March

𝒫

MARTIN GILBERT'S *ATLAS OF THE HOLOCAUST* features 316 maps documenting World War II in Europe. The maps start with the escalating anti-Semitic violence in prewar Germany, span the final tragic months of the war, and close with the postwar fate of Jewish survivors. They pinpoint Jewish communities on the eve of war, trace the deportations to ghettos and death camps, reveal the sites of massacres, revolts, and resistance actions, and delineate evacuations from labor and concentration camps late in the war. A great many of the maps trace the routes of death marches—the harrowing forced marches of inmates from one Nazi camp to another, often over long distances, with inadequate clothing and little food or water.

Most marches took place in 1944 and 1945 as the Nazis evacuated prisoner-of-war, labor, and concentration camps before the advance of Allied armies. The Nazis did not want such prisoners falling into the hands of the Allies and eventually testifying about war crimes. They destroyed many camps in an effort to hide evidence of atrocities and mass murders, and sometimes they shot prisoners on the spot to prevent them from revealing what they knew. Especially near the end of the war, evacuations were often hurried, even chaotic, and the number of prisoners too great to transport by train. Prisoners, sometimes numbering in the thousands and already in deteriorating health, had to walk for days and weeks, covering distances of as much as five hundred miles. En route, they were severely mistreated by their SS or army guards, and many were murdered. Many more succumbed to hunger, disease, exhaustion, and exposure. Nearly a quarter of a million prison-

ers, of various nationalities, Jews and non-Jews, died on death marches between the summer of 1944 and the end of World War II in Europe.

I first came across Gilbert's *Atlas of the Holocaust* in my local public library. I had just begun documenting my mother's life and wanted to see what kinds of resources were available close at hand. I took the atlas off the shelf and began browsing through it.

Out of curiosity, I looked at the index. Much to my surprise, I saw an entry for Neusalz, along with the numbers for two maps. The first map's caption read, "A forty-two-day death march, 26 January–11 March 1945." The caption for the second read, "From death march to death train." Turning the pages to the first map, I sat there for what seemed like an eternity, numb. I was staring at my mother's death march.

The route passed a number of relatively large towns in Germany and the Czech Sudetenland and crossed three rivers. It began at the Neusalz slave labor camp and ended six weeks and about 280 miles later at the Flossenbürg concentration camp. After a week there, the survivors were put in train cars and sent north to the Bergen-Belsen concentration camp.

I have viewed Gilbert's map many times since then, and it no longer overwhelms me in quite the way it did on the day I discovered it. Once in a while, though, I am caught off guard by the unimaginable suffering it represents. I have tried, unsuccessfully, to conjure up in my mind what my mother and her companions must have endured—but there is nothing in my life experience that can even bring me close to understanding what a single day on a death march must have been like, much less six weeks of marching.

It turned out that Gilbert's source of information for the two maps was the same unpublished memoir, the one by Aliza Besser, that served me as a rich source, too. In describing the death march from Neusalz to Flossenbürg, Besser mentioned towns and landmarks that later formed the basis for Gilbert's diagram. The general route, heading southwest from Neusalz, seems to have followed established roads.

Besser actually penned her memoir in 1946 while she was being held in a British detention camp on Cyprus, awaiting immigration to

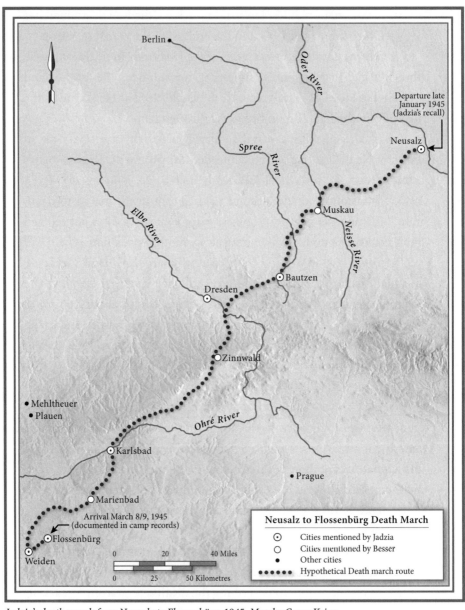

Jadzia's death march from Neusalz to Flossenbürg, 1945. Map by Gerry Krieg.

Palestine. She wrote in the present tense, as if the work were a diary, beginning with the eve of World War II and ending in May 1945, several weeks after the liberation of Bergen-Belsen on April 15.

My mother remembered that the Neusalz inmates began their march as three separate groups, or transports, of about three hundred prisoners each, and Besser confirmed this. Each of the three transports seems to have taken a slightly different route toward the final destination, which would have made the daily search for food and shelter a little easier. Besser mentioned several times that the transports briefly united, once at a large, abandoned farmstead and later in the German town of Bautzen, where the women stayed in a large factory warehouse.

I believe that Besser and my mother were in different groups. My mother read Besser's description of the death march eagerly, and at times she agreed with depictions of events, such as the constant struggle to find food and water. She even recalled some of the towns Besser mentioned. But there were also places and experiences that seemed completely foreign to her, while others remembered by my mother were not mentioned in Besser's account. For this reason, I commissioned a map that more accurately reflected my mother's narrative.

Besser's memoir offers a sense of continuity because of its chronological structure, whereas my mother's recollections of the death march resembled a scattered collage of experiences, often linked to neither place nor time. Perhaps I should not have been surprised. I was asking my mother to recall extremely traumatic events from more than six decades earlier. Considering her self-described state of physical, mental, and emotional exhaustion during most of the march, it is remarkable not how little she still remembered but how much. Amnesia, suppressed memories, and the passage of years left her with only a smattering of anecdotes regarding the march—which she often referred to as "my hike across the Reich." Nonetheless, she emphasized: "This experience has branded me forever. It isn't something you can easily forget."

~

The prisoners walked out of Neusalz in late January overwhelmed by fear and uncertainty. They had no idea where they were going or what to expect. Were they heading toward another camp? If so, why? How long would it take? Their food ration would not last more than a couple of days. Or were they being led to some remote spot to be massacred?

My mother's recollection was that her transport started out marching five abreast under the guard of SS women and a few soldiers: "We marched in formation, neither talking nor stopping, for if you fell down, that's where you remained. I walked alongside Estera and Hania, the two women who worked with me in Neusalz [the dentist and the nurse]. Hania's mother and Estera's sister were in our group as well."

At first the march took them along rural roads and the outskirts of villages and towns, "out of sight of the general population." It seemed to my mother that during the early days of the trek, the group would stop for the night in prearranged places, sleeping in barns, stables, and cowsheds, sometimes in buildings abandoned by Germans fleeing the approaching Allied front. She recalled seeing civilians traveling the same roads in wagons and carriages packed with household items, sometimes leading farm animals.

One night, when the women had stopped at a deserted farmstead and were settling down in the dirty straw of the stable to get some sleep, a German guard called Jadzia outside. He was armed with a rifle. As they walked toward the farmhouse, he ordered her to remain silent, no matter what:

"A second guard also warned me to not say a word, just to look. We entered an empty room devoid of furniture, just some straw on the floor. Two young women were lying in the straw, bleeding. I didn't recognize them. I don't know if they were from my group. They were probably hungry, out looking for some food, and a guard thought they were trying to escape. Both were shot in the neck, and one was bleeding badly. The guard let me check her pulse but wouldn't allow

me to help her or to say anything. The other woman was less seriously wounded. Then one of the guards turned to me and asked, 'How long will they live?'

"*This* was why they brought me, not to give aid but to confirm how long before they would die! I wanted to say, 'It depends on God,' but instead I just said that I didn't know, that I couldn't tell.

"I can still see these young women lying in front of me, looking at me with those sad and frightened eyes. I don't know what happened to them, whether they were taken to a hospital or just left there bleeding to death, because the next day we had to march on."

My mother was deeply disturbed by the memory of these two young women: "Why did they try to leave?" she asked me—a rhetorical question. "It was so senseless. Where would they have gone? Nowhere. They didn't know anyone or anything. Who would help them? If the Germans saw two Jewish women wandering around, they would turn them in to the authorities. And they would get shot. . . . The memory of this night stayed with me for a long, long time."

After so many years, my mother still felt outrage as she recounted this incident: outrage at the brutality, at the senselessness, at the perversion of medicine that violated her identity as a physician—someone who was supposed to heal and not just stand by.

⁓

A week or so into the march, the SS women accompanying the group were replaced by soldiers from the Wehrmacht, the Germany army. From Jadzia's perspective, this was an improvement, because the SS women could be vicious: "They were worse than the men. The soldier who guarded our section of the transport was older and more tolerantly inclined than most. They all had rifles, of course, but I don't remember him ever hurting us."

The meager provisions in the women's backpacks—several loaves of bread, some marmalade, and packets of margarine—lasted only a few days. Finding food and potable water quickly became a critical problem. In the first days of the march, when it seemed to Jadzia that the group

was stopping in prearranged places, the guards would requisition food from local farmers: "There was a wagon filled with cooking utensils that was pulled along by some of the women who had worked in the kitchen at Neusalz. When we stopped for the night, this field kitchen would get set up, and they would make a kind of weak herb tea and some sort of soup to feed the whole group."

With each passing day, food became scarcer, and the women grew increasingly plagued by hunger. According to my mother, "Even the local Germans didn't have much to eat, since everything was rationed and times were chaotic. Sometimes we got lucky and there was a bit of food for us. At other times, there was none."

When the women marched through populated areas, local Germans occasionally took pity on them and tossed them bread: "I remember one time when several of the women were so hungry that they just threw themselves at the bread, crumbling it all up. The soldiers started beating them with their rifles to make them get back up again and start marching. I was hungry as well, but I didn't do this."

The first time my mother said this, I thought she was being judgmental. But after hearing her mention such incidents repeatedly, I realized that she was relaying something about her strategy for survival. These incidents upset her then and continued to unsettle her during our conversations, not only because of the mistreatment the women suffered but also because the deprivation and cruelty dehumanized them to the point of "turning them into animals. Formerly civilized human beings had now become wild." Jadzia was determined that this would not happen to her, under any circumstances, for she was convinced that her survival hung by the thread of human dignity.

~

By the third week of the southwestward march, the women were well inside Germany, having passed the towns of Muskau, Weisswasser, and Bautzen and crossed two rivers, the Niesse and the Spree. In early February, according to Besser, all three of the Neusalz transports met up at a large farmstead and then, after a day or so of rest, went their separate

ways. They would reunite once more before reaching their destination. My mother vaguely recalled such a coming together, but had no specific memories linked to it.

The women had walked well over one hundred miles by now, in freezing temperatures and all sorts of weather. They were poorly clothed, starving, exposed to the elements, and fatigued—and all this was taking its toll. Aliza Besser wrote in her memoir: "Unfortunately, with increasing frequency, we leave behind in every stable a corpse or two."

My mother did not dramatize or embellish her narrative; this was not her style. But this actually made her story more powerful, because I was forced to imagine the hardship, the fear, the uncertainty that she and the other women endured. I tried to envision what it must have been like to walk and walk and walk, with no end in sight, destination unknown: hungry, thirsty, cold to the bone, exhausted, and still imprisoned, even though out in the open. I wished I could know, if only superficially, what my mother felt—to tap into the emotional core of her suffering and the collective suffering of all these women.

I pressed her repeatedly for details about how she and the others managed from day to day on the march. I tried to push her beyond the set of anecdotes she always repeated. I succeeded only in making her impatient, even angry. She dismissed my efforts as futile—and she was right:

"You don't understand. All this asking why, what, where? . . . Who bothered to pay attention to how many, how much, or whatever else you want to know? You can't think properly when you are so malnourished. I don't know the answers to your questions, Basiu. No one was interested in such details at the time because everyone felt so bad."

She would not be drawn into my documentary goals, into my desire for heightened drama and details of suffering. My mother echoed the sentiments of many survivors—of all sorts of violence and deprivation—when she asserted: "Unless you went through this yourself, you can listen, someone can tell you all about it, but you have no idea what it is like. You cannot even imagine."

~

Winter came early that year and was one of the coldest on record, with bitter temperatures and lots of snow. The ripped long underwear Jadzia had laughed about in the camp commandant's office at Neusalz now turned out to be a lifesaver, helping to keep her warm. An unknown German villager's generosity also helped her survive.

"About halfway into our march, when we were trudging through snow, my shoes, those wooden clogs covered with material that we all wore, fell apart. I'm amazed my feet didn't get frostbitten. Luckily, someone from among the bystanders tossed me an old pair of men's shoes to wear. I can't remember who or where or when, but this also saved me."

Intent only on survival, Jadzia became oblivious to what was going on around her. Her recollections of the later weeks of the march were especially hazy. "My mind was focused on living and on walking, walking, walking. I have no idea how we survived. When you're marching from morning until night, then get just a bit to eat, and nothing nutritious, and then lay yourself down in litter somewhere to try and sleep . . . your brain stops working. After a while, you are like an automaton, placing one foot in front of the other, unaware of what is going on around you. You did everything not to fall down. Because if you fell, that would be the end. There you would remain."

Although she knew that women fell sick and some died, she retained no specific memory of women succumbing: "It may be true that so many died along the way. I just don't know." She did recall occasionally seeing people lying alongside the road who had either fainted or fallen from exhaustion, but she was vague about what happened to them:

"How can I know? I can't tell you how many of us survived. Absolutely not. Some of the women did fall, but I don't know who and I don't know where. If someone collapsed, then there they stayed. Maybe they were shot. I simply don't know. They would be left behind while the rest of us had to continue marching. No one told you anything. You just kept moving because you knew that otherwise you would die."

Accounts by survivors of other death marches confirm my mother's memories and describe even worse situations, in which officers gave guards direct orders to shoot prisoners who were too weak to go on. In the last months of the war, with the Nazi leadership in chaos and issuing conflicting communications, SS commanders were often left to act on their own. Because camp prisoners, especially Jews, were considered enemies of the Reich and less than human anyway, the idea of shooting those who lagged behind would have given a Nazi guard little pause. Freeing such prisoners would have been unthinkable.

~

As the women marched, the war raged on around them. They were ahead of the front and away from the sites of ground battles, but they were still at risk.

Part of the Allied military campaign involved heavy bombing of targets inside Germany. On the night of February 13, 1945, the British Royal Air Force dropped several thousand tons of high-explosive and incendiary bombs on the city of Dresden, in a strategy known as carpet bombing. This was followed on the next day with bombing raids by the U.S. Air Force. The resulting fires merged into one huge inferno, sucking oxygen with such force that it created a self-sustaining firestorm, with hurricane-like winds and temperatures so high that anything combustible caught fire instantly. The fire burned for days and could be seen tens of miles away. The estimated death toll from this bombing mission was thirty-five thousand civilians, with a quarter million more left homeless and the entire inner city, an area of almost six square miles, completely destroyed.

Jadzia's transport happened to pass several miles south of Dresden just around the time of the bombing. My mother remembered seeing a sustained red glow far away on the horizon to the northwest. At the time, she had no idea what was happening, although later she realized what she had witnessed: "When you looked back, you could see the fires from a distance. You could see Dresden burning."

Hearing this, I was struck by the juxtaposition of these two terrible events, the Nazi death march of civilian prisoners and the Allied firebombing of a city and its people. The events were entirely different, of course: starving women stumbling down an endless road on a grueling forced march in the bone-chilling February cold and German residents sitting at their kitchen tables for an evening cup of coffee just moments before bombs level their neighborhood and send it up in flames. But the human capacity for inhumanity lay at the heart of both events—the destruction of civilian lives, the tremendous suffering of ordinary people.

~

Jadzia and her companions wearily marched on, crossing yet another river, the Elbe, and continuing toward the southwest. They had no sense of where they were heading; they simply concentrated on making it through yet another day. In the confusion of retreat, the guards leading them might have been just as uncertain of their final destination.

In addition to wartime risks, starvation and thirst, cold and snow, disease and fatigue, my mother talked about another plague the women had to contend with:

"We all had lice. If you go for weeks without changing your clothes, without taking a bath, walking, sleeping cramped together in stables, you think there wouldn't be lice? Your entire body was bitten, scabbed from all the scratching."

Every time my mother mentioned lice, her voice would catch in her throat, her eyes brim with tears. "Okay, enough!" she would declare. "I have to stop talking about this."

Body lice are parasites that feed on humans by sucking blood, and their bites cause rashes and itching. Spreading rapidly in crowded, unsanitary conditions, they brought terrible discomfort to prisoners and refugees during the war. More important, body lice are vectors for the microorganism that causes a serious and potentially fatal, highly infectious disease—typhus fever. This was a major killer in the large ghettos and in concentration camps such as Auschwitz, Ravensbrück,

and Bergen-Belsen, where malnutrition, filth, and overcrowding were part of everyday life. Memoirs by survivors of such camps graphically describe how scratch marks crisscrossed their backs and legs like road maps—the travelogue of lice.

At one point, while reading the memoir aloud, my mother came upon Besser's mention of how the lice were multiplying. She got choked up: "Everything is coming back to me, how awful these lice were! How they would hang from your hair!" I must have looked alarmed, because she reassured me: "I'm not telling you this to make you feel bad. These memories just come back. As I'm reading this, I can feel my skin start to itch. The wounds may heal, but the memories remain."

Not surprisingly, Jadzia and her fellow marchers jumped at any opportunity to wash up even a little. Several farmsteads where they stopped for the night had wells with water pumps: "Even though it was cold, I would pump so that Estera could get herself clean. Then she would do the same for me. We all took turns." But chances to bathe were rare, and the lice flourished.

The marchers also had to put up with abuse from bystanders along the roads in more populated areas. One demeaning incident remained fixed in my mother's mind, and Aliza Besser mentioned a similar occurrence in her memoir. It involved a group of Hitlerjugend, teenage boys who were part of Hitler's youth movement, which served as a paramilitary organization during the war. Indoctrinated in Nazi ideology, including hatred of Jews and other racially vilified groups, the young members were being trained to become soldiers when they came of age and were equipped with uniforms and even bayonets. My mother's voice cracked with anger as she related the story:

"One day, as we were marching, we noticed these young boys in uniform along the road. They were being specially raised to be Nazis. They began to yell, mocking us and beating us on the legs with their sharp-pointed whips." The soldiers who were guarding the women eventually chased the youths away, but not before Jadzia made a remark that nearly got her in serious trouble:

"There was a water pump with a spigot by the side of the road, near these boys. I was so very thirsty, I just couldn't bear it. So as we approached them, I stepped out of line to take a quick drink of water—and as I stepped back in line, I said loudly in Polish, "I hope someday someone beats you like you're beating us!" A moment later, our guard came alongside me and said, 'Get into the middle of the group, quickly, and hide yourself, because they're looking for you.' One of the bystanders must have understood Polish, heard me, and reported what I said. I was lucky, for I could have been shot."

For a moment, after sharing this anecdote, my mother was once again overcome by a flood of memories, unable to talk. She was not a person who cried easily, but certain memories still had the emotional power to undo her.

~

One day, early in our conversations, my mother suddenly asked: "Did I ever mention that I went begging for food?" I was taken by surprise and asked her to tell me more. It turns out that during the death march, as food became ever scarcer, the women resorted to begging at local farmhouses, usually getting a bit of bread or a few potatoes from some kindly peasant. My mother added that the soldiers who guarded the prisoners looked the other way and even encouraged them to do this:

"The guards were hungry, too. Even I did this, when we were someplace just beyond Dresden. At that point, there were a lot of people traveling along the road, escaping from cities and towns that had been bombed. And these Germans, who were now refugees, would stop at homes and farms along the way to ask for food and water. So the German soldier who was guarding our group let some of us also go begging. There was nothing to eat. We had to try and find some food. But he warned us not to run away, because he would be punished and we would be caught and shot."

The marchers who could pass for German, those who had blond hair and spoke the language well, were the safest to send out: "Estera, the dentist from Neusalz, was a blond and her German was perfect.

So the guard let us go, and I went begging with Estera from house to house. I kept silent, because I spoke only rudimentary German. Estera did all the talking. She would say that we were Germans fleeing the war and had run out of supplies. Could they help us? And so we got all sorts of food—eggs, bread, other stuff, even a bit of bacon. When we returned, all the food was pooled and prepared in the field kitchen. Everyone got something to eat, including our guard, who was just as hungry as we were."

Sometime in the early part of March, the women crossed into what was then the Czech Sudetenland, the border area largely occupied by native German speakers and annexed to the Reich in September 1938. They had been marching for more than a month, malnourished and exhausted, and their number was dwindling. Every day, someone fell by the wayside. Every night, someone died. And now they were entering a mountainous region, difficult to traverse.

Much of this final stretch was lost from my mother's memory. She did, however, recall the night the group stopped at a farm on the outskirts of the Czech city of Karlsbad (now Karlovy Vary), probably because of what happened there. Jadzia recognized the area. Located at the juncture of two rivers, Karlsbad was a spa resort because of its many mineral springs:

"Karlsbad was an old, well-known town, a favored destination for wealthy and famous people before the war. We stopped for the night at a stable, where we were going to have to sleep with the cows and horses, but we were so worn out and tired that we didn't care. The farmhand was a Polish fellow, one of the many Poles who were periodically rounded up by the Nazis and deported to Germany to work on farms and in factories. He had a small room right near the stable, where he slept and prepared food."

When the man found out that Jadzia and her three companions—Estera, her sister, and Hania—were also from Poland, he offered them his room. He was on duty that night, so he told them. He wouldn't be using the room, and his wife supposedly was in the hospital. He even offered them a change of clothes:

"This farmhand told us to go ahead, get undressed, wash up, and make ourselves some tea. We were so thrilled to finally be able to get clean. You can imagine how lice-ridden we were. Oh, how those lice would bite! And how those bites would itch! So we heated up some water, got undressed and properly washed up, and then sat down to drink our tea. All four of us crawled into the large bed and instantly fell asleep.

"Sometime in the middle of the night, this scoundrel came and tried to get in bed with us! All four of us started to yell at him, 'You pig! You told us you had a wife, and you lied to us! You even showed us women's clothing, told us to get washed, have some tea—and now you come back for your payment? And you claim to be a Pole?'"

My mother's sense of violation and betrayal was palpable: "He wanted to take advantage of his fellow Poles, poor women prisoners! We threatened to report him to our German guard. That startled him, and he began to apologize, admitting that there was no wife and pleading with us to not turn him in. In the end, we agreed because we knew he would have been shot on the spot. Instead, we quickly got dressed and, as we were leaving, made him promise never to do this kind of thing again. Later on, we were able to laugh about the incident, but at the time it was really awful."

~

From Karlsbad, the women plodded on through the heavily forested mountain region just inside the Czech border, passing by small towns and villages, including another resort town, Marienbad, also known for its mineral springs. They were just across the border from the part of Germany known as Bavaria.

My mother had only vague recollections of these final days of the six-week-long march and no sense of how many women from her transport had managed to survive. Nor did she remember how she herself made it—only that she was close to collapse: "I was barely conscious. Most of us could hardly walk. I vaguely remember being put into some covered truck, packed in tightly, and driven up a long, long hill. This must be how we made it to our final destination."

She thought that the survivors' next-to-last stop was a town called Weiden, back in Germany and about ten miles from another major Nazi concentration camp, Flossenbürg. Other accounts suggest that the marchers first arrived at a subcamp of Flossenbürg, Zwodau (in what is now the Czech town of Svatava, near Sokolov), not far from Karlsbad. After spending a day or two there, the women were transported in trucks to Flossenbürg.

This concentration camp had been established in March 1938 for male criminals and "asocials"—people who did not fit Nazi social norms. It was purposely located near an SS-owned granite quarry so that the prisoners could be used as slave laborers. The camp expanded throughout the war, eventually housing male prisoners of various nationalities who labored in the stone quarries or in a nearby factory owned by the German aircraft manufacturer Messerschmidt. Between 1938 and 1945, the Flossenbürg camp system registered more than a hundred thousand prisoners from thirty countries; nearly one-third of them perished.

Like many other concentration camps, Flossenbürg had almost a hundred satellite subcamps, about one-third of them designated for women. The inmates of these subcamps generally worked as slave laborers for companies in the armaments industry. Near the end of the war, Flossenbürg also served as a transit point for prisoners being evacuated, by death march or cargo train, from one camp to another, in advance of the Allied front.

In the final months of the war in Europe, as the Germans retreated, they hastily tried to destroy incriminating documents and files. Most of the camp files for Gross-Rosen, for example, were destroyed just days before the main camp's liberation by the Soviet Red Army. Luckily, this did not happen at Flossenbürg. When the U.S. Army liberated the main concentration camp on April 23, 1945, the Americans seized a large number of official records, including registration lists for new prisoners. Because the women from Neusalz were entering another concentration camp system, the SS—even at this late date in the war—registered them and issued them new prisoner numbers.

By contacting the International Tracing Service in Bad Arolsen, Germany, I was able to get a copy of the page from the Flossenbürg female inmate entry register on which my mother's name appears. The page lists thirty prisoners, with six columns of information for each one. My mother's entry, three-quarters of the way down the page, records the following:

Assigned Flossenbürg prisoner number: *64,973*

Nationality and prisoner type: *Polin ZA* (meaning that she was a Polish *Zwangsarbeiter*, or forced laborer)

Name: *Lenartowicz Jadwiga*

Date of birth: *1.10.10*

Place of origin and date of arrival: *Gross-Rosen, 8–9.3.45*

Place and date of transfer: *Mehltheuer, 19.3.45*

My mother's name, I noticed, seemed to come at the very end of an alphabetical list, after the names beginning with Z. All the inmates listed above her on the page came from the Gross-Rosen camp system on the same day, all of them were Jewish, and all were being transferred to the Bergen-Belsen concentration camp.

I began to wonder, could these have been the women who, along with my mother, endured the march from Neusalz to Flossenbürg? With the help of the United States Holocaust Memorial Museum, I acquired copies of all the relevant pages from this Flossenbürg prisoner entry book for this particular transport, which arrived on March 8 and March 9, 1945.

My hunch was correct. The page was part of an alphabetical listing, twenty-nine pages long. I am reasonably sure that it names the women from Neusalz who managed to make it to Flossenbürg. On it I found names familiar to me: Estera Bodner (the dentist who lived with Jadzia) and her sister, Hela; Rajsla and Bluma Garncarz (this is how their names are listed, although in the memoir *Sala's Gift* they are referred to as Raizel and Blima); Miriam Mehler (Mitzi, the Neusalz Lagerälteste); Hanna Priester (Hania the nurse) and her mother, Nani; Franja Kokoszynska (this is Aliza Besser—her given name was Frania and her last name at the time, Kokocinska, is misspelled); and the names of several other women whose postwar testimonies I had read.

As I viewed this long list of names, each printed precisely in ink on the lined paper of the ledger—starting with Regina Abraham and ending with Paula Zyto—I was amazed that this artifact of history had survived. And because it did survive, I was able, decades later, to hold in my hand stark evidence of acute suffering, as well as a reminder of resilience. All the women but one on this list were Jewish, with Jadwiga Lenartowicz tacked on at the end as the only non-Jew. Most were either Polish or Hungarian Jews, listed in the second column as *Pol. J.* and *Ung. J.*, with a few Czech, Dutch, and German Jews and one Jewish woman from Yugoslavia.

The registration book helped me estimate how many women died during the forty-two-day march. The list starts with prisoner number 64104 and ends with my mother's number, 64973, for a total of 870 women. If all the women on the list were from the Neusalz group, then the number who died during the march was probably about 130 out of approximately a thousand, although no one knows the actual number of women who started out from the Neusalz camp. This is a tragically large loss of life, but smaller than the one Aliza Besser gave in her memoir, where she wrote of the march that "there are almost 300 victims"— although she did not say how she arrived at this number. The Flossenbürg list also shows that three women died during the short stay in that camp. Many more would die before the war came to an end.

～

As each group of Neusalz women arrived at the concentration camp, they were greeted by the Nazi motto that crowned the entrance to several concentration camps. In Flossenbürg, the motto was engraved on one of the granite posts of the main gate: *Arbeit macht frei* (Work makes one free). My mother did not think her transport entered the camp through those main gates. She remembered being taken to some transition barracks just outside the main entrance:

"I think the other transports arrived soon after we did. A number of women in our group had typhus, and they were immediately separated from us and taken away, but who knows where."

Examining a diagram of the camp, it seems likely that most of the new arrivals were brought to an isolation area consisting of four barracks and a lavatory building, separated from the rest of the camp by a barbed-wire fence. There, the women were given bowls of thick barley soup to eat and afterward were led to the large washroom that was used to disinfect incoming prisoners. A photo of what I assume is this room, taken by a member of the U.S. armed forces after liberation, shows a huge area with a floor of diamond-shaped tiles, glazed brick reaching halfway up the walls, and rows of pipes hanging from the ceiling, with multiple shower heads spaced several feet apart. Many of the women, already weak and disoriented, thought this was their final destination—that they were walking into a gas chamber. After making it through a six-week death march, were they now to die in this horrible way?

The discussions my mother and I had of her entry into Flossenbürg brought back a flood of painful memories: "We had to take everything off and leave it behind—our backpack, our clothes, our shoes—because everything was infested with lice. And then we walked over to this large shower. We were like skeletons packed into this room. We waited for what seemed an unbearably long time, exhausted, cold, anxious—and then, finally, warm water came pouring from the shower heads above.

"Then this fat male prisoner who had a shaved head and really looked like a eunuch came over to disinfect each of us. Imagine how I felt! There I stood, naked, while he sprayed delousing powder, using something that looked like a bicycle pump, all over my body—on my hair, under my arms, on my back, even between my legs."

My mother paused, her eyes squeezed tight, her lips pressed into a grimace: "I have this image before my eyes, of all of us naked in this washroom. How pitiful we looked, and how horrible and degrading this was."

She stopped talking and tried to collect herself. I sat there waiting, and it was all I could do to keep from crying. After the mortification at Ravensbrück—where she had been stripped naked, examined publicly, and had her head shaved—almost exactly a year later at Flossenbürg, physically and mentally exhausted from the death march, she had been subjected to a similar humiliation.

We took a break from revisiting the past and turned to the comforting ritual of a cup of Earl Grey tea and a slice of my mother's famous "millionaire cake," which she has been baking for decades—lemon pound cake so delicious one might pay a million dollars for it, or so the story goes. One or two cups of tea accompanied by something sweet was a requisite part of every visit to my mother's apartment.

Twenty minutes later, she decided to resume her tale:

"You know, the soup and the shower must have revived me, because from that moment I remember more clearly some of what happened after we got to Flossenbürg. Once we were disinfected, they gave us different clothes that obviously were from former women prisoners who probably had died. It was such a hodgepodge of old clothing. Some pieces were ripped or cut up, some were formal long dresses, others were ordinary clothes. Nothing matched, and they were handed out with no regard for size and shape. There was even men's clothing. Nothing fit, and we all looked like clowns, like we belonged in a circus. But we had to laugh as we looked at ourselves and each other—what else could we do but laugh?

"The barracks we were sent to had wooden bunks covered with straw and some sort of sheet. This is where we slept, with a blanket and a hard pillow, packed in together, several to a bunk. During the day, we would have to use outdoor toilets. No privacy at all, because there were SS men guarding us. During the night, we were locked in. If you had to relieve yourself, there were these huge barrels standing in the corners of the room that would sometimes end up overflowing."

Over the next few days, men in gray-and-navy-striped prison garb would bring huge kettles of soup from the main camp to the transition barracks. Word got out that women had arrived. Among the male prisoners was a Polish officer who somehow found out that a female compatriot was among the new arrivals. My mother remembered how surprised she was:

"He must have been able to receive packages from time to time. When the prisoners from the kitchen came with kettles of soup, one of them passed a small package to me, which this man had managed

to sneak out of the main camp. When I opened it, I found some bread and a dried sausage [kielbasa] and a short message from this prisoner: 'I'm sharing whatever I have with you.'"

~

The stay in this camp was destined to be short. About ten days after their arrival, the women from the Neusalz group left Flossenbürg—but Jadzia was not among them. Almost a week earlier, without warning, a guard had escorted her out of the barracks, away from her companions, and to a cell elsewhere in the camp: "I had no idea what was going to become of me—I thought my time had come."

On March 17, the rest of the women were crammed into freight cars that usually held cattle or coal, with barely any food or water for the trip, and sent on to yet another concentration camp, in the north of Germany—Bergen-Belsen. Aliza Besser described this hellish journey in her memoir:

"We're packed so tightly into the freight car, we are almost suffocating. The windows are tightly nailed shut . . . you can't stretch out your legs, a whole pile of legs lies one on top of another. We try to stay in place, but eventually someone whose legs are at the very bottom moves them to the top of the pile, and so the legs wander, when all they want is to rest after the 1000 km march. . . . Every other day, when we beg and cry, they give us a few cups, sometimes a bucketful of water, intended for 70 people. . . . We use the same cups at night for urinating. . . . We hear frequent bombardments. We have nowhere to hide. . . . Two women have died and their corpses remain, smelling. . . . Late into the night the women, unable to sleep, call out for *Wasser* [water]."

After seven agonizing days, they arrived at their destination: "The doors of the train were opened for us, [and] they removed the noose of the condemned from us at the last moment—before the verdict could be executed. But unfortunately, not everyone got off. This time the Neusalz transport of women was diminished by 30. No one even looks any more to see who died."

Chances are that more of the Neusalz women than thirty died on that train journey, and many more would die before the war came to an end. Conditions in Bergen-Belsen, especially in the last months of the war, were horrendous. The already severe overcrowding grew worse with each successive transport of prisoners evacuated from other camps in the path of the advancing Allied front. Many arrived barely alive, to find no place to sleep and little food or water. Typhus flourished. From January until mid-April 1945, when British soldiers liberated the camp, an estimated thirty-five thousand people died there, including Anne Frank and her sister. Tragically, another ten thousand or more, too sick to recover, would perish after liberation.

This was what awaited the Neusalz women as they entered the gate of the Bergen-Belsen concentration camp. Not until several months after the war, when Jadzia traveled to Bergen-Belsen, by then a refugee camp, in search of her sister, would she discover what had happened to her Neusalz companions. And only later, while living in a refugee camp herself, would she learn even part of the reason she herself had been spared their fate.

14

Flossenbürg and the End of War

JADZIA REMAINED BEHIND IN FLOSSENBÜRG, locked up in the condemned prisoners' section of the camp. "There were these separate buildings for prisoners who were being punished. They called the cells *Bunkers* in German. When they first put me into this very small, windowless cell, all alone, with no idea what was happening, I thought this was to be my fate. I was sure they were going to kill me."

The Flossenbürg concentration camp had a detention block of forty cells where prisoners were kept in solitary confinement for days, usually with little or no food, before being executed. The SS ordered many executions at Flossenbürg, often by hanging, and especially in the last months of the war. Jadzia, understandably, was disoriented and terrified. But one aspect of her detention did not quite fit with the notion that she awaited execution:

"What puzzled me from the start was that I was fed quite well. Someone would bring my meals on a metal tray, which they would slide in through a narrow slot near the bottom of the locked door. When I was through eating, I would leave the dirty tray by the door, and at the next mealtime, it would be taken away and another tray of food slid in its place. No one ever opened the door or came into my cell. I don't remember what I was given to eat, but it was regular food, even vegetables, and plenty to drink."

With each passing day, Jadzia began to hope that she would be allowed to live. She rested and ate regularly, slowly recovering her strength and becoming more aware of her surroundings.

"Then, one day, much to my surprise, I found a small slip of paper with a message tucked under my bowl, assuring me that everything would turn out all right, that I was not to worry, not to be afraid. I was being sent to a different camp where things would be better for me. After I got this anonymous message, I calmed down a bit."

Listening to my mother describe this turn of events, I thought how terrible it must have been, after all the ordeals, to end up in solitary confinement. I must have made some remark to this effect, for once again my mother surprised me with her response:

"Not really. Once I realized that nothing bad was going to happen, it was okay. Well . . . of course, you couldn't leave. But I had everything I needed. It was quite elegant, actually," she added, with a grin.

"The Bunker was small, but it had a real toilet and a sink, so I could wash up. And a single wooden bed. I wasn't being herded along with the others to the outdoor communal toilets. I had my own clean bed and blanket. So compared to what I had been through, it could have been much worse."

Then, naively, I asked my mother how she had spent the days, whether someone let her out daily for a walk.

"Doing nothing. That's how I spent my time. What was there for me to do?" she answered impatiently. "I just sat there. What do you think? That from the Bunker they would take you out for a walk? Are you crazy? But it was tolerable because I wasn't mistreated, I wasn't being interrogated. I realized later that I was being fed to gain strength while they waited for someone to arrive and take me to the next slave labor camp where I had been assigned. Yes, I suppose it was like being in jail. I just sat and waited. That's what I did."

~

Whenever we talked about her experiences in the last weeks of the war, my mother would comment on her narrow escape from the horrible fate that befell the other women from Neusalz. "Suddenly, I was pulled out of my group in Flossenbürg. What miraculous good fortune that

I didn't go on that transport with the others! I was so weakened and malnourished that I might well have died either on that train journey or in typhus-plagued Bergen-Belsen. Going to Bergen-Belsen was like a death sentence."

She paused for a moment. "You know, Basiu, this was not war. These were inhuman and inhumane actions. This was not war. This was murder!"

Moments like these afforded me a rare glimpse of the outrage my mother felt but rarely expressed regarding what she and others had suffered at the hands of the Nazis. Whenever she thought back on this close call and others she had during the war, she always remarked, "Some force was looking over me." And then she often added, "My mother prayed for me constantly."

Our discussions underscored for her the number of fateful decisions people made about her during her sixteen months of imprisonment, decisions that either improved her lot or in some instances saved her life. Of course, not being a Jew or a Roma was critical in her survival, as was being a doctor, for she received preferential treatment at times. But these factors were no guarantee, considering the ever-present brutality, malnutrition, disease, and random violence that characterized the Nazi concentration camps. So it seemed miraculous to her—and to me—that she had been saved, yet again, at Flossenbürg.

My mother knew only bits and pieces of the behind-the-scenes actions that spared her the fate of her Neusalz companions. In supplementing her remembered fragments with archival information from Flossenbürg, I pieced together a plausible scenario. I believe the story comes back to that list made when Flossenbürg personnel officially registered the survivors of the march from Neusalz. The list would have been incorporated into that day's census report and the paperwork filed in the camp office. Because Flossenbürg was largely a camp for men, the arrival of women prisoners undoubtedly attracted attention among the male prisoners. And at the very bottom of the entry list, the name of the only non-Jewish Polish prisoner would have stood out conspicuously.

At Flossenbürg, as in most of the camps, certain long-term prisoners were assigned administrative duties, especially if they had useful skills. My mother knew that one of the Polish male prisoners who worked in the camp office had spotted her name and somehow found out that she had been at Ravensbrück. She recalled that "his name was Iwaniec, and his wife had also been taken to Ravensbrück."

It was Mr. Iwaniec, I believe, who played a key role in keeping Jadzia out of Bergen-Belsen: "During those first few days, when all of us were together in the barracks, male prisoners would bring us food in large kettles, and this Iwaniec had one of those prisoners ask me if I had come across his wife while I was in Ravensbrück. I was sorry to say that I had not, but I guess he and others in that office decided to try and get me out of this transport, which they knew was slated for Bergen-Belsen. I found out about this after the war because, by chance, we ended up in the same refugee camp. He recognized my name and was able to tell me what happened."

My mother had no sense of how long she stayed in the Bunker, but despite her isolation, one experience made her aware she was not the only prisoner being kept there. Flossenbürg held prisoners of various nationalities: Germans, East European Jews and political prisoners, and prisoners of war, mainly Russian soldiers but also French, British, and American.

"One day, I heard a knocking on the wall. And then I heard a faint voice urging me in German to come closer." She put her ear right next to the wall and discovered that her "neighbor" was an American soldier, a prisoner of war who had been in the camp for quite a while:

"He was very ill and had scurvy. He said his teeth were falling out. He had heard that I was a doctor and asked if I could help him. But I was a prisoner, just like him. Unfortunately, there was nothing I could do for him." Jadzia's neighbor was probably slated for execution, and indeed, on March 29, 1945, thirteen Allied POWs were hanged in Flossenbürg, including one American.

According to records, Jadzia was in solitary confinement for slightly more than a week. Just before her departure from Flossenbürg, she was

outfitted with a new pair of clogs and a new pasiak, the prison uniform. She now belonged to the Flossenbürg camp system. A female SS guard accompanied her on the trip to a subcamp, Mehltheuer, about eighty miles north and less than ten miles from the German city of Plauen. Like Neusalz, Mehltheuer was a Jewish women's slave labor camp.

~

Women began to be incorporated into the Flossenbürg concentration camp system relatively late in the war, as Germany's need for military-related labor increased. The first subcamps for women were established in early September 1944 and the last ones in late January 1945. More than sixteen thousand women passed through these twenty-seven subcamps in the final seven months of the war in Europe.

The Mehltheuer camp became operational on December 2, 1944, with a transport of 200 Jewish women sent from Bergen-Belsen. Most of them were Polish, but there were also some Czech and German women, and they were young—more than half of them under twenty-five. The women were given Flossenbürg prisoner numbers ranging from 59454 to 59653. A second transport, of 146 Polish and Hungarian Jewish women evacuated from yet another subcamp, arrived in Mehltheur in early March 1945.

All these women worked for the firm Vogtländische Maschinen-fabrik AG (Vogtländi Engine Works AG), known by its acronym, VOMAG. The company was based in the nearby city of Plauen and during World War II was Germany's second largest manufacturer of commercial motor and military armored vehicles. In 1944, the company transferred some of its armaments production to Mehl-theuer, probably as part of the larger German strategy of moving key industries away from urban targets of Allied bombing. In the refitted Mehltheuer factory—which previously had produced nets and curtains—the women prisoners made parts for airplanes and armored personnel carriers. Some of them were put to work clearing away damage from Allied bombing raids and doing shipping work at the Plauen railway station.

Transport records for Mehltheuer show, besides the Jewish women who were sent there, another entry for just a single prisoner coming from a Gross-Rosen subcamp. She arrived on March 19, 1945, and was assigned prisoner number 64973. This was my mother.

Her work assignment was different from those of the other prisoners: "I was sent there to work, yet again, as a doctor, although when I first arrived, I myself was quite sick. When you've gone for so long without any food and then start eating regular meals, your body isn't used to this. Then a week or so later, much to everyone's surprise, another female physician arrived at the camp."

Her name was Wanda Szajniuk (a phonetic spelling, because my mother did not recall how it was written). My mother was uncertain but thought this new physician had spent some time in Siberia during the war and had been active in the Polish underground. When the Nazis arrested her, they sent her to Auschwitz. Later, when that camp was evacuated before the advance of the Soviet army, she must have been sent to another camp and from there transferred to Mehltheuer:

"Her coming to Mehltheuer was actually a mistake, and the male camp commander was as surprised as we were when she arrived. He wondered aloud why another doctor had been sent, for she really wasn't needed. But then he decided to let her stay. 'We might as well keep her,' he said."

I suspect it was actually Jadzia who was the "mistake." Speculating about what happened, I think it likely that before she appeared in Flossenbürg, the Mehltheuer commander submitted a request to the main camp office for a prisoner-doctor. Given the ponderousness of the Nazi bureaucracy and now its disorganization in the final months of the war, clerical staff probably took weeks to process Dr. Szajniuk's transfer.

In the meantime, I think, the Polish prisoners in Flossenbürg's main office were trying to find a way to save Jadzia from the Bergen-Belsen transport and took advantage of this submitted request. I imagine they told the Flossenbürg commander that there was a prisoner doctor in the transport that had just arrived, all ready to go, and he agreed to pull Jadzia out of the group from Neusalz. He could not have known

that another physician, a prisoner from a different camp, had already been designated and was being processed for the same request. Such administrative details were left to the office assistants. It is not impossible that the prisoners working in the main camp office even took the risk of destroying documents they had received regarding Szajniuk's transfer. Making this scenario all the more plausible is the fact that Flossenbürg had long been plagued by mismanagement and corruption on the part of the SS staff, and its administration became even more chaotic in 1945.

The typical bureaucratic requirements accompanying every official action might have worked in Szajniuk's favor, too. The commander of Mehltheuer would have had to submit more paperwork in order to return her to her previous camp. Questions would have been asked about the mix-up, perhaps even leading to an investigation. And it must have been evident to the commander that the war was reaching an end. In short, it simply was not worth the trouble to send her back.

~

My mother clearly felt great affection and admiration for Dr. Szajniuk: "She was older than I by at least ten years, and she had gone through a lot in life. I think she was originally from Warsaw, and a widow. Her husband died before the war. She was much more experienced, so I was glad that she was able to stay, because she was so helpful, often giving me useful advice. For example, I learned from her the nutritional value of leaves from that common yellow flower you see growing everywhere. She would make a salad of greens, which I didn't particularly like, but they had vitamins that protected your gums and teeth." My mother was referring to dandelion leaves, which contain a lot of vitamin A, as well as moderate amounts of vitamins C and D and minerals.

As physicians, Jadzia and her colleague could do little for the women prisoners: "If one of the women got hurt, we would try to help

her, give aspirin, but we didn't have much in terms of supplies. I do remember that there was a large hospital in the nearby city of Plauen, and after liberation some of the really sick women were taken there."

As was the case in Neusalz, the prisoners were responsible for the daily running of the camp. The Lagerälteste, the most senior prisoner, was a Czech Jew who was accountable to the female SS guards and to the SS commander, Lagerführer Fischer. "We were told that he was bad," my mother recalled, "a brutal man." Other accounts suggest that it was his predecessor, a man named Maier, who was exceptionally cruel; Fischer was supposedly more lenient.

According to a brief published description of the Mehltheuer camp, the women who came when the camp was first established stayed in a barrack linked to the factory by a corridor. The second group, arriving just before Jadzia, supposedly was housed on the second floor of the factory—but this differs slightly from my mother's recollection:

"The large heavy steel doors of the camp opened each morning, and the women walked out under guard. Some of them worked in a factory in this small town. The building we lived in had windows with really small panes, and it was surrounded by guards and towers. I also remember that there was a forest nearby. The building used to be a factory or warehouse but had been converted into a barrack, with double and triple bunks made of wood. Some of the women slept downstairs, the rest upstairs. Dr. Szajniuk was assigned to the second level, while I slept on the ground floor. There were also heavy machines of some kind being stored on the second level."

My mother could recall few details of daily life in Mehltheuer. She was in the camp for only a short time, still recovering from the ordeal of the death march. But she did remember the final days before liberation, days filled with uncertainty, fear, tumult, and incessant bombing. Food was in short supply, and there were frequent power failures as the Allied forces drew near.

During one of our conversations, I asked my mother when it was that she began to realize that the end of the war was near. "We could

hear the city of Plauen being bombed by the Allies, repeatedly," she responded. "There was tremendous bombardment, so much so that the building we were in seemed to shake at times.

"A few days before it all ended, an SS officer came from the main camp of Flossenbürg to see the Lagerführer. We found out about this visit because the prisoner who cleaned the offices, a Czech woman, overheard the conversation, or rather, the heated argument. The officer brought orders with him from the main camp, and these supposedly stated that all the inmates were to be marched into the nearby forest and shot. But the camp commander refused, saying, 'Enough of this murdering, this killing! I won't murder any more.' According to the cleaning woman, the two of them argued vehemently."

Other accounts substantiate this version of events—that Lagerführer Fischer refused to follow through on the evacuation orders issued by the Flossenbürg headquarters, thus sparing the inmates, who otherwise would have been either massacred or forced on another death march. According to my mother, however, certain SS guards were eager to carry out the orders:

"Some tried to convince the women to go into the forest, claiming that it was safer to hide in the woods than to be in buildings that might be bombed. But Dr. Szajniuk and I had had a premonition that something like this might happen, and so we had already talked to the women. 'Not one of you should agree to go out,' we told them. 'Say no, no, no.' So, thankfully, this plan didn't work. The commander didn't agree to the killing, and no one left the camp."

Afterward, the camp commander came to Jadzia and Szajniuk and told them that the war was ending: "He informed us of what he had done, that he had refused to follow through on the order to destroy the camp and kill all the prisoners. He asked if we would speak up on his behalf when the Americans came in, tell them what he did, that he protected the prisoners and treated them well, that he was 'good to us.' What could we say except yes? But we didn't actually have to make such a decision because when the Americans finally came, they immediately hauled him and all the SS women away. It was a miracle

that we survived—that Mehltheuer was not destroyed by bombs and that he did not obey this order."

~

When my mother described the moment of liberation, she did not dwell on the things I expected, such as her emotions when she finally comprehended that she was free, or what the "liberators" looked like, or how they acted and what they said. When I asked, "How did you feel at that moment when the Americans arrived? What actually happened?" she answered impatiently, "Basiu, leave me be! They opened the gates and we were free. A person felt free. I don't know exactly how or what I felt, it's been so many years. I don't know what else to tell you about this."

In my mother's memories, this moment was lost somewhere between the terrifying bombing immediately before liberation and the chaos afterward: "In the last days, we were very hungry. We had had little food over the previous two weeks, because there was no delivery of supplies. Our daily fare was a thin slice of highly salted beef, a piece of bread, and some water. And on the last two days, not even water, because the Americans had bombed the water mains. The Allies were bombing this area very heavily. It was awful. Even the forests around us were burning."

Nearby Plauen, with a prewar population of about 110,000, was an important industrial and railroad center and therefore a key target for Allied bombers, who attacked in a devastating series of air raids. The last one, on April 10, destroyed most of the city, leaving twenty thousand residents homeless. Photographs taken by U.S. Army personnel at the time show streets full of rubble, bomb craters everywhere, and leveled buildings with only remnants of walls still standing.

My mother never forgot those last days: "The women in the barracks were terrified. They were crying and howling from fear during the bombing. And above us, on the second level, was all this heavy machinery that at any moment could fall on us. This was so awful that my nerves almost couldn't stand it. These women, they were so

young, and they cried so terribly. Dr. Szajniuk and I tried to reassure them. 'Calm down!' we pleaded. 'If the walls get bombed, we'll find some way of getting out. But stop the screaming. We can't hear anything. We can't hear what is happening.' But this didn't help much.

"Then suddenly, at the end of it all, there was a tremendous silence. Not a sound. The silence was almost torturous; it seemed to last forever. A complete quiet came over everything. The bombing had stopped. We didn't know what to think. We didn't know what was happening. Then, after what seemed like an eternity, the Americans entered the small town where this camp was located, the doors to our barracks were opened, and that's how it ended. With freedom."

~

I cannot imagine how frightening the noise of bombing must have been. But until my mother described her experience, I had never thought about the silence afterward—how the sudden, unexplained stillness could hold its own kind of terror.

I was curious about which unit of the U.S. Army actually liberated Mehltheuer. My mother could give me no clues, so I went searching on the Internet for information about troop movements. It turned out that sometime on April 16 or 17, the 347th Infantry Regiment of the 87th Infantry Division entered Plauen, meeting little German resistance. It was probably one of the soldiers of this regiment who took the photos I saw of the devastation of Plauen. After the soldiers cleared the city, another regiment, the 345th, also moved in. The incessant air raids had forced both residents and German soldiers to flee, leaving behind a great deal of food and equipment, which the Allied soldiers immediately secured.

A history of the 87th Infantry's movements during World War II notes that its soldiers liberated more than five thousand French, Dutch, Belgian, Russian, and Polish slave workers and prisoners of war in Plauen and the surrounding region. A map of the campaign route suggests that troops would have passed near Mehltheuer the day before, April 15, the very day Jadzia's camp was liberated.

When the American soldiers opened the heavy gates of the camp, the women prisoners went wild. The ensuing scene, above all others in the first days of liberation, etched itself deeply in my mother's memory:

"The women all flew out like birds uncaged. Many of them were still so young. They broke into the warehouses nearby, like savages, and took everything. The Germans had stored marmalade and other food, as well as beautiful goods from France, stolen of course by the Nazi officers, who were planning to take them back to their families. The women found some small carts, from who knows where. They emptied out the warehouses, piled stuff on the carts, and hauled everything away."

Amazed at what I was hearing, I interrupted my mother to ask whether the American soldiers somehow intervened. She responded, "Of course not. They had just arrived, just entered. They might not even have noticed what was happening. They were busy with other things, securing the camp and rounding up the German staff."

The sight that seemed to have had the most lasting and unnerving effect on my mother was that of the starving women gorging themselves on food:

"It was a terrible thing for me, how a person can be transformed into an animal. Some of the women ran out with carts into the nearby town, where there were stores. They raided the bakery, took all the bread off the shelves, and piled the loaves, still hot, on the carts. And they also ransacked other stores, brought back sausages, meats, and other goods.

"When they returned to camp, everyone threw themselves in a frenzy on the food, like wild animals. They ripped into the bread with their teeth. Dr. Szajniuk and I just stood there in shock. We were hungry, too, but couldn't bring ourselves to do this. We shouted at them, 'Don't eat so fast, so much. Go slowly. Fine, you found all this. They held you here for so many years, and you suffered so much. So yes, you deserve to have this. Fine. But act like humans, not like animals. If you eat too much, too quickly, you'll all get sick!'"

This was a very real concern. In searching the Internet for accounts of other experiences immediately after liberation, I came across a

bulletin issued on May 6, 1945, to American soldiers just released from a German POW camp. The U.S. camp surgeon explained why the men were not being allowed to gorge themselves on "doughnuts and hotdogs complete with mustard and sauerkraut." He cautioned them against their "new enemy"—their appetite and digestive system: "Most of you have been on a starvation diet for months. . . . You have lost tremendous weight, there have been changes in your digestive system, your skin, and other organs. You have become weak and susceptible to diseases. . . . If you overload that weak, small, sore stomach of yours you will become acutely ill."

Unfortunately, there was no bulletin to stop the desperate young women in Jadzia's camp—only two doctors, newly liberated themselves, trying in vain to warn them: "Sure enough, the next day many of them were sick. Diarrhea, stomachaches, moaning and groaning. We had no supplies, nothing that we could give to those who were ill. A French doctor who was with the Americans did eventually come by and brought us some things for treatment, like charcoal. And we got provisions from the Americans, so we were able to have the women who worked in the kitchen make up gruel for those who were sick."

Every time my mother recounted this disturbing story, she began to cry: "I can't get that sight out of my mind, the sight of all those poor women madly devouring that hot bread."

⁓

The American soldiers brought clothing as well as food, so the women could get rid of their striped prison garb. The men treated Jadzia and Szajniuk with special regard: "They gave us navy blue pants and sweaters—this is basically what they had in the Army stores, the PX. And we got some medical supplies—stethoscopes and a surgical kit. We were then moved into camp commander Fischer's former office so that we could have regular beds to sleep on instead of those wooden bunks. 'This is for the two of you,' one of the Americans said, 'since you are the doctors.' And they brought us some Benedictine liqueur and several small cans of ground coffee. They were green cans as I recall, also from

the American PX. After so many months of ersatz coffee, this was the real stuff, and it was delicious!"

As the Americans took over the running of the camp, life slowly acquired a small semblance of normality. The camp kitchen prepared food that the Americans supplied, the women had clean water to drink, and those who were sick were treated or transferred to the hospital in nearby Plauen. And not surprisingly, when the young women recovered and began to relish their freedom, "it was a blanket under the arm and off into the woods with a soldier," as my mother so delicately put it. Having survived the war and Nazi brutality, these young women were now starved for love and companionship.

What had been a Nazi slave labor camp was now a camp of war refugees. And as refugees, Jadzia and Szajniuk began to think about what might come next, where they might go, what they could do. After so many months of imprisonment, they could finally begin thinking realistically about the future: "We were eager to get away from all this, to go somewhere else, to start anew."

They somehow learned that about fifteen miles from Mehltheuer were a former Polish prisoner-of-war camp and a civilian labor camp. They approached the French doctor who was with the U.S. soldiers and asked him whether they could leave: "We told him that we weren't Jewish, that we had been sent to Mehltheuer to work there, and that we were eager to find other Polish Catholic refugees."

The French doctor tried to tell them that they could not leave, that they were needed to help out in the camp. Szajniuk refused to accept this answer:

"She said, 'What do you mean, *no*? We're supposedly free. You haven't hired us to work for you, so we should be able to decide on our own where we want to go!' She was more experienced, and she confronted him. I don't think I would have been able to do that if I were alone."

The military had good reason for requiring that former prisoners remain where they were, for the war was not yet over. The Allies did not want civilians crowding or blocking roads and highways needed

by soldiers on the move. At the same time, one can understand why these two strong-minded women were infuriated by the French doctor's refusal. After the concentration camps, death march, bombings, and other terrors, they were eager to leave what only recently had been their place of imprisonment and hardship. That evening after supper, Jadzia and her companion plotted their escape:

"Dr. Szajniuk said, 'Let's disobey them. The women are now free, and there are German hospitals nearby that the soldiers can take them to if one of them gets sick. We absolutely need to leave.' I would never have had the courage or been able to do this on my own, but Dr. Szajniuk felt that we had nothing to lose. The plan was that we would just get dressed in the morning and pretend that we were going out for a walk."

And that was precisely what they did. The next morning after breakfast, dressed in navy pants and sweaters, with some food in their backpacks, Jadzia and Szajniuk stepped out of the camp and started walking in what they hoped was the direction of the Polish POW camp.

Part III

Surviving Survival

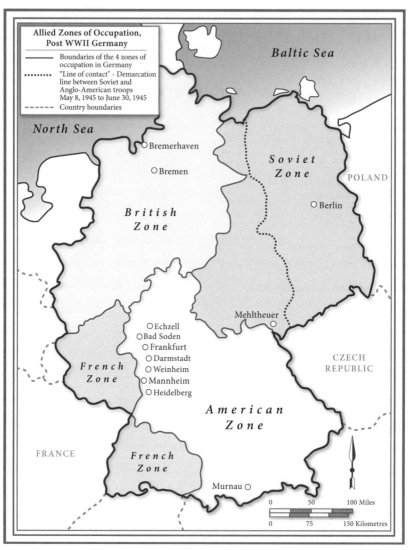

**Allied Zones of Occupation,
Post WWII Germany**

——— Boundaries of the 4 zones of
occupation in Germany
•••••••• "Line of contact" - Demarcation
line between Soviet and
Anglo-American troops
May 8, 1945 to June 30, 1945
- - - - - Country boundaries

Baltic Sea

North Sea

○ Bremerhaven

○ Bremen

*S o v i e t
Z o n e*

POLAND

○ Berlin

*British
Zone*

Mehltheuer
○

○ Echzell
○ Bad Soden
○ Frankfurt
○ Darmstadt
○ Weinheim
○ Mannheim
○ Heidelberg

CZECH
REPUBLIC

*French
Zone*

*American
Zone*

FRANCE

*French
Zone*

Murnau ○

0 50 100 Miles

0 75 150 Kilometres

*Cities in post–World War II Germany where Jadzia spent her refugee years.
Map by Gerry Krieg.*

15

Displaced Person

⁊

JADZIA AND DR. SZAJNIUK WALKED OUT of Mehltheuer and into a country that lay in ruins, beset by chaos everywhere. Just a few weeks later, on Tuesday, May 8, 1945, Germany would surrender unconditionally, and the Allies would declare victory in Europe. V-E Day signaled the end of fighting, but the struggle for recovery in a devastated, exhausted Europe had just begun.

Like Jadzia and her companion, millions of people were on the move throughout Germany in 1945. Allied troops spread out everywhere. Demobilized German soldiers and evacuated native Germans tried to return to their towns and cities any way they could. Ethnic German refugees wandered the country, homeless, after being expelled from territory newly acquired by Poland or after having escaped from the east as Soviet troops advanced. And there were the recently liberated concentration camp inmates, slave and forced laborers, and prisoners of war, all trying to return to their countries of origin or at least find a temporary place of safe refuge. The war had uprooted and displaced seven to nine million Europeans, from every country that Germany invaded or occupied. The refugee crisis facing the Allies after V-E Day staggered the imagination.

Even while dealing with millions of refugees, the occupying Allied forces had to restore law and order, establish a functioning government, get basic services working again, and somehow ensure that civilians got food, clean water, clothing, and shelter. The bombing campaigns of 1944 and 1945 had reduced many parts of German cities to rubble. Seventy percent of Frankfurt am Main, for example—the city where I

was born almost five years later—was destroyed. In many cities, up to 90 percent of all dwellings were damaged or leveled, so the housing shortage was severe. Roads, bridges, and railways had been bombing targets, too, which made transportation difficult. A shortage of coal hampered the recovery of both transportation and industry. Food stocks had been damaged, farms abandoned, and food production and distribution badly disrupted, causing Allied medical personnel to worry that hunger and malnutrition, combined with overcrowding in cities and refugee camps, would trigger deadly outbreaks of influenza, tuberculosis, diphtheria, dysentery, and typhoid fever. In the spring of 1946, the food shortage became so acute that the ration allotted to average German citizens was reduced to 1,275 calories a day.

Luckily for Jadzia and Dr. Szajniuk, the part of Germany in which they found themselves was, for the moment, in American hands. Even before V-E Day, in February 1945, the political leaders of the major Allied powers—Great Britain, the United States, and the Soviet Union—had met in Yalta in Soviet Ukraine and finalized an agreement to partition Germany into four zones of occupation. Reflecting trade-offs made to accommodate the Allies' competing political and economic goals, the zones would be governed, respectively, by the military forces of Britain, France, the United States, and the Soviet Union. By the time Germany actually surrendered, however, British and American troops had pushed far to the east of their predetermined borders before meeting up with westerly marching Soviet troops at what became known as the "line of contact." Briefly, then—and crucially for Jadzia—from May 8 to June 30, 1945, British and American troops controlled some of the territory that eventually, on July 1, would be handed over to Soviet occupying forces.

It was against this unstable and shifting backdrop that my mother began her postwar efforts to reclaim her life. Her memories of the initial chaotic months after liberation were hard to piece together, and I relied on historical accounts to sort out the chronology of what happened to her between April 15 and the end of July 1945. For later times, I had photographs and personal documents (items my father

had the foresight to safeguard from my mother's tendencies to "clean and throw out") and these helped trace her movements. The existence of these documents in itself attested to the eventual return of some semblance of order and normalcy, both in occupied Germany and in Jadzia's life. In talking with her about the weeks and months following liberation, and sorting through these photographs and documents, I quickly understood that the conclusion of war in Europe hardly brought an end to Jadzia's wanderings. Her future seemed filled with uncertainty and challenges.

How was she to find help just to live day to day in this devastated place? Would she be able to find gainful work? How might she reclaim her identity and her life, when she had no documents or identifying papers? What had happened to her parents and sisters, to other family members and friends? Would she be able to reconnect with those who survived? And the ultimate question: Should she return to Poland, now that it was under Soviet Communist control? Did she have any other choice?

～

After Jadzia and Szajniuk left Mehltheuer, they walked almost the entire day, asking directions from people they met on the roads, before they located what they thought was the camp they were looking for. They would later learn that soldiers from this very camp had already heard about the two Polish physicians at Mehltheuer: "They had plenty of sick ex-prisoners and needed doctors to provide care, so they were coming by car to take us back to their camp—and we missed each other!"

My mother could not remember either the name or the location of this camp. From what she did tell me, it seems to have been a former forced labor camp for Polish civilians that the U.S. Army had turned into a refugee camp.

"They were so happy to see us, for they really needed doctors. And it turned out pretty well for us, since we were given a separate room, whereas most of the other refugees had to sleep in the barracks, on those wooden beds.

"Many of the former prisoners had worked under harsh conditions, in the fields, stables, barns, and they were undernourished, weakened, with various diseases spreading in this labor camp. There were not only Poles but also Russians, and they [the Russians] were especially ill. They took up much of the infirmary. When we examined these patients, we found that they had active TB. Many of the Russians were dying from this. So we told the camp personnel that they needed to be transferred to a hospital."

The Nazis harbored special animosity toward the Soviets and were particularly brutal toward Russian prisoners, so it is unsurprising that these were among the sickest. "Then this young American doctor showed up and dismissed the cases as just mild TB. But we strongly disagreed. He was 'freshly baked' and didn't know anything. The men's lungs were collapsing, they were dying, and he declared that it was just a bit of TB!"

Fortunately, the Americans took Jadzia and Szajniuk's advice and sent the sickest patients to a nearby hospital. My mother knew nothing more of what became of the TB patients, for she and her friend did not stay long at this camp.

Former POWs and displaced refugees were housed initially in whatever safe shelter could be found, including partly damaged hotels, apartment buildings, and hospitals, as well as abandoned schools and warehouses. Most common were former German labor and concentration camps and military barracks. For example, the former SS training complex at Wildflecken became, in mid-1945, the largest camp in Germany for Polish refugees, housing as many as twenty thousand at a time. Once basic needs such as food and shelter were met, refugees began to search for familiar faces or people from their home towns and regions. Informal means of exchanging such information quickly evolved, and that was how Jadzia came upon a couple she had known in Łódź.

"We shared a mutual friend, who used to visit me at the Anna Maria Hospital, and that's how I got to know the Krzeminskis. Janek had been an inspector of schools, and his wife was a special education teacher. But it wasn't until we met again, after liberation, that we became close friends."

Lola and Janek Krzeminski ended up in Warsaw during the war, where they were active in the Polish Home Army, the AK. After the Nazis crushed the Warsaw uprising (a major attempt by the AK to liberate the city from the Nazis, not to be confused with the 1943 Warsaw Ghetto uprising) in August 1944, the couple was among more than a hundred thousand civilians who were deported to forced labor camps in the Reich.

Jadzia and the Krzeminskis, like other Polish refugees in Germany, often talked anxiously among themselves, wondering what to do about the future. Rumors were filtering back from the east about the evolving Communist government in Poland and its mistreatment of former Polish soldiers and resistance fighters—rumors that often turned out to be true. The stories they heard made many Polish refugees uneasy, and no one was sure when the repatriation program would begin.

~

During the Yalta Conference, the Allied powers reached agreements concerning the care and repatriation of millions of displaced persons (DPs), some of whom filled refugee camps weeks before the war officially ended. The U.S. Armed Forces in Europe defined DPs as "civilians outside the national boundaries of their own country by reason of the war who are desirous but not able to return home." DP camps were located throughout Germany, initially administered by the respective military government in each occupation zone. DPs in the U.S. zone received food, clothing, fuel, housing, and eventually transport for their repatriation or resettlement. Many of the camps, however, were overcrowded and lacked the resources necessary to support all the refugees properly. Rapid repatriation became a top priority for the occupying forces.

Refugees who were citizens of liberated Allied countries in Western Europe, such as France, Belgium, and the Netherlands, began returning home soon after V-E Day, with the assistance of the United Nations Relief and Rehabilitation Administration (UNRRA). This agency had been established in November 1943 to help administer relief to victims of the war, and by late 1945 it was running most of the DP

camps in Germany. The old or seriously disabled went home by air or by passenger train, but the majority rode in trucks or open boxcars.

My mother recalled that "with the peace accord, refugees were beginning to be allowed to return to the regions where they originally came from. But you couldn't do that yet for Poland." At the Yalta Conference, Joseph Stalin had insisted on priority for Soviet and Yugoslav citizens. Only when their repatriation was well under way would citizens of other East European countries be helped to return home. By September 1945, nearly all DPs from Czechoslovakia and Yugoslavia had been repatriated, as had more than two million Russians. This still left over a million DPs in the U.S., British, and French zones, more than half of them Polish.

Not all Eastern Europeans were eager to go back to their prewar homes. Many Holocaust survivors, for example, felt that their countries of origin offered nothing but tragic memories and danger, and many hoped instead to immigrate to Palestine. For example, upon returning to Poland, some Jews faced hostility and violence from their neighbors. In the first postwar year, more than a thousand Polish Jews were murdered. The most notorious incident was the July 4, 1946 pogrom in Kielce, where a mob of local townsfolk, incited by false rumors of the kidnapping of a Christian child, killed forty-two Jews and wounded many others. Historian Michael Steinlauf observed that the Kielce pogrom convinced many survivors that Poland held no future for them. Such violence was due to a mix of factors: existing anti-Semitism, exacerbated by the Nazi's wartime anti-Jewish propaganda, murder, and plunder of Jewish property; manipulation of these residual sentiments by postwar Communist authorities; actions of former members of the nationalistic right-wing underground; and fear on the part of gentile Poles that returning Polish Jews would reclaim property that their neighbors now occupied.

The U.S. military government initially treated Jews like any other refugees, but protests, coupled with the highly critical Harrison Report, led to the acknowledgment that they were victims of special persecution during the war. Separate DP camps were established, and Jews were allowed to choose resettlement rather than being forced to repatriate.

Another case complicated by political circumstances concerned DPs from the formerly independent Baltic states, which the Soviet Union occupied in 1944. The Western Allies rejected Soviet claims of sovereignty in these countries and refused to repatriate refugees who did not want to return to Communist-controlled Latvia, Lithuania, or Estonia.

Reluctant Russian and Yugoslav citizens found themselves treated very differently from their Baltic counterparts. The forced return of displaced Soviet citizens by American and British forces is a controversial episode in the complex and messy peace that followed the war in Europe. The Yalta Conference agreement required the repatriation of displaced Soviet POWS and refugees regardless of whether or not they wanted to return—and many did not, often out of fear. The Soviet government tended to view Russian former POWs and forced laborers as collaborators or, worse, as traitors, because they had allowed themselves to be captured rather than fight to the death. Britain and the United States agreed to Stalin's demand for unconditional repatriation because they needed Allied unity to end the war and because they wanted to ensure a smooth handover of their own ex-POWs being held in territory now controlled by Soviet forces.

Many former Russian POWs were sent directly to gulags for hard labor and others received a death sentence. The Soviets are known even to have summarily executed Russian refugees right there in Germany, as soon as they were handed over to the Soviet zone of occupation. Small wonder that many Poles, especially former soldiers, military officers, and resistance fighters, were reluctant to return to a Poland under Soviet control.

〜

One day when Jadzia was visiting the Krzeminskis, Lola announced that she had a solution to the problem of where Jadzia might go: "Lola spoke excellent French, and her sister, who was in the same camp, had married a Frenchman. Lola and Janek were hoping to immigrate to France, along with her sister and husband, so she worked out this scheme for helping me."

As she told this story, my mother's eyes lit up and she started to chuckle: "Lola said, 'If you marry a Frenchman, you could come to France with us.' It turned out that this brother-in-law had a good friend, and Lola suggested that we marry, just to get me out. Later, I could divorce him. So here's what we did. I had a nice dark green wool army blanket, and so did Lola and Janek. They invited this French guy over and presented the plan to him. I wasn't bad looking, and he was young, tall, and fairly handsome. So Janek asked him, 'Would you consider marrying Dr. Lenartowicz, just temporarily, so she could go to France with us?' And he agreed, so Lola gave him these two blankets as a gift.

"You see, Basiu, I almost got a husband for the price of two blankets!" We both burst out laughing. "Well," I said to my mother, "you certainly would have had a different life."

"Perhaps," she replied. "Who knows . . . but nothing came of this. A few days later, when Dr. Szajniuk and I were visiting the Krzeminskis again, a truck pulled up and a U.S. soldier jumped out. In fractured Polish [he was Polish American], he announced, 'The Ruskis are coming! They're on the outskirts of town!' Anyone who was a member of the Polish army was welcome to get into his truck. The Russian army, you see, was taking over this sector. Technically, I wasn't an official member of the AK, the Polish Home Army, but Dr. Szajniuk declared, 'We're all army!'"

The British and American troops that had liberated Plauen and Mehltheuer in mid-April were still administering this area. Both towns sat close to the line that would become the border between the U.S. and Soviet zones of occupation, and eventually they would be handed over to Soviet forces. But during these first weeks after V-E Day, the border was fairly open. It is entirely possible that some unit of Soviet troops might have ventured into the area.

Jadzia and her friends were torn. They stood there, hesitating, wondering what to do next. How could they leave so precipitously when they were in the midst of planning their move to France? But rumors of the Soviet army's brutality and a fundamental mistrust of the Soviet Union

led many Poles to fear what might happen if they found themselves in the Soviet zone. When the driver added that Americans had heard reports of Russians beating up and arresting Polish soldiers, all four friends quickly got into the truck. They took off for another former POW camp well within the American zone of occupation.

At this point, my mother stopped talking, got up, and went to her bedroom. A few minutes later, she returned with a small, wrinkled photo that I had not seen before. As she handed it to me, she resumed her story:

"This other POW camp that we were taken to is where they signed us up as recruits to the peacetime Polish army that was re-forming under U.S. military command. I think this tiny photograph is from that place." She was referring to a one-by-two-inch mug shot of herself, taken by a photographer with the U.S. Army Signal Corp and about the right size for an identity card. This is the earliest image I have of my mother after liberation—looking somberly into the camera, her hair short but finally grown back.

Nearby, another camp was being set up for former AK members. Dr. Szajniuk was accepted there immediately, because she had been an AK officer, but the others were told they would first have to undergo six weeks of quarantine in an adjacent civilian DP camp. My mother recalled that this latter camp seemed disorganized and disorderly— which was the case for many early postwar DP camps:

"The young people there, recently liberated, didn't have much to occupy their time and were sort of demoralized, without purpose, while they waited for what the future would bring. There was a lot of drinking, carousing—lots of 'hula-lula' [my mother left terms like this to the imagination]. This didn't appeal to us. Then Janek happened to strike up a friendship with a Polish American soldier, who offered to take us elsewhere. So we told him that we wanted to go searching for Eisenhower."

I looked at my mother incredulously. "What do you mean? Why on earth did you want to go looking for Eisenhower?"

She shook her head and laughed. "I don't know. I guess we thought he might give us some help. All we knew was that we didn't want to stay

Jadzia soon after liberation, U.S. Army Signal Corps photo; May 1945.

in that refugee camp for six weeks. We stopped at several army posts and eventually came to the town of Wetzlar, where there were both a U.S. Army post and a Polish DP camp. Since it was dinnertime, we were led into the army mess hall. There were ten of us in the group, and when they found out that we were in the AK and had survived former Nazi camps, the soldiers stood up, saluted, and greeted us like royalty."

My mother paused, blinked tears away, and got a distant look in her eyes. She clearly was moved by the recollection of this moment of tribute. After a minute, she continued: "They gave us a wonderful dinner. I remember that German women had to serve us in this mess hall. Afterward, the colonel informed us that they had recently requisitioned a former German boarding school in another town, Echzell, not too far away. It was currently empty, so we could all stay there for the time being, and he would try to find us some supplies."

The earliest document in my mother's postwar papers was issued by the U.S. Army Field Artillery, a "Military and Displaced Persons Camp Registration," dated June 7, 1945. The location given is Bingenheim, a small community on the outskirts of Echzell. My mother no longer remembered the circumstances surrounding this registration, but it is likely that she and the others were officially signed up so that they would have identification papers and be able to move into the requisitioned boarding school.

They were lucky, for the school turned out to be spacious and well furnished, neither damaged nor badly plundered during the war: "It was quite luxurious. We were in the dormitory, with the school attached. Each of us had a separate room—for the first time in a long time. We even found clean linens still piled up in the closet, and the soldiers brought us extra clothes, army-issued wool pants and sweaters, along with lots of food like flour, sugar, and canned goods, and other supplies. Since I was a physician, the Americans asked me to be in charge of our group. So I was responsible for running everything."

The building had a well-equipped kitchen in the basement that clearly made an impression on my mother: "It was laid out with tiles, large stoves, very clean. One of the men in our group was a great cook

and baker, so we ate well. The American soldiers would come to visit us frequently. After we had settled in, we invited the Americans over for dinner, to show our appreciation. The table was elegantly set, with linens, dishes, and cutlery that someone found hidden in a cabinet. The soldiers were amazed at the wonderful meal our cook prepared from the canned goods they had supplied. For dessert, he baked some delicious cookies in the shape of long fingers. We even had music, performed by one of the young women in our group on a piano that sat in the corner of the dining hall."

Other camps in the area were overcrowded, so word soon got out that space was available at this boarding school in Echzell. Eventually, a large group of young women arrived, and life became more complicated for Jadzia and her colleagues. One benefit from the change, however, was that some of the young women knew how to sew. My mother grinned as she remembered the results of some of this sewing:

"The Americans confiscated quite a bit of fabric from German warehouses and brought it to us to be made into dresses, so we would have something to wear besides these heavy sweaters and pants. The women got busy sewing for all of us. At that time, buttons were hard to find, so they improvised by covering large dried beans with pieces of material and stitching them on. This worked fine until it was time to wash the dress—the beans cooked, and that was the end of those buttons!"

⁓

Everywhere in Germany, refugees like Jadzia wondered and worried about family members who might also have made it through the war. Unfortunately, my mother and I never discussed how and when she first contacted her family in Poland to learn whether they had survived the war and to let them know she was alive and well. The topic simply never came up, perhaps because we both had long known that the family suffered no more losses after Jadzia's arrest. Her parents and the two sisters who remained with them all survived in their home just outside of Łódź. In any case, at the time it may have been nearly impossible for Jadzia to directly contact her

family. Wartime damage to infrastructure in Germany and Poland had severely disrupted postal, telephone, and telegraph services, and I suspect that regular countrywide mail delivery did not resume in Poland until late 1945. In addition, with political tensions growing between the Soviet Union and the Western Allies and with each side wanting to limit the flow of information, the Communist government in Poland was beginning to strictly control the extent to which civilians could contact someone in the U.S. zone of occupation, and vice versa. In the early postwar period, Jadzia most likely passed information to her family via friends or colleagues who were repatriating to Poland.

The search for lost family members was especially challenging for Jewish survivors, because entire Jewish communities in villages, towns, and cities throughout Europe had been wiped out. Echzell was one such town; Jews had lived in this region for hundreds of year. Among several photos of my mother from the early postwar months, one shows her standing in a small Jewish cemetery located somewhere in Echzell. "It seemed very old and looked abandoned," she said. Then she added, "Well, you know how the Germans treated the Jews, so perhaps it's not surprising that some of the monuments were vandalized." Such vandalism started well before the war. The Jewish Telegraphic Agency in London reported on June 6, 1931, that "in the town of Echzell . . . the Jewish cemetery was entered, and . . . the swastika was painted on many of the tombstones."

Immediately after the war, Jewish groups began setting up registries to help trace survivors. The Jewish Agency for Palestine created a Search Bureau for Missing Relatives and published a *Register of Jewish Survivors* in 1945 and 1946 listing the names of thousands of Jews rescued in Europe and more specifically, those found surviving in Poland. UNRRA's Central Tracking Bureau led another full-scale effort to reunite families, with the help of the International Red Cross. The bureau eventually became the International Tracing Service (ITS), and Jadzia would later turn to it for help in tracing her concentration camp records. In the meantime, the fate of her sister Marysia—the one

arrested in 1942 and sent to Auschwitz—weighed heavily on her mind. But before she could even start making formal inquiries, a set of lucky coincidences led to an unexpected reunion.

It came about because former Polish POWs living nearby in Echzell often came to visit Jadzia and her friends. One of them, a Colonel Rutkowski, learned that his wife had survived the war and was now in Bergen-Belsen, where the liberating British army had established a refugee camp. He went there to get her, and when the two returned to Echzell, the woman contacted Jadzia to ask whether she had a relative named Maria Lenartowicz, for she had met someone with that name at Bergen-Belsen. My mother described how she reacted to this startling news:

"I immediately answered, 'Yes! She's my sister!' I couldn't believe that she had survived. Rutkowski managed to get permission to use a jeep, and the very next day we drove the two-hundred-plus miles to Bergen-Belsen."

In late 1944, as Soviet Allied forces approached, the Nazis began sending prisoners, either marching on foot or transported in cattle cars, from Auschwitz to other sites in Germany. Marysia, who had barely survived Auschwitz-Birkenau, having nearly died from typhus, found herself at war's end in Bergen-Belsen, the same concentration camp where the Jewish women from Neusalz had been sent.

Tears glistened in my mother's eyes as she paused to remember the moment at Bergen-Belsen when she first saw her sister. "This must have been a very emotional meeting for the two of you," I said.

"It certainly was," my mother answered. "We were both so excited and happy. Neither of us knew that the other one was still alive. We took Marysia back with us to Echzell that same day.

"And one more thing. During that visit to Bergen-Belsen, I discovered that Estera [the dentist], Mitzi [the Lagerälteste], and some of the other Jewish women I had known in Neusalz had also survived. Unfortunately, we could stay there for only a short while, so I didn't have time to find out about others."

Jadzia learned that day that Mitzi had gotten married and, along with her husband and sister, immigrated to Palestine. "I tried to talk Estera into coming back with us, but she didn't want to because she was waiting

for a visa to immigrate to Palestine as well. Her sister had already left."

Hania, the nurse from Neusalz, had also made it, but my mother thought that Hania's mother had died during the trip by cattle car from Flossenbürg to Bergen-Belsen: "The saddest part was that Hania, who had always been plump, was now just skin and bones. She was suffering from leukemia, diagnosed by the doctors in the camp hospital. When I went to the infirmary to see her, she was so happy and surprised and tried to get up, but her legs were unsteady. I wish I had had more time to spend with them and to find out what happened to the rest of the women."

～

Jadzia stayed in Echzell until the end of July, when the Americans began returning requisitioned properties, including the boarding school where she and her companions were living, to local German control. The Allies meant for all DP camps to be temporary and dismantled them as soon as the residents left for their postwar destinations. During the first fifteen months after liberation, Jadzia would move six times as camps were dissolved, job assignments ended, and new employment opportunities appeared for her in camps enlarged to handle the residual refugees.

Her next camp was in the city of Darmstadt, just south of Frankfurt am Main. It was known officially as Polish WAC PWX Camp 7 (in army parlance, WAC stands for Women's Army Corp, and PWX for Ex-Prisoner of War), but everyone referred to it as "Burg," after the town farther north where the camp had initially been set up, right after liberation. The place was part of a network of ex-POW camps run in the early postwar months by former officers of the Polish Armed Forces, with the knowledge of the U.S. military. Such camps were eventually dismantled after the Communist government in Poland accused the Americans and British of fostering a separate Polish army on foreign soil.

The camp was for female former AK members, whom the British and Americans considered to have been soldiers in the resistance and who therefore had POW status. For Marysia, who had been active in

the resistance, and the Krzeminskis, who had fought in the Warsaw uprising, acceptance into the camp was immediate. But Jadzia's status was questionable. She was not an official AK member; the Gestapo had arrested her for other political reasons.

Marysia was determined that she and her sister would not be separated again. She argued to the camp officials that her sister qualified, too, because she had worked informally for the AK during the war, providing clandestine medical care to sick and injured resistance members. Marysia prevailed, and Jadzia received an ex-POW identity card dated September 8, 1945, listing her as a private in the Polish Armed Forces.

Jadzia was eager to put her medical skills to use again. Her chance came with this transfer to Darmstadt, where she went to work in the small camp infirmary. In several photos from this time, she is wearing a uniform provided by the U.S. Army, a drab olive jacket and skirt with a dark blouse and tie. In the early months of the occupation, the U.S. forces confronted the enormous challenge of providing clothing for all the people in their employ and all the refugees under their care. Upon discharge, German prisoners of war and disarmed German

Jadzia's ex-POW identity card; Darmstadt, September 1945.

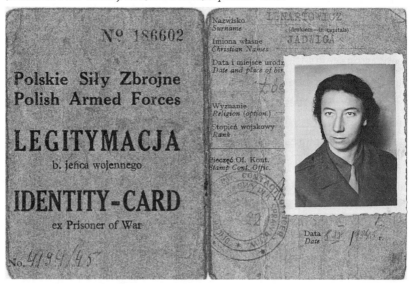

troops received what the army had—namely, U.S. military uniforms. This was also the case for DPs, civilians who worked for the U.S. Army, and Allied ex-POWs. But the army's expedience created a new problem: it was difficult to distinguish U.S. military personnel from everyone else. Late in the fall of 1945, while Jadzia was working in Darmstadt, the army issued orders that clothing for civilian workers and refugees had to be dyed. The uniform Jadzia and her colleagues wore was now navy blue.

Several of the German cities where Jadzia lived after the war had suffered extensive damage from Allied bombing, and one of the worst was Darmstadt. On September 11 and 12, 1944, a large group of RAF bombers attacked the city, kindling a firestorm that left 10,550 residents dead and almost fifty thousand homeless. Having read some accounts of the World War II bombing of German cities, I was curious about my mother's impressions of Darmstadt, for the only destruction I remembered her mentioning was what she saw of Berlin during her transport by train from Ravensbrück to Gross-Rosen.

Her response surprised me at first: "No, I don't recall seeing lots of destruction. However, our camp in Darmstadt was outside the city. Frankfurt was badly damaged, I know, but by the time we were there, the cleanup and rebuilding were well under way. Anyway, in those first months after the war, people were busy trying to regain their health and figure out how to live again."

Having endured so much during the last sixteen months of the war, Jadzia might well have been inured to some extent to the destruction all around her. Germany had been so thoroughly bombed that rubble and burned-out buildings must have filled cities everywhere. More than 130 cities had been attacked, some of them repeatedly, and many were completely destroyed. Roughly six hundred thousand civilians (seventy thousand of them children) had died during such raids, and three and a half million homes were destroyed. Such devastation was part of the early postwar landscape. What my mother remembered, sixty years later, was not so much this landscape as her struggles in it—to restart her life and plan for the future.

Part of the adjustment to this new postwar life included developing friendships and taking advantage of rare opportunities for relaxation and camaraderie. In going through some boxes in which my mother stored old photographs, I came across a souvenir packet of ten scenes from Avignon, France. It looked old—the gold lettering of the word *AVIGNON* was tarnished, and the exterior of the folder that held the small photos, its lavender color still visible on the inside, had faded to a light beige. I wondered where it had come from. When I showed the packet to my mother, she recognized it immediately:

"This was a souvenir from a trip that five of us took in late November through December 1945. We were given a month's leave—I can't remember what the circumstances were—so we decided to go to France. The group included Lola and Janek, as well as another woman from our camp, a marchioness, and her fiancé, who had access to a car. Marysia couldn't come with us, because there was no more room. The situation was still chaotic in Europe. No one had money, so a lot was done by barter and bribery. We took items such as shoes and blankets that we had gotten from the U.S. Army; I traded one blanket for a nice watch to bring back for Marysia. We also took special passes that allowed us free lodging and food in hotels that had been requisitioned by the U.S. Army. And we tried to stop over in places where former Polish soldiers were stationed."

Someone in the group must have brought a camera, because my mother had quite a few photographs from this trip. The five travelers look as if they are having a splendid time, laughing, standing in front of the cathedral in Reims, visiting Notre Dame, the Louvre, and other sites in Paris. It was far from a luxurious vacation. The lodgings were undoubtedly spartan and the food simple. Nevertheless, the joy of being able to freely travel again must have been profound. The year had started with imprisonment, growing despair about the future, and, for my mother, a death march. It ended with freedom and great hopes for new lives. Small wonder that my mother, years later, often recalled with pleasure moments from this trip in December 1945.

"I was so scared when we drove through the Alps on our way to Grenoble, with the narrow winding roads and edges that dropped right off. But it was very beautiful. In Fontainebleau, outside of Paris, we found a hotel with two empty rooms, for which we exchanged a blanket. I remember that we got light-headed from all the aperitifs the proprietor offered us. Everywhere we went, people treated us well, especially when they found out that we were survivors of Nazi camps."

Her photographs also show scenes from Avignon, the palm-tree-lined boulevards of Nice (where the friends spent New Year's Eve and enjoyed a delicious dinner hosted by American soldiers), even Monte Carlo, "although," my mother noted, "the casinos were still closed. I really liked Marseilles, but we had trouble finding lodging because the hotels were filled with soldiers. We finally managed to get a room with two beds in a small inn down some side street.

"The marchioness and her fiancé slept in one bed, while Lola, Janek, and I had to share the other. Janek, always the joker, said that he wanted to be 'in between two roses,' but Lola quickly set him straight. He slept on one edge, I on the other, and Lola in the middle, and that was that."

Soon afterward, the trip came to an end. The friends headed back to their jobs in Germany, where the question of whether or not to return home to Poland was gaining urgency.

～

The repatriation of Poles began around the middle of July 1945, but it moved slowly. Even though the Polish government clamored for a quick return of its displaced citizens and sent representatives to propagandize in the DP camps in Germany, the country was far from ready to receive and process a huge influx of returning refugees. The war had claimed a substantial portion of its population and had devastated its cities and infrastructure.

At the end of September 1945, more than eight hundred thousand Polish DPs remained in Germany, partly because of logistical problems (for example, a shortage of Polish coal for locomotives to take refugees through Czechoslovakia to the Polish border) and partly because of the

refugees' distrust of the increasingly entrenched Communist government in Poland. Many of them felt that the Allies had betrayed Poland with the agreements among Roosevelt, Churchill, and Stalin at the Yalta Conference in February 1945. The Allied powers had redrawn Poland's borders in favor of the Soviet Union and at the expense of Germany, resulting in mass expulsions—with tragic consequences—of Poles and Germans, respectively, from territories now under new sovereignty. Equally significant for the future was the Allies' recognition of the Soviet-sponsored provisional government established after Poland's liberation by the Red Army, rather than the London-based Polish government-in-exile. Stalin promised free elections and representation by all parties, but in reality he made sure that Poland remained firmly under Communist control.

Many Polish DPs faced a dilemma. On the one hand, they fervently wanted to go home. They missed their native land, their families, their communities, and they wanted to participate in building a new Poland. On the other hand, many of them viewed the Communist government in Poland as yet another foreign occupation, this time by the enemy from the east. The Soviet Union had, after all, attacked Poland in 1939.

Personal safety was also an issue. Those who had fought in the Polish army or Polish resistance feared Soviet reprisals upon their return—fears that were not unfounded. The Soviets and their Polish counterparts viewed the non-Communist resistance fighters, especially members of the AK, as hostile and even as threats to the emerging Communist government. Thousands of former AK members in Poland had been arrested and deported to Soviet camps, even in cases where amnesty had been promised.

The alternative to repatriation was resettlement elsewhere. As of April 1946, 180,000 Poles still lived in the U.S. occupation zone alone, most of them in UNRAA-run DP camps. By the fall of 1946, it had become clear that resettling DPs in other countries would be difficult—many nations had immigration quotas or wanted only certain kinds of refugees. The U.S. command and UNRAA tried again to convince Poles, in particular, to return home, with a program called "Operation Carrot," which met with some success. From October to

December 1946, about 48,000 Polish DPs agreed to be repatriated after being promised a sixty-day supply of rations.

By this time, the AK camp where Jadzia lived had been moved to the city of Weinheim. Even though she was busy working in the infirmary, she was increasingly homesick and considered a return to Poland. She remembered how representatives from the Polish government came to this camp in Weinheim:

"They wanted to convince the young people that conditions in Poland were good. And many did decide to go back, including my sister Marysia and my good friend Jaga, who had been a lieutenant in the AK in Warsaw. I still remember her descriptions of how they traveled through the underground sewers during the 1944 Warsaw uprising, to avoid the Germans. When the resistance was crushed, Jaga was arrested and sent, along with thousands of other AK members, to a German POW camp. We met soon after the war, in one of the refugee camps, and became fast friends—that's why your father and I later chose Jaga to be your godmother.

"I was seriously thinking of going back to Poland with Jaga and Marysia. But when Janek and Lola Krzeminski found out, they were very upset. They invited me down to Ludwigsburg, where they were temporarily living in a large Polish DP camp, and tried to talk me out of going back. They told me all sorts of stories about what had happened to others who returned to Poland. In fact, they wouldn't let me go back to Weinheim until I promised that I would not leave. Since it was close to the day when our transport was to move out, I had to figure out an excuse. As it so happens, I had a severe upset stomach, probably from something I had eaten that didn't agree with me. I pretended, however, that it was possibly appendicitis. Jaga and Marysia stayed back, too, supposedly to take care of me."

Marysia eventually returned to Poland, but Jaga did not. Several years later she immigrated to the United States. Jadzia's decision to delay her return home was another major turning point in her life.

Refugee Doctor

᙭

IN MID-1946, THE U.S. ARMY DECIDED to eliminate the camp in Weinheim where Jadzia had been working. Repatriation efforts were at least partly succeeding, and enough Polish DPs had returned to Poland that the army could close some of its refugee camps. The next transfer for Jadzia, along with her sister Marysia, friends Lola and Janek Krzeminski, and other colleagues, was to the training center at Käfertal. On March 18, 1947, an article about this center appeared in the *New York Times*, headlined "DP Civilian Guards Key to Occupation":

"The number of civilian guards recruited among Polish and Baltic displaced persons now has grown to a point where they outnumber United States troops in some areas such as Mannheim and Nuremburg. Men in United States uniforms dyed dark blue and sky blue . . . watch over supply depots, post exchanges, dependents' homes, prisoners of war and interned civilians, drive and repair trucks and jeeps and do a hundred other chores formerly performed by American troops . . . an essential part of the United States occupation. More than 27,000 men, mostly Poles, are organized into companies and are on duty after receiving basic training as guards or as labor specialists . . . at Camp Kosciuszko, the civilian guard training and replacement center at Kafertal, near Mannheim."

This training center operated under the command of the U.S. Army's Military Labor Service but was staffed and largely run by Poles, many of them former officers in the Polish army. They unofficially called it "Camp Kosciuszko," after the Polish hero who fought in the American Revolutionary War. Among those helping to teach and provide for the men (and some women) who passed through the training center was Dr. Jadwiga Lenartowicz.

This center was based in a complex of former German army barracks that the U.S. forces initially converted into an assembly center for "Recovered Allied Military Personnel," or RAMPs—the military's jargon for released Allied prisoners of war, among them soldiers from Poland and the Baltic states. Poland was considered an important ally because Polish troops—who either escaped after Germany's invasion of Poland or who were released from Soviet POW camps after Germany invaded the USSR—were re-formed into major contingents of the Allied forces in Europe, under British command in the west and Soviet command in the east. The Polish resistance movement also made significant contributions to Allied intelligence.

At war's end, the U.S. military quickly recognized a ready work force in the former Allied POWs. Starting in May 1945, it began hiring these men, many of them Poles, to guard U.S. Army installations, warehouses, prisons, and former German soldiers in work crews that were clearing rubble and rebuilding roads, water mains, and other critical infrastructure. By October 1945, the army employed some twenty-five thousand ex-POWs in guard and labor units set up wherever they could be used for security, transportation, and technical work. As the army closed down its facilities in other liberated European countries and moved them to Germany, the need increased. By the following June, the number of DPs working for the U.S. Army in this capacity had swelled to more than sixty thousand. The military transformed the RAMP assembly site at Käfertal into a center for organizing, equipping, and training new guards recruited as others left for repatriation or resettlement. By July 1946, the Civilian Guard Training and Replacement Center was fully operational.

The army referred to these civilian guard and labor units as Labor Service Companies, while the Poles called them the Oddziały Wartownicze, meaning "guard companies," or the OW for short. Even though the OW was a civilian labor service, the army structured it along military lines, with a hierarchy of ranks that determined pay level. The highest rank given to Polish officers working in the OW, even colonels and generals, was that of guard major.

For the Americans, the OW was a very good deal in terms of army morale and politics at home. The cost of using non-U.S. civilian labor in occupied Germany was so low that some critics asked whether the military was exploiting the DPs. On average, a civilian guard cost the army $30 a month, versus $350 a month for a U.S. soldier. More important, the guard and labor companies relieved many American soldiers from duties in occupied Germany, so they could return to the United States sooner than they might otherwise have been able to.

For young men in DP camps facing uncertain futures, the OW was an attractive alternative. Life in the camps could be frustrating and demoralizing; few refugees had any gainful employment. Those who signed up with the OW might have received meager pay for often monotonous work, but they did get housing, meals, uniforms at a subsidized cost, and a chance to be productive rather than just sit around. Their association with the U.S. military gave them a sense of security and hope.

Working for the OW also had political overtones for many former officers and soldiers of the Polish army, who had envisioned a postwar return to a free Poland. Among those who resisted repatriation to Communist-governed Poland, there were a fair number who believed that escalating tensions between the West and the Soviet Union might lead to another war and a chance to liberate their country from its newest occupier. The OW offered them an opportunity to regain and develop preparedness.

Already, cold war politics had imposed themselves on postwar Germany. Stalin suspected the U.S. and its allies of undermining Soviet influence in Eastern Europe and believed that a Communist-controlled Germany would serve as a buffer. The Western allies, in turn, viewed a democratic Germany as a critical deterrent to perceived Soviet expansionism. The border separating the British, French, and U.S. zones of occupation in Germany from the Soviet zone—areas that in late 1949 would respectively become West and East Germany—was now part of the Iron Curtain, so named by Winston Churchill in a speech in March 1946, when he declared that "an iron curtain has descended across the Continent."

The Polish government-in-exile, which had operated from its base in London throughout the war, supported the OW's expansion, and saw it as a means of retaining influence over Polish affairs and promoting the goal of a postwar Poland independent of Soviet control. The London government had been rendered largely impotent when the Allied powers allowed Poland to come under the Soviet sphere of influence during the Yalta Conference.

The Soviet-installed Polish government, in turn, viewed the OW with suspicion. It accused Western forces of discouraging repatriation, of promoting resettlement—as a means of providing cheap labor for countries in western Europe and overseas—and of creating paramilitary organizations that might eventually try to undermine the Communists. The Soviet Union echoed these charges and raised them repeatedly over the next few years in the United Nations. It was to help deflect such criticism and underscore the OW's civilian role, despite its military-like structure, that the U.S. Army named the facility at Käfertal the *Civilian Guard Training and Replacement Center* and changed the color of its civilian uniforms to navy blue.

Although the U.S. Army's Labor Supervision command held ultimate authority over all guard, labor, and transport companies, on the ground these units were run mostly by Poles, with some involvement by Estonians, Lithuanians, and Latvians. To facilitate communication between the Polish OW and the Americans, the army in October 1945 created what it called the Main Polish Liaison Section, which included translation services. Its chief, and also the nominal chief of the OW, was the Polish colonel Franciszek Sobolta. His deputy chief was someone Jadzia would soon get to know very well—Colonel Władysław Ryłko, the man who would become her husband and my father.

⁓

Jadzia arrived in Käfertal on June 30, 1946. Assigned the rank of guard second lieutenant, she immediately began working as a physician in the camp's dispensary (infirmary). At first she stayed in the large communal hall of a barrack: "Eventually, the Americans assigned me an apart-

ment with four other women, each of us with her own room and a shared kitchen. There was a German woman who would come and clean for us. And we had a spacious living room where we could entertain guests."

My mother recalled that the town of Käfertal was not very big: "It was a suburb of Mannheim. But the camp, which was located on the outskirts of town, was quite large. It was guarded by the camp police, and whenever you left the area, you had to show your personal ID card to the guard stationed inside a small booth at the gate."

Jadzia worked in the dispensary alongside two other Polish physicians: "There was Dr. Gierzyński, a surgeon, and Dr. Butkiewicz, chief of the dispensary, who was a gynecologist from Kiev." My mother started to chuckle: "Of course, since Käfertal was largely a camp for men, his specialty was not in much demand.

"There were also several male and female nurses, including one who specialized in radiology. We would see patients from eight in the morning until five o'clock and then rotate the on-call duty so that someone was available after hours and for house calls."

Jadzia (second from left) and medical staff of the camp dispensary; Käfertal, 1947.

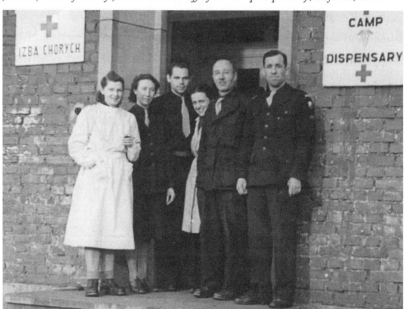

At the height of the training center's existence, the dispensary served as many as four thousand people. One of my mother's photos from her stay in Käfertal shows members of the medical staff, including her, standing in the doorway of the dispensary. Besides treating patients, Jadzia and her colleagues taught classes to the recruits in first aid and basic health care. This was part of a much larger effort by Polish leaders to deliver education to the young people working in the civilian guard companies.

The U.S. Army's main purpose for the training center in Käfertal was to prepare young men from the civilian DP camps for duties as guards, drivers, mechanics, and technicians. The Poles in the command structure had bigger goals. They saw the center as an opportunity to expand the general knowledge and training of Poles whose education had been disrupted by the war. With this in mind, they established on site a library, clubs, sports teams, and cultural activities including a theater and a small orchestra.

Many of the recruits came from small towns and villages in Poland where they had scant educational opportunities even before the war. The rate of illiteracy was high enough that one of the instructors' first tasks was to teach new recruits how to sign their names. Many of the trainees had been very young—some no more than thirteen—when the Nazis deported them for forced labor, separating them from family and community at a critical time in their lives. After enduring difficult and demoralizing wartime experiences, the young men needed much more than just food and wages. Teaching them basic reading and writing in Polish, rudimentary English, some technical skills, and fundamental principles of citizenship not only enhanced their value as workers but also boosted their morale and confidence.

The U.S. command supported these projects, especially as it became evident that a fair number of the remaining Polish DPs were likely to resettle in countries other than Poland. Acquiring useful skills would make their transition to new lives easier. A more immediate benefit was that educating these young people and giving them a goal helped forestall petty crime and rowdiness in the camps.

Many of the Poles on staff at the training center in Käfertal contributed their skills and knowledge to the education effort. Jadzia's friends Lola and Janek Krzeminski, who had been educators in prewar Poland, helped organize the training of potential teachers, who then returned to their guard companies in other parts of Germany and began teaching classes, especially at the elementary level, to guards stationed in those areas. The staff even tried to provide for exams and certification.

In addition to general education, specialized courses were available for guards already employed, as a reward for good work. These employees got several weeks to several months off duty in order to live and attend classes at the center in Käfertal. The curriculum included training as cooks, mess hall managers, drivers, mechanics, carpenters, shoemakers, and medical aid workers—the course that Jadzia helped teach:

"Fairly large groups of these guards . . . would take the basic medical aid classes over several weeks and upon finishing would be certified by the American commander. I taught general medicine. Anka Irrek, our radiology nurse, would lecture on nursing care, while Dr. Gierzyński would teach basic surgical techniques. We also had a chemist and several other nurses on our team."

Jadzia (top row, left) and first aid course instructors and graduates; Käfertal, 1946.

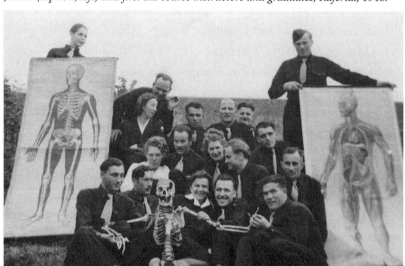

At the end of the training, the staff always held a graduation ceremony, replete with bouquets of flowers, a traditional Polish touch. My mother had photographs of several graduating classes, grouped in front of the dispensary, laughing as they gathered around and on top of an ambulance, or, in my favorite, posed with a skeleton used in teaching basic anatomy.

Jadzia's medical work at times overlapped with her social life, for a sizable number of her patients came to see her *just* to see her: "All the officers, when I was on duty, came complaining that they had something wrong with them."

My mother started to laugh. "Each one hoped I would marry him. And then one day, Colonel Ryłko came to see me, as a patient. He complained that 'it hurts here, it hurts there,' but I recognized the 'problem' immediately and replied, 'There's nothing wrong with you!' Well, then he paid me a visit at my apartment, which I shared with four other women. After that, he began sending me flowers, via his lieutenant."

~

Władysław Ryłko began working at the training center in Käfertal just six days before Jadzia did. He had been a career officer in the Polish armed forces, enlisting as a young man at the start of World War I with the Polish Legions of Józef Piłsudski to fight against the Russian army. After finishing his officer's training in 1918, he served in the artillery during the Polish-Soviet war of 1919–20.

During the interwar period, Ryłko taught at the Artillery Academy (Szkoła Podchorążych Artylerji) in Toruń, and in the 1930s he won promotion first to lieutenant colonel, and later was advanced to the rank of colonel, but the war broke out before this became official. During World War II he commanded the 23rd Light Artillery Regiment of the Polish Army and was captured by the Germans on September 20, 1939.

After spending several months in a Red Cross POW hospital in Kraków, Ryłko was sent to a POW camp for officers—"Oflag VIIIA" in German military parlance—in Kreuzburg, Germany, where he was

Władysław Ryłko (front row, 4th from left) in German POW camp, Oflag VIIA; Murnau.

registered as prisoner number 421. On June 14, 1940, he was transferred to Oflag VIIA, a large camp in Murnau, Bavaria, that held Polish army officers. There he remained until the end of the war. On January 1, 1946, the commander of the Polish Armed Forces of the Polish government-in-exile confirmed his prewar promotion to colonel.

In Murnau, he became good friends with a younger officer, Second Lieutenant Władysław Stefanik. During their long imprisonment, the two taught English to the other inmates of the camp, a skill that quickly became useful once the war ended. Many years later, I discovered that the old, battered, Polish-English dictionary I had consulted since adolescence, which I assumed my father had bought in some secondhand bookstore after immigrating to the United States, was actually the dictionary he used in the POW camp. On the last page of the book is a stamp identifying it as belonging to the Oflag VIIA Camp Library, donated to the Polish POWs by the Polish American Council.

The friendship between my father and Władysław Stefanik—Uncle Władek, as I called him—continued for decades after the war. Both men worked for the OW in postwar Germany, and after immigrating to the United States, they lived just a few blocks apart in the same Polish

American neighborhood of Detroit. My parents chose Uncle Władek to be my godfather. When he died in 1998, I acquired a few mementos of him, including a small red notebook he used while a prisoner in Murnau. In the tiniest of handwriting, he wrote crowded notes in pencil, including names of fellow prisoners, English words, definitions, and titles of books he hoped someday to read. On the last page, at the very bottom, Uncle Władek had scrawled, in Polish: "29 April 16:20 hrs. The Americans are in the camp."

Like many other liberated camps throughout Germany, the POW camp in Murnau first became a RAMP camp for released Polish POWs and then an ad hoc training center for guards whom the U.S. Army was starting to hire. From July 1, 1945, until June 20, 1946, my father served as a contact officer for the OW, facilitating communications between the Polish ex-POWs and U.S. officers. On June 24 of that year, the U.S. Army command appointed him guard major and transferred him to the Civilian Guard Training and Replacement Center in Käfertal. After working there at first in a supervisory role, he was promoted to deputy director of the Main Polish Liaison Section of the OW.

~

"Your father was quite a romantic," my mother remarked one afternoon as we sat in her apartment sipping Earl Grey tea and looking at old photos and documents. "I think I may even have, in that old briefcase of his, several letters he wrote to me before we were married. You know how your father liked to hold onto things, all those old documents from our time in Germany. Unlike him, I don't like to keep old things. I tend to toss them out."

Thank goodness for my father and his archiving tendencies, perhaps influenced by his military training, in which documentation was the norm. He was also interested in history and recognized the value of primary documents. I recently discovered that he even wrote a slim book, published in 1929, that was part of a series on the history of Polish regiments in wartime from 1918 to 1920—still available on the shelf at the Main Military Library in Warsaw.

I found two letters in my father's old briefcase, written in black foun-tain-pen ink on plain blue-gray paper. The first was dated April 21, 1947. By this time, my father had received his promotion as deputy director and was based in Weinheim, about eight miles from Käfertal. The letter, as I have translated it from the Polish, begins with a simple salutation:

"Jadziu,

"I do not expect everything in this world to make sense. In fact, much of it seems without sense, but despite this, the world is beautiful. . . . If everything were perfect, the world would be a dull and colorless place, just as it would be intolerable if we only had injustice and absur-dity. It seems to me that the key to human happiness lies in the capacity and ability to balance and enliven perfection and reason with some nonsense. . . . Jadziu, your conduct seems always sensible and just, and only occasionally nonsensical. My conduct seems to me largely non-sensical, as this letter demonstrates, although I do have moments of reason. My dearest Jadziu, let us intertwine your sense with my non-sense and 'let history repeat itself.'"

My mother remembered the moment when my father actually pro-posed to her: "One day during a visit, he got down on one knee and declared himself, telling me that we'd now known each other for a while, that I was a person with whom he could share his life. And so I said yes, I would marry him."

I did not get a chance to ask my mother about the timing, but I assume she accepted his proposal on the heels of that first letter. A second note, written just eight days later, begins with "My beloved Jadzia" and talks of how much he loves her, how devoted he is to her, and how much he is looking forward to the upcoming weekend they will spend together.

Once, when my mother and I were talking about her marriage, I asked her what it was that attracted her to Władysław—whom she called by the diminutive Władziu, pronounced Vwah'-joo—who was fifteen years older than she.

"I don't know, really," she answered. "It's true that he was quite a bit older. And he was divorced—but this had happened many years before the war. He did have family in Poland but no longer had obligations

that might tie him down. Some of my friends wondered what I was doing. But I didn't care about that. When you go through so much during the war, you start to see things differently. He appealed to me. He was very intelligent, concerned with social issues, and took an active part in solving them. You know, while in Käfertal, he helped set up a cooperative and the Guard Welfare Fund."

I wasn't sure what she was referring to, so I asked her to explain:

"Both were efforts by the Polish guards to be more self-sufficient, not so dependent on the Americans. Members would pay a certain amount into the co-op and have access to a small store, a vegetable garden (most of the food we got from the Americans was canned), a café, and various services like tailoring, shoe and watch repair. Oh, and there was a barbershop as well."

"And the welfare fund, what was that all about?" I asked.

"It was a way of helping those working for the Oddziały Wartown-icze who were less fortunate. Your father was interested in promoting education, physical fitness, solidarity, and a sense of community among Poles in exile. He used to excel in sports when he was in the Polish army. The fund was started soon after I arrived in Käfertal, and later your father served as head of the board of directors. Everyone in the OW was encouraged to join by contributing a small monthly amount. The money supported various educational, sports, and cultural activities, as well as a newspaper published several times a week, called *Ostatnie Wiadomości* [*The Latest News*]. Most important, the fund helped guards and their families in times of need. Like with medical care, funeral expenses, and care of the disabled and those chronically sick with TB. I admired the fact that your father was a person of action."

Then my mother got a faraway look in her eye and smiled: "Plus, he looked quite elegant in his uniform. He carried himself well. He had presence and a strong personality."

～

In looking through papers my father saved from this time, I came across several documents that made me realize how closely the U.S.

Army supervised its civilian employees in occupied Germany. One of the documents was a request for permission to marry, submitted by Jadzia on June 8, 1947, to the commanding officer of the training center in Käfertal. It was accompanied by a statement of "acquiescence" by her fiancé, who probably had to go through a similar process. The other document shows that official approval was granted on June 23.

Jadwiga Lenartowicz and Władysław Ryłko were married on June 28, 1947, in the resort town of Bad Soden, just outside Frankfurt, Germany. "We were married there because Władziu by then had left Käfertal and was stationed in Bad Soden. The flowered dress I wore was made from material that the Americans had confiscated, and I was able to go to a warehouse and pick out some things I needed. There were many women in the camp who knew how to sew, and one of them made the dress for me."

The newlyweds, Jadzia and Władziu; Bad Soden, 1947.

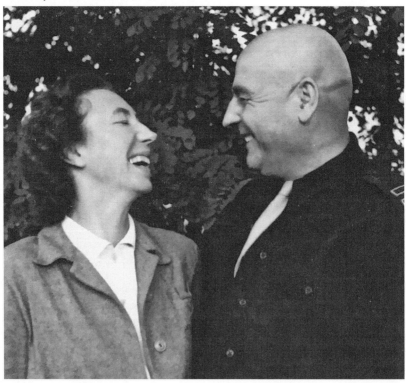

From the cards and photographs that have survived all these decades, it is clear that many well-wishers shared in the happy occasion. Life was still difficult in postwar Germany, but friends managed to host a small, elegant, candlelight dinner that evening at the local Hotel Adler, in honor of the newlyweds. All too soon, they had to part, for Jadzia was still living and working in Käfertal. Within a few months, however, the training center closed down, and Jadzia joined her new husband in Bad Soden.

17

Reclaiming the Past

𝒫

Two years after the war's end in Europe, many refugees in the U.S. occupation zone of Germany had gone home. A small minority had emigrated to other countries. The Americans still hoped that most DPs remaining in the U.S. zone—more than five hundred thousand of them, including about one hundred thousand Poles—could be repatriated. In April 1947, the U.S. command resumed the sixty-day ration plan that had convinced many Polish refugees to return home in 1946, but this time the plan was available to all nationalities. As the incentive program commenced, the *New York Times* quoted commander-in-chief General Lucius D. Clay, who urged DPs to seize the opportunity: "For those of you who choose to remain here in the United States zone of Germany rather than return home . . . assistance from the American people through the United States forces here cannot continue indefinitely."

The new push met with some success, in part because food, like coal, was still scarce in Germany in 1947, as was housing and pretty much everything else people needed. Nevertheless, it was clear that many DPs had no intention of going back. Some had personal reasons—they had formed romantic liaisons with or married German natives. For many others, the reasons were political and ideological, and Jadzia and Władysław Ryłko were prime examples. They opposed the Soviet takeover of their native country, and they believed that because Władziu had been a colonel in the Polish Army and was still loyal to the Polish government-in-exile, he risked being arrested if he returned to Communist Poland.

By this time, the U.S. Army had discharged most of its German prisoners-of-war, consolidated its military depots, and eliminated many of its DP camps. The need for civilian labor and guard units, so acute in the earlier months of the occupation, had diminished, and the U.S. command was more willing to employ local Germans. Concerns about the cost of the occupation were coupled with suspicions that the civilian guard system, by providing work, housing, food rations, and other benefits, was keeping DPs from considering alternatives.

For all these reasons, the U.S. command decided in mid-1947 to dismantle most of the civilian guard and labor units and replace them with "industrial police"—locally based men trained to guard low-risk U.S. installations. Those hired would receive only a wage and a daily meal, and the military expected that most applicants would be Germans and DPs living outside of camps. The aim was to reduce costs while removing incentives for DPs to stay in Germany. At the beginning of July, the U.S. Army employed about thirty-seven thousand DPs; by the end of the year, the number had fallen below ten thousand.

After working for fifteen months at the training center in Käfertal, Jadzia now found herself among the employees being discharged. The army was closing the center where she and her colleagues had trained and cared for more than thirty-nine thousand Polish and Baltic guards. On October 24, 1947, a few days after Jadzia's discharge, the commanding officer of the training center wrote a memo stating that during her employment she had performed "duties of a physician with the Center's Dispensary which she carried out in an excellent manner proving to be a very experienced doctor and showing the best traits of an honest and reliable person."

Obtaining this memo was a small first step on Jadzia's part to try to reclaim her past professional life by compiling documents attesting to her status and skills as a physician. In the wake of her arrest and imprisonment by the Nazis, she had lost every document related to her medical schooling and postgraduate training, and it was difficult to acquire copies of them from Poland during the early postwar years. Her file would grow—all too slowly—throughout her last three

years in Germany, and she would keep those treasured documents for the rest of her life.

~

"For a brief while after I left Käfertal," my mother remembered, "I was able to spend some time with Władziu. But we saw each other only on weekends, since your father traveled around a lot in his job, inspecting the remaining Polish guard units. He was initially stationed at Bad Soden, where we married, but then I think he went to Mannheim, and then Heidelberg."

Jadzia soon found both a job and a place to stay in the nearby city of Weinheim: "I worked as an administrative assistant for the YMCA, which was helping the DPs by delivering packages and providing other services. I was able to get a room in the lodgings that the army had assigned to the YMCA."

The "Y" was one of many voluntary organizations aiding in the relief effort, along with national Red Cross agencies, ethnic organizations such as American Polish Relief, and religious-based groups such as the National Catholic Welfare Conference. These groups provided DPs with food, clothing, recreation, leadership and skills training, and help in applying for emigration. But Jadzia's work with the YMCA was unrelated to medicine, and she worried about losing knowledge and skills if the hiatus lasted too long. She and Władziu began to talk about leaving Germany. They even took the first step toward signing up for possible immigration to France but then, for reasons my mother no longer remembered, dropped the plan. Regardless of where they resettled, Jadzia had every intention of practicing as a physician.

Finally, an opportunity to work with patients again presented itself: "I was able to volunteer at a clinic in the hospital that was associated with the University of Heidelberg. I did this for three months, as a way of keeping up my skills. Weinheim was about sixteen miles from Heidelberg, and I would take the bus back and forth. I made rounds with the head doctor and saw patients in internal medicine."

When Jadzia completed her three months at the hospital, she requested a formal letter—a new addition to her file—signed by the head doctor of the Ludolf-Krehl Clinic, stating that she had practiced as a physician from June 14, 1948, to September 14, 1948. It was also in 1948 that, through the efforts of her sister Marysia, who by then had returned to Poland, Jadzia was at last able to get a notarized copy of her medical diploma from the Medical Academy in Poznań.

Several months after leaving the clinic, she took an examination given by a special board created by the International Refugee Organization (IRO), which in July 1947 had taken over responsibility for Europe's refugee population from the United Nations Relief and Rehabilitation Agency (UNRRA), which was being dismantled. Sometime after the exam Jadzia traveled to Frankfurt for an interview, and soon afterward she received a "Certificate of Professional Status." Dated November 30, 1948, it declared her "to be a qualified physician" and affirmed that she had graduated in accordance with the regulations of Poland. It was signed by the chief medical officer of the IRO in the U.S. zone of Germany and by Dr. Jenő Kramár, a former Rockefeller Fellow and a professor of pediatrics at the University of Szeged, Hungary, one of the most distinguished universities in Central Europe.

This certificate was the result of a concerted effort by the IRO to register qualified DP physicians in Germany who were working as camp doctors, staffing IRO hospitals, and providing public health services. The screening of these displaced physicians was overseen by IRO medical officers and conducted by special qualification boards composed of refugee doctors with international reputations (such as Dr. Kramár) who represented different branches of medicine and various nationalities. In 1949, the IRO published its *Displaced Persons Professional Medical Register,* a list of certified medical and paramedical professionals along with facts about their personal status, training, and qualifications. The list included 2,570 refugee physicians. As the foreword to the Register noted, "It is hoped . . . that this . . . will be of assistance to Governments, Medical Associations and Teaching Bodies,

INTERNATIONAL REFUGEE ORGANIZATION

Certificate of Professional Status

THIS IS TO CERTIFY THAT

R Y L K O JADWIGA

NATIONALITY _____ POLISH _____ AGE __37__ HAS BEEN FOUND

TO BE A QUALIFIED - - - - PHYSICIAN - - - -

AFTER EXAMINATION OF HER PROFESSIONAL QUALIFICATIONS BY THE SPECIAL

QUALIFICATIONS BOARD IN _____ U.S. ZONE OF GERMANY _____

AND GRADUATED ON __11. XII. 1936__ IN ACCORDANCE WITH THE

REGULATIONS OF _____ POLAND _____

I. R. O. MEDICAL REGISTER NO.: __U.S. 1472__

ADDITIONAL QUALIFICATIONS :

- -

- -

- -

Signed: *Prof. D.r ław Krasir*
President of Special
Qualifications Board

Signed:
Chief Medical Officer
IRO U.S. ZONE OF GERMANY

At BAD KISSINGEN on 30 NOVEMBER 1948
U.S. ZONE
GERMANY

The foregoing representations, based on
investigations by competent persons, are
correct to the best knowledge and belief
of the undersigned.

Signed
Director General

Jadzia's Certificate of Professional Status from the IRO; November 1948.

not only in the confirmation of the claims of refugee members of the Medical and Para-Medical Professions, but also in the selection of such refugees for medical work."

Jadzia's name appears on page 108 of the *Register* as a general practitioner with experience in pediatrics, together with information about her medical education and training, her work as a physician during the war, and as a "Doctor in Concentration Camps, 1944–1945; Doctor attached to U.S. Army Unit, 1945–1947; [and] Med. Clinic of Heidelberg Univ., 1948."

By 1948, most of the remaining displaced persons in Germany were either unable or adamantly unwilling to return to their countries of origin. Their only choices were to remain in Germany or to resettle in another country. Considering what they had been through, it is not surprising that most chose the latter option. Just as responsibility for assisting DPs still living in camps had shifted from UNRRA to the IRO, so the approach to solving the DP situation now shifted from repatriation to resettlement.

Unfortunately, many countries refused to take large numbers of refugees. Host countries often placed conditions on immigration that reflected their national labor shortages rather than humanitarian concerns. Belgium was the first to offer a large-scale immigration plan, eventually accepting and resettling more than twenty thousand DPs in 1947, but these were all younger men who could work in the nation's coal mines. A report prepared by the IRO in May 1948 noted that DP labor tended to be treated "solely as a commodity" and that countries recruited only strong, able-bodied men, leaving their dependent families and the elderly behind in German DP camps. It criticized recruiting countries for their indifference toward finding other work opportunities and housing so that families could be reunited and for failing to accept their fair share of DPs "regardless of age, sex, nationality, or working status."

A related problem, pertinent to Jadzia as a physician and to Władziu as a military officer in his fifties, was what the IRO referred to as the "embargo on brains." Most countries preferred agricultural workers and manual laborers over refugees with higher education and training, such as university professors, writers and artists, lawyers, journalists, engineers, and physicians. The argument—influenced in part by prejudice—was that skilled immigrants would create competition in their new countries while lowering professional standards.

The resettlement of specialists was an ongoing problem for the IRO, as its director-general reported in late 1948: "One present plan is concerned with acquainting the world with the vast numbers of refugee

physicians and other members of the medical profession whose train-
ing and experience is being wasted because nations refuse to accept
doctors as immigrants." The IRO's publication of the *Professional Medi-
cal Register* was part of this plan.

Immigration quotas, which many countries imposed on different
nationalities, also curbed DP resettlement. In the United States, the
national origin quotas being used were those established in the Immi-
gration Act of 1924 and they favored western and northern Europeans.
For example, the annual quotas for immigrants to the United States from
Great Britain–Ireland and from Germany were set at 84,000 and 26,000,
respectively, whereas only 39,000 visas were available for all the coun-
tries of origin of the remaining DPs combined. Refugees from Poland
who wished to start new lives in the United States faced a daunting wait,
because only about 6,500 Poles were allowed in each year.

During the months following the end of the war, public opinion in
the United States strongly opposed a large influx of immigrants from
Europe. Members of some segments of U.S. society harbored preju-
dices against DPs that were grounded in stereotypes and lack of knowl-
edge about East European countries and their histories and cultures.
Public opinion at times wrongfully associated refugees, especially
intellectuals, with the communist movements in their countries of ori-
gin. Politicians and representatives of business and industry worried
that the arrival of too many immigrants would hurt the economy and
overwhelm local job markets, leading to higher unemployment. Many
Americans did not understand why refugees still living in DP camps
did not simply go home now that the war was over.

As postwar economies started to recover, however, and the need
for labor grew, countries such as Great Britain, Canada, Australia,
and several in South America began recruiting DPs. Between July 1,
1947, and December 31, 1951, the IRO was able to resettle 357,635
Polish refugees in forty-seven countries; they came from camps in all
three western occupation zones of Germany and from occupied Aus-
tria. Jadzia and Władziu discussed the possibility of going to France,

Argentina, or even Australia—which eventually accepted 60,000 Polish refugees. Their first preference was the United States.

The likelihood that they might be admitted to the United States increased in mid-1948 with the passage of the Displaced Persons Act, which allowed 202,000 DPs to come into the country over a two-year period. Congress fought bitterly over the bill, but it passed because of support by President Truman and other prominent Americans such as Eleanor Roosevelt and because the tide of public opinion was changing. Americans were beginning to accept that the United States had to play a larger part in solving Europe's refugee crisis. The act was amended in 1950, raising the nation's total quota of DPs to 400,000 by 1952.

Would-be immigrants found applying for a U.S. visa to be a ponderous task, requiring lots of paperwork, numerous documents, repeated medical exams, and a security check. Each applicant had to be sponsored by someone living in the United States who would guarantee housing and a job. One political cartoon, published in 1950, quipped that "a camel gets through the eye of a needle easier than a D.P. to the U.S.A."

~

One thing in Jadzia and Władziu's favor was that DPs who had served the U.S. Army in the labor and guard units received preferential treatment and help with their applications and screenings. As they grew increasingly serious about immigrating to the United States, the couple—like other refugees anywhere, at any time in modern history—faced the problem of lost documentation. Because of the war, they had no personal papers, no diplomas testifying to their education, no employment records, no professional certifications. And the postwar situation in Poland made getting official copies difficult, if not impossible.

Probably the most important documents they needed were birth certificates. Among my parents' old papers I found two forms printed in English, mimeographed on coarse paper now browned with age and crumbling along the edges. Each of my parents had filled out this "Affirmation in lieu of birth certificate" form and presented it to the

local IRO legal counselor. My mother's form begins with personal information that she provided about herself and the two witnesses she brought with her. The form then supplies the following words: "For the purpose of emigration I need to have a Birth Certificate. As I do not posses [sic] an original certificate and it is impossible to obtain such one at present, I would like to make a statement in accordance with the order issued. I solemnly state herewith. . . ." The blank spaces are filled in with her date and place of birth and the names of her mother and father. The form concludes: "My birth certificate has been lost during the war time. I have stated the whole and pure truth and I am prepared to repeat this statement under oath, if necessary."

Two people witnessed Jadzia's signature, stating that they could confirm the information she provided because they had known her from childhood and had known her parents as well. The form was dated November 28, 1949, and signed by the IRO legal counselor. Władziu filled out a similar form about a month later.

At first glance, I was amazed that my mother and father had each somehow found people within their circle of acquaintance in Germany who had known them for such a long time. "What were the chances of that?" I asked.

My mother looked at me as if I were crazy and then started to laugh: "These were just colleagues of ours. I had met them only after the war, and we worked together. The two witnesses your father used were his boss, Colonel Sobolta, and a co-worker from their office." The war and its aftermath demanded ingenuity in problem solving. If people needed official documentation in order to emigrate, then sympathetic authorities helped them devise means to create it, whether those means were precisely legal or not.

It was also important for refugees to document their wartime experiences, partly to demonstrate that they were victims of Nazi injustice and not collaborators. Even a hint of the latter could derail or delay emigration. This task was relatively easy for Władziu, because he had been liberated from a German prisoner-of-war camp and soon afterward began working for the U.S. Army. He also had

with him his Polish Armed Forces personal identity card, which he had been allowed to keep in the POW camp. He had the metal ID tag issued by the Germans that he wore at all times in the camp, identifying him as prisoner number 421. And soon after being freed, he received two additional ID cards, issued under the auspices of the U.S. Army, designating him an ex-POW.

Civilians were treated differently from POWs, both by their German captors and by the liberating Allied forces. Jadzia had no ID tags or cards that she could use to prove she had been in three concentration camps. It would take time before former Nazi camp records could be traced and examined—those that the Nazis had not managed to destroy in the final months of the war.

Jadzia's initial efforts at documenting her wartime imprisonment got her a certificate issued in Munich on October 15, 1948, by an organization called the Main Verification Commission for Poles Politically Persecuted by German National Socialists. The document certified the basic fact that she had been arrested in 1944 and subsequently detained in three concentration camps until April 15, 1945. The certificate said nothing about how her history was verified. I assume it was based largely on what she herself told the commission, perhaps supported by testimony from others.

A year later, Jadzia contacted the International Tracing Service to try to obtain a "Certificate of Incarceration" based on actual camp records. At first the ITS's response was disappointing. In January 1950 she received a letter stating that "no such certificate can be issued. . . . Ravensbrück and Gross-Rosen concentration camp records held by the International Tracing Service are incomplete." Not until eight months later was the ITS able to issue her a certificate—still incomplete—as proof of her imprisonment.

Jadzia would persist in trying to obtain more detailed documentation over the next decade or so, partly for personal reasons and partly in the hope that she might qualify for compensation from the German government. With time and a changing political landscape, new records surfaced and access to existing records opened up, especially

for camps that after the war lay in territory under Soviet control. This was the case for Ravensbrück. Twenty years after the date on which her initial Certificate of Incarceration was issued, she received a letter from the director of the ITS informing her that new information from the Ravensbrück prisoner entry lists (*Zugangsliste*) had been discovered that gave additional facts about her incarceration there.

~

Throughout the late 1940s, Władziu continued his work as deputy liaison director of the Polish civilian guard and labor companies, the OW. Although the U.S Army had cut the number of its civilian guard units in mid-1947, it did not completely eliminate the OW but retained a sizable number of better-trained units to guard high-security installations, airports, and the offices and residences of European Command personnel. One of Władziu's duties was to inspect these OW units periodically, which meant he traveled a lot.

As my mother recalled, "He even went to France to inspect some camps and returned with several bolts of lovely material that I had a seamstress make into dresses. I'm wearing one of these, a deep pink with a black pattern, in several of the photos your father took of me standing by the river Main in Frankfurt."

This was not the only trip Władziu took to Paris. In looking through some boxes where my mother kept her old photos, I came across two postcards my father had sent her. The first, dated September 23, 1948, shows the Eiffel Tower. On the back he wrote that he and his brother Kazek had climbed the tower and gazed down at the site where the third session of the United Nations General Assembly was meeting. He mailed the second postcard four days later: "My dearest Jadzia, I'm sending you my love from the United Nations gathering here at the Palace de Chaillot."

When I found these postcards in late 2006, my mother's eyesight and memory were beginning to fail. She no longer remembered what my father might have been doing in Paris. I was not surprised that he was there with his brother, for I knew that Kazek, too, worked for

the OW. The two had been imprisoned in the same POW camp in Murnau and continued working together after the war. As my mother explained: "Your father and Kazek were very close, and he would come visit us frequently. I liked him a lot and he was very witty. But they would sit and talk for hours in the evening, eating and drinking from this big pitcher of buttermilk, while I went to work. This is why your father gained so much weight after we were married!"

I can only speculate about why my father traveled to Paris and what role he played during this session of the UN General Assembly. Among the issues being discussed between September 23 and 29 was the transfer of the remaining assets of the now defunct UNRRA to the United Nations. Because civilian guards with the OW had served in many UNRRA-administered DP camps, perhaps my father attended as an observer and a representative of the OW. Incidentally, this was the same UN General Assembly that several months later, on December 10, adopted one of the most important documents of the twentieth century, the Universal Declaration of Human Rights.

In mid-1949, the liaison office where Władziu worked was moved yet again, this time to Frankfurt. Jadzia, luckily, got a job as a physician in the nearby suburb of Höchst. She had reenlisted on July 1 as a civilian with the U.S. Army, and worked once more for the OW, providing medical care in the thirty-bed dispensary that served all the Polish civilian guard companies in the Frankfurt area. She was also newly pregnant.

My father enjoyed photography—he had an old Leica camera and developed his own negatives—so I have many photos from this time period. One of my favorites shows my mother sitting at the microscope in the laboratory in Höchst, examining a specimen slide. Like this image, quite a few of the photos depict facets of my mother's work in the dispensary, and I wondered whether my father was trying to document her status as a physician for future reference. My mother described some of her work.

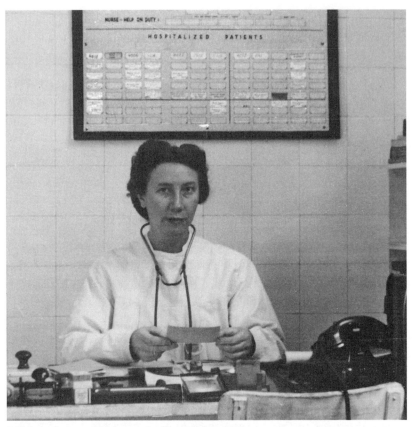

Jadzia in the camp dispensary's office; Höchst, 1949.

"I had a small office for seeing patients and another area where I kept medicines and did lab work. I'm wearing a white doctor's gown in all these photos. I would examine and treat patients and, if necessary, admit them into the dispensary. In that photo where I'm sitting at my desk, you can see the chart behind me on the wall, listing the 'hospitalized patients.'" Even though most of the young men who came to Jadzia for medical treatment were Polish, the dispensary operated under the auspices of the U.S. Army, so all formal communications, including signs, were in English.

Several other physicians worked in this dispensary: "Dr. Runcik was in charge, and when he emigrated to the United States, I took his place. I also remember another physician, Dr. Boris. We didn't have too many

seriously ill patients, but we did a lot of screening and checkups and took care of injuries. There was also a fair amount of venereal disease, which the male doctor and nurse dealt with primarily. For a while I had a medical student from Frankfurt assisting me, named Stasiu."

When Jadzia first arrived in Höchst, the army assigned her a room at a hotel. Władziu, when he wasn't traveling, had living quarters near his office in Frankfurt. The two saw each other on weekends or when he had a day off. My mother remembered the hotel well, partly because of a lovely photograph that seemed particularly special to her:

"The living quarters were quite nice, with individual rooms and a communal kitchen. On the floor where I lived there was also a living room area where everyone could gather. This is where I was sitting when your father took this photo."

The day was October 15, 1949, Jadzia's name day—considered more important in Polish culture than a birthday and celebrated traditionally by friends and family who gather for dinner and give gifts and flowers.

Jadzia surrounded by flowers on her name day; Höchst, 1949.

In this photo, Jadzia, now about five months pregnant, looks serene, surrounded by bouquets: "Yes, my friends and my patients sent them. The beautiful chrysanthemums. And all those roses. Lots of roses. I remained in this hotel until after you were born."

Jadzia continued to work for as long as she could, until she developed complications in her pregnancy. She had to spend about six weeks in a hospital because of elevated blood pressure and polynephritis, a kidney infection. When her doctors discharged her, near the end of January 1950, they gave her strict orders to rest. She was now eight months pregnant.

"Your father was at this time living in Heidelberg, which was some distance away. He had come to see me over the weekend and left on Sunday. He was going to be on the road, doing camp inspections. On Monday I went in for a checkup, and the doctor became increasingly concerned. He felt that unless my condition improved overnight, it was too dangerous to wait. He decided to schedule a Caesarean section for the next day.

"In the meantime, your father didn't know anything about this because he was traveling. His colleagues were trying to track him down but kept missing him as he went from camp to camp. I returned home and decided to take a long, warm bath. I also hand-washed my robe and hung it to dry, so I could take it with me—it was a gift from him, with a beautiful floral pattern on a maroon background."

Jadzia went into labor at eight the next morning, avoiding the scheduled surgery, and I was born that afternoon: "Maybe that warm bath helped get things started! Your father arrived after it was all over. Both you and I ended up staying in the hospital for three more weeks; you were born about four weeks premature, and I was being treated for my kidney problem."

If there were any discussions about who I should be named after, my father clearly won. I was named Barbara, after the patron saint of his artillery regiment, and Maria, after my paternal grandmother.

Several months later, my mother moved us into more suitable quarters. "The hotel where I was staying with you, which the U.S. Army had requisitioned right after the war, was now being returned to its German owners. So I had to move out. About this time, Dr. Boris (who worked with me in the dispensary) emigrated, and I took over his one-bedroom apartment. It was on the top floor of a small building, with a bathroom on the floor below that others used. There was also a small kitchenette, which was really convenient for heating bottles and making meals for you and me. The other tenants had to share a larger kitchen on the first floor. Your father was still working in another city and would come to see the two of us on the weekends."

As soon as she felt well enough, Jadzia returned to the dispensary: "We hired a German woman to take care of you, although I insisted on bathing you myself. One day when I came home unexpectedly, I discovered that she was bringing her own children over and feeding them lunch from my supplies. I wouldn't have minded, but I was upset that she didn't tell me. It was hard to leave you, but I had to work."

While going about their jobs, Jadzia and Władziu stepped up their efforts to immigrate to the United States. As head of the family, Władziu had already completed an IRO Resettlement Registration Form at the end of November 1949. Now the couple had to fill out additional forms, undergo physical exams, get smallpox vaccinations, apply for visas, and eventually arrange for transportation to Bremen, the port of embarkation. They also had to find someone who officially would agree to sponsor them.

Helping them from the U.S. side to line up a sponsor—in this case, a Polish American unknown to them but willing to help—was their friend Władysław Stefanik. He had been in the Murnau POW camp with Władziu, had worked with him in the OW, and would eventually become my godfather. He had immigrated the year before and settled in Detroit, home to a well-established Polish American community

and hosting a growing number of postwar immigrants. Assisting the DPs who were coming to the United States was the War Relief Services of the National Catholic Welfare Conference (NCWC), with offices both in Bremen, Germany, and at the point of entry in New York City.

Once the visas were granted, in early September 1950, Jadzia resigned her position at the dispensary and rejoined her husband, so they could begin their final preparations: "We had some money saved up, German marks, and I sold them for dollars. In addition, since we both worked for the U.S. Army, we got monthly allotments of certain provisions, such as cigarettes, which I was also able to sell. After buying some necessities, like two good wool blankets that I got at the army PX, we had about seven hundred dollars. This was our entire fortune, along with two wooden chests filled with books and copies of the OW newspapers (which your father refused to part with), the blankets, some clothes, and a silverware set that I had bought earlier. The money, these two chests, and you . . . that's all we had."

18

"Beginning a New Book"

🙢

"When your father and I decided to immigrate to America, we closed the book on our past. We set it aside and vowed not to look back. Whatever the future held, we would live that life. We were beginning a new book—a different life in a new country." This was a sentiment my mother often repeated.

The first chapter in this new book started sometime in late September 1950, when my parents, carrying me as an infant, passed through the gates of the IRO Embarkation Center in the northern part of the German city of Bremen. Camp Grohn, as the center was called, had originally been a German air force barracks, but the IRO had refitted and expanded it into a huge relocation camp.

Refugees slated for emigration went first to one of the IRO resettlement centers scattered throughout Germany, to fill out paperwork, apply for visas, and undergo physical exams, X-rays, laboratory tests, and vaccinations. U.S. quarantine regulations required a clean bill of health and a valid certificate of vaccination before a DP was allowed to board a ship bound for the United States. Once everything was in order, IRO staff sent the refugees on to Camp Grohn. There, men and women were housed in separate quarters until their day of departure, when trucks carried them to the seaport of Bremerhaven, about twenty-five miles to the north.

Jadzia and Władziu had taken care of all their necessary paperwork by August, in anticipation of a late September departure. "But then," my mother explained, "our plans got derailed.

"You were seven months old and had been eating soft, freshly prepared foods for a while. When we moved into the emigration camp,

however, we were told that infants had to start eating canned food, to get used to it, since that was all there would be on the ship. You ended up getting very sick with diarrhea. They kept you in the hospital for almost six weeks. And so we had to postpone our departure.

"We were allowed to see you every day. Most parents could only look through the window into the hospital ward, but because I was a physician, they let us come in. But it was still a long time to be separated as a baby, and when you finally got out of the hospital, you didn't recognize us at first. The doctor had suggested that I make a puree by boiling carrots with veal bones, to add protein. And then slowly reintroduce other food."

My mother started to laugh: "Your poor father. He had to run all over town, searching for veal bones. You really liked those carrots and would reach for the bowl to see if there were any more left."

Finally, the day of departure arrived. Drivers in army trucks took us and our fellow emigrants from the dormitories to the staging area, where we gathered with our luggage. The day was sunny but cold. My father must have been snapping photos as we waited, for years later I

Emigrants awaiting departure to the United States; Bremen, 1950. Photograph by Władysław Ryłko.

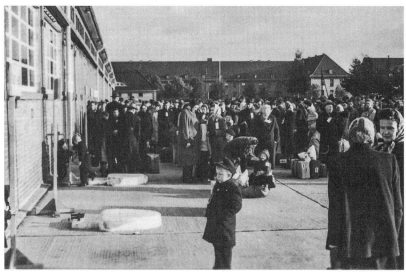

found a strip of tiny contact prints in his old briefcase. When I had them enlarged, they turned out to be views of this very scene. In the pictures, men, women, and children all wear required identity tags pinned prominently to the fronts of their coats.

The ship our family boarded was a former World War II troopship, the USNS *General W. C. Langfitt*, now part of the Naval Military Sea Transport Service. A fleet of such ships, flying the flags of various nations, carried refugees to new homes throughout the world. Nine months earlier, the *Langfitt* had transported more than a thousand Polish war refugees from transit camps in East Africa to Fremantle, Western Australia.

My mother recalled that "each person had some job to do. Your father was in charge of the ship's volunteer police force, and he slept with the other men." Because the IRO covered the cost of the voyage, it kept the size of the crew as small as possible and expected passengers to perform some shipboard duties. Women often helped in the kitchen, served meals, and cleaned cabins and communal bathrooms, while men were assigned jobs on deck and in the engine room.

The *Langfitt* left the port of Bremerhaven on November 4, 1950, heading into the North Sea and toward the English Channel. I was only ten months old, so I have no recollection of the voyage, but my mother remembered it well, especially the first few days: "Everything shook so much, we thought the ship was going to break apart!" I discovered later, from the ship's newsletter, that converging waves had tossed the ship around as it passed near the west coast of Ireland, so a lot of people were seasick on the third full day out. Thankfully, the weather turned calm and mild for the rest of the trip.

Aboard ship, men and women had separate quarters in large halls set up with hammock-like bunks. My mother, like other women with young children, enjoyed a slightly better situation than most passengers:

"Since I had you to take care of, I got a cabin, rather than having to stay in the general area with lots of other people. I shared it with a Ukrainian woman who had an eight-month-old baby, who was already starting to walk. She was surprised that you, at ten months, were not.

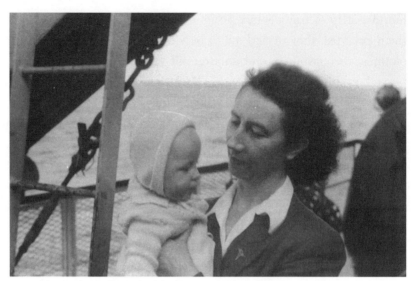

My mother and I on the deck of the ship; November 1950.

But I wasn't worried—you had plenty of time. Like us, she was traveling to Detroit. There were two beds, and you slept in the baby carriage we had bought in Germany. Since your father was very busy, I spent a lot of time walking with you all around the ship."

In a photograph my father took of my mother standing on the ship's deck with me in her arms, she is wearing a lapel pin on her jacket. On close inspection, it looks like a small silver caduceus, the winged staff with two intertwined snakes that in the United States is often associated with medicine. I wish I had noticed this detail in the picture earlier, so I could have asked my mother about it. Perhaps it was a parting gift from her American colleagues, a symbol of what she hoped for as she traveled to a new future.

∼

As the *Langfitt* sailed toward New York City, it carried 1,295 passengers, almost all of them Eastern European. Poles made up the majority, but many of the refugees came from Latvia and Russia, and smaller numbers were Yugoslavian, Lithuanian, Czechoslovakian, Estonian, Hungarian, and Romanian. The ship's crew published, in German, a

one-page, two-sided daily newsletter called the *Emigranten Neptun*, the first issue appearing on Monday, November 6. The paper supplied daily announcements, details about events happening on board, and brief summaries of world news.

My father saved his copies of the *Emigranten Neptun*—they are now yellowed with age but still in fairly good condition—so I was able to draw on them to supplement my mother's recollections of the voyage. A friend of mine who is fluent in German, Alan Bedell, met me at a favorite coffee shop, where he read through the newsletters and summarized their contents for me. They announced the daily religious services held in the officers' club, gave the schedule for the three meals served every day in the mess hall, publicized the ongoing immunizations of young children (especially against diphtheria and measles), and offered admonitions about "the importance of punctuality in work." The newsletter identified which room in the living quarters was the sloppiest and which the most orderly after each morning's inspection. Clearly, the ship's captain was not above using a bit of public shame to keep the passengers in line. Not surprisingly, the neatest compartment was often the one occupied by the ship's police. No doubt my father's military background had something to do with this.

After one sunny day, the newsletter reported that several passengers had spotted dolphins swimming near the ship and some whales in the distance; they hoped for "a repeat performance." The crew also discovered a few stowaways—birds nesting in the lifeboats. Passengers fed the birds scraps of food. Meanwhile, musically inclined passengers tried out for a concert scheduled for the sixth day at sea.

That was November 11, which must have been a painfully poignant day for the Poles on board. Until 1939, this date was a national holiday commemorating Poland's independence at the end of World War I in 1918, after 123 years of partition. When the Communists took over in 1945, they changed the date of the holiday to July 22, the day when, a year earlier, the Soviets had issued the "July Manifesto" in the eastern Polish territories just liberated by the Red Army. This political manifesto asserted the legality of the Soviet-backed

provisional government in Poland. November 11, then, was doubly symbolic for many of the passengers on board the *Langfitt*, for they believed their native country had once again lost its independence. To observe the day, an emigrating priest conducted a special church service in the early morning. According to the ship's newsletter, the service included remarks by my father "memorializing the freedom of other neighboring peoples and nations."

On the day before the anticipated arrival in the port of New York City, everyone received a souvenir issue of the *Emigranten Neptun*. It featured statements of thanks and good wishes from the ship's captain, the crew, and the escorting IRO officers. The lieutenant commander proclaimed: "Tuesday, November 14, is a day you will long remember. For most of you, it will be forfullment [sic] of a long dream: Entrance into a Land of Opportunity—a land that has absorbed thousands of your relatives and countrymen . . . A land that stands willing and able to give you all a helping hand . . . A land where you will be permitted to work at any job that you are capable of doing . . . A land that is made up of 150 Million people who came from a 1000 countries and speak a 1000 languages—yet all Americans. People—AMERICA WELCOMES YOU."

Rounding out the souvenir issue, representatives of the ethnic groups on board published messages in their respective languages. My father even wrote an article in English on the role of the "good policeman"—referring to the sixty men who had been recruited from among the passengers to help enforce ship regulations and keep passengers safe.

In searching for more about the *Langfitt*, I discovered the passenger and crew list for this voyage in the U.S. National Archives and Records Administration. My parents' names and mine are the first three listed on passenger sheet 51. When the ship arrived in New York City, an immigration inspector came on board and proceeded to check and sign each sheet before passengers were permitted to disembark. According to the records, immigration officials sent some passengers to Ellis Island instead of allowing them to leave the ship freely, owing

either to paperwork irregularities or to suspicions of infectious diseases such as tuberculosis. From 1892 to 1924, Ellis Island—located off the tip of Manhattan—served as the reception and processing center for more than twelve million immigrants hoping to enter the United States. After 1924, it became a detention and deportation center for those whose legal papers were not in order or who did not pass medical inspection.

Luckily for my family, we were healthy and had the appropriate paperwork. A representative of the organization that had assisted my parents in emigrating from Germany—the War Relief Services of the National Catholic Welfare Conference (NCWC)—met us in New York. He gave my parents money for meals and two tickets for the train that was leaving that evening for Detroit. I remember my mother relating, with humor, how shocked she was to discover that Americans ate dogs—it was not until later that she understood that "hot dogs" were a type of sausage, similar to Polish *parówki*. My parents' inland transportation expenses, including delivery of baggage, which came several days later, amounted to $100. It was not until 1954 that my parents were finally, in four installments, able to repay the NCWC.

One day, when my mother and I were looking at old photographs from our first years in the United States, I asked why she and my father had decided to settle in Detroit. We certainly had no family there. She agreed. "No, we didn't have family. But we had good friends on whom we could rely. Your godfather, Władysław Stefanik [my fictive Uncle Władek], had come a year earlier, thanks to the efforts of his friend Anka, who had worked as a nurse at the training center in Käfertal. That's where they met and became informally engaged.

"She was able to immigrate earlier because she had an aunt in Detroit. Anka then arranged a sponsor for Uncle Władek, a man named Mr. Kuźwa, who worked at one of the large bakeries in Detroit. He was both kind and resourceful and helped many new immigrants find jobs. Thanks to Władek's efforts, a relative of Kuźwa's then became our sponsor." Sadly, Uncle Władek and Anka never married, for she developed a brain tumor and died in February 1952.

My parents appreciated how difficult it could be to arrange a sponsor: "You know, they were taking a risk in helping us. Most postwar immigrants were very grateful to these sponsors. All too often, they had to sign the affidavits blindly, with very little information about the prospective newcomers." Even when the sponsor was a family member, their relatives coming from Europe were essentially strangers. Who knew what they were like, how they would adapt to their new life, whether they could find and keep a job?

When my parents applied for emigration in 1949, their sponsor, Arthur Reclaw, who did not know them at all, guaranteed both lodging and a position for Władziu as a laborer with the Ford Motor Company. Times were hard, and prospective immigrants took whatever work and housing were offered, just to get their feet in the door. Our sponsor's name and address appear on the identification card issued by the NCWC, which my father carried with him from the time we left Germany until we were settled in Detroit.

"Unfortunately," my mother continued, "before we arrived, our sponsor's wife became very ill, so they couldn't help us in the usual way." My parents never got to know the Reclaws, but they did maintain social ties with the Kuźwas.

"Since we weren't able to stay with the Reclaws, Uncle Władek managed to get a room for us in the house where he was living, on Martin Street [in southwest Detroit]. The room was right next to the kitchen. For the first few days we had nothing, because our trunks were being shipped from New York. The room did have an old mattress, but no box springs, and a makeshift board on some bricks served as our table. When we had visitors, they had to sit on the trunks that came over with us from Germany."

I interrupted my mother: "You know, I still have those wooden trunks. I think they're sitting under the stairwell to the basement of my house. They take up room, they're very musty, and I don't store anything in them any more, but somehow I can't get rid of them."

"That's good," my mother responded, "because those trunks and the two brown wool blankets I gave you are the only things remaining

from our time in Germany." Then she picked up where she had left off:

"You slept in the baby carriage, although it was getting a bit small for you. Soon after we arrived, your father and Uncle Władek went out to buy you a bed. Neither of them was very practical about such things. Sure enough, they returned carrying the most beautiful, most expensive crib, and here we were, with hardly any money. They weren't thinking. Your father also bought himself this heavy, padded, red plaid jacket. You can imagine how awful it looked—he was not a small man. I did manage to convince him, the next day, to take that jacket back! He didn't have a good sense for clothes; he didn't need to, because for most of his life he had worn a military uniform."

~

When my parents were preparing to leave Germany, my mother recalled, their American colleagues told them, "We need people like you in America, with your skills, your character. You'll have a good life there."

Like so many other immigrants, Jadzia and Władziu had an idealized vision of America and Americans. These were the people who had liberated them from the concentration and prisoner-of-war camps. The Americans whom the two had met and worked for in Germany recognized their skills, treated them with respect, admired their resilience, and offered them a chance to be gainfully employed. Among my parents' papers from the early postwar years are photographs, letters, and cards that attest to the regard shown them by their counterparts and superiors in the U.S. Army and the IRO. Their good experiences with Americans bolstered their idealized notion of the United States as a beacon of freedom, a nation of wealth and resources, and a land of opportunity.

They also looked forward to help from "Polonia," the large Polish American community they were about to join in Detroit—help in finding housing and a job for my father, who would support the family while my mother initially stayed home with me. They had every reason to expect this kind of support. During the war, Polish American

organizations, most prominently the Polish American Council (Rada Polonii Amerykańskiej), had been enthusiastic donors of money and other forms of humanitarian aid to Polish refugees throughout Europe, the Middle East, Africa, and India. The Polish American Council sent thousands of packages to Polish POWs in Germany; it donated that Polish-English dictionary my father used while he was a prisoner in Oflag VIIA.

After the war ended, the Polish American community stayed engaged, lobbying to improve conditions in Polish DP camps and promoting and assisting with the resettlement of refugees in the United States. Thanks to efforts of people such as Franciszka Dymek, director of the American Committee for the Resettlement of Polish DPs and vice-president of the Polish National Alliance, some 130,000 displaced Poles came to the United States between 1948 and 1953. My parents had even met Mrs. Dymek during her six-month stay in Europe in 1949 and 1950, when she visited Frankfurt and talked to Władziu and other leaders of the OW, the Polish civilian guards.

The reality of life in Detroit did not match my parents' expectations. They repeatedly faced disillusionment and disappointment. Although both eventually won the esteem of American neighbors and colleagues, Władziu's age—already fifty-five in 1950—and lack of a civilian profession hindered him in finding steady work at adequate wages. For a time, Jadzia's limited English and role as a mother kept her out of the work force altogether. All too often, they were just two more postwar DPs, struggling like so many others to forge a new life. It took them almost fifteen years of hard work and frugality even to approach a middle-class life in the United States.

As it turned out, Jadzia and Władziu's expectations of local support from Polonia were unrealistic, especially in a place with a strong working-class culture like Detroit. Earlier Polish immigrants, especially those who arrived between 1870 and 1914, had come to the United States largely for economic reasons and often from peasant backgrounds. They valued their heritage and Polish identity, which was shaped by recollections of pre–World War I Poland. Their primary allegiance, however, was

to the United States, and their experiences during World War II—either as soldiers in the U.S. armed forces or as civilians supporting the war effort—solidified their identity as Americans of Polish descent.

Some long-time Polish Americans viewed the postwar newcomers critically, expecting them to set aside past aspirations and social status, embrace their new country, and be grateful for whatever work they could find. As my mother recalled: "Some of the members of Polonia tended to look down on us recent immigrants. They had read things in the newspapers about the DP camps and would call us "dipisi" (dee-pee-shee)—'These dipisi,' some would say, 'they want everything to be so easy.' But it wasn't easy, not at all."

The new immigrants themselves associated the term "DP" with war-time losses and with the difficult, demeaning life in the DP camps. They resented being identified primarily by these experiences. Instead, many saw themselves as political exiles, holding out hope that the Communist government in Poland would be overthrown and they could triumphantly return home. Their identity was based on life in independent, interwar Poland and on their common wartime suffering—experiences not shared by members of Polonia, who often did not fully understand the dehumanizing ordeals that many DPs had endured.

Meanwhile, members of Polonia equally resented some new immigrants' attitudes toward them. Refugees from the educated middle and upper social classes often felt uncomfortable with the working-class lifestyle of most Polish Americans. Some newcomers decried what they saw as Polish Americans' lack of sophistication, loss of Polish language skills, idealizing of folk culture, and "Americanization." Members of Polonia did not view these features as shortcomings. And they derived a sense of pride from the community institutions they had established, such as fraternal organizations and Polish Catholic churches, thirty-two of which were built in Detroit between 1886 and 1929. These differences led to friction and conflicts between the two groups.

"Your father and I thought there would be more help getting started," said my mother, referring to their first years living in the United States. "Individual people were kind, but Polonia in general

wasn't that helpful when we first got here. I remember early on getting a call from one of the women's organizations. They had found out that I was a physician and asked if I could come and teach first aid and hygiene to the members. All voluntary. And when I asked what I was going to do with my young child, they said, 'Get a babysitter, of course.' Well, I didn't have money for a babysitter. I barely had money for food. I never did join any of these organizations because I really didn't feel I had that much in common with them."

My parents understood that America's streets were not paved with gold—indeed, their first view was the streets of New York, littered with trash. But they expected a certain standard of living in the wealthiest nation in the world. My mother remembered one of the first places she and my father looked at as a possible rental of their own, after spending a short time in the room Uncle Władek had arranged for them on Martin Street. It was a two-room apartment in a Polish American neighborhood. My mother asked where the bathroom was, and the landlady pointed toward the backyard, where a shed stood. "What bathroom?" she said. "Out there, that's where you go."

"Can you imagine!" my mother exclaimed to me. "There were out-houses, here in America, in the midst of a city like Detroit," which in 1950 was the fourth largest city in the United States.

⁓

Jadzia and Władziu soon found more suitable lodging, on Burwell Avenue in a nearby neighborhood, but it had its own drawbacks. The house was owned by a man of German descent who was divorced and took in immigrants as boarders in exchange for their cooking, cleaning, and doing laundry.

"It wasn't ideal," my mother said. "But we didn't have much choice. We had little money, and a lot of people didn't want to rent to a family with a small child. I can't remember the landlord's name, but you used to call him 'Bye-Bye.' We had the first floor, which included a living room with small dinette, one bedroom, the kitchen, and a bathroom that we had to share with him. He lived on the floor above us.

"I had to clean the entire house and do his laundry. Oh, I hated that! I would pick up his dirty clothes with a poker and put them in the sink. I also made the sandwiches he took to work, and I had to prepare dinner, which he ate with us. I barely knew how to cook. When we lived in Germany, I ate most meals in the mess hall of whatever camp I was working in at the time. I did, however, know how to make beef patties. I would mix them with an egg and bread crumbs, then fry them up with onions and serve boiled potatoes on the side. We had this day after day! A week or so after we had moved in, the owner came into the kitchen and asked if I could cook up some '*Schinken*.' 'How?' I asked him, and he replied that you just put the ham into some water and boil it. But I stuck to what I knew—beef patties.

"I did eventually learn to make a few other things. And much later I became quite a good cook, but not in those early years when we were struggling. I remember the first time we invited several couples over for a nice dinner. This was later, once we had our own house. I had never made a goose before, so I began cooking it early that day. Every time I checked, it seemed tough. I ended up baking that goose until it was completely dried out. In a panic, I called my good friend Lusia. Not only had I baked that goose for six hours, but I had left the giblets inside! She suggested I get a nice piece of veal and told me a simple way for preparing it. I put the goose in the trash and ran to the A&P, where another immigrant friend worked in the meat department. He quickly got me the right cut of meat, and thankfully, the meal turned out fine. But for years after, we would laugh about that goose.

"The landlord had an old-fashioned icebox that I didn't trust. And so in June 1951, once your father got a better-paying job, we made our first big purchase in America—we bought a General Electric refrigerator." Seven months later, Jadzia and Władziu took out a mortgage for $5,200 to buy an older wood house with a front porch and a small backyard in a mixed neighborhood of recent immigrants and second- and third-generation Polish and other ethnic Americans. It sat about

equidistant from two Catholic parishes with strong Polish American ties that offered weekly Sunday masses in Polish. The address was a reminder of the homeland they had left behind: 6115 Chopin Avenue.

This was the house in which I spent my childhood. I remember an old wringer washing machine and the big furnace in the basement that my father had to stoke with coal every morning in winter. My bed was pushed up against the wall, right near the register, where I could place my feet to get them warm. It was a spacious house with creaky wooden floors, furnished with dark, ornately carved furniture, secondhand but solid. There was a basement with two separate rooms off to the side. One served as my father's darkroom, where he developed photographs; I found it mysterious. The other was the coal bin, which always seemed spooky, even when empty.

My favorite spot was the attic, largely unfinished except for one big room that looked out over the roof and onto the street below. That was where I often played—there and in the alley out back. I was a bit of a tomboy and was always searching through other people's garbage, looking for treasures, or off in the field a block away, catching bugs or collecting earthworms. I tended to wander off in search of friends or adventures, and neighbors became familiar with the sound of my mother going up and down the nearby streets, calling, "Basiu, Basiu, where are you!" I know now that my parents struggled in those early years, but for me that light yellow house on Chopin is a place of carefree memories—a testament to my parents' success in shielding me from the worries they faced.

～

Within a few weeks of arriving in the United States, Władziu got a job as a common laborer earning fifty cents an hour, working for a carpenter of Polish descent. He unloaded trucks, cleaned toilets, did whatever odd jobs the boss assigned. In the meantime, he began taking night classes to transform the skills he had honed as an artillery officer in the Polish army—in mathematics, surveying, engineering, and topographic drawing—into proficiencies that might land him a better job in the United States. In June 1952 he completed a three-hundred-hour course

in tool design offered by the Polish-American Technical Society of Detroit. With his new certification, he hoped to find steady employment with one of the many engineering and design firms in the city and its surrounding suburbs that did contract work for the big auto companies and their subsidiaries.

Władziu's first job as a draftsman, with Alpha Engineering, lasted fourteen months. The next job involved, among other things, designing fixtures for the assembly of Boeing (B-52) aircraft wings. But after two and a half years, just before Christmas 1954, he was again laid off. This was a pattern that would repeat itself throughout his career—finding what seemed to be a good job, only to have it last a few weeks, more often a few months, or, if he got lucky, a couple of years. His abilities and performance were never in question; he was smart, had great personal discipline, and took pride in his work. Instead, the pattern of short-lived jobs reflected the seasonal and piecemeal nature of automotive contract work, his advanced age, and the vagaries of the automobile industry, to which so many businesses in Detroit—the Motor City—were linked.

Between 1955 and 1957 my father had a relatively good job, which allowed my parents to fulfill another part of the American dream: owning a new car. They bought a '57 Chevy, a silver and white two-door sedan. By the end of 1957, though, my father was once again unemployed, and during the following year he found work for only four months. Things got even worse in 1959. He took whatever he could find and ended up working at six consecutive engineering firms. A key factor operating against him was his age—by this time he was sixty-four. The frequent job searches and adjustments to new work settings, the long commutes to jobs in the suburbs, the repeated layoffs and applications for unemployment compensation—these were constant sources of stress.

I never recognized, while growing up in Detroit, how much uncertainty my parents faced. They kept their troubles hidden from me and did their best, within their means, to make my childhood safe and comfortable. Instead, I remember Sunday picnics with family

friends at sites like Belle Isle and Kensington Park, playing with the other children in our neighborhood (all of us products of the postwar baby boom), walks around the block with my father in the evening, the places he took me in his efforts to round out my education—the art museum, the library, swimming lessons at the Y, piano lessons, summer camp. And best of all, getting a small, black and white terrier when I was twelve. Jumpy was the only dog in the neighborhood that understood Polish.

Only recently, when I started looking at old papers and tax records my father had saved, did I truly begin to understand the anxiety that my parents' financial uncertainty must have created. My father kept copies of letters he sent to Poland, and in some of them he shared his feelings and concerns. He admitted to being depressed and discouraged by the loss of social status the war had brought him. His five-and-a-half-year imprisonment as a POW had taken its toll, as had the need for constant adaptation in the changing postwar climate of Germany. That he had survived these events with his intellect and spirit relatively intact he attributed partly to the good fortune of having his brother Kazek by his side and partly, later, to the support of his relatively young wife.

But hardest on him, he told family in Poland, were the demands and vagaries of life in the United States. In one letter, written to his sister and nephew in 1958 during a long spell of unemployment, he bemoaned the sporadic nature of his work. It was especially poignant for me to read the following passage (translated from the Polish):

"For the first time I am grappling with the fact that I am old (even though I feel young). But here [in the United States] you can't afford to be old. Suddenly, I am facing this stark reality. And so far, I have not been able to reconcile myself to this fact—nor dare I, for I have a daughter who is not yet 9 years old. We are alone here and must rely on ourselves. Jadzia works hard, but her earnings only cover about 1/3 of our modest home budget."

In another letter, addressed to the same sister and nephew a year earlier, he captured aspects of American culture that must have been distressing, or at least disorienting, to many immigrants: "What I want

more than anything is time. I've been here six years and each day get up at 5:30 and go to sleep at 10:30, sometimes later. Even though I struggle to keep my eyes open at work, I can't remember when last I took a nap after supper. . . . As soon as one returns from work, there is so much to do at home. . . . This lack of time means that everything is done in a hurry in America: you eat dinner quickly, sleep quickly, love quickly, and just glance at the newspaper headlines. This lack of time makes life here seem so superficial, oversimplified, without much depth. Life is difficult. Everyone is focused on himself. No one is willing to help another. Woe if you get sick, which is why Jadzia and I do everything to stay well. Most important, however, is to retain your sense of self and not get lost. . . . America demands youth and strength. My age here is a huge disadvantage; it's unacceptable. Thus, you can only imagine how hard I work not to be left behind. This takes so much effort. America has everything, and yet most people live in debt. It takes hard work to have even the basics of a good life, meaning food and housing; there is so much more here, but most people have neither the time nor the money to enjoy it."

I have no idea whether my parents talked much to others about what they had experienced during the war. Perhaps they shared their stories only with close friends over dinner or a glass of vodka. I have no doubt that memories of what my father endured as a POW and what my mother underwent in Nazi camps and on the death march haunted them from time to time. How could such things not leave a deep and indelible mark? My parents did not hide this history from me, yet I do not recall much talk about their experiences in any depth—just individual anecdotes that I overheard as I sat at the dinner table. I knew—but I didn't really know.

My parents were determined not to dwell on the past; life in America required that one look forward, that one "begin a new book." It is not so easy to escape such a past, but they never stopped trying. On February 11, 1958, Władziu and Jadzia took the emotionally painful step of renouncing their Polish citizenship and were sworn in as new citizens of the United States of America.

19

Shattered Dreams

𝒫

MY MOTHER REPEATEDLY TOLD ME that she had every intention of practicing medicine in the United States: "Your father and I truly believed that things would all work out, that I would return to my profession." She expected that her past training, practical experience, and letters of recommendation from her U.S. Army employers in Germany would make this possible. She knew her poor English was a problem, and Uncle Władek tried to help by tutoring her occasionally. But other barriers existed that she did not anticipate.

During her first ten years in Detroit, she tried various strategies for becoming a licensed physician. As a first step, she told me, "Your father and I traveled to Lansing to talk to the state medical board. I really wanted to get admitted into an internship. I knew that my Polish medical diploma would be accepted in some European countries, but I didn't realize how complicated the process was in the United States. I was told that I'd first have to take an advanced course in English and repeat a year of medical school."

Foreign-trained doctors who immigrated to the United States during and immediately after World War II faced many hurdles, and their influx generated heated debate within the American medical establishment. Some American physicians raised concerns about the quality of foreign medical schools and the competency of their graduates, about potential competition from immigrants, and about who should take responsibility for their retraining.

But supportive voices were heard as well, from doctors who believed that the skills of their colleagues from war-torn Europe

should not go to waste. The writer of a letter to the *Journal of the American Medical Association* in 1953 argued: "Since these persons are immigrants who have entered the United States legally . . . everything possible should be done to facilitate their assimilation in the medical profession. . . . Theirs is a peculiar plight. They are the victims of their fate, not the architects."

Writing in another journal, the same author decried "the obstacles that [medical licensing] boards place in the way of well qualified immigrant colleagues—colleagues, it should not be forgotten, who have undergone terrible suffering." Another physician urged his fellows "to do a little soul-searching, because in many instances the handling of these foreign physicians has been awkward and unfortunate. . . . America is still the land of opportunity. We should not forget that our own ancestors were immigrants."

During the 1950s and 1960s, the United States actually experienced a shortage of home-grown doctors, because U.S. medical school enrollment remained tightly controlled even as the number of places available in hospital-based postgraduate programs swelled. Increasingly, foreign-trained physicians filled the shortage, but they were of two different sorts. One group came largely from non-European countries on temporary visas, specifically to further their training through internships and residencies. The other group consisted of émigrés who had fled persecution in their native countries during the 1930s and 1940s and immigrants like Jadzia, displaced by World War II and unable to return to their native countries because of postwar politics. These refugee doctors faced a uniquely difficult situation. Many of them were relatively old and had been forced by the war to suspend their medical practice for years. In order to be licensed as physicians in the United States, they needed to gain proficiency in English, acquire updated knowledge and training, obtain missing documentation, and learn a new way of taking exams, all the while trying to support themselves and their families in any way possible.

Americans advocating on their behalf called for the establishment of retraining programs, for placement in settings where unlicensed DP

physicians could work temporarily under supervision while improving their English, and for the creation of courses to orient and prepare foreign doctors for U.S. medical practice. One of the most active organizations was the New York–based National Committee for Resettlement of Foreign Physicians. Its aim was to evaluate medical credentials, assist these physicians in preparing for exams and familiarizing themselves with American medical practice, and help resettle them in communities, urban or rural, where medical services were needed. Such mentoring and support was critical for immigrant doctors struggling to become licensed to practice in the United States, but it seems to have been centered in New York and surrounding northeastern states. To the best of my knowledge, no comparable services or opportunities were available to Jadzia and other refugee doctors who settled in southeastern Michigan.

~

The rules governing medical licensure varied widely from state to state and changed frequently. In 1950, foreign medical graduates from outside the United States or Canada could not even apply for licenses in fifteen states, and nineteen states required them to hold full citizenship before doing so. Over the next ten years, even more states—from twenty to twenty-six, depending on the year—imposed this requirement.

Until 1958, Michigan required foreign graduates to be U.S. citizens or to have filed a petition for naturalization—known as "second papers"—before they could apply for licensure. This petition could be submitted only after a person declared his or her intent to become a citizen and had lived in the United States for at least five years. Under these rules, Jadzia would be ineligible to apply for a medical license until 1956. In the meantime, she could do the required year of internship at an approved hospital, but only after she had met several other requirements.

State licensing boards in the 1940s and 1950s tended to assess a foreign physician's competency by the perceived quality of his or her medical education. To guide the boards in their assessments, the American Medical Association and the Association of American

Medical Colleges published, from time to time between 1950 and 1957, a list of foreign medical schools whose graduates they recommended be considered on the same basis as graduates of approved U.S. medical schools. Schools omitted from this list were not judged as inadequate; they simply were not judged at all, because insufficient information existed about them—in part because the evaluators had not visited the institutions. The list was ad hoc, incomplete, rarely updated, and biased toward places where inspectors happened to have traveled. For example, the list published in 1955 included fifty schools in fourteen countries; all but three schools were in western Europe, and none was in eastern or southern Europe. A number of states (between sixteen and twenty-one, depending on the year) recognized medical degrees only from this limited set of schools, effectively shutting out most foreign medical graduates who came to the United States between 1933 and 1952.

Luckily, Michigan was not among them. However, the state licensing board required that a foreign medical diploma be certified by the U.S. embassy in the country where the medical school was based. Jadzia had a copy of her medical diploma, acquired with her sister's help while Jadzia was still in Germany. Getting it certified in a country that was now in the Soviet bloc, though, was no easy matter. The Special Committee on Displaced Physicians of the American Medical Association tried to address the problem by repeatedly suggesting that state examining boards accept IRO certification of medical school graduation and professional status. This would have helped Jadzia, since she possessed an IRO certificate, but the committee's recommendation seems not to have been widely followed—and certainly was not in Michigan.

When Jadzia first arrived in Michigan in 1950, the state required foreign-trained doctors to repeat the fourth year of medical school. In 1952, the State Board of Registration in Medicine agreed to exempt physicians who had entered the United States before June 14, 1951, and had resided in Michigan since that time. Instead, the applicant would be interviewed and would take an hour-long oral exam given by a

screening board composed of faculty from local medical schools. The candidate's level of knowledge was expected to be comparable to that of a recent U.S. medical school graduate.

If Jadzia passed the oral exam, then she could apply to take Michigan's three-day written licensure exam, offered twice a year. Passing the written exam would allow her to apply for an internship, which was mandatory before the state would grant a license to practice. The topics in the written exam covered the basic sciences as well as a broad range of fifteen subjects in clinical practice, ranging from anatomy, histology, and embryology, to obstetrics, gynecology, surgery, and medicines and therapeutics. Five to ten questions were asked for each subject, with about twenty minutes allowed per question, so the test must have demanded a great deal of writing. For foreign physicians, taking such an exam years after graduating from medical school, usually writing in a second language, was extremely difficult, and the failure rate was high.

Jadzia decided to postpone taking the oral screening exam for a year, so she could improve her English. Then, on January 9, 1953, Władziu suffered a heart attack that put him in the hospital for ten days. The couple had no health insurance and spent more than a month's wages on medical bills. The following year, Władziu caught a severe case of flu and almost died. Under Jadzia's care, he recovered fully, but these events made her realize that her immediate concern was to find a steady job.

~

Henry Ford Hospital, which first opened its doors in 1915, was one of the largest health care facilities in the Detroit area, and during the postwar years it saw rapid growth in both patient care and clinical research. Jadzia knew several recent immigrants who worked there, and they kept her informed about job openings:

"One day Mrs. Zosia, who was a pharmacist by profession but worked in the hospital's Central Supply, called to tell me that there was an opening for a nurse's aide in the pediatrics division. I knew Ford Hospital was accepting foreigners, and I decided to immediately go and apply. I didn't tell your father about this. I just went there and

they gave me the job. The head nurse on the pediatrics floor was both pleased and surprised, and she asked me if I really was willing to do this work. She knew that I had been trained as a physician. I replied yes. I had no other choice. On May 24, 1954, I began working on the pediatrics ward."

Jadzia had accepted the lowest patient care position in the hospital. When she returned home and told Władziu that she had taken a job as a nurse's aide, he became very upset: "Your father said to me, 'I didn't marry an aide. I married Dr. Lenartowicz!' I know he really wanted me to practice medicine in the United States, but his reaction made me angry. He married me because he loved me, not because I was a doctor!"

Jadzia had not given up on pursuing licensure, but she felt that in the meantime, working on the pediatrics ward of the hospital, in any capacity, would be better than not working at all.

"I was not the only one who did this," she pointed out. "Henry Ford Hospital hired a lot of immigrants into these kinds of less-skilled positions. Many people who came here were something special in their own country but became nothing special in this new country.

"I felt that I had to work, because we needed the money. Władziu had a hard time in the 1950s and '60s because of his age. Since you were still at home and too young to go to school, we found friends who could watch you—for a small fee, of course. I'll admit, it was very difficult for me at the beginning. I would often cry as I was returning home late at night."

Jadzia worked the second shift, which meant she got home after midnight. She took a bus to the hospital in the early afternoon, while Władziu was at work, and he usually came to pick her up at the end of her shift. There were times, however, when he was sick and unable to meet her.

"I would be so nervous, waiting for that bus. I'd stand in the shadow of a doorway and hope that no one would come by. More than once, some car would slow down or stop and a man would ask me if I wanted a ride. Even the attendant at the gas station where I waited to transfer onto the second bus once asked me out for a steak dinner!"

Eventually, Jadzia got used to working as a nurse's aide. In the early years, the hospital differentiated the staff sharply by type of uniform, and Jadzia disliked the starched yellow dress with white collar and white bands around the sleeves that she had to wear. But she loved caring for the children, even though the work was physically difficult. She fed the young patients, changed the beds and linen, cleaned up messes, and wrote notes on each patient. A side benefit of the job was that her English improved.

Over time, as the nurses and doctors recognized her skills and knowledge, she won greater responsibility. Physicians would request that she be assigned their most seriously ill patients, knowing they would be well cared for. She also earned the respect of the young nursing students—the hospital had a highly regarded school of nursing—and they often worked with her. Although this growing respect did not extend to higher pay or an opportunity to improve her professional position, it did help to boost her morale.

～

After becoming a U.S. citizen in 1958, Jadzia tried again to follow the path toward medical licensure. She requested, and received by mail, another copy of her medical school diploma, this time with the original 1936 signatures authenticated by both the current dean of medicine and the current president of the Academy of Medicine in Poznań. Unfortunately, this was still insufficient.

When she wrote in mid-1959 to the American embassy in Poland, asking its staff to certify the diploma as required by the Michigan State Medical Board, she was informed that the embassy was "able to authenticate only the signatures of certain officials of the Polish Ministry of Foreign Affairs." The American consul advised her to first have an official of the appropriate ministry in Poland authenticate the diploma signatures: "The Embassy is unable to assist you in this."

This convoluted process was unfolding against the backdrop of the cold war, when correspondence between the United States and countries like Poland was difficult and mail often took a long time. Even

for residents of Poland, taking care of official business there required knowing where to go, whom to contact, and often what kind of gift to bring to grease the wheels of officialdom. One can only imagine how much harder it was to negotiate the bureaucracy from outside Poland.

In the meantime, Władziu inquired and found out that Michigan's rules for licensure were unchanged. He never stopped encouraging Jadzia to try. But with each passing year, the idea of preparing for and taking the written exam while working full-time seemed more daunting to her. In describing her efforts to me, my mother commented that pursuing medical licensing "was much easier for men than for women," by which she meant that the medical profession in the United States during the 1950s and 1960s was largely a male domain. In 1963, only 6 percent of physicians were women, and even by 1970, women made up only 10 percent of all interns and residents in the United States. Such a climate offered greater encouragement and support to men than to women who wanted medical careers. In our conversations about this issue, however, my mother never suggested that she felt discriminated against because of gender. Rather, she believed women had different and more complicated obligations—especially women with families, who had to juggle many responsibilities—and this made the pursuit of a career harder for them. She had colleagues who did succeed, but their circumstances were different:

"Several of the male doctors I worked with in Germany did eventually practice medicine here; however, one of them was single and the other worked this out somehow through the army. I also remember a young woman who assisted me in the dispensary in Germany. She had taken the first-aid course that we offered. After arriving in the United States, she was able to enroll in medical school in Ann Arbor. But she was in her early twenties and spoke English well."

My mother did have an older friend who succeeded in getting her medical license and who tried to help my mother do the same. This woman had been a radiologist in Poland and immigrated to the United States in the early 1950s. "Helena came alone, to live with her sister in Chicago. She had a close colleague, also a radiologist, who worked at a

local hospital there, and he got her a job in the X-ray department. Then she took English lessons and was somehow able to get into a radiology residency program. Once she was licensed, she continued working at this hospital."

Helena tried to arrange a job for Jadzia at the same hospital. "Władziu and I traveled to Chicago during the summer of 1960, and Helena introduced me to one of the doctors she worked with. By then my English had improved, and the doctor was quite enthusiastic about the possibility of my doing an internship there, while I prepared for the licensing exam."

This was probably Jadzia's last chance to reenter the profession she had trained for so many years earlier and still wanted so badly to practice. She had friends in Chicago who were willing to help her out, and as an intern she would receive a stipend that probably came close to the meager annual salary she earned as a nurse's aide at Henry Ford Hospital. My mother could not recall the details of Illinois's licensure requirements, but my sense is that the state had relatively flexible rules that allowed physicians who were preparing for licensure to practice in supervised situations, especially in state-run hospitals. Illinois certainly was more accepting of foreign-trained doctors than most other states; between 1946 and 1959 it placed second in the nation in the number of foreign-trained physicians it licensed.

Unfortunately for Jadzia, bureaucracy struck again: "It was my bad luck that just about this time, the rules were changing. A short time after our visit to Chicago, I found out from the doctor at that hospital that they could not offer me a position after all. In a letter Helena sent me several weeks later, she wrote that if only I had started trying to get an internship at that hospital a year or even six months earlier, it might have worked out."

Helena was right: 1960 turned out to be a pivotal year for postgraduate medical education of immigrant doctors. Several medical education and licensing organizations had been working to develop a standardized national system for evaluating foreign graduates. Together they created a new organization, the Educational Council for

Foreign Medical Graduates (ECFMG), whose function was to certify foreign physicians on the basis of their credentials and performance on a newly devised exam, the American Medical Qualification Examination. The one-day exam included an evaluation of the candidate's command of oral and written English along with four hundred multiple-choice questions covering clinical medicine, surgery, pediatrics, OB/GYN, and the basic sciences. The ECFMG administered its first exam in March 1958.

By July 1, 1960, all hospitals that wanted to maintain accreditation for their internship and residency programs had to ensure that the foreign medical graduates on their staff either had a full state license to practice, had been awarded a certificate from the ECFMG, or were in their final six months of training. Jadzia fit none of these criteria, so the hospital in Chicago was reluctant to offer her an internship in the latter part of 1960. Any physician who did not meet the criteria by December 31, 1960, was to be relieved of patient care duties until he or she became certified. It took a number of years for these regulations to be fully enforced, but because the ECFMG was located in the Chicago area, it is safe to assume that area hospitals were especially careful to meet its requirements.

On September 9, 1960, Jadzia received a letter from the assistant director of the ECFMG, confirming these policies. "Dear Dr. Rylko," it began: "Your letter of August 30 to the American Medical Association has been referred to this council for answer. The advice that you must be certified by the council after December 31, 1960 is correct. Unless the American Medical Association answered your letter separately, it is doubtful whether you could start internship now and take the April [1961] examinations, inasmuch as to our knowledge no exceptions are being made." This setback was the final straw for Jadzia, who was about to turn fifty.

Fighting back tears, my mother tried to explain to me why things did not work out: "It wasn't my fault, you know. It was just fate. I had every intention of practicing in America, and your father supported this. But I just couldn't, because of circumstances—you were still a

young child, we didn't have much money, and we had no family here that we could rely on to help us. Your father was never certain how long his job would last, and he was getting older. A lot of the immigrants who came over when we did faced similar situations. It just didn't work out for me."

Throughout much of my adult life, I thought of my mother as a victim of circumstances and of American culture's tendency to devalue the knowledge and skills that immigrants bring to the United States. As my mother once told me: "What you did in the past, your qualifications, really didn't matter here. You were an immigrant and you didn't fit, and so you took whatever work you could, because you had to survive."

I still believe there is truth in this statement, but I now understand that the reality was more complex. My mother did face a combination of barriers beyond her control—gender and age bias, nationalistic chauvinism, citizenship requirements, state licensing rules and other bureaucratic hoops to jump through, her financial status, the unfortunate timing of events such as my father's illnesses, and simply the passage of time. Few, if any, supportive services existed for helping immigrant doctors improve their English language skills, familiarize themselves with the American medical system, and prepare for the required medical exams. And in hindsight, some of the choices my mother made also undermined her efforts to gain medical licensure—for example, her early decision to postpone taking her oral exam. All these factors and undoubtedly others I know nothing about created a situation that she ultimately found insurmountable.

Looking back, I can only imagine how my mother must have struggled as an immigrant with family obligations and constraints who was still healing from the horrific experiences of World War II and the hardships of its aftermath. I do remember her telling me that there were times during the first few years in the United States when money was so scarce that she went without eating so that my father and I would have a decent meal.

In one sense, my mother's immigration to the United States—the land of opportunity—deprived her of something that even the concen-

tration camps had not taken away: her profession. But I no longer view her efforts to practice medicine in this country simply through the lens of victimhood. To think of her in this way diminishes her as a person. A woman of determination, self-discipline, and a desire to fulfill her potential, she was also a pragmatist with a strong sense of personal integrity and responsibility toward those closest to her. She was, after all, only human. She tried her best within the constraints set up not only by American society and the medical establishment but also by history, by chance, and by herself.

My mother never lost her identity as a physician. She repeatedly told me that the loss of her profession was harder for her to bear than the imprisonment and suffering she endured during the war. It was a loss she regretted for the rest of her life.

20

Returns and Departures

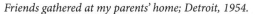

THE FIRST DECADE OF IMMIGRANT LIFE was difficult for my parents, but it was not all frustration and worries. They had friends—mostly other new immigrants, some of whom they had known in postwar Germany—and an active social life. Their circle of friends gathered in each other's backyards and they celebrated name days (*imieniny*) with sumptuous dinners. One of my clearest childhood memories is of those multi-course meals, carefully prepared, elegantly served, and enjoyed for hours, accompanied by lively conversation and anecdotes from the past. My parents also attended Polish cultural events, and in the summers someone would organize potluck picnics to take advantage of free concerts on Belle Isle, Detroit's historic island park.

Friends gathered at my parents' home; Detroit, 1954.

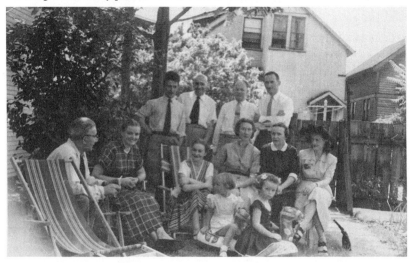

They stayed in touch with family, too, via letters that might take weeks to arrive. My father was the avid letter writer and often composed rough drafts first, some of which he saved—which is why I have copies of them. His most active correspondence was with his sisters and nephew in Poland and his brother Kazek, who had remained in Germany. My mother's letter writing was less frequent and linked to holiday and name-day greetings. In early 1958, her sister Marysia wrote urging her to come to Poland in the autumn to celebrate their parents' fiftieth wedding anniversary, but of course the trip was out of the question—the cost was prohibitive and the political situation in Poland would have created difficulties. But whenever possible, my mother sent her parents, and the sisters who lived with them, money or a box packed with prized goods such as coffee, chocolate, aspirin, vitamins, nylons, and clothing.

My father took part in a variety of social and civic organizations within the Polonia community, especially those concerned with the status of Polish Americans in U.S. society or with political actions opposing the Communist-led government in Poland. He frequently took me along to such meetings, where I invariably got into trouble, because I was not one to sit still. My mother did not participate with us. As she said later, rolling her eyes: "I was too busy earning a living, running a household, cooking, cleaning, and raising a child. I didn't have time for all this talking, talking, and more talking."

Postwar Polish immigrants also established Saturday schools, often using classrooms in neighborhood parish grade schools that were empty on the weekend, to teach their children the native tongue and culture. This was certainly my experience growing up on the southwest side of Detroit. During the week I attended the nearby public school and played with kids in my neighborhood, but on Saturdays my father drove me to St. Andrew Church for classes in Polish language, Polish history, and Polish cultural achievements, taught by immigrants who had been professional teachers in Poland before the war. We learned of heroic events in Poland's past and about the great composers, painters, writers, and scientists who never were mentioned in my public

school textbooks: Paderewski, Wyspiański, Mickiewicz and Maria Skłodowska-Curie. I belonged to the Polish scouts, went to Polish summer camp, and took Polish folk dance lessons—I even had my own Polish folk costume.

The 1950s, a largely carefree decade for me, ended on a somber note for my parents. My grandfather died unexpectedly of a heart attack in February 1959. The last time my mother had seen him was during the Christmas holidays in 1943, just a few weeks before she was arrested. She was beside herself with grief: "When I read the telegram from my sisters announcing his death, I threw on a coat and ran out the door. I just walked around for hours and hours, crying. I could not believe I would never hear from him, never see him again." Two years later, her mother died from complications of pneumonia.

A few months after my grandfather's death, the family received another setback. My father landed in the hospital with a slipped disk in his back. This incident is hazy in my mind. It must have happened during the summer, because he underwent surgery while I was at Polish scout camp. Afterward, my parents sent me directly to stay with close friends of theirs until my father recovered. "We were so lucky that I worked at Henry Ford Hospital," my mother recalled, "where the care was excellent. Whatever costs the insurance did not cover, the surgeon dismissed. Even though I was working as an aide, he honored the fact that I was a fellow physician. When Władziu returned home, we had to slip a wooden board under the mattress so he would have enough support. Thankfully, he recovered completely from the surgery."

~

The 1960s began on a more upbeat note. In February 1960, my father turned sixty-five and was able to start drawing Social Security checks, even as he continued to work on a seasonal basis. Social Security supplemented my parents' income, especially during times when my father was laid off. Their overall earnings also improved, and they were able to boost their savings while paying off the mortgage on the house on Chopin Avenue. My mother was the financial wizard of the pair: "I

would deposit something into the bank account from each paycheck when I cashed it, regardless of what expenses we had for that month. And then I just made ends meet."

Many of my parents' friends had recently moved from the southwest side of Detroit to the northeast part of the city, into neighborhoods of newer brick bungalows with freestanding garages. The engineering firm where my father had finally found steady seasonal employment was located in the northeast suburbs, so a move there would be advantageous for him as well.

This dream came true in the summer of 1964. My parents sold their forty-five-year-old wooden house and bought a three-bedroom red brick ranch house with white trim and a fenced yard that my dog, Jumpy, laid claim to by promptly digging up flowers and shrubs. Soon afterward, a new olive-green Dodge Coronet stood parked in the one-car garage. I thought it was ugly, but I was fourteen, more interested in sports cars and the cute guys who drove them.

Our new house had a contemporary look, having been built in 1952. Although it measured only a thousand square feet, to me it seemed like a palace. My mother took a week off from work to give the interior a fresh coat of paint, and at Hudson's department store she bought new wool carpeting, elegant drapes, and Danish-modern furniture in burnt orange and browns. My bedroom was a soft green that went well with the blond wood bed, dresser, and desk that were delivered right before the new school semester started. And much to my delight, the following spring we got our first television, in RCA color. As far as I was concerned, we had made it in America.

In a letter penned in mid-October to family members in Poland and elsewhere, with whom he carried on a steady correspondence, my father wrote that we were very happy with our new home. He ended on a hopeful note: "We manage to keep our spirits up. We continue to believe that despite the chaos of the past, the world is slowly heading toward a better future. And I am equally convinced that somehow we will come together and see each other again." Three years later, that last hope was realized.

On July 7, 1967, my parents and I landed at Okęcie Airport in Warsaw. I was seventeen, excited, distracted by all the new sights and sounds, and not really attuned to the profoundly emotional moment my parents were experiencing. Almost twenty-eight years had passed since my father last walked on Polish soil, and twenty-three years for my mother. Both had lost their parents during that time, but siblings and other relatives eagerly awaited our arrival, greeting us traditionally with armfuls of flowers. My father must have been anxious about how the Polish authorities would receive him, especially given his past career as a military officer. All three of us were considered Polish citizens as soon as the plane landed, because Poland (then and now) did not recognize foreign or dual citizenship if a person was born either in that country or elsewhere to Polish parents. Some difficulties did arise at the airport, according to my mother, at the end of the trip: "When we were leaving, they took our passports and made us wait for quite a while. But finally, we were allowed to board the plane back to America."

The six-week trip went by fast as we combined sightseeing with family reunions. My father had grown up in the mountainous region of southern Poland, so we paid visits to towns where his family members still lived. We explored the resort town of Zakopane; toured the famous Wieliczka salt mine, one of the oldest in the world; and took a side trip to the revered shrine of Matka Boska Częstochowska—the Black Madonna.

We spent several days with my godfather's family in beautiful Kraków, where we visited the centuries-old Wawel royal castle and bought handcrafted folk art in the Renaissance-era Cloth Hall, which fronted the main Old Town market square. For years afterward, my mother decorated the walls of her home with items purchased during this and later visits to the city: intricately carved wooden plates, woven kilims, and colorful paper cutouts of folk motifs, known as *wycinanki*.

We also visited the site of the Auschwitz-Birkenau concentration camp. I recall little about that visit, though I have been back several times since. I can only imagine how difficult it must have been for my mother to enter the same gates that her sister Marysia had passed

through, to see the barbed wire fences and tall guard towers, and to view the exhibits of confiscated shoes, eyeglasses, suitcases, and piles of shorn hair. How did she deal with the flood of terrible memories that the sight of these artifacts must have released?

About midway into the trip, another set of worries distracted my parents as they learned bits of information about what would turn out to be one of the worst riots in U.S. history. The urban uprising in Detroit began on July 23 and ended five days later with forty-three people dead and more than a thousand injured. An after-hours police raid on an illegal drinking club in a black neighborhood sparked the riots, but they were fueled by long-standing grievances over police brutality, lack of affordable housing, job discrimination, racism, and poverty.

State police and troops were called in, and the images we saw, forty-five hundred miles away, made Detroit look like a war zone. It appeared that the area where we now lived was not directly affected (it wasn't), but it was difficult to get accurate information—in Communist Poland you could not simply pick up a telephone and dial a friend in Detroit to find out what was happening. The riots and their aftermath remained topics of conversation as we continued our trip.

Both my parents had family or friends in Warsaw. My memories of the Polish capital include walking through the narrow streets of beautiful, historic Old Town (leveled by the Nazis and meticulously rebuilt after the war), near the home of my father's daughter Marysia, from his previous marriage. We enjoyed a free Chopin concert in the Łazienki Park and visited the composer's birthplace in Żelazowa Wola, thirty miles west of Warsaw.

My memories of Łódź, on the other hand, revolve mainly around visits to my mother's family. We had much to see and many people to get to know in such a short time. My mother's sister Zosia had come with her husband from Romania, and we all attended their daughter's wedding. The other sisters—Marysia and Basia, who were single, and Halina, with her children—had remained on the family's old country estate after the death of their parents, eking out a living partly by farming the land. Their lives were hard, and it pained my mother to see

how much they had aged. Over the years, she sometimes got impatient and judgmental about her sisters, criticizing them for not being more resourceful; but then she would remember that life in Poland was difficult, and her sisters had endured a lot. She continued to help by regularly sending them packages and depositing money into their bank accounts.

Near the end of our stay, we accompanied my father's family to the coast of the Baltic Sea, in northern Poland, where we spent time on the beach and explored nearby historic towns. One of my favorite photos from that trip is a shot of my parents and me standing in front of Neptune's Fountain, in the center of the Long Market in the old town section of Gdańsk. Thirteen years later, that city's Lenin Shipyards would become the birthplace of Solidarność (Solidarity), the trade union and political movement that precipitated the downfall of Communism in Poland.

My parents and I in front of Neptune's Fountain; Gdańsk, 1967.

On August 15, we boarded a plane back to the United States. Writing to an acquaintance several months later, my father reflected on his return to the place where he had left so much of himself, after an absence of almost thirty years: "I feel as if, after a long period of troubles and hardships, I had submerged myself in a refreshing, reviving, and rejuvenating bath. What can I say about our trip to Poland? Only one thing: It was splendid from start to finish."

I am sure my mother felt similarly, but unlike my father, she did not write drafts of her letters, and so I have no paper trail of her thoughts and impressions. Nor was I around the house to hear her musings, for just a few weeks after our return, I left to begin my freshman year at the University of Michigan.

~

The memory of this momentous trip sustained my parents over the next year as they faced one distressing event after another. They had been planning a family vacation to Florida to visit my mother's friends from the early postwar years in Germany, Lola and Janek Krzeminski. Then, sometime in April 1968, as I was finishing my first year of college, my father had a stroke. Luckily, it was a mild one. He recovered fully and was able to resume working, but this blow to his health aged him visibly. He had always stood ramrod straight and walked like the soldier he was; now his gait was slower, he stooped slightly, and his brow looked more furrowed. The trip to Florida was indefinitely postponed.

Soon afterward, my father suffered two additional shocks: the death from cancer of his beloved brother Kazek, who had remained in Germany, and a month later the unexpected death of his sister, Bronia, who lived in Poland. Being so far away, he felt helpless. He had been close to both of them, and they had corresponded regularly. Their deaths deeply affected both my parents.

Less than a year later, misfortune struck again, and this time I, too, felt its full impact. I had just finished my sophomore year of college and moved back home for the summer. Early on a Tuesday morning, May 6, 1969, my mother and I received a phone call informing us that my

father was dead. He had left for work early that day and was alone at Premier Engineering when he had a massive stroke. He died instantly. My mother was in shock, so I stepped in to make the necessary funeral arrangements, with the help of close family friends. Three days later we buried my father under a maple tree at Mount Olivet Cemetery in Detroit, just three miles from our home.

He was seventy-four years old when he died; my mother was fifty-eight, and I was just nineteen. I grew up that summer, and I think it was about then that I began to understand how strong a person my mother truly was. Adding to her stress was the fact that with my father's death, our financial situation took a dramatic turn for the worse—now it was she alone earning a steady income. She was determined, however, that I return to Ann Arbor that fall, no matter what. I managed to save enough money from my summer job at least to pay for textbooks and minor expenses.

I had a close relationship with my father. He was someone I could talk to, and he spent a lot of time with me throughout my childhood. Granted, he had more free time than my mother, partly because he was periodically laid off from work, whereas my mother was always overworked. My relationship with my mother was close, too, but also stormy at times, as is often the case between young daughters and their mothers. We were cut from the same cloth—neither of us liked being told what to do—and I got told a lot.

During that summer, I worked through my grief by spending time each day at my father's gravesite, often in the company of my dog. I brought fresh flowers from the garden and sat for a while under that maple tree, sometimes talking to my father, sometimes just taking in the silence. By the end of August, I was ready to go back to college—not really thinking much about leaving my mother alone, with her grief still fresh.

Just recently, I came across a packet of photos and old family letters sent to me by my father's nephew many years ago. I had stuck them in a box, put them in the attic, and forgotten about them. Among the papers, I discovered a note that my Uncle Józek, another

of my father's brothers, had sent to this nephew just a month after my father's death. He had copied, verbatim, the letter (written in Polish) that my mother had sent him in early June 1969.

"Dear Józek and family: It is my sad duty to inform you of Władziu's death. He died suddenly on May 6 at 7:20 in the morning, at the office where he worked. He was taken from us at a time when we least expected it. During our life in America he almost died on four separate occasions, and each time it was possible to save him—unfortunately, it was not to be this fifth time. As he left home that morning, he bade me goodbye, as usual, and when I asked how he was feeling, he answered 'fine'—this was his last word. . . . The funeral was modest, reflecting the modesty and hard work that characterized his life. Józek, everyone and everything wept with us, even the sky. I miss him wherever I turn—I simply cannot resign myself to this loss. . . . Please inform the rest of his family about this tragic fact—I apologize for placing this burden upon you, but I do not have the energy to write, this is all so painful for me."

~

The following summer, my mother and I returned to Poland for a month-long visit. Looking back, it is clear that my mother's ties to her native country and to family there became even stronger after my father's death. She made six more trips to Poland over the next thirty years, four of them on her own. Her last solo trip was in 1994, when she was eighty-four. Polish traditions also seemed to take on greater meaning for her. I came to realize that Easter Sunday and Christmas Eve were holidays I could never miss—she celebrated them in the same way as the family in Poland did.

The Christmas Eve, or Wigilia, dinner was especially significant—it linked my mother to the culture of her heart and soul. Joining us on Wigilia were usually my godfather—Uncle Władek, and our close friends the Krogulskis; later, my husband's parents often came, too. This multicourse meatless feast began with the sharing of a special, blessed wafer, the *opłatek*. The traditional Polish dishes were labor-intensive but

delicious: gefilte fish (a fishloaf in aspic), *barszcz* (beet soup), pierogi (dumplings filled with potatoes and cheese), sauerkraut, and for dessert *piernik* (honey spice cake) and *makowiec* (poppy seed cake). For many years, my mother made the entire meal. Only when her eyesight began to fail, at the age of ninety-six, did my son, John, and I step in, first to assist and eventually to take over.

These traditions were important to me, as well, but they carried a much greater meaning for my mother. Even after spending half a century in the United States—having mastered English (with a heavy accent), grasped the principles of American consumer culture, and (with my father) achieved a modest version of the American dream—my mother never really felt American. Her apparently successful assimilation was only superficial, and she would comment on facets of American culture that she never got used to: the informality, the casual familiarity of social relationships, the fast pace of life, the overreliance on credit. She had a deep appreciation for the freedoms she enjoyed and no illusions about returning to Poland, but she never quite felt she belonged.

As my mother adjusted to widowhood, her independent spirit manifested itself in many ways. Once an appropriate length of time had passed, suitors began to appear—my mother was, after all, still relatively young for a widow, attractive, witty, and known to be a wonderful cook. Several Polish bachelors from their circle of friends came calling with flowers or bottles of cognac in hand. She was uninterested: "There was only one man in my life, and no one could live up to him. Anyway," she would say with a grin, "why would I want to start washing dirty socks and underwear and ironing shirts again, for some other guy?"

My mother had never learned to drive. My parents could afford only one automobile, and she usually was able to get around on her own. She could take a bus to Henry Ford Hospital and downtown for shopping, and she could walk to the nearby bank, deli, and bakery or simply wait until my father was able to drive her. After his death, she discovered how much she had relied on him. She was uncomfortable taking a bus from work and coming home to an empty house late at night. My father had normally picked her up when she got off work at

11:30 or waited for her at the bus stop near our home. Now, she either had to walk alone down dark streets or ask others for a ride.

As my mother repeatedly told me over the years: "I never liked being dependent on the kindness of others. I wanted to be self-reliant, to take care of everything myself." And so she enrolled in a driver's training program. On Sunday mornings, the husband of one of her closest friends would take her out to the shopping mall to practice in the empty parking lot. Years later, once she was driving regularly, we would laugh about some of the close calls they had. At the age of sixty, my mother got her first driver's license and mustered up the courage to take on Detroit's busy traffic.

Another reason for her learning to drive might have been that I became engaged late in 1970. I had met Daniel Bauer early that fall semester, after my father died. We were lab partners in a course in microbiology, which was my major at the University of Michigan. Dan was a senior and hoped to become a doctor. By the time we married, shortly after I graduated in May 1971, he was starting his second year of medical school. My mother must have recognized early on that I was not going to be returning home after college, so she was very motivated to learn to drive. Three years later, Dan graduated from medical school, and we moved from Ann Arbor to Lexington, where he began a surgical residency at the University of Kentucky. My mother felt happy and proud for us but also saddened at the distance now separating her from the only family she had in the United States.

~

By 1975, as my mother approached the age of sixty-five, she was still working at Henry Ford Hospital. Her supervisors urged her to stay on for at least a few more years, but she was tiring of the hard work and the long hours—leaving home at 1:30 in the afternoon and not returning until after midnight. And there were some frightening moments:

"Once, as I was driving up Woodward Avenue after work, a car side-swiped me. Then the driver pulled over as the light was turning yellow, and he gestured for me to do the same. I was so scared that I put my

foot down on the accelerator and ran the red light. Another time, my car stalled just as I was crossing the railroad tracks—and a train was coming in the distance! No one got out to help me. I really thought this was going to be the end. Finally, the car started and I was able to move it just enough so that I was off the tracks. I thought about all these things and finally decided it was time for me to leave." On December 2, 1975, she retired from Henry Ford Hospital, having worked there as a nurse's aide for more than twenty-one years.

She had many plans for that first year of retirement, hoping to get work done around the house and travel more, both to Poland and to visit friends in other parts of the United States. Two months into her retirement, these plans were derailed when she had a serious accident. She had just dropped her car off at a gas station on a rainy February morning for repairs and an oil change. As she stood at the curb waiting for a bus, a young man backed out of the parking lot too quickly, knocked her down, and ran over her arm with his pickup. Months later, she would still wake up at night in terror, reliving the moment when she lay underneath that truck. Her broken right collarbone healed fairly quickly, but her badly fractured left arm needed further treatment.

This was one time when her independent spirit served her poorly, for at first she forbade others to inform me of the accident. After several days, her closest friend, Lusia Krogulski, rebelled, recognizing that my mother could never manage on her own with two non-functioning arms. When she called me, I immediately drove to Detroit, had my mother discharged from the hospital, and brought her back to Lexington, where she underwent surgery. Dan and I had a two-bedroom apartment, and she stayed with us for several months, until she recovered. By the following summer, she was able to travel to Poland on her own again.

In 1980, my mother was delighted to learn that Dan and I were returning to Michigan. He had completed his postgraduate training in urology and found a position in Grand Rapids, two hours northwest of Detroit. By this time, many of my mother's friends had retired and were beginning to move away to be closer to children and grandchildren. She

loved her house and had no desire to leave, but with time she began to reconsider. Her closest friends were relocating to Ohio, and her neighborhood was becoming increasingly dangerous, with a rise in burglary attempts, including one at her home. In August 1984, she reluctantly sold her house and moved into an apartment complex in Grand Rapids, about a mile and a half from our home.

Fifteen months later she was glad of her move, for her one and only grandchild, John Michael, was born in November 1985. My mother spent many hours taking care of and playing with him. At the age of seventy-eight, she would crawl around the floor on all fours with three-year-old Johnny on her back crying, "Faster, horsey, faster." We took her along on our yearly vacations in Michigan's Upper Peninsula, and the two of them would walk for hours down our gravel road or on the beach beside Lake Michigan.

As John grew older, he and his grandmother remained close. Her apartment was filled with his yearly school photos, and she always remembered birthdays and special holidays. She instilled in him an appreciation for tradition, good cooking, and the lessons of history—if not by teaching, then by example. He kept her young.

There were other reasons for celebrating in 1985. My mother had always stressed the importance of education and often told me, "A woman needs to have a profession or career that she can fall back on." She had been supportive when, nine years earlier, I had decided to go to graduate school in anthropology. Now she was delighted when at last I completed my doctoral degree in the spring of 1985. A month later, we both boarded a plane for Poland. It had been six years since her last visit, and fifteen years since mine.

This was an interesting time to visit Poland, for big changes were in the wind. The Communist government had imposed martial law in December 1981, in response to growing political opposition and pro-democracy movements, most notably the trade union organization Solidarność. Martial law was lifted in 1983, but many restrictions on civil liberties remained two years later, and food shortages were so severe that even staples like flour, sugar, and butter were rationed. I

remember this well, because I was three months pregnant and worried about eating enough without burdening our relatives. But they were generous with their food, as always, and we had a warm and joyous reunion—if sometimes tinged with sadness over the absence of my father. We even had the opportunity to visit several sites linked to Solidarność, especially the church where activist priest Father Jerzy Popiełuszko had preached his sermons against the Communist regime before being murdered by the state security police. The church grounds were an oasis of protest, with masses of flowers and banners in support of freedom and in memory of the martyred priest. Just a few years later, Poland's peaceful movement of resistance and protest would inspire anti-Communist revolutions throughout Eastern Europe, eventually leading to the dissolution of the Soviet Union.

21

One Hundred Years

MY MOTHER MADE HER LAST TRIP TO POLAND in the summer of 2001, when she was ninety years old, with me at her side. We had talked intently over the previous twelve months about her past, and she was becoming increasingly comfortable with the notion that I might write a book about her life. Our discussions had stirred not just painful memories but also happy ones. During our stay with family, first in Warsaw and then in Łódź, I was pleasantly surprised to hear my mother ask family members about times before and during the war, which led some of them to bring out photos or documents that we were able to take back with us.

The most memorable event on this trip was our visit to the former Anna Maria Hospital, where my mother had been a pediatric resident at the start of World War II. On our first day in Łódź, after a satiating late lunch, my mother said she would like to see the hospital, now renamed after the Jewish pedagogue Janusz Korczak. On our way there, I wondered aloud if we might detour and find the street, Zawiszy Czarnego, where her parents had lived before the war. The streets in this older part of town were not laid out on a neat grid, and it took some searching, but we finally found it. Cousin Czarek parked the car, and we started walking along the sidewalk—it was a chilly, gloomy late afternoon, a light drizzle in the air. My mother remembered the apartment as a two-story red brick building, but the only structures on this street were covered with dingy yellow-gold stucco, stained with age.

Suddenly she stopped and cried out, "There it is! There's the balcony that was off my parents' bedroom." She turned toward us with a broad

smile: "I remember how one night, when my parents had gone to bed and left the window open, a burglar climbed up onto that balcony over there. They were fast asleep and didn't hear him come through that very window. He stole my father's good suit, which was draped across the nearby chair, leaving him with just an old pair of pants!" Sure enough, as we approached the building, we could see a set of four windows on each floor, with a small balcony attached to the outermost ones.

My mother pointed to the window farthest from us: "That was where my father saw his patients," she said with growing excitement. "The two middle windows were where he had his waiting room and a spare room that he hoped I would use to set up a practice, once I finished my residency." She paused, trying to recollect those times. "Oh yes, a barber lived above us, and the ground floor had a store where my mother sometimes shopped."

From the apartment building, we drove on to the hospital, which my mother recognized immediately. I expected her to become emotional, perhaps even start crying—so much time had passed since that moment in 1940 when she was dismissed from her post at Anna Maria—the moment, in retrospect, when her dream of becoming a pediatrician ended. Yet she was composed as we got out of the car. As we approached the main entrance, she remarked that this building, which a sign identified as Pavilion II, was where she and other female house officers had lived on the second floor.

The administrative staff on duty grew excited when we told them that my mother had worked at the hospital so many years before. The personnel director led us on a tour of the pavilions and introduced my mother to some of the nurses and physicians. Most of them were eager to talk to her, even if only briefly. Everyone we met seemed dedicated not only to the care of their young patients but also to the historical legacy of this unique institution—a legacy linked to the city's history of industrial and social development. As we walked through several of the buildings and around the grounds, my mother recognized features and shared anecdotes that came to mind. As the tour ended, our guide asked if we could come back the next morning to meet the hospital director.

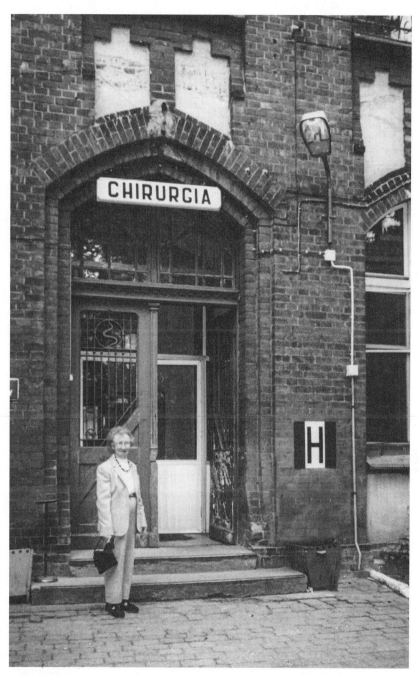

Jadzia by the surgical pavilion of the former Anna Maria (now Janusz Korczak) Hospital; Łódź, 2001. Photograph by Barbara Rylko-Bauer.

My mother expressed mixed feelings as we headed back to my cousin's apartment: "It was good to return after so many years, and they treated us so warmly," she said. Then she added with a note of sadness, "I remember the hospital as being very modern and with an open feel to it. But so much has changed, and it doesn't seem like that now."

When she was a young resident, many of the pavilions were new, and the hospital was considered innovative. Now, sixty years later, although the hospital was sparklingly clean, parts of it looked outdated, with old-fashioned radiators, metal side tables and beds, and green tiled walls evoking a bygone era. A lack of funds, coupled with constraints on how such a historic structure might be altered, had delayed needed renovations and installation of newer technology.

The next morning, the director of medical affairs and the director-in-chief welcomed us and produced some old photographs and a record book from the 1930s to show my mother. They also presented her with a framed poster commemorating the hospital's ninetieth anniversary and invited us to come back that afternoon to meet with a historian who had produced a documentary about the hospital.

Upon our return, we were surprised at the reception. A third hospital director had joined the other two, along with the historian and members of the press—a photographer, a journalist from Radio Łódź, and a reporter from the daily paper *Dziennik Łódzki*. My mother was a bit overwhelmed at first but quickly relaxed as she began to look at a book of old photographs of the hospital that the historian had brought with him. I was able to audiotape the entire interview, which lasted about forty minutes. My mother answered questions, shared recollections of what the hospital had looked like and the kind of work she did there, and talked about some of the staff to whom she was especially close—information that was invaluable to me when I began to write this book. Near the end of the interview, unexpectedly, she plunged into a concise summary of her wartime experiences after her arrest, while everyone sat quietly, listening and nodding. This was Poland, this was Łódź, and they had heard many such stories over the years, each one different, each with its own tragic twists.

On the day we left to travel back to Warsaw, an article appeared in the "People" section of the Łódź daily newspaper, titled "The Hospital of Her Memories." With it ran a picture of my mother looking at the book of historical photos: "This is the oldest Polish pediatric hospital, established on May 16, 1905 . . . Mrs. Lenartowicz-Ryłko is its oldest living physician, having worked there during the 1930s." The half-page article went on to describe some of her history and impressions of the hospital and ended by quoting my mother: "My heart has always remained in Łódź."

∼

The trip to Poland was a turning point for this writing project. My mother began to believe that perhaps her story did have broader meaning and value. As I wrote up some of our material for conferences and academic publications, she gained a greater appreciation and respect for what I was trying to achieve. She could see how her story fit into the broader context of the Nazi occupation in Poland, the political economy of Nazi slave labor, and the realities of immigrant life in the United States. By the time I started writing this book, she was strongly supportive. Sometimes, when I called to tell her about my day, she would ask, "And what about the book? Shouldn't you be writing rather than spending time doing all these other things? You'll never get it done this way." I had to smile—this had become a joint project.

At ninety, my mother had good reason to want me to hurry up and "get it done." She felt the same way about another project of ours: an attempt to have her awarded a war reparation payment. In March 2001, before our trip to Poland, I had helped her submit a claim to the German Forced Labor Compensation Programme, set up a year earlier by the German Foundation Act. Both my parents had applied repeatedly between 1949 (while they were still in Germany) and 1958 to try to obtain reparations from the German government for pain and suffering caused by their respective imprisonments. Their efforts came to nothing. Decades later, another opportunity arose when a growing number of class-action lawsuits filed in the United States led German industries to agree to a compensation program. Half the funds came from the Ger-

man government and half from more than six thousand German companies complicit in Nazi-era slave labor.

Because my mother had documentation proving she was a survivor of forced labor in Nazi concentration camps, her claim was accepted. The first check, for $3,737.29, came in August 2002. The second one, for $4,899.97, arrived in 2005, a few months before she turned ninety-five.

"One could die waiting for this so-called compensation," my mother remarked at one point, shaking her head. Her expression turned serious and her voice took on an edge: "After everything I went through, I deserve whatever I get, but this payment is only symbolic. No amount of money can ever erase the memories, the pain, the suffering." My mother spent most of this money, but she set aside a thousand dollars in a special folder that she refused to touch, putting it in a safe deposit box that we shared at the bank. I inherited this remaining money but have yet to decide on the most appropriate way to spend it, given its history.

Helping my mother apply for compensation was one small way in which I could acknowledge the debt I owed her for sharing her life story. Another opportunity came several years later, when my mother had the satisfaction of reading about her wartime experiences in a scholarly anthropological publication. My colleague Alisse Waterston and I had written an article on our research with our respective parents, embedding their individual family narratives in a broader, shared history. Alisse's father, Miguel—then living in Puerto Rico, having changed his name from Mendel—was a Polish Jew who had left Poland well before the war, although other family members perished in the Holocaust. A composite photograph of my mother and Miguel, created from two daughter-parent photos, appeared on the cover of the August 2006 issue of *American Ethnologist*. My mother was thrilled, although she wondered aloud why she had to share the limelight "with this old guy!"

⁓

The last decade of my mother's life saw her increasingly constrained by age, but true to character, she did not give in easily. Well into her nineties she maintained her trim figure by taking daily walks of one to two

miles around the neighborhood. With her usual sense of humor, she would quip: "I learned to walk on that trek across the Reich."

Although her general health remained excellent, she began to be bothered by episodes of asthma—brought on the first time, in 2003, by her honoring a Polish Christmas tradition. My mother always insisted on putting up a real Christmas tree and would take it down, with my help, on the day after the Feast of the Three Kings, January 6. That year she decided to take the tree down herself, hacking up the dry, dusty branches with hedge clippers, stuffing the pieces into a plastic bag, and hauling it to the nearby dumpster. That evening I rushed her, coughing and wheezing, to the emergency room. As each new person—the intern, the nurse, the technician, the doctor—came in and asked, "What brings you here today?" I recounted the story, and soon they were chuckling as they looked at this petite woman in her nineties, now resting comfortably with an oxygen mask.

A more serious limitation was her eyesight. She had macular degeneration as well as cataracts, conditions common among those lucky enough to reach their nineties. We paid frequent visits to the ophthalmologist, who seemed to have a special regard for my mother—especially after one appointment, when he had just delivered the good news that her vision was stable and started to leave the room. I could see the relief on her face. Suddenly she said, in her thickly accented English:

"I want to live some more, Doctor. You know, I survived the concentration camps."

He stopped in his tracks—this was not an exit line he could ignore. He, too, was of Eastern European descent, as well as Jewish. He turned around, came back in, and for the next few minutes talked about his own loss of family members to the Holocaust.

I have him to thank for convincing my mother to give up driving—at the age of ninety-five. She was proud of her teal-green 1996 Dodge Neon and came over to our house at least once a week to wash it in our driveway, grabbing an apron from the kitchen and a bucket from our basement. When she was finished, she would call out, "I'm leaving!" and soon we would hear her pull out onto the busy street, gunning the

engine so that within a few seconds she was up to the speed limit of forty-five miles per hour. Even after the eye doctor informed her that her vision was too impaired for safe driving, she held onto that car for another six months, hoping some miracle would happen. She finally sold it in May 2006—with an odometer reading of 5,488 miles.

~

Unfortunately, macular degeneration continued to take its toll, and my mother began to have difficulty reading—a development that would seriously diminish her sense of well-being. Books were a central part of her life, and I often stopped at the library to pick up a pile of mysteries, biographies, or historical novels for her. She progressed from large print to using specially lit magnifiers, until finally she had to give up this activity that she so cherished and that helped exercise her mind. Books on tape were not an option, because she was also hard of hearing and her English was weak from lack of use. She and I always spoke in Polish, and it seemed unnatural for me to interact with her in English.

The inability to read narrowed her life, but at ninety-six my mother still lived on her own in her two-bedroom apartment and cooked full meals, usually from scratch. Yet cooking—especially on a gas stove—was becoming dangerous. My husband and I bought devices for her that would automatically shut themselves off, such as an electric kettle and an egg boiler, which helped with breakfast and lunch. Dinners, though, had to be brought in, and I found myself spending more and more time taking care of things that until recently my mother had managed on her own. Still, she continued to walk daily and luckily knew the route around her apartment complex well enough that she never tripped or fell. "I have to walk," she would tell me when I tried to warn her to be careful. "I have to keep myself fit so that I can live a little bit longer on this earth."

Eventually, Dan and I came reluctantly to the realization that my mother was showing signs of progressive dementia. Her increasing tendency to speak in her native language, often without realizing it, was just one symptom. Independent living no longer seemed feasible.

Shortly after her ninety-seventh birthday, my mother left her apartment and moved into a spacious room in a local assisted living facility, a small, beautifully landscaped place with a lake, duck ponds, and an intimate atmosphere. This was not her choice—it took all our persuasive powers to get her to agree.

The next twelve months were awful. My mother was upset, unhappy, resentful about the move, and anxious over her loss of faculties, of which she was well aware. She knew her memory was going, and she could no longer remember my father. The hardest thing for her to accept was her loss of independence. She had too much pride to show her feelings to the staff—people who were essentially strangers—and always tried to be charming and gracious to them. I bore the brunt of her anger and frustration.

At first, naively hoping to make the transition a bit easier, Dan and I asked my mother's pastor, Father Jim Chelich, to come and bless her new apartment. The two respected and admired each other, and with an East European family background of his own, Father Jim was well aware of that region's history and understood what my mother had endured. My hope was that an affirming ritual would help her feel more comfortable in her new surroundings.

When he first arrived, Father Jim sprinkled her doorway with a branch from a fir tree dipped in holy water and then took his pen and made a cross above the door, with alpha and omega on either side, to keep her safe and at peace. As we sat down for tea and cake, he complimented her on the lovely, peaceful setting visible from her three big windows. My mother put down her teacup, looked straight at him, and said in English: "If you think this is so great, why don't you move in and I'll go live in your apartment!"

The next year, my mother moved into the building next door, which had a higher ratio of staff specially trained to care for people with early dementia. Another benefit was that one of the aides came from Poland, and several others were from Bosnia or Croatia. My mother reminded them of their own grandmothers and mothers, whom they had left behind. They were better able to communicate

with her—she spoke Polish almost exclusively by then—and they showered her with attention and affection. This move, along with a medication adjustment, seemed to settle her emotions, and she started to become, once again, the mother I had known. Her memory, however, was changing rapidly. On sunny days when she felt well, we would walk outside around the complex. In her mind, time would get compressed and she would think she was back on her family's country estate. She would tell me how, as a child, she used to sit at that pond—the one we were passing by—soaking her feet in the water.

Her good days were interspersed with days when she saw her life closing in. "What has happened to me?" she would ask, her voice trembling. "I am nothing anymore. I just eat, sleep— that's all." She was often frustrated, anxious, and depressed, although she rarely showed such feelings to visitors or staff. Instead, she smiled when they came into her room and offered them Russell Stover chocolates. Even as she became frailer and seemed to draw inward, she held herself with quiet dignity. All the caretakers remarked on her demeanor and how well dressed she was, always wearing her Polish amber bracelet with matching necklace or a string of carved ivory-colored beads, also from Poland.

My mother was still able to walk, with assistance, but her loss of vision caused her anguish. She had a theory she would share with me: "You know, the Germans did this to me. They wanted to make sure I didn't see everything they were up to, so they left me with just enough vision to get by." After hearing this several times, one day I made the mistake of contradicting her.

"No, Mom," I said, politely, gently, but perhaps a bit condescendingly. "You're ninety-eight years old. Everything wears down with age, and your loss of vision is because you have macular degeneration. It wasn't the Germans. It's simply old age."

My mother stared at me fiercely, lips pressed together. And then, in a stern voice that reclaimed her authority, she asked: "What? So now you're defending the Nazis?"

Over the last decade of her life, my mother often told people that she wanted to live to be one hundred years old. She gave no specific reason. But her friends, her doctor, her pastor—anyone who knew her— reinforced that sentiment, remarking with admiration on her good health, energy, fierce independence, and remarkable self-discipline.

On October 1, 2010, my mother's wish came true. By this time she was living in a skilled nursing center, for she was almost blind and very frail. My family had arranged a little party in her honor in the bright, airy café on the first floor of the center, attended by a few friends who had known her a long time. Our son, John, prepared a butternut squash soup served with sandwiches, followed by ice cream cake and cookies. Her nursing aide wheeled her in, dressed smartly in a gray wool suit, a lace-collared blouse, and her favorite necklace of carved beads.

Fortunately, she was having a good day, and I could tell that she understood there were other people present and that they were there to honor her. By this point in her life, she could barely see and rarely spoke, but she took each person's hand as he or she walked up to greet her, nodding as each wished her a happy one-hundredth birthday. When we sat down to eat, I took a spoon in my hand, ready to feed her. She grabbed that spoon from me and proceeded to feed herself while I gently cradled her hand to make sure the spoon stayed level. My mother was not about to be fed in front of all those people! That was the image that kept coming to mind as I sat at her bedside two months later.

At her birthday celebration, family and friends joined in the traditional Polish song for such special occasions: *Sto lat, sto lat, niech żyje, żyje nam*, "One hundred years, one hundred years, may you live, live with us." As everybody clapped and cheered, I jokingly asked, "So what are we going to sing next year?"

It turned out to be a moot question. My mother died two months after that hundredth birthday, on a Thursday evening, the second of

December. She died of frail old age, peacefully in her sleep, at the end of a slow decline that had lasted several years. At her burial, we sprinkled several handfuls of soil on her lowered coffin—soil that I had brought back from my 2005 trip to Poland.

~

I recall a conversation I had with my mother's pastor, Father Jim, just a month before she died. We were discussing some remarks he had made at the birthday celebration about the power and responsibility of memory and how my mother's life story connected all of us to the past. Indeed, one of the guests at the party brought her young son and daughter along precisely because she felt it was important that they meet someone who embodied a war and an era that to them was otherwise "just history."

What we learn from stories like my mother's is another matter. From the start of this project, I have been inspired by a quote from the philosopher Tzvetan Todorov. In struggling with the thorny question of whether moral life was even possible in concentration camps, he argued that it is not enough for us to hear the stories of such times, not enough for us to listen in awe and admiration. Instead, "our memory of the camps should become an instrument that informs our capacity to analyze the present."

Through my writing as an anthropologist, I have tried to use my mother's story to bring the past into the present as Todorov urged. For example, my mother's experiences as a prisoner-doctor, played out against the larger context of Nazi abuse of medicine, led me to think critically about the more recent role health care professionals have played in the torture of prisoners in various contexts, including the United States' ongoing "war on terror." Current proponents justify such practices with arguments eerily similar to those presented by Nazi doctors at the Nuremburg trials. There are many lessons to be learned from Jadzia's story and its surrounding history—lessons about the dangers of inflexible political ideology, the injustices of racism, the exploitation of workers, and the ethics of war, as well as

about the positive facets of the human spirit that enable people to survive against unimaginable odds.

During her sixteen months of incarceration, my mother was helped repeatedly by many people, both strangers and friends and colleagues who knew her as a physician—from the guard in the Łódź prison who brought her charcoal tablets to her medical school classmate Maria Adamska, who saved her from "selection" at Ravens-brück. And while in the slave labor camps—especially the one in Neusalz—my mother was at times able to touch people, to try to heal or comfort wounded bodies, and in at least one instance, to save a life. Medicine preserved her humanity and gave her psychic strength.

While many threads made up the fabric of my mother's life, the most prominent was that of medicine. As Father Jim aptly remarked of her war years, "Medicine provided your mother a thread of sanity in an otherwise insane world." Losing her profession wounded her deeply, because medicine for her was not just a job, a source of liveli-hood, or even a vocation. It was her life project, her passion. And during the war, it was a set of skills that ultimately saved her life. To have this taken away from her, to have this thread cut, produced trauma and sorrow that echoed through the rest of her life.

Yet I think the most remarkable aspect of my mother's life story is that she was able to share her memories without rancor or anger. In the six decades that I knew her, I never once heard hatred or a desire for revenge when she spoke about those who perpetuated the violence. She never ceased being amazed at "how such a civilized people could follow a madman like Hitler," and in the last decade of her life she repeatedly declared, "War is a terrible thing. It never solves anything and just causes misery."

I once asked her why she did not feel rage or hatred for what she had to go through during the war. Her answer was brief: "That would be a waste of time. There was no other way, nothing else to do, but to move on with life." She certainly believed that injustice should be punished, but she did not project feelings of bitterness, and she did not weigh me down with the baggage of her past. Instead, she opened me

up to a sensitivity regarding war, oppression, brutality, and the violence of racism and injustice—an awareness that has shaped my work and my thinking as an anthropologist and as a person.

Most of my mother's life unfolded "in the first century of world wars." In sharing her experiences and allowing me, through the writing of this book, to make them my own, my mother passed on a story that carries with it a responsibility—to ensure that the next century, our century, leaves a better legacy than the one into which she was born.

Notes

~

Chapter 1

5 I use the Polish version (with diacritics) for proper names and geographic locations (e.g., Łódź, pronounced "woo-dge," as in edge), with the exception of the capital, Warsaw, which may be the only Polish city familiar to many readers.

7 Researchers at the United States Holocaust Memorial Museum have catalogued some 42,500 Nazi ghettos and camps throughout Europe. For a discussion of these recent findings, see "The Holocaust Just Got More Shocking" (Eric Lichtblau, *New York Times,* March 1, 2013).

8 "Two peoples fed from the same suffering": last line of Antoni Słonimski's poem "Elegia miasteczek żydowskich" [Elegy for Jewish villages], written in 1947 (Kryda 1986: 277–78); my translation from the Polish.

9 "The site of two catastrophes": Hoffman 2004: 16–17.

11 Issues of memory have been examined extensively in the field of Holocaust studies, in part because of the significance of survivor testimonies (e.g., Greenspan 1998; LaCapra 2001; Langer 1991), which are being incorporated more frequently as integral parts of historical analysis (Bauer 2009; Browning 2010). Writings by children of survivors—the second generation—have led to new ways of thinking about memory (Cassedy 2012; Hirsch 1997, 2012; Hoffman 2004; Weisel 2002). Others have explored the meaning of memory—how it is presented and used in the broader social sphere (Climo and Cattell 2002; Rothberg 2009; Young 1993).

14 Eva Hoffman (2004: 77–78) remarks that "the importance of emigration in the biographies of survivors and their children has been . . . oddly underestimated." Yet this "uprooting [is] an almost intrinsic part of the Holocaust's aftermath." Other works that explore this aftermath include Berger 2001; Hoffman 1989; Laqueur 2001; and Whiteman 1993.

15 I have used my mother's experiences in the concentration camps in several academic publications to illustrate broader social and historical issues (Rylko-Bauer 2009; Waterston and Rylko-Bauer 2006). See also the edited collection *Bringing the Past into the Present* (Rylko-Bauer 2005a), which incorporates family histories relating to the Holocaust and exile into

broader social analyses (Bourgois 2005; Bourguignon 2005; Farmer 2005; Rylko-Bauer 2005b; Waterston 2005).

15 For a discussion of "intimate ethnography," see Waterston and Rylko-Bauer 2007 and Waterston 2014.

15 In focusing on one woman's recollections—decades later—of traumatic and life-changing events, I went beyond the usual cross-referencing of text and verification through other sources, to reflect on the relevance of "truthfulness" of memory as it related to accuracy and veracity. "Given the distortions of memory and the mediation of language, narrative is always a story about the past and not the past itself" (Ellis and Bochner 2000: 745). I came to realize that my mother's recollections of her history and her understanding of its context were "right" in the sense of "story," separate from the question of how they fit historical fact. Auschwitz survivor and poet Charlotte Delbo (1995: 1) once observed, "Today, I am not sure that what I wrote is true. I am certain it is truthful."

15 The photographs of confiscated bedding stored in the Church of the Assumption of the Blessed Virgin Mary in Łódź can be found in Dobroszycki 1984: 424–25 and Adelson and Lapides 1991: 290–91.

18 The concept of the "third voice" is discussed by Marc Kaminsky (1992: 7) in his introduction to Barbara Myerhoff's *Remembered Lives*. He quotes from a 1983 panel discussion on storytelling, in which Myerhoff commented about "the third voice, which is neither the voice of the informant nor the voice of the interviewer, but the voice of their collaboration." She later wrote about the emergence in ethnographic text of a "third person . . . born by virtue of the collusion between interlocutor and subject" (Myerhoff 1992: 292).

Chapter 2

This chapter benefited from English-language works on Polish history by Norman Davies (2001, 2005), Michael Steinlauf (1997), and others (Leslie 1980; Lukowski and Zawadzki 2001; Zamoyski 2000).

21 "Nation without a state": taken from the title of a book about nineteenth-century Poland (Nance 2006).

22 "Big Losses in Lodz Battle": *New York Times*, December 18, 1914.

23–24 For more on the two visions for independent Poland in the interwar period, see Steinlauf 1997; for the status of Jews in Poland during this time, see Gutman et al. 1989; Melzer 1997; Michlic 2006; Rudnicki 2005.

26 The use of feldshers in Poland evolved during the nineteenth century, especially in the territory occupied by Russia, which included Łódź (Roemer and Roemer 1978: 42, 73; see also Sidel 1968).

28 "You came here seeking knowledge": Professor Stanisław Kasznica, rector, University of Poznań, annual report for the academic year 1930–1931; see *Kronika Uniwersytetu Poznańskiego za lata szkolne 1929/30 i 1930/31* (1932, p. 22), at http://www.wbc.poznan.pl/dlibra.

28–29 The enrollment statistics for women at the Poznań Medical Academy come from two sources in the Digital Library of Wielkopolska's collection, 90 Lat Uniwersytetu im. Adama Mickiewicza w Poznaniu, http://www.wbc .poznan.pl/dlibra (accessed January 20, 2013). The first is the course catalog of the University of Poznań (*Spis wykładów i skład Uniwersytetu w latach 1920–1936*), which provides statistics for the last three academic years; see 1933–34: 155; 1934–35: 167; 1935–36: 171. It also includes the medical school curriculum for Jadzia's six years of attendance, 1930–36. The second is the university's annual report for the 1935–36 academic year; see *Kronika Uniwersytetu Poznańskiego za rok szkolny 1935/36*, p. 327.

33–34 For discussion of anti-Jewish actions at universities in the 1930s, see Aleksiun 2012; Michlic 2006: 111–14; Rudnicki 1993.

Chapter 3

43 For historical information about public health and serious infectious diseases in Poland overall and in Łódź specifically, see Balinska 1996. I also relied on several Polish-language articles: Posłuszna 2004; Sadowska 2005; Sztuka-Polińska 2002.

44 The situation for other health care providers was even worse; in 1938 there were only 11 dentists, 11 pharmacists, and 46 nurses or technicians per 100,000 people. Statistics on health-care personnel in Poland during the interwar period come from Weinerman and Weinerman 1969: 12.

45 The history of the Anna Maria Hospital in Łódź is documented in a Polish-language volume published to commemorate the hospital's centennial (Gołębiowska 2005). Also useful was an unpublished manuscript (author unknown, "Szpital Anny Marii w okresie okupacji niemieckiej: Kinder Klinik 'Anne Marie', 1939–1945"), acquired from the hospital in 2001. The hospital was renamed in 1950 in honor of the Jewish pediatrician and educator Janusz Korczak, who founded progressive orphanages in Warsaw. When deportations of Jews to Treblinka began in 1942, he refused offers of rescue and accompanied the children under his care, perishing with them.

52 "Mobilization! A great many neighbors": excerpted from diary entries for August 24, 26–28, and 30, 1939 (Adelson 1996: 27–30).

Chapter 4

Historical accounts of events leading up to World War II, the invasion of Poland, and Nazi occupation policies and treatment of Poles can be found in Burleigh 2000: 432–57; Davies 2005; Lukowski and Zawadzki 2001: 227–35; Rossino 2003; Snyder 2010; and Steinlauf 1997: 23–27.

Timothy Snyder (2012: 52) elaborates on the reasons for the German attack on Poland: "Germany tried to draw Poland into an uneven alliance for five years; once it was clear that this effort had failed, Hitler decided that he had to destroy Poland if he wanted to reach the USSR." According to John Connelly (2004: 20),

the viciousness of the attack and the brutality of the subsequent occupation were shaped not only by the Nazis' racist ideology and view of Poles as biologically and culturally inferior but also by Poland's political stance. "Unlike Hungarians, Romanians, Slovaks, Croats, and Soviets, Poles had refused offers of military cooperation. . . . Like no other people save the Jews, the Poles had provoked Hitler's hatred."

Specific information on the Nazi occupation of Łódź can be found in Siemiński 2005. I also relied on Polish-language volumes (Cygański 1965; Iwanicki, Janaszek, and Rukowiecki 2011) and the official compilation of Nazi camps found on Polish soil, which includes those in the Łódź region (Główna Komisja Badania Zbrodni Hitlerowskich w Polsce 1979: 292–300).

54 "Germans in Poland are persecuted": Yale Law School's Avalon Project, http://avalon.law.yale.edu/wwii/gp1.asp (accessed January 20, 2013).

56 "Łódź is occupied!": Adelson 1996: 36.

56 Snyder (2010) provides a detailed discussion of the Soviet invasion of Poland, including the Katyń Forest massacre. Not until 1992 did the Russian government release archival records that acknowledged Soviet responsibility, as reported by Celestine Bohlen, "Russian Files Show Stalin Ordered Massacres of 20,000 Poles in 1940" (*New York Times*, October 15, 1992). These events became more widely known through the 2007 Oscar-nominated film *Katyń*, by the acclaimed Polish director Andrzej Wajda, whose father was among those murdered. Poland continues to be haunted by this history—on April 10, 2010, a plane carrying Polish president Lech Kaczyński and other government dignitaries, traveling to commemorate the seventieth anniversary of the massacre, crashed not far from the site, killing everyone aboard.

57 Poland's large loss of professionally trained citizens during World War II is noted in Lukowski and Zawadzki 2001: 229 and Burleigh 2000: 441–42.

57–58 An overview of Nazi racial ideology can be found in the United States Holocaust Memorial Museum's (USHMM) online Holocaust Encyclopedia, http://www.ushmm.org/wlc/en/article.php?ModuleId=10007457 (accessed January 20, 2013). For more detailed analyses of how Nazi racism ultimately led to the Holocaust, see Proctor 1988 and USHMM 2004, 2007. The Nazis were obsessed with racial purity and ways of measuring it. For a discussion of how this was applied to selecting various populations, with the goal of resettling or eliminating them, see Aly 1999 and Schafft (2004, 2005), who also examines the supportive role played by anthropology in legitimizing racism, eugenics, and the resulting Nazi racial and genocidal policies.

58 "Anus Mundi": Miłosz 2001: 39.

58 "The Polish population was to be thinned out": Gutman 2006: xxix.

58 Nouns are capitalized in German and this convention is followed throughout the book.

59 "[Poland] is of use to us only as a reservoir of labour": quoted in Burleigh 2000: 441. Ulrich Herbert (2000) offers an excellent historical overview of

Germany's use of foreign forced laborers, noting the distinctions between forced and slave labor, and provides details about German treatment of Polish forced workers (2000: 194, 197, 199). In addition, several million Poles were arrested and sent by the Nazis to prisons, labor camps, and concentration camps, where many were forced to work as essentially slave labor, unpaid and with little freedom of movement, if any.

60 "The sole goal of this schooling": quoted in Milton 1990: 151–52.

61 The Web site Shtetlinks offers a useful Łódź Streets Database, http://www .shtetlinks.jewishgen.org/Lodz/streets-index1_pol.htm (accessed January 20, 2013). It traces street names changes over six periods of the city's history: around 1913 (Russian occupation), 1925 and 1933 (Second Polish Republic), 1939 (Nazi occupation), 1945 (People's Republic of Poland), and 1990 (postcommunist Polish Republic).

61–62 For more on Herbert Grohmann and his racial approach to public health in Łódź, see Schafft 2005. For the Nazi's "T4 euthanasia" program within the broader context of Nazi racial ideology and medical ethics, see Michalczyk 1994 and Nicosia and Huener 2002. For information on the murder of patients at Kochanówka and other psychiatric hospitals, see Jędrzej Słodkowski, "Zbrodnia z Kochanówki," Gazeta.pl, July 13, 2012; see also Aly 1999: 70–76.

62–63 In the Polish territories annexed to the Reich, the Volksliste had 959,000 ethnic Germans and 1,861,000 Poles of German descent or relation. In Łódź alone, by October 1, 1944, more than 107,000 people were registered as Volksdeutsche. For more information, see Burleigh 2000: 449–50; Krakowski 1990c; Siemiński 2005: 97. John Connelly (1999) notes how flexible and opportunistic Nazi racial policy was with regard to Slavic populations. Rules about who qualified as Volksdeutsche often changed, as Doris Bergen (2005: 276) points out: "In early 1940 the minister of the interior announced that, in the interests of the fatherland, Volksdeutsche should be defined as generously as possible. . . . Himmler took expansion of the category even further. Sometime in 1940–41 he ordered the Germanization of 'racially valuable Poles.'"

63 Halina Kłąb's experiences during the war are described in her memoir about anti-Nazi espionage in the Polish resistance, ZWZ-AK (Szwarc 2008).

65 German efforts in the 1930s to identify sympathetic ethnic Germans living in Poland and create lists of Poles to target once the country was invaded are discussed by Shmuel Krakowski (1990c) and Alexander Rossino (2003: 15, 16, 24).

65–66 The use of an Estonian doctor at the hospital to replace Dr. Tomaszewska was not unusual. Michael Burleigh (2000: 448–49) notes the recruitment of hundreds of thousands of ethnic Germans from Baltic regions, including Estonia, many of whom spent months in holding camps before they resettled in the annexed territories; see also Aly 1999.

68 The number of Polish doctors in Łódź in 1941 comes from Siemiński 2005: 109.

72 The role of various sectors of Polish society vis-à-vis the Nazi persecution of Jews, especially with regard to the plunder of Jewish property and the hunting down and killing of Jews, has generated a lot of recent debate and scholarly attention, especially after the publication of Jan Gross's *Neighbors* (2001) and more recently, *Golden Harvest* (2012). See, in particular, Glowacka and Zylinska 2007; Grabowski, forthcoming; Gross 2012; Polonsky and Michlic 2004; Zimmerman 2003.

72 Michael Steinlauf (1997: 25–26) discusses the black market and other clandestine activities in Nazi-occupied Poland and how such actions were at times seen simultaneously as self-serving and as a form of resistance.

Chapter 5

The term "Holocaust" refers to the state-sponsored persecution and attempted total destruction of European Jews by the Third Reich. Although the Nazis oppressed, terrorized, and murdered millions of people from numerous countries, ethnicities, religious groups, and political affiliations, the Holocaust stands as a unique case of such actions taken to the extreme. For an introduction to this topic, see Berenbaum and Peck 1998; Bergen 2009; Dwork and van Pelt 2003; Hilberg 1985; and USHMM 1996, as well as several Holocaust encyclopedias (Gutman 1990; Laqueur 2001), including that of the USHMM, http://www.ushmm.org/wlc /en/ (accessed January 22, 2013). For a discussion of the Holocaust in the context of World War II, see Burleigh 2000.

 Some Jews were able to immigrate to safety before the arrests, deportations, and killings began. One such account is *Exile: A Memoir of 1939,* by Bronka Schneider, about a Viennese couple's first year of exile. Published decades later, it was co-edited by Schneider's niece, the anthropologist Erika Bourguignon, who herself left Vienna with her parents soon after Nazi Germany annexed Austria in March 1938. In the book's foreword, Bourguignon (1998: x) asks a question that has also intrigued me: "How do ordinary people live in extraordinary times?"

 Until the 1990s, Holocaust research largely ignored issues of gender (Saidel 2000). Works focusing on women's perspectives and experiences during the war are cited throughout this book; see also Baer and Goldenberg 2003; Dublon-Knebel 2010; Flaschka 2009; Goldenberg and Shapiro 2013; Hedgepeth and Saidel 2010; Ofer and Weitzman 1998; and Rittner and Roth 1993. Memoirs by female survivors of ghettos and camps and by those who survived by hiding offer a more intimate, subjective understanding; those that are relevant to Jadzia's story because of where they take place or the experiences described include Adelsberger 1995; Bernstein 1997; Kirschner 2006b; Margolis-Edelman 1998; Meed 1993; Perl 1998; Tillion 1975. The role of women as perpetrators or collaborators in the Holocaust has garnered more attention recently, especially the role played by female nurses and guards in Nazi camps and prisons (Benedict 2003; Benedict and Kuhla 1999; Brown 2002; Lagerwey 2003).

75 For information on the prewar Jewish community of Łódź, see Krakowski 1990b and Polonsky 2005.

76 "They have issued an order forbidding Jews": Adelson 1996: 53–54. The oppression of Jews from the start of the German occupation of Łódź is detailed in Baranowski and Rukowiecki 2004 and Baranowski 2005.

76 For the translation of the public decree ordering the establishment of the Łódź ghetto, see Adelson and Lapides 1991: 31–32.

77–78 Original records, diaries, testimonies, and historical studies offer extensive documentation of the administration of the ghetto and of daily life and work for those who lived in it. Sources I relied on include Adelson and Lapides 1991; Baranowski 2005; Baranowski and Nowinowski 2009; Baranowski and Rukowiecki 2004; Dobroszycki 1984; Grossman 2001; Horwitz 2008; Krakowski 1990b; and Trunk 2006. Only traces of the ghetto remain in contemporary Łódź (Baranowski 2005; Maleńczyk 1994; Podolska 2009).

78 The figures for the number of Jews deported to Chełmno (for gassing) or to Auschwitz (where only a small percentage survived) come from Baranowski 2005: 96, 100, 106, and Trunk 2006: 267.

78 "There is really no way out": Adelson 1996: 268. The figures for deaths due to disease and starvation come from Trunk 2006: 219; see also Baranowski 2005: 74–93; Krakowski 1990b.

81 Information about Dr. Henryka Frenkel comes from Falstein 1963: 345; Federowicz, Machnik, and Maziarz 2006: 96–97; Gołębiowska 2005: 41; and personal communication with Professor Isak Gath.

82 The little I could find out about Dr. Sima Mandels comes from Falstein 1963: 414 and from the Central Database of Shoah Victims' Names, http://www.yadvashem.org/wps/portal/IY_HON_Welcome (accessed January 22, 2013).

82–83 Information about Dr. Anna Margolis and her family comes from several sources: Cygański 1965: 62; Falstein 1963: 414–15; Gołębiowska 2005: 40; and Meed 1993: 304, 318–19. Alina Margolis-Edelman wrote about life in prewar Poland and during World War II in a memoir, *Ala z elementarza* (1994), excerpts of which were translated into English as *Ala from the Primer* (1998). The memoir's title refers to the fact that Alina and her brother were the inspiration for two children, Ala and Olek, featured in a widely used Polish early reading primer, the author of which was a friend of the Margolis family. I still own a well-thumbed copy from when I attended Saturday "Polish school" in Detroit in the mid-1950s. While 98 percent of Warsaw's Jews perished during World War II, about twenty-eight thousand—including Anna Margolis and her children—managed to avoid entering the ghetto or escaped and hid from Nazi authorities (Paulsson 2002).

After Margolis-Edelman moved to France with her children, she was involved in Doctors without Borders, Doctors of the World, and efforts against child abuse; she died in March 2008 (Apt 2008). Marek Edelman

(1990) wrote an account of his experiences during the Warsaw ghetto uprising and retold the story in the 1995 documentary, "Chronicle of the Warsaw Ghetto Uprising According to Marek Edelman," directed by Jolanta Dylewska; see also Grupińska 2000; Kaufman 2009; and Krall 1986.

83 The "March events of 1968" began with student protests about freedom of speech in cities throughout Poland. The Polish government falsely accused "Zionist elements" of being anti-Polish and inciting the protests, with the aim of consolidating power by weakening political opposition within the Communist Party and deflecting attention from this growing grass-roots movement. Many Polish Jews, even in high levels within the party, the military, the academy, and the government, lost their jobs and positions— among them the Edelmans. A majority of Poland's forty thousand Jews emigrated because of direct government pressure, rising anti-Semitism, a hostile social environment, and loss of livelihood. For different perspectives on these events, see Eisler 1998; Michlic 2006; Steinlauf 1997: 75–88; and Stola 2000.

Chapter 6

For discussion of the Polish resistance in general and the Armia Krajowa (AK) specifically, see relevant sections in Davies 2001, 2003; Leslie 1980; Steinlauf 1997; and Zamoyski 2000. Two Polish-language memoirs (Szwarc 2008; Wiland 2005) provide insight into resistance activities in Łódź. The goals of the resistance movement varied and differences in ideology and politics led some smaller groups to act separately from the AK, most notably the Communist-organized People's Guard, which evolved into the People's Army, and the nationalistic right-wing National Armed Forces.

The AK was by far the largest, and it was linked to the London-based Polish government-in-exile. It consisted of three basic types of members: full-time, hard-core activists who remained underground; partisan units, who lived mainly in the forests and openly fought the Germans; and the largest group, ordinary citizens who performed occasional tasks such as gathering information, acting as couriers, and carrying out sabotage, under orders from resistance unit commanders (Leslie 1980: 234–35).

The most dramatic actions of resistance were the two uprisings against the Germans in Warsaw. The first was the Warsaw Ghetto uprising in the spring of 1943, conducted against great odds by Jewish resistance fighters from inside the ghetto. Nazi SS-Brigadeführer Jürgen Stroop, who was ordered to liquidate the ghetto, compiled a formal record of the campaign, with daily reports, communications, and photographs—bound in leather, like a commemorative album—which he titled "The Jewish Quarter of Warsaw Is No More!" A translated, facsimile edition of this official report was published as *The Stroop Report* and makes for chilling reading (Milton 1979). For compelling personal accounts by survivors, see Edelman 1990; Krall 1986; Margolis-Edelman 1994; Meed 1993; and Rotem 1994.

The second major resistance action began on August 1, 1944, when the AK tried to seize control of the city from the Germans as the Soviet army approached from the east. After sixty-three days of fierce fighting, during which the Soviets stood by, refusing to provide aid, the remaining AK fighters surrendered. The Germans retaliated by sending captured soldiers and most remaining civilians to concentration and forced labor camps in Germany and by systematically dynamiting much of the city, leaving behind only rubble as they withdrew. In January 1945 the Red Army crossed the Vistula River and "liberated" Warsaw—a city with only about 6 percent of its prewar population remaining. For different perspectives on this arguably heroic but tragic set of events, see Borodziej 2006; Davies 2003; and Connelly's (2004) critique of the latter. The Warsaw Rising Museum was opened on the sixtieth anniversary of the outbreak of fighting.

86 One account that confirms Marysia's early resistance activities is a testimony written in 1946 in Mannheim-Käfertal, Germany, by a former patient of the Łódź hospital where injured POWs were held during the early weeks of the German occupation. He lists some of Marysia's actions: "She provided medicines, bandages, shoes, clothing, food, and books for soldiers . . . She assisted, and even personally accompanied, the escape of officers and soldiers who were POWs. She helped organize spiritual support and care for the III Hospital for Polish Prisoners of War from 10.X.1939 to 10.X.1940. She was the contact person between these officers and soldiers . . . and the civilian population, as well as various social welfare and political groups. . . . She was arrested by the Gestapo for the above activities" (my translation from the Polish).

91 For more on the kidnapping and Germanization of Polish children, see Lukas 2001: 105–25; Milton 1990: 151–52; Schafft 2004: 128-33, 2005; Siemiński 2005: 39, 140. For a historical perspective on the Lebensborn program, see Hillel and Henry 1976.

Chapter 7

I am aware of only one English-language source on the seventy-year history of the prison on Gdańska Street in Łódź; see Głowacka and Lechowicz 2009. This book includes photographs and recollections by former prisoners, including Jadzia, in her case based on materials I sent to the museum curators, which they incorporated into both the book and an exhibit on the period when the building was the Gestapo-controlled Police Prison for Women, 1939 to 1945. I received valuable research assistance during my 2005 and 2011 visits from curators Maria Głowacka and Małgorzata Lechowicz. Also useful were Polish-language publications based on archival materials and prisoner testimonies (Baranowski 1989; Michowicz 1969; Szwarc 1972, 2008) and an unpublished memoir archived at the Museum of Independence Traditions (Wiland 2005).

98 Nouns and personal names are declined by gender in Polish: for example, Mr. Raburski and Mrs. Raburska.

99–100 The details regarding Jadzia's incarceration at the prison on Gdańska Street come from the National Archives, Łódź Branch, file "Zakłady karne w Łodzi, 1939–1945" [Penal institutions of Łódź, 1939–45], (a) the index of prisoners (*Namensverzeichnis der Gefangenen Buch 3, 1941–1944*), catalogue 5, k. 206; (b) prison registry book (*Gefangenen Buch B, 1943–44*), catalogue 3, k. 376. The prison photo comes from the Archiwum Akt Nowych, Warsaw, file 1690 ("photographic collection of the former Central Archives KC PZPR, XIX-XX century"), reference number K-684.

103 Zofia Goclik died on November 4, 2010; after her death, her daughter (who had cared for her in the final years of her life) gave me permission to quote from her mother's letters.

105 "Many women signed the [transport] list": Wiland 2005, letter in the appendix, p. 6. Mrs. Wiland died in 2012. Permission to quote from this memoir was given by the Museum of Independence Traditions in Łódź, where it is archived.

106 "In the final months of 1943": Wiland 2005: 26–27.

106 "During undoubtedly very difficult questioning": Wiland 2005: 32.

112–13 Regarding *Gefangenen Buch B*, see note for p. 99. The transport list that includes Jadzia's name comes from the National Archives, Łódź branch, file "Zakłady karne w Łodzi, 1939–1945" [Penal institutions of Łódź, 1939–45], transport lists of female prisoners from this prison (*Polizei Frauengefängnis Litzmannstadt Danzigerstrasse 13 Verzeichnisse von Häftlingen nach anderen Gefängnisse überfuhrten*), reference number 9e, pp. 250–52.

Chapter 8

The USHMM's *Encyclopedia of Camps and Ghettos* (Megargee 2009) provides general information about Ravensbrück (Strebel 2009) and detailed descriptions of its subcamps (pp. 1192–1228). See also the Ravensbrück National Memorial Web site, http://www .ravensbrueck.de (accessed January 26, 2013), and the University of Minnesota's Center for Holocaust and Genocide Studies exhibit *Women of Ravensbrück*, http://chgs.umn. edu/museum/exhibitions/ravensbruck/index.html (accessed January 23, 2013).

Historian Jack Morrison's (2000) detailed history of Ravensbrück discusses the different categories of prisoners, the relationships forged among women, and the larger social context of the camp. Other writers have focused specifically on the experiences of Jewish women, girls, and children in Ravensbrück (Dublon-Knebel 2010; Saidel 2004). Memoirs by former prisoners of the camp flesh out details about daily life and individual experiences; examples are Anthonioz 1999; Lanckorońska 2007; and the eyewitness account and historical study by the French anthropologist Germaine Tillion (1975).

For diagrammed plans of the camp, see Morrison 2000: 15; Tillion 1975: 238–39; USHMM 1996: 153–56. The camp was separated from the town of Fürstenburg by both the Havel River and Schwedt Lake. Morrison (2000: 30-31) notes that prisoners usually arrived at the Fürstenburg railroad station at night, but those who disembarked during the daytime were sometimes herded through the center of town.

118 Some scholars assert that in many Nazi camps, especially in the later years of the war, foreign forced laborers were essentially treated as slave labor (Schafft and Zeidler 2011: 14–18). Benjamin Ferencz (2002: xiii), a prosecutor at the Nuremberg trials, has even argued that many concentration camp prisoners, especially Jews, were treated as "less than slaves," because they were considered expendable. Even though the terms are often used interchangeably in the literature, there were key distinctions between forced and slave labor (Simpson 1995: 87–90; Herbert 2000; see also chapter 4). Forced labor was involuntary and often included harsh, abusive, or dangerous working and living conditions, but it did afford some freedom of movement and minimal payment for the work being done. Slave labor was equally brutal or worse, with no freedom of movement and no compensation. Jews who were forced to work in ghettos were performing slave labor, as were concentration camp prisoners.

Bella Gutterman (2008) demonstrates how forced and slave labor evolved in Nazi Germany and its occupied territories as the purpose of concentration camps shifted from the political (holding and "re-educating" those deemed enemies of the state) to the economic (exploiting the imprisoned). Companies were not overly worried about labor costs, because "they simply recouped them by investing less in the prisoners' well-being, nutrition, and housing" (Gutterman 2008: 25). This extensive exploitation is discussed by Herbert (2000: 199), who estimates that Germany used as many as 10 million foreign civilian prisoners and prisoners-of-war within its borders, in addition to the 2.5 million inmates sent to concentration camps.

118 According to Timothy Snyder (2009: 16), "the ideology that legitimated mass death was also a vision of economic development . . . [that] integrated mass murder with economic planning." For German industry's involvement in slave labor, see Allen 2002; Ferencz 2002; Hayes 1998; Herbert 2000; Krakowski 2001; Simpson 1995; and Wiesen 1999. Recent efforts to award compensation for victims of Nazi slave labor led to a more complete listing of complicit SS-owned and German and Swiss private companies; see the court documents of the United States District Court, Eastern District of New York (2000a, 2000b).

119 Jack Morrison (2000: 207–209) and Christopher Simpson (1995: 306–307) offer partial listings of companies that contracted with the SS for use of prisoner labor from Ravensbrück, focusing largely on the munitions, aircraft, and electronic industries.

119 "Foreign forced labor was": Herbert 2000: 199.

119–20 The figures for population growth and death rates in Ravensbrück come from Morrison 2000: 276, 277, 283.

121 For the 1941 photograph of the concentration camp gate, see http://www .deathcamps.org/websites/pic/big0501%20KL%20Ravensbrueck%20 Gate%20Tor%201941.jpg (accessed January 23, 2013).

122 Morrison (2000: 32) describes the trauma women felt as they underwent the public physical exam and shaving upon arrival in Ravensbrück. Their feelings and words echo those expressed by my mother; see also Bernstein 1997: 195–205. The violence of such acts cannot be understood simply in terms of physical consequences. It also includes "assaults on personhood, dignity, sense of worth or value of the victim. The social and cultural dimensions of violence are what give violence its power and meaning" (Scheper-Hughes and Bourgois 2004:1).

123 The excerpt from the poem "Arrival (1942)," by Maria Rutkowska, comes from Voices from Ravensbrück, a Web-based art project by Pat Binder, http://www.pat-binder.de/ravensbrueck/en/ankunft/station2.html (accessed January 26, 2013), reproduced here with Binder's permission. The poem was originally written in Polish in Ravensbrück on June 20, 1942 and titled "Odarli nas . . ." It appeared in a collection of Rutkowska-Kurcyuszowa's poetry, in both Polish and German (*De Profundis Clamavi – Z głębokości wołam –Aus der Tiefe rufe ich: Wiersze – Gedichte,* translated by Anna Mielniczuk-Pastoors and Michael Pastoors, Annweiler, Germany: Plöger, 1994) and later in her memoir, *Kamyki Dawida* (Katowice: Wydawnictwo Unia, 2005, pp. 226–27). The German version was then translated into English for Binder's art project by Rebeccah Blum. For other examples of poetry and art created by women prisoners while at Ravensbrück, see Morrison 2000 and Pat Binder's *Voices from Ravensbrück* project.

Chapter 9

130 "If one offers a position of privilege": Levi 1996: 91. For an example of the way the Germans used prisoners as tools of control and oppression, see Browning 2000: 89–115.

133 Morrison (2000: 35–36) writes about the vulnerability of prisoners newly arrived at Ravensbrück.

135 On the use of dogs to control prisoners, see Morrison 2000: 26–27.

136 Medical experiments conducted in Ravensbrück without prisoners' consent included deliberately infecting wounds to test the effectiveness of various drugs, breaking or removing parts of bones to study bone transplants, and severing muscles and nerves to study regeneration. Doctors also practiced methods of sterilization in order to perfect ways of easily limiting the reproduction of "undesirable" populations. Descriptions of such medical experimentation are provided in Morrison 2000: 245–49 and Tillion 1975: 78–89. Similar experiments were conducted in other Nazi camps (Annas and Grodin 1992; Cornwell 2003: 348–66). For more on the abuses of Nazi medicine, in general, see Michalczyk 1994 and Nicosia and Huener 2002. Many of these Nazi doctors were later tried as war criminals before the

Nuremberg Military Tribunal, as were camp officials, nurses, and female SS guards during the Ravensbrück trials held in Hamburg after the war; see Schmidt 2008 and the USHMM's Web exhibit "The Doctor's Trial," http://www.ushmm.org/research/doctors (accessed January 24, 2013).

138 "Everything was traded": Morrison 2000: 143.

139–40 According to Morrison (2000: 208), about twelve hundred women prisoners from Ravensbrück worked at the Auerwerke plant near Oranienburg during 1944. An SS memo dated March 10, 1944, notes: "In Oranienburg we are employing 6000 prisoners at the Heinkel works now for construction of the He177. . . . at the mechanical workshops at Neubrandenburg [a subcamp], 2500 women are working now in the manufacture of devices for dropping bombs and rudder control" (Yale Law School's Avalon Project: Nazi Conspiracy and Aggression, vol. 4, document no. 1584-III-PS, http://avalon.law.yale.edu/imt/1584-III-ps.asp [accessed January 24, 2013]). The female prisoners of the mentioned subcamp worked for the firm Mechanischen Werkstätten Neubrandenburg Gmbh (MWN), which specialized in munitions and aircraft parts.

Morrison reports that in 1943 the MWN director came to the concentration camp to pick out prisoners for the factory: "By going to Ravensbrück he could personally interview and examine potential employees. Female prisoners were examined for good teeth and healthy hands. . . . Not unnaturally, women who were examined in this way found the process upsetting and humiliating . . . [as though] they were being 'bought . . . just like slaves'" (Morrison 2000: 211–12).

140 The drawing *Fit for Work*, by Violette Rougier-Lecoq, can be found in Morrison 2000: 239, along with eleven other of her drawings that Morrison used to illustrate daily life in the camp. Rougier-Lecoq was imprisoned in Ravensbrück because of her involvement in the French resistance and eventually worked as a prisoner-nurse. She testified against the Nazi medical staff at the Ravensbrück trials held in Hamburg, where her drawings were presented as evidence. They were published in France soon after the war as *Témoignages 36 Dessins à la plume Ravensbrück* (Morrison 2000: 161–62; Saidel 2004: 58–59).

140 The information about Maria Adamska's arrival at Ravensbrück comes from a camp chronology constructed by Germaine Tillion (1975: 241). In writing her account of life in the camp, Tillion supplemented her own experiences with prisoners' clandestine notes and salvaged camp records. Because many records were destroyed as the war ended, she listed only a handful of prisoners by name in her chronology. It is truly remarkable that one of these turned out to be someone known to Jadzia. During my own research in the USHMM archives, I came across Adamska's name listed in the camp record books for Block 22 (on microfilm).

Chapter 10

144 Information about Jewish forced and slave labor and about Organization Schmelt is provided in Gutterman 2008; Konieczny 1990b; Mazya and Ronen 1990; Robinson and Reichmann-Robinson 1998; and Steinbacher 2000. An excellent memoir detailing life in a number of Organization Schmelt camps is *Sala's Gift: My Mother's Holocaust Story,* which also lists additional sources on this topic (Kirschner 2006b: 268–69; see also Dwork and van Pelt 2006; Kirschner 2006a).

145 The 1942 roundup in Sosnowiec is described in Kirschner 2006: 133–37, 270–71 and depicted in Art Spiegelman's (1986) *Maus.*

145 "Seeing the camps as sources of prisoner labor": Gutterman 2008: 29.

145–46 For more on the tensions that existed within the Nazi leadership regarding the primacy of racial ideology versus economic and military pragmatism with regard to the fate of the Jewish population, see Browning 2000: 58–88, as well as Gutterman 2008 and Steinbacher 2000. Dwork and van Pelt (2006: 72) specifically mention the role of the Warsaw Ghetto uprising in Himmler's decision to dismantle Organization Schmelt and deport most of the Jewish workers to Auschwitz.

146 The number of women in the former OS camps that were reconfigured as Gross-Rosen subcamps is discussed in Konieczny 1990b and Gutterman 2008: 161–63.

147 General information about Gross-Rosen can be found in Braiter 2009; Gutterman 2008; Konieczny 1990a; and USHMM 1996: 156–59. One personal account of life in the main camp mentions the camp orchestra and how prisoners would "be seated in an open field playing marches as thousands of emaciated skeletons in ill-fitting striped uniforms passed by" (Kramer and Headland 1998: 55).

150 A list of Gross-Rosen subcamps and information about the ones Jadzia passed through—in Grünberg, Trautenau, and Neusalz—are available in Gutterman 2008: 110–18; Megargee 2009: 698–812; ITS (International Tracing Service) 1949: 273; and the official Gross-Rosen museum Web site, http://www.gross-rosen.pl (accessed January 24, 2013).

155 "When accounts of drastic actions": Hilberg 2001: 73. The discussion of train departure schedules comes from Hilberg 2001: 74–77.

155 "Absolutely . . . the official travel bureau": Lanzmann 1985: 143.

156 Gutterman (2008: 170–73) discusses pregnancies and births in the Gross-Rosen labor camps, but policies varied across camp systems. For example, in Ravensbrück there were, at different times in the camp's history, quite a few children who accompanied their mothers. At one point, officials even allowed women to birth and care for their infants, but tragically, given the harsh living conditions, almost all died soon after (Morrison 2000:261–74; see also Dublon-Knebel 2010).

Chapter 11

Information on the history of the town of Neusalz and the use of forced and slave labor by the industries located there during World War II, including the Gruschwitz textile firm, comes from several Polish-language sources: Andrzejewski, Gącarzewicz, and Sobkowicz 2006; Mnichowski 1987; and Wyder, Nodzyński, and Benyskiewicz 1993. Near the end of the war, the three Allied powers redrew Poland's borders during the Yalta and Potsdam Conferences. The Soviet Union acquired a large part of what had been eastern Poland, and in compensation, Poland received territory that before the war had been part of eastern Germany. As a result, the former German city of Neusalz became Nowa Sól. The Gruschwitz firm abandoned the factory site before Soviet troops entered the city. After the war, this industrial complex became a Polish state-owned enterprise, renamed "Odra," that produced linen, cotton, and synthetic threads for the Eastern bloc market until its bankruptcy at the turn of the century.

There are only a few published sources of information specifically about the Neusalz Jewish slave labor camp: Andrzejewski 2010; Lewandowska 2009; ITS 1949: 277, 1979: 141, 422. However, a fair number of testimonies by former camp inmates exist, and I benefited from accounts by the following (including several from the Yad Vashem Archives [YVA]): Anna Katz (taken in Poland shortly after the war, YVA O.16/520, in Polish); Mila Zigorski Bachner (videotaped in English on July 9, 1987, Kean College Holocaust Research Center Oral History Collection, available at USHMM Archives, RG-50.002*0072); Hanka Rotenberg Zylberminc (videotaped in English on February 23, 1993, Holocaust Memorial Center Zekelman Family Campus); Lenke Abramowits (taken in Hungary shortly after the war, YVA O.15.E/2300, in German); Esther Salamanovich Fortgang (n.d., available at USHMM Archives, Acc.1995.A.531, in English); Gisela Theumann (taken on June 22, 1964, in Israel, YVA O.3/2737, in German); and several published memoirs (Bachner 2010; Laufer 2009).

Especially useful was the unpublished memoir by Aliza Lipszyc Besser, titled *Już więcej nie będzie wojny* (*There will be no more war*), written in 1946 while she was in a British detention camp in Cyprus awaiting immigration to Palestine. The manuscript, handwritten in Polish, was deposited in the Yad Vashem Archives in 1980, file YVA O.3/3394, and I acquired a copy from the archives. All quotations from Besser's memoir throughout this book are my translations from the Polish; the page numbers refer to the original, handwritten version. Ann Kirschner also provides some information about the Neusalz camp, based in part on the letters that her two aunts, Raizel and Blima Garncarz, sent to Kirschner's mother, Sala (Kirschner 2006a: 31–33, 2006b: 142–43, 161–63, 177–78, 181–82).

159 The German vertical aerial photograph comes from the map collection of the Herder Institute, Marburg, Germany, inventory number 10-7191-022.

160 Details about the transfer of the Neusalz camp from Organization Schmelt to the Gross-Rosen concentration camp system, including the degrading selection, are provided in Besser's memoir. This process was repeated in

other OS labor camps that were acquired by Gross-Rosen; see Gutterman 2008: 65–67 and the testimony of Halina Kleiner (taped on March 30 and July 23, 1987, Kean College Holocaust Research Center Oral History Collection, available at the USHMM Archives, RG-50.002*0087). Several sources note that conditions in the Neusalz camp worsened after the SS took over (Gutterman 2008: 113, 134; Mnichowski 1987; Robinson and Reichman-Robinson 1998).

160 My understanding of flax processing, linen production, and the nature of work at the Gruschwitz factory was greatly enhanced by materials received in 2011 from Dr. Tomasz Andrzejewski. These include a series of photographs and an old film, without sound, that Andrzejewski thinks was produced in 1941 to coincide with the 125th anniversary of the factory. He believes that both the photos and the film were probably made for propaganda purposes; the workers featured appear to be from the native German population and look adequately fed. In many of the photos, the women, in particular, are shown relaxing and laughing or eating in a community center or cafeteria.

160 "[Conditions for the Jews] were even worse than those faced": testimony provided by Helena Wesołowska and published in a booklet about the wartime Nazi forced and slave labor camps in Nowa Sól (Mnichowski 1987: 6–8).

163–64 Descriptions of how specially trained female SS guards abused the prisoners come from Gutterman 2008: 113, 134; Mnichowski 1987: 8; Robinson and Reichman-Robinson 1998: 5–6; and Besser's memoir. Such scrutiny made escape difficult but not impossible. Besser (pp. 516, 517, 525–28) describes the two attempts mentioned in this chapter, and the unsuccessful one is confirmed by Mila Bachner (2010: 58–60). Bella Gutterman (2008: 104–105) describes the relationship between Gross-Rosen and Auschwitz and notes that Auschwitz was the destination for women in the Gross-Rosen subcamps who were deported either because of selection or as punishment.

169 "It was terrible, we could barely catch our breath": Besser, p. 594.

170–71 "Our living conditions were": this and three other quotations are from Anna Katz's testimony (YVA O.16/520, p.1); my translations from the Polish.

171 The complaint submitted by one of the guards against the Neusalz commandant, Gerschowa, is discussed in Gutterman 2008: 135–37.

172 "France has been liberated": Besser, p. 581.

172 "Some of the girls . . . would wear oversized panties": Besser, p. 531.

173 During the first few years of the camp's existence, inmates were allowed to send and receive mail and even packages to and from family. Kirschner writes about letters her mother, Sala, received from her two sisters in Neusalz; these were dated from August 1942 to July 24, 1943, but after that, "there were no more letters, no more packages" (Kirschner 2006b: 182). This suggests that mail was suspended. Almost a year later, however, Jadzia received a Red Cross package while in Neusalz, so it is unclear what the policy was at that time.

173 "Women talked constantly of recipes": Morrison 2000: 114–15. For the role and significance of "food talk" in sustaining women in the concentration camps, see De Silva 2006 and Goldenberg 2003.

175 "It is terribly cold, temperatures are well below zero": Besser, p. 590.

Chapter 12

Many of the main concentration camps had an infirmary or hospital, supervised by SS physicians. Most of the actual care, however, was provided by prisoners who worked as doctors, nurses, and orderlies. Conditions in these main camp hospitals, especially in the final years of the war, were often a parody of public health and medical care—among the problems were lack of medicines and dressings, overcrowding, and poor hygiene—and in some cases they were also sites of unethical experimentation conducted by the Nazi doctors. Nevertheless, prisoner-doctors and -nurses managed to find ways of easing suffering and at times even saved lives. Less is known about medical care in smaller subcamps such as Neusalz.

Sources useful for understanding the roles and dilemmas faced by prisoners who worked as health care personnel in Nazi camps and ghettos include Brush 2004; Chclouche 2005; Levi and de Benedetti 2006; Lifton 2000: 214–53; Ritvo and Plotkin 1998; Roland 1992; and Rylko-Bauer 2009. Memoirs by Holocaust survivors who worked as prisoner-doctors offer additional insights into the nature of care and the ethical and practical challenges faced by caregivers under difficult and even dangerous circumstances (Adelsberger 1995; Lengyel 1983; Mostowicz 2005; Nyiszli 1993; Perl 1998; Vaisman 2005).

178 Gutterman (2008: 130–31) provides an example of the weekly report submitted to the main Gross-Rosen camp, in this case from a different Gross-Rosen subcamp in October 1944.

180–81 Aliza Besser's memoir provides examples of the different health problems that women endured in Neusalz and notes the potential for accidents (see pp. 480, 524); see also Gutterman 2008: 164; and the testimonies of Anna Katz (YVA O.16/520) and Mila Zigorski Bachner (USHMM Archives, RG-50.002*0072).

181 Prontosil was originally synthesized as an orange-red dye in the early 1930s but later was found to have antibacterial properties. It was the first of what came to be known as the sulfa drugs, which dramatically reduced death rates from infections such as pneumonia and meningitis.

183 Primo Levi's (1989: 36–69) concept of the "gray zone" evolved from his experiences as an inmate in Auschwitz, where he observed the moral ambiguity that characterized life in the concentration camps. Bella Gutterman (2008: 137–40) also refers to the gray zone in her discussion of the role played by camp functionaries in Gross-Rosen. They were often resented by the other prisoners because of their privileged positions. Some used their position to abuse fellow prisoners, while others helped in whatever ways they could. Either way, they served at the whim of their Nazi masters and

could be demoted or sent to Auschwitz on any pretext. A more detailed exploration of whether moral life was possible in Nazi camps is provided by the philosopher Tzvetan Todorov (1996).

183 "Nobody could live during the nightmare years": quoted in Ritvo and Plotkin 1998: 17.

183–85 "That you take care of yourself first of all": Levi 1989: 78–79.

185 "We camp prisoners had only one yardstick": Ella Lingens-Reiner (1948: 142), quoted in Todorov 1996: 35.

188–89 "To the ovens": Besser, p. 525.

190 "The Russians are approaching": Besser, pp. 602–603.

190 For a discussion of the evacuation of Gross-Rosen and its subcamps, see Gutterman 2008: 194–210.

Chapter 13

Although books on Holocaust history include some discussion of death marches, this topic has received less attention than the Nazi camps; see Bauer 1989; Gilbert 1993; Krakowski 1989. For information specifically about marches from Gross-Rosen and its camps, see Gutterman 2008: 188–217. Historian Martin Gilbert (2000: 144) explains that "thousands who were too weak to march away were shot on the eve of evacuation," as were those who could not keep up with the march, because of illness or exhaustion.

193 The forty-two-day death march from Neusalz to Flossenbürg is depicted in Gilbert 1993: 218, maps 285 and 286.

199 "Unfortunately, with increasing frequency": Besser, p. 638.

201 The firebombing of Dresden and other German cities had devastating consequences and generated controversy at the time; debate over its justifications continues to this day (Friedrich 2006; Grayling 2006; Sebald 2003). For an eyewitness account for Dresden, see Victor Klemperer's (1999) February diary entries; for Hamburg, see Nossack 2004. Schafft and Zeidler (2011: 39–47) describe the bombing of another city, Nordhausen, and note that the legacy of this World War II military strategy remains current and challenges simplistic notions of "perpetrator" and "victim."

207 Zwodau is mentioned by Robinson and Reichman-Robinson (1998: 7) and by Hans Brenner (1999: 11) as the stopping point just before the marchers were taken to Flossenbürg.

207 For information about Flossenbürg, see Huebner 2009; Kramer and Headland 1998; and the memorial Web site http://www.gedenkstaette-flossenbuerg .de/en/home/. For historic photographs and camp site plans, see the memorial tour brochure at http://www.gedenkstaette-flossenbuerg.de/fileadmin/ dokumente/RSGB.pdf; the website maintained by former prisoners, at http:// www.flossenburg.be; and the online drawings depicting the horrors of camp life by the Belgian artist Fernand Van Horen, at http://www.jewishgen.org/ ForgottenCamps/Exhib/MainExhibEng.html (all Web sites accessed Janu-

ary 26, 2013). For a list of Flossenbürg subcamps, see ITS (1949: 210–11, 1950: 559–62) and Megargee 2009: 566–91.

208 The Flossenbürg registration lists are held at the International Tracing Service in Bad Arolsen, Germany. This was the largest closed Holocaust archive in the world, overseen by an eleven-nation International Commission that included the United States. The archive was recently opened to the public, and each member nation received a digitized copy of all the ITS records, which by agreement are to be housed in a designated repository. For the United States, the repository is the USHMM, http://www.ushmm .org/museum/exhibit/focus/its/. The listing I acquired, which includes Jadzia's name, comes from the Flossenbürg *Nummernbuch* [Number book] for female inmates, covering prisoner numbers 62011 to 66060. The reference is 1.8.1.1 List Material Flossenbürg, folder 17, p. 74 (bottom) to p. 103.

208 The Flossenbürg female *Nummernbuch* alphabetically lists 870 names of women who arrived there on March 8 and 9 from a Gross-Rosen subcamp— which I assume refers to Neusalz, since I recognized some of the names as Neusalz inmates. I based my calculations of the approximate age distribution for the Neusalz prisoners (mentioned in chapter 11) on this Flossenbürg listing. Since many Gross-Rosen camp records were destroyed near the end of the war, this may be the best approximation.

If this truly is a listing just of the surviving Neusalz prisoners, then it would appear that about 130 perished on the death march. Another possibility, although less likely, is that prisoners from other Gross-Rosen subcamps arrived in Flossenbürg on these same two days and they were all registered as one group. In that case, this listing would include women from other camps, as well as Neusalz, which would suggest that the Neusalz death numbers were higher—but without a roster of all the prisoners who originally left Neusalz, we have no way of truly knowing what these numbers might be.

The historian Martin Gilbert writes that "by the time the marchers reached Flossenbürg, all but 200 had been killed" (1993: 218), and he cites Aliza Besser's memoir as the source for this figure. Besser, however, gave a higher number: "All three transports are together. Unfortunately, there are almost 300 victims, from our transport they count barely 700 left" (p. 668). It is unclear where Besser got her figures or if Gilbert's much higher toll is based on additional material.

210 The photograph of the camp showers is part of the Flossenbürg Photographs collection (photo no. 45681), Oregon State University, Holocaust Memorial, http://oregonstate.edu/dept/holocaust/flossenburg/photographs.php (accessed January 24, 2013).

212 "We're packed so tightly": series of quotes from Besser, pp. 681–84, 686–87.

213 Information about Bergen-Belsen comes from Krakowski 1990a; Rahe 2009; and USHMM 1996: 165–66.

Chapter 14

217　During my 2011 trip to Poland, I discovered confirmation regarding the events that led to Jadzia's diversion from the transport to Bergen-Belsen. While visiting the medical school in Poznań, I received from the director of the dean's office copies of my mother's medical school records and miscellaneous correspondence, which included notations regarding several letters sent to the medical academy in the mid-1970s from Michał Iwaniec, the Flossenbürg prisoner whom Jadzia met after the war. He was trying to reestablish contact and wanted my mother's current address. He mentioned that in 1945 he had "saved her from death by gassing." Perhaps he was referring to the fate she would probably have suffered if she had been sent to Bergen-Belsen. There were no gas chambers there, but many people assumed that what existed in Auschwitz was also true for other concentration camps. Unfortunately, the only address the medical school had on record for my mother was from the late 1950s; since my parents had moved by 1964, Mr. Iwaniec was unable to contact my mother.

217　The Flossenbürg *Nummernbuch* indicates that Jadzia was sent to Mehltheuer on March 19, 1945, ten days after being registered in the main concentration camp.

218　Information on the Mehltheuer slave labor camp comes from Fritz 2006; ITS 1949: 232, 1950: 562, 1979: 113; and Brenner 1999, who begins with a chronological listing of transports sent to all the Flossenbürg subcamps. The first entry for Mehltheuer (p. 11) shows that two hundred women from Bergen-Belsen arrived there on December 2, 1944; near the bottom of the page is another entry for Mehltheuer, showing one woman arriving on March 19, 1945—my mother.

219　Later in the book, Brenner (pp. 183–87) lists by name the prisoners who were sent to Mehltheuer, but he does not name my mother, nor is there evidence of Dr. Szajniuk's arrival. This puzzled me at first, but it makes sense if the prisoners working in the main camp office destroyed such records to protect Jadzia's transfer.

222　Brenner (1999: 184, my translation from the German) notes: "The camp commander was SS-Unterscharführer Fischer, who refused to carry out the order issued by the main commander of the Flossenbürg concentration camp." In another publication, he adds that the commander stopped Hungarian Arrow Cross Fascists, who arrived shortly before U.S. troops liberated the camp, from carrying out the shooting instead (Brenner 2009: 633).

223　For an overview of the liberation of Nazi camps based on documents, journalistic reports, photographs, and eyewitness accounts from the time, see United States Holocaust Memorial Council 1995.

223–24 The bombing of Plauen by the RAF on April 10–11, 1945, left twenty thousand people homeless. See *An Historical and Pictorial Record of the*

87th Infantry Division in World War II, 1942–1945 (87th Infantry Division Association, 2007, pp. 43–93, 94, 110–13, http://www.87thinfantrydivision.com /History/HistoryBook/index.html) and the 87th Infantry's campaign map, http:// www.87thinfantrydivision.com/History/87th/Media/Maps/CampaignLarge .gif (both accessed January 25, 2013).

226 "Most of you have been on a starvation diet": "Take the Doctor's Advice," *Surgeon's Bulletin*, May 6, 1945, Le Havre, France, http://www.merkki.com /images/ramp4.jpg (accessed January 25, 2013).

Chapter 15

A number of sources were helpful in understanding the complex political, social, and economic context of early postwar Germany, the refugee situation, and the challenges faced by the occupying Allied forces. These include Bergahn and Poiger n.d.; Bessel 2009; Frederiksen 1953; and Ziemke 1990. The Office of the Chief Historian European Command published, between 1947 and 1949, a set of volumes that provided an official history of the U.S. postwar occupation—the "Occupation Forces in Europe Series," located at the Combined Arms Research Library (Fort Leavenworth, Kansas) and online for the first year of occupation (1945–46), http:// cgsc.contentdm.oclc.org/utils/getfile/collection/p4013coll8/id/2970/filename/2950. pdf (accessed January 8, 2013).

Also of value was the University of Wisconsin's digital collection, "Germany Under Reconstruction," http://digital.library.wisc.edu/1711.dl/History (accessed March 1, 2013), especially the following: *Documents on Germany, 1944–1959* (1959); *A Year of Potsdam: The German Economy Since the Surrender* (1946); and the U.S. Military Government's *Weekly Information Bulletin*, published between July 1945 and March 1953. These bulletins offer glimpses of the range of policies, regulations, and problems that existed within the U.S. zone of Germany—from repatriation of displaced persons and the acute shortage of food to the resumption of beer production; see especially the "Review of 1946" (*Weekly Information Bulletin* 74, January 6, 1947) and "Review of 1947" (*Information Bulletin* 126, January 13, 1948). For a different perspective on early postwar Europe, especially concerning the injustice and violence that accompanied the expulsions and forced migrations resulting from postwar boundary changes, see Demshuk 2012; Lowe 2012; Ther and Siljak 2001; and Thum 2011.

234 An account of daily life in the largest Polish DP camp, Wildflecken, from the perspective of an UNRRA administrator is provided by Hulme 1953; see the accompanying scrapbook and photo album, http://beinecke.library. yale.edu/digitallibrary/ (accessed January 9, 2013).

235 "Civilians outside the national boundaries": Office of the Chief Historian European Command 1947a: 67. Wyman (1998) offers an overview of the problems facing displaced persons in postwar Germany and their struggles to create some semblance of family and community life while awaiting an uncertain future, whereas Jaroszyńska-Kirchmann (2004) focuses more

specifically on Polish DPs. For the U.S. occupying forces' perspective, see Frederiksen 1953: 73–80 and "Displaced Persons—Past and Future," *Weekly Information Bulletin* 10, September 19, 1945, pp. 8–11, http://digital.library. wisc.edu/1711.dl/History.omg1945n010 (accessed January 9, 2013).

236 The treatment of Jewish displaced persons and their special circumstances is discussed in Dinnerstein 1982; Grossman 2007; and United States Holocaust Memorial Council 1995: 169–237. Growing complaints about the conditions in DP assembly centers led President Truman in mid-1945 to appoint a committee, headed by Earl G. Harrison, to investigate the DP camps, with a special focus on Jewish refugees. The resulting "Harrison Report" (*New York Times*, September 30, 1945) was scathingly critical of conditions in many of the camps and led to improvements in the way DPs were treated, with separate camps established for Jewish refugees. See also the online exhibit of works by Maxine Rude, an UNRRA photographer: "Jewish Refugees and Other Displaced Persons, Europe 1945–1946," http://www.chgs.umn.edu/museum/exhibitions/displaced/exhibition.html (accessed January 9, 2013; last modified August 21, 2012).

236 For an analysis of the hostility and violence encountered by Jews returning to Poland, see Gross 2006 and Steinlauf 1997: 43–61.

237 Wyman (1989: 61–85) provides an extensive discussion of the repatriation of POWs and refugees to countries that were part of or under the influence of the Soviet Union. See also Murray-Brown 1992 and Ziemke 1990: 412–20. For a dramatization of this issue, see *Foyle's War (Series 6): The Russian House*, an episode in the British TV detective drama, which takes place during and immediately after World War II.

243 "In the town of Echzell": *Daily News Bulletin*, Jewish Telegraphic Agency, London, vol. 12, no. 128, June 6, 1931, p. 1, http://cdn.jta.org/archive_pdfs/1931/1931–06–06_128.pdf (accessed January 9, 2013); see also Kaufman 1992.

247 W. G. Sebald (2003:3) mentions the numbers of people killed and homes destroyed by the Allied bombing of Germany, and Grayling (2006), in an appendix to his book, provides a chronology of British RAF attacks on Germany, with estimated civilian deaths; statistics for Darmstadt are on p. 317.

249 The number of DPs remaining in Germany in September 1945 comes from Dinnerstein 1982: 277.

250 The number of Poles remaining in the U.S. zone of occupation in spring 1946 comes from a *New York Times* article by Dana Adams Schmidt, "U.S. Acts to Clear Zone of Refugees," April 3, 1946. According to Schmidt, the number of Polish DPs in the British zone was even greater—300,000—with another 46,000 in the French zone.

250–51 "Operation Carrot": Frederiksen 1953: 76–77; Wyman 1989: 71.

Chapter 16

252 "DP Civilian Guards Key to Occupation": Dana Adams Schmidt, *New York Times*, March 18, 1947.

253 I relied on two sources for understanding the changing context in which the U.S. military relied on civilian labor and for the history of the Civilian Guard Training and Replacement Center in Mannheim-Käfertal: Siemon and Wagberg 1968 and Office of the Chief Historian European Command 1947b, especially vol. 4: 199–215. Information about the Polish labor and guard companies, the *Oddziały Wartownicze* (OW) comes primarily from two Polish-language volumes (Fundusz Społeczny O.W. 1955; Mazanek-Wilczyńska, Skubisz, and Walczak 2011).

254 Winston Churchill's reference to the "iron curtain" is from a speech, "The Sinews of Peace," given at Westminster College in Fulton, Missouri, where he accepted an honorary degree; see http://www.youtube.com/watch?v=jvax5VUvjWQ (accessed January 13, 2013).

255 For more on the long-standing tensions between repatriation and resettlement and on complaints filed by the Soviet Union and its allies, see Jaroszyńska-Kirchmann 2004: 67; Wyman 1989; and two reports in the *United Nations Bulletin* regarding resolutions submitted to the United Nations General Assembly by Poland on this issue: "Assembly Debate on Repatriation and Resettlement" (June 1, 1949, vol. 6, no. 11, pp. 599–601) and "Treatment of Immigrant Labor" (November 1, 1949, no. 9, pp. 553, 554, 562).

Chapter 17

266 "For those of you who choose to remain": "Pressure Revived on U.S. Zone DP's," *New York Times*, April 15, 1947. For statistics on the number of DPs remaining in the U.S. occupation zone in 1947, see Dinnerstein 1982: 281–82.

266 Numerous articles in the *Weekly Information Bulletin* during 1947 and early 1948 reveal that life in Germany was still very difficult, with shortages of housing, food, coal, and means of transport slowing the economic recovery. The low level of food production was partly due to a harsh winter followed by a severe drought during the summer and early fall. The food ration in spring 1947 amounted to 1,550 calories per day for the average German. Refugees in DP camps fared slightly better, because some of their food was imported from the United States.

269–70 "It is hoped . . . that this . . . will be of assistance": J. Donald Kingley, in the foreword to International Refugee Organisation 1949: 4.

271 "Solely as a commodity" and "embargo on brains": Tuck 1948b: 426. This article summarizes an IRO report on "why Europe's refugee problem is still unsolved." The resettlement of displaced physicians was especially chal-

lenging, since immigrant countries were reluctant to accept professionals such as lawyers, physicians, and engineers. The extent of the problem is underscored by the fact that a total of 4,437 medical personnel were still in DP camps as of December 31, 1948 (*United Nations Bulletin*, May 15, 1949, p. 509). In the summer of 1948, the IRO organized two postgraduate medical refresher courses in its hospital in Munich, taught by a handful of professors from the United States and attended by 152 refugee doctors who had been experienced specialists or university professors before the war (Findlay and Burgess 1948). For an explanation of the IRO certification process and a discussion of the challenges immigrants faced in proving their professional competence and adapting to different standards for medical licensure and clinical practice in the United States, see Brunot 1951 and Burgess 1950, 1952.

271–72 "One present plan is concerned with": Tuck 1948a: 855.

272 The immigrant quota figures for the United States come from Wyman 1989: 186; the statistics for resettlement of Polish DPs are from Jaroszyńska-Kirchmann 2004: 104. Both authors detail the problems faced by DPs wishing to emigrate from Germany to the United States, as does Leonard Dinnerstein (1982), who focuses on the situation of Jewish DPs but also provides statistics and analyses of issues concerning DPs in general in the western Allied zones, including the ponderous process involved in helping a refugee apply for U.S. immigration under the 1948 DP Act (Dinnerstein 1982: 189–91).

273 The political cartoon about obstacles facing DPs immigrating to the United States is in the USHMM's Norbert Wollheim collection, photograph 49098.

Chapter 18

285 A brief history of the *Langfitt* is available in the "Dictionary of American Naval Fighting Ships," http://www.history.navy.mil/danfs/g3/general_w_c_langfitt .htm (accessed January 13, 2013). For another voyage made by Polish refugees in 1950 on this ship, but to Australia, see The *General Langfitt Story* (Allbrook and Cattalini 1995).

291–92 The information about aid to Polish refugees provided by Polish-American organizations during and after World War II comes from Jaroszyńska-Kirchmann 2004: 41–42, 113–18.

292 Jaroszyńska-Kirchmann (2004) provides a detailed analysis of the complex and at times conflicting relationship that existed between the post–World War II immigrants and the older, established Polonia. For general information about Polish-American history and social, political, and cultural life, see Pula 2010. For Polonia of Detroit more specifically, see Jensen 2006; Radzialowski 1974; Rylko-Bauer 1980; and Wrobel 1979.

Chapter 19

300 Published comments from the 1940 Annual Congress on Medical Education and Licensure offer a glimpse of both sides of the debate within the medical community concerning refugee physicians (*Journal of the American Medical Association* [*JAMA*], vol. 114, no. 16, pp. 1580–83.

301 "Since these persons are immigrants": Burgess and Graef 1953: 1260.

301 "The obstacles that [medical licensing] boards place": Burgess 1952: 419.

301 "To do a little soul-searching": McCormack 1954: 818.

301 For a broad overview of issues concerning U.S. licensure of foreign medical graduates, see Butter and Sweet 1977; Irigoyen and Zambrana 1979; Stevens and Vermeulen 1972.

302 Between 1939 and 1954, the National Committee for Resettlement of Foreign Physicians assisted more than ten thousand doctors. Not all succeeded in getting licensed or finding relevant jobs, but such support improved their chances of success. According to Edsall 1940, the relatively high rates of exam failure were due partly to lack of familiarity with American-style examinations, language difficulties, extended clinical inactivity caused by war, and economic realities in the United States that required refugee physicians to take any job available; see also McCormack 1954. Two other organizations that tried to match screened professionals with available refresher courses, additional training, and job opportunities were the International Rescue Committee and the National Committee for Resettlement of Displaced Professionals (Brunot 1951; McCormack 1954).

302 The National Committee for Resettlement of Foreign Physicians argued against licensure restrictions that were irrelevant to assessing physician competence, such as citizenship. In the mid-1930s, few states had such requirements, but this changed by 1940. Sixteen states would not consider foreign-trained doctors, ten states required a filed declaration of intent to become a citizen, and twenty-three states required full citizenship before an applicant could take the exam (see "Medical Licensure Statistics for 1940," *JAMA*, 1941, vol. 116, no. 18, p. 2045).

A major factor in this change was a resolution adopted in 1938 by the American Medical Association's (AMA) House of Delegates, urging state medical boards to demand full citizenship as a criterion for licensure. This reflected concerns that an influx of foreign doctors would increase competition. Supporters of the resolution argued that medical competency must also include familiarity with "the American conception of patriotism and of ethical ideals in medicine"—wording taken from the 1938 resolution (see "Resolutions Requiring of Foreign Graduates Full Citizenship in the United States" *JAMA*, 1938, vol. 111, no. 1, pp. 41, 45). From this perspective, "alien nationality" was seen as a potential "factor of unfitness," because foreign physicians supposedly could not fulfill their social,

spiritual, and moral responsibilities toward the community; the imposed five years of residency prior to citizenship was viewed as time for them to gain this familiarity (McIntyre 1939: 1075). In reality, it discouraged immigrant doctors and limited their licensure potential by enforcing five years of professional inactivity, leading to deterioration of medical skills and knowledge, and a greater chance of failure when applicants eventually took the licensing exam; see also Szulc 1949. Various restrictions were also applied by professional licensing bodies for dentistry, optometry, pharmacy, and law (see "Refugees and the Professions," Harvard Law Review, 1939, vol. 53, no. 1, pp. 112–22).

303 For the list of approved foreign medical schools, see "Medical Education in the United States and Canada" (*JAMA*, 1955, vol. 159, no. 6, pp. 601–603).

303 Report of the Committee on Displaced Physicians regarding IRO certification, *JAMA*, vol. 141, no. 17, p. 1247.

307 Statistics on the number of women in medicine in the United States come from Stevens and Vermeulen 1972: 124, 161.

Chapter 20

322 The experiences of postwar immigrants to the United States or Canada varied greatly, as did the nature and extent of their assimilation and adjustment and these were determined by a multitude of factors—historical, cultural, social, and personal. Many, however, shared the sense of being caught between two worlds, between two cultures (Berger 2001; Hoffman 1989).

Chapter 21

331 The quote from the *Łódź Daily News* appeared in "Szpital Jej Wspomnień," Jolanta Bilinska, *Dziennik Łódzki,* June 19, 2001, p. 19.

332 For the article that accompanied the photograph on the cover of the *American Ethnologist,* see Waterston and Rylko-Bauer 2006.

338 During his eulogy at my mother's funeral, Father Jim Chelich raised the question of how someone who has endured great tragedy or suffering manages to "survive survival" and continue to live a seemingly normal life—this is the origin of the title for part 3 of this book.

338 "Our memory of the camps": Todorov 1996: 259.

340 "In the first century of world wars" is from the first line of Muriel Rukeyser's "Poem" (*A Muriel Rukeyser Reader,* edited by Jan Heller Levi, New York: W. W. Norton, 1995, pp. 211–12).

Bibliography

༉

Adelsberger, Lucie. 1995. *Auschwitz: A Doctor's Story.* Trans. Susan Ray. Boston: Northeastern University Press.

Adelson, Alan, ed. 1996. *The Diary of Dawid Sierakowiak: Five Notebooks from the Łódź Ghetto.* Trans. Kamil Turowski. New York: Oxford University Press.

Adelson, Alan, and Robert Lapides, eds. 1991. *Łódź Ghetto: Inside a Community under Siege.* New York: Penguin Books.

Aleksiun, Natalia. 2012. Christian Corpses for Christians! Dissecting the Anti-Semitism behind the Cadaver Affair of the Second Polish Republic. In *The Holocaust in Occupied Poland: New Findings and New Interpretations*, ed. Jan T. Gross, pp. 9-28. Frankfurt am Main: Peter Lang.

Allbrook, Maryon, and Helen Cattalini. 1995. *The General Langfitt Story: Polish Refugees Recount Their Experiences of Exile, Dispersal, and Resettlement.* Available at www.immi.gov.au/media/publications/refugee/langfitt/index.htm.

Allen, Michael Thad. 2002. *The Business of Genocide: The SS, Slave Labor, and the Concentration Camps.* Chapel Hill: University of North Carolina Press.

Aly, Götz. 1999. *"Final Solution": Nazi Population Policy and the Murder of the European Jews.* Trans. Belinda Cooper and Allison Brown. London: Arnold.

Andrzejewski, Tomasz. 2010. "Marsz śmierci" z Neusalz: Skradziona pamięć! ["Death march" from Neusalz: A stolen memory!]. *Tygonik Krąg* 8 January, available at www.tygodnikkrag.pl/cms/index.php/artykuy/nowa-sol/33-historia/628-marsz-mierci-znneusalz-skradziona-pami, accessed January 24, 2013.

Andrzejewski, Tomasz, Małgorzata Gącarzewicz, and Ryszard Sobkowicz. 2006. *Dzieje Nowej Soli: Wybór źródeł i materiałów [History of Nowa Sol: Select sources and materials].* Nowa Sól, Poland: Muzeum Miejski w Nowej Soli.

Annas, George J., and Michael A. Grodin. 1992. *The Nazi Doctors and the Nuremberg Code: Human Rights in Human Experimentation.* New York: Oxford University Press.

Anthonioz, Geneviève de Gaulle. 1999. *The Dawn of Hope: A Memoir of Ravensbrück.* Trans. Richard Seaver. New York: Arcade Publishing.

Apt, Krzysztof R. 2008. Alina Margolis i stan wojenny. *Zeszyty Literackie* 102:198–200.

Bachner, Mila. 2010. *Before My Eyes: A Memoir of Childhood during the Holocaust.* New York: Targum Press.

Baer, Elizabeth R., and Myrna Goldenberg, eds. 2003. *Experience and Expression: Women, the Nazis, and the Holocaust.* Detroit: Wayne State University Press.

Balinska, Marta Aleksandra. 1996. The National Institute of Hygiene and Public Health in Poland 1918–1939. *Social History of Medicine* 9(3):427–45.

Baranowski, Julian. 1989. Więzienie dla kobiet w Łodzi przy ulicy Gdańskiej 13 (1939–1945) [The Łódź women's prison at 13 Gdańska Street, 1939–1945]. *Biuletyn Okręgowej Komisji Badania Zbrodni Hitlerowskich w Łodzi.* Instytut Pamięci Narodowej, 1:24–29.

———. 2005. *The Łódź Ghetto / Łódzkie Getto 1940–1944: Vademecum.* Łódź: Archiwum Państwowe w Łodzi & Bilbo.

Baranowski, Julian, and Sławomir M. Nowinowski. 2009. *Getto Łódzkie, Litzmannstadt Getto 1940–1944.* Łódź: Archiwum Państwowe w Łodzi and Instytut Pamięci Narodowej.

Baranowski, Julian, and Andrzej Rukowiecki. 2004. *"Pomiędzy życiem a śmiercią": Litzmannstadt Getto, 1940–1944.* Exhibit catalog, April. Łódź: Muzeum Tradycji Niepodległościowych w Łodzi.

Bauer, Yehuda. 1989. The Death-Marches, January–May, 1945. In *The End of the Holocaust,* ed. Michael R. Marrus, vol. 9 of the series, The Nazi Holocaust, pp. 491–511. Westport, Conn.: Meckler.

———. 2009. *The Death of the Shtetl.* New Haven: Yale University Press.

Benedict, Susan. 2003. The Nadir of Nursing: Nurse-Perpetrators of the Ravensbrück Concentration Camp. *Nursing History Review* 11:129–46.

Benedict, Susan, and Jochen Kuhla. 1999. Nurses' Participation in the Euthanasia Programs of Nazi Germany. *Western Journal of Nursing Research* 21(2):246–63.

Berenbaum, Michael, and Abraham J. Peck, eds. 1998. *The Holocaust and History: The Known, the Unknown, the Disputed, and the Reexamined.* Bloomington: Indiana University Press.

Bergen, Doris L. 2005. Tenuousness and Tenacity: The *Volksdeutschen* of Eastern Europe, World War II, and the Holocaust. In *Heimat Abroad: The Boundaries of Germanness,* ed. Krista Molly O'Donnell, Renate Bridenthal, and Nancy Reagin, pp. 267–86. Ann Arbor: University of Michigan Press.

———. 2009. *War and Genocide: A Concise History of the Holocaust,* 2nd ed. Lanham, Md.: Rowman & Littlefield.

Berger, Joseph. 2001. *Displaced Persons: Growing Up American after the Holocaust.* New York: Scribner.

Berghahn, Volker, and Uta Poiger, eds. n.d. Occupation and the Emergence of Two States (1945–1961). In *German History in Documents and Images,* Vol. 8. Available at www.germanhistorydocs.ghi-dc.org/pdf/eng/English%20Introduction%20Vol%208-2.pdf, accessed January 25, 2013.

Bernstein, Sara Tuvel. 1997. *The Seamstress: A Memoir of Survival.* New York: Berkeley Books.

Bessel, Richard. 2009. *Germany 1945: From War to Peace.* New York: HarperCollins.

Besser, Aliza. 1946. Już więcej nie będzie wojny [There will be no more war]. Unpublished memoir, Yad Vashem Archives, file no. O3/3394.

Borodziej, Włodzimierz. 2006. *The Warsaw Uprising of 1944*. Trans. Barbara Harshav. Madison: University of Wisconsin Press.

Bourgois, Philippe. 2005. Missing the Holocaust: My Father's Account of Auschwitz from August 1943 to June 1944. *Anthropological Quarterly* 78(1):89–123.

Bourguignon, Erika. 1998. Foreword. In *Exile: A Memoir of 1939*, by Bronka Schneider, ed. Erika Bourguignon and Barbara Hill Rigney, p. vii–xii. Columbus: Ohio State University Press.

———. 2005. Memory in an Amnesic World: Holocaust, Exile, and the Return of the Suppressed. *Anthropological Quarterly* 78(1):63–88.

Braiter, Leslaw. 2009. Gross-Rosen Main Camp. Trans. Gerard Majka. In *United States Holocaust Memorial Museum Encyclopedia of Camps and Ghettos, 1933–1945*, Vol. 1, ed. Geoffrey P. Megargee, pp. 694–97. Bloomington: Indiana University Press.

Brenner, Hans. 1999. *Frauen in den Außenlagern des KZ Flossenbürg*. Regensburg, Germany: Arbeitsgemeinschaft ehem. KZ Flossenbürg e.V.

———. 2009. Mehltheuer. Trans. Eric Schroeder. In *United States Holocaust Memorial Museum Encyclopedia of Camps and Ghettos, 1933–1945*, Vol. 1, ed. Geoffrey P. Megargee, pp. 632–33. Bloomington: Indiana University Press.

Brown, Daniel Patrick. 2002. *The Camp Women: The Female Auxiliaries Who Assisted the SS in Running the Nazi Concentration Camp System*. Atglen, Pa.: Schiffer Publishing.

Browning, Christopher R. 2000. *Nazi Policy, Jewish Workers, German Killers*. Cambridge: Cambridge University Press.

———. 2010. *Remembering Survival: Inside a Nazi Slave Labor Camp*. New York: W. W. Norton & Co.

Brunot, James. 1951. Resettlement of Displaced Physicians: A New Approach. *Journal of the American Medical Association* 145(14):1059–62.

Brush, Barbara L. 2004. Nursing Care and Context in Theresienstadt. *Western Journal of Nursing Research* 26(8):860–71.

Burgess, Alexander M. 1950. Resettlement of the Displaced Physician in the United States. *New England Journal of Medicine* 143(5):413–16.

———. 1952. Resettlement of Refugee Physicians in the United States. *New England Journal of Medicine* 241(12):419–23.

Burgess, Alexander M., and Irving Graef. 1953. Foreign-Trained Physicians (Letter to the Editor). *Journal of the American Medical Association* 152(13):1260.

Burleigh, Michael. 2000. *The Third Reich: A New History*. New York: Hill and Wang.

Butter, Irene, and Rebecca G. Sweet. 1977. Licensure of Foreign Medical Graduates: An Historical Perspective. *Milbank Memorial Fund Quarterly* 55(2):315–40.

Cassedy, Ellen. 2012. *We Are Here: Memories of the Lithuanian Holocaust*. Lincoln: University of Nebraska Press.

Chclouche, Tessa. 2005. Some Ethical Dilemmas Faced by Jewish Doctors during the Holocaust. *Medicine and Law* 24:703–16.

Climo, Jacob J., and Maria G. Cattell, eds. 2002. *Social Memory and History: Anthropological Perspectives*. Walnut Creek, Calif.: AltaMira Press.

Connelly, John. 1999. Nazis and Slavs: From Racial Theory to Racist Practice. *Central European History* 32(1):1–33.

———. 2004. Those Streets over There. *London Review of Books*. 24 June, pp. 19–20.

Cornwell, John. 2003. *Hitler's Scientists: Science, War, and the Devil's Pact*. New York: Viking.

Cygański, Mirosław. 1965. *Z dziejów okupacji hitlerowskiej w Łodzi, 1939–1945* [*A history of the Nazi occupation of Łódź, 1939–1945*]. Łódź: Wydawnictwo Łódzkie.

Davies, Norman. [1984] 2001. *Heart of Europe: The Past in Poland's Present*. Repr. Oxford: Oxford University Press.

———. 2003. *Rising '44: The Battle for Warsaw*. New York: Viking.

———. 2005. *God's Playground: A History of Poland. Vol. II: 1795 to the Present*. New York: Columbia University Press.

Delbo, Charlotte. 1995. *Auschwitz and After*. Trans. Rosette C. Lamont. New Haven: Yale University Press.

Demshuk, Andrew. 2012. *The Lost German East: Forced Migration and the Politics of Memory, 1945–1970*. New York: Cambridge University Press.

De Silva, Cara, ed. 2006. *In Memory's Kitchen: A Legacy from the Women of Terezín*. Trans. Bianca Steiner Brown. Northvale, N.J.: Jason Aronson.

Dinnerstein, Leonard. 1982. *America and the Survivors of the Holocaust*. New York: Columbia University Press.

Dobroszycki, Lucjan, ed. 1984. *The Chronicle of the Łódź Ghetto, 1941–1944*. New Haven: Yale University Press.

Dublon-Knebel, Irith, ed. 2010. *A Holocaust Crossroads: Jewish Women and Children in Ravensbrück*. Portland, Ore.: Vallentine Mitchell.

Dwork, Debórah, and Robert Jan van Pelt. 2003. *Holocaust: A History*. New York: W. W. Norton & Co.

———. 2006. Sala's World: 1939–1945: Sosnowiec, Schmelt's Camps, and the Holocaust. In *Letters to Sala: A Young Woman's Life in Nazi Labor Camps*, by Ann Kirschner, pp. 50–77. New York: New York Public Library.

Edelman, Marek. 1990. *The Ghetto Fights: Warsaw 1941–43*. London: Bookmarks.

Edsall, David L. 1940. The Émigré Physician in American Medicine. *Journal of the American Medical Association* 114(12):1068–73.

Eisler, Jerzy. 1998. March 1968 in Poland. In *1968: The World Transformed*, ed. Carole Fink, Philipp Gassert, and Detlef Junker, pp. 237–51. Cambridge: Cambridge University Press.

Ellis, Carolyn, and Arthur P. Bochner. 2000. Autoethnography, Personal Narrative, Reflexivity: Researcher as Subject. In *Handbook of Qualitative Research*, 2nd ed., ed. Norman K. Denzin and Yvonna S. Lincoln, pp. 733–68. Thousand Oaks, Calif.: Sage Publications.

Falstein, Louis, ed. 1963. *The Martyrdom of Jewish Physicians in Poland*. New York: Exposition Press.

Farmer, Paul. 2005. The Banality of Agency: Bridging Personal Narrative and Political Economy. *Anthropological Quarterly* 78(1):125–35.

Federowicz, Grażyna, Hanna Machnik, and Iwona Maziarz, eds. 2006. *Bibliografia Polska, 1901–1939, Tom 8, Fr-Gef.* Warsaw: Biblioteka Narodowa.

Ferencz, Benjamin B. [1979] 2002. *Less than Slaves: Jewish Forced Labor and the Quest for Compensation.* Repr. Bloomington: Indiana University Press.

Findlay, Louis, and Alexander M. Burgess. 1948. Refugee Physicians in the U.S. Zone of Germany and the Munich Medical Teaching Mission of 1948. *Journal of the American Medical Association* 138(110):813–16.

Flaschka, Monika J. 2009. Race, Rape, and Gender in Nazi-Occupied Territories. Ph.D. diss., Kent State University.

Frederiksen, Oliver J. 1953. *American Military Occupation of Germany 1945–1953.* Karlsruhe, Germany: Historical Division, Headquarters, U.S. Army Europe. Available at www.history.hqusareur.army.mil/Archives/Annual%20Folder/aocc45-53. pdf, accessed July 11, 2010.

Friedrich, Jörg. 2006. *The Fire: The Bombing of Germany, 1940–1945*, trans. Allison Brown. New York: Columbia University Press.

Fritz, Ulrich. 2006. Mehltheuer (translated for me from the German by the author). *In Der Ort des Terrors: Geschichte der nationalsozialistischen Konzentrationslager.* Vol. 4, *Flossenbürg, Mauthausen, Ravensbrück*, ed. Wolfgang Benz and Barbara Distel, pp. 191–93. Munich: C. H. Beck.

Fundusz Społeczny O. W. 1955. *Dziesięciolecie Polskich Oddziałów Wartowniczych przy Armii Amerykańskiej w Europie, 1945–1955* [*Tenth anniversary of Polish Civilian Guard Units with the U.S. Army in Europe, 1945–1955*]. Mannheim: Drukarnia Polskich Oddziałów Wartowniczych.

Gilbert, Martin. 1993. *Atlas of the Holocaust.* New York: William Morrow and Co.

———. 2000. *Never Again: A History of the Holocaust.* New York: Universe.

Glowacka, Dorota, and Joanna Zylinska, eds. 2007. *Imaginary Neighbors: Mediating Polish-Jewish Relations after the Holocaust.* Lincoln: University of Nebraska Press.

Głowacka, Maria, and Małgorzata Lechowicz. 2009. *The Prison in Długa (Gdańska) Street in Łódź, 1885–1953.* Łódź: Museum of the Independence Traditions in Łódź.

Główna Komisja Badania Zbrodni Hitlerowskich w Polsce, Rada Ochrony Pomników Walk i Męczeństwa. 1979. *Obozy hitlerowskie na ziemiach polskich, 1939–1945.* Warsaw: Państwowe Wydawnictwo Naukowe.

Goldenberg, Myrna. 2003. Food Talk: Gendered Responses to Hunger in the Concentration Camps. In *Experience and Expression: Women, the Nazis, and the Holocaust*, ed. Elizabeth R. Baer and Myrna Goldenberg, pp. 161–79. Detroit: Wayne State University Press.

Goldenberg, Myrna, and Amy H. Shapiro, eds. 2013. *Different Horrors, Same Hell: Gender and the Holocaust.* Seattle: University of Washington Press.

Gołębiowska, Maria, ed. 2005. *Szpital Anny Marii w Łodzi* [*The Anna Maria Hospital in Łódź*]. Łódź: Wydawnictwo BESTOM-DENTOnet.pl.

Grabowski, Jan. Forthcoming. *Hunt for the Jews: Betrayal and Murder in German-Occupied Poland.* Bloomington: Indiana University Press.

Grayling, A. C. 2006. *Among the Dead Cities: The History and Moral Legacy of the WWII Bombings of Civilians in Germany and Japan*. New York: Walker & Co.

Greenspan, Henry. 1998. *On Listening to Holocaust Survivors: Recounting and Life History*. Westport, Conn.: Praeger.

Gross, Jan T. 2001. *Neighbors: The Destruction of the Jewish Community in Jedwabne, Poland*. Princeton: Princeton University Press.

———. 2006. *Fear: Anti-Semitism in Poland after Auschwitz*. New York: Random House.

———, ed. 2012. *The Holocaust in Occupied Poland: New Findings and New Interpretations*. Frankfurt am Main: Peter Lang.

Gross, Jan Tomasz, and Irena Grudzińska Gross. 2012. *Golden Harvest: Events at the Periphery of the Holocaust*. New York: Oxford University Press.

Grossman, Atina. 2007. *Jews, Germans, and Allies: Close Encounters in Occupied Germany*. Princeton: Princeton University Press.

Grossman, Naomi. 2001. Ghettos: Hunger and Disease. In *The Holocaust Encyclopedia*, ed. Walter Laqueur, pp. 259–65. New Haven: Yale University Press.

Grupińska, Anka. 2000. *Ciągle po kole: Rozmowy z żołnierzami Getta Warszawskiego*. Warszawa: Twój Styl.

Gutman, Israel, editor-in-chief. 1990. *Encyclopedia of the Holocaust*. New York: Macmillan.

———. 2006. Introduction: The Distinctiveness of the Łódź Ghetto. In *Łódź Ghetto: A History*, by Isaiah Trunk. Ed. and trans. Robert Moses Shapiro, pp. xxix–lvii. Bloomington: Indiana University Press.

Gutman, Yisrael, Ezra Mendelsohn, Jehuda Reinharz, and Chone Shmeruk, eds. 1989. *The Jews of Poland between Two World Wars*. Hanover, N.H.: University Press of New England.

Gutterman, Bella. 2008. *A Narrow Bridge to Life: Jewish Forced Labor and Survival in the Gross-Rosen Camp System, 1940–1945*. New York: Berghahn Books.

Hayes, Peter. 1998. State Policy and Corporate Involvement in the Holocaust. In *The Holocaust and History: The Known, the Unknown, the Disputed, and the Reexamined*, ed. Michael Berenbaum and Abraham J. Peck, pp. 197–218. Bloomington: Indiana University Press.

Hedgepeth, Sonja M., and Rochelle G. Saidel, eds. 2010. *Sexual Violence against Jewish Women during the Holocaust*. Lebanon, N.H.: University Press of New England/Brandeis University Press.

Herbert, Ulrich. 2000. Forced Laborers in the Third Reich: An Overview. *International Labor and Working-Class History* 58(Fall):192–218.

Hilberg, Raul. 1985. *The Destruction of European Jews*. New York: Holmes and Meier.

———. 2001. *Sources of Holocaust Research: An Analysis*. Chicago: Ivan R. Dee.

Hillel, Marc, and Clarissa Henry. 1976. *Of Pure Blood*. Trans. Eric Mossbacher. New York: Pocket Books.

Hirsch, Marianne. 1997. *Family Frames: Photography, Narrative, and Postmemory*. Cambridge, Mass.: Harvard University Press.

————. 2012. *The Generation of Postmemory: Writing and Visual Culture after the Holocaust.* New York: Columbia University Press.

Hoffman, Eva. 1989. *Lost in Translation: A Life in a New Language.* New York: Dutton.

————. 2004. *After Such Knowledge: Memory, History, and the Legacy of the Holocaust.* New York: PublicAffairs.

Horwitz, Gordon J. 2008. *Ghettostadt: Łódź and the Making of a Nazi City.* Cambridge, Mass.: Harvard University Press, Belknap Press.

Huebner, Todd. 2009. Flossenbürg Main Camp. In *United States Holocaust Memorial Museum Encyclopedia of Camps and Ghettos, 1933–1945,* Vol. 1, ed. Geoffrey P. Megargee, pp. 560–65. Bloomington: Indiana University Press.

Hulme, Kathryn. 1953. *The Wild Place.* Boston: Little, Brown.

International Refugee Organisation. 1949. *Professional Medical Register.* Geneva: International Refugee Organisation.

Irigoyen, Matilde, and Ruth E. Zambrana. 1979. Foreign Medical Graduates (FMGs): Determining Their Role in the U.S. Health Care System. *Social Science and Medicine* 13A:775–83.

ITS (International Tracing Service). 1949. *Catalogue of Camps and Prisons in Germany and German-Occupied Territories, Sept. 1st, 1939–May 8th, 1945,* Vol. I. Arolsen, Germany: International Tracing Service.

————. 1950. *Catalogue of Camps and Prisons in Germany and German-Occupied Territories, Sept. 1st, 1939–May 8th, 1945,* Vol. II. Arolsen, Germany: International Tracing Service.

————. 1979. *Verzeichnis der Haftstätten unter dem Reichsführer-SS, 1933–1945* [*Catalog of Places of Imprisonment under SS Command, 1933–1945*], Vol. I. Arolsen, Germany: International Tracing Service.

Iwanicki, Ryszard, Grażyna Janaszek, and Andrzej Rukowiecki. 2011. *Łódź i Ziemia Łódzka w okresie wojny i okupacji 1939–1945.* [*Łódź and its surrounding region during the war and occupation 1939–1945*]. Łódź: Muzeum Tradycji Niepodległościowych w Łodzi.

Jaroszyńska-Kirchmann, Anna D. 2004. *The Exile Mission: The Polish Political Diaspora and Polish Americans, 1939–1956.* Athens: Ohio University Press.

Jensen, Cecile Wendt. 2006. *Detroit's Polonia.* Arcadia Publishing.

Kaminsky, Marc. 1992. Introduction. In *Remembered Lives,* by Barbara Myerhoff, pp. 1–97. Ann Arbor: University of Michigan Press.

Kaufman, M. 1992. The Daily Life of the Village and Country Jews in Hessen from Hitler's Ascent to Power to November 1938. *Yad Vashem Studies* 22: 147–98.

Kaufman, Michael T. 2009. Marek Edelman, Commander in Warsaw Ghetto Uprising, Dies at 90. *New York Times,* October 3.

Klemperer, Victor. 1999. *I Will Bear Witness: A Diary of the Nazi Years, 1942–1945.* Trans. Martin Chalmers. New York: Random House.

Kirschner, Ann. 2006a. *Letters to Sala: A Young Woman's Life in Nazi Labor Camps.* New York: New York Public Library.

————. 2006b. *Sala's Gift: My Mother's Holocaust Story.* New York: Free Press.

Konieczny, Alfred. 1990a. Gross Rosen. In *Encyclopedia of the Holocaust*, Israel Gutman, editor-in-chief, pp. 623–26. New York: Macmillan.

———. 1990b. Organisation Schmelt. In *Encyclopedia of the Holocaust*, Israel Gutman, editor-in-chief, pp. 1093–95. New York: Macmillan.

Krakowski, Shmuel. 1989. The Death Marches in the Period of the Evacuation of the Camps. In *The End of the Holocaust*, ed. Michael R. Marrus. pp. 476–90. Westport, Conn.: Meckler.

———. 1990a. Bergen-Belsen. In *Encyclopedia of the Holocaust*, Israel Gutman, editor-in-chief, pp.185–90. New York: Macmillan.

———. 1990b. Łódź. In *Encyclopedia of the Holocaust*, Israel Gutman, editor-in-chief, pp. 900–909. New York: Macmillan.

———. 1990c. Volksdeutsche. In *Encyclopedia of the Holocaust*, Israel Gutman, editor-in-chief, pp. 1581–83. New York: Macmillan.

———. 2001. Forced Labor. In *The Holocaust Encyclopedia*, ed. Walter Laqueur, pp. 210–13. New Haven: Yale University Press.

Krall, Hanna. 1986. *Shielding the Flame: An Intimate Conversation with Dr. Marek Edelman, the Last Surviving Leader of the Warsaw Ghetto Uprising*. Trans. Joanna Stasinska and Lawrence Weschler. New York: Henry Holt and Co.

Kramer, Naomi, and Ronald Headland. 1998. *The Fallacy of Race and the Shoah*. Ottawa: University of Ottawa Press.

Kryda, Barbara, ed. 1986. *Krajobraz poezji polskiej: Antologia*. Warsaw: Wydawnictwo Szkolne i Pedagogiczne.

LaCapra, Dominick. 2001. *Writing History, Writing Trauma*. Baltimore: Johns Hopkins University Press.

Lagerwey, Mary D. 2003. The Nurses' Trial at Hadamar and the Ethical Implications of Health Care Values. In *Experience and Expression: Women, the Nazis, and the Holocaust*, ed. Elizabeth R. Baer and Myrna Goldenberg, pp. 111–26. Detroit: Wayne State University Press.

Lanckorońska, Countess Karolina. 2007. *Michelangelo in Ravensbrück: One Woman's War against the Nazis*. Trans. Noel Clark. Cambridge, Mass.: Da Capo Press.

Langer, Lawrence L. 1991. *Holocaust Testimonies: The Ruins of Memory*. New Haven: Yale University Press.

Lanzmann, Claude. 1985. *Shoah: An Oral History of the Holocaust. The Complete Text of the Film*. New York: Pantheon Books.

Laqueur, Walter. 2001. *Generation Exodus: The Fate of Young Jewish Refugees from Nazi Germany*. Hanover, N.H.: University Press of New England/Brandeis University Press.

———, ed. 2001. *The Holocaust Encyclopedia*. New Haven: Yale University Press.

Laufer, Fran. 2009. *A Vow Fulfilled. The Fran Laufer Story: Memories and Miracles*. Southfield, Mich.: Targum Press.

Lengyel, Olga. [1947] 1983. *Five Chimneys: The Story of Auschwitz*. Repr. New York: Howard Fertig.

Leslie, R. F. 1980. *The History of Poland since 1863*. Cambridge: Cambridge University Press.

Levi, Primo. 1989. *The Drowned and the Saved*. Trans. Raymond Rosenthal. New York: Vintage International.

———. [1958] 1996. *Survival in Auschwitz: The Nazi Assault on Humanity*. Trans. Stuart Woolf. Repr. New York: Touchstone.

Levi, Primo, with Leonardo de Benedetti. 2006. *Auschwitz Report*, ed. Robert S. C. Gordon, trans. Judith Woolf. London: Verso.

Lewandowska, Leokadia. 2009. Neusalz. Trans. Gerard Majka. In *United States Holocaust Memorial Museum Encyclopedia of Camps and Ghettos, 1933–1945*, Vol. 1, ed. Geoffrey P. Megargee, pp. 767–69. Bloomington: Indiana University Press.

Lifton, Robert Jay. [1986] 2000. *The Nazi Doctors: Medical Killing and the Psychology of Genocide*. Repr. New York: Basic Books.

Lingens-Reiner, Ella. 1948. *Prisoners of Fear*. London: Victor Gollancz.

Lowe, Keith. 2012. *Savage Continent: Europe in the Aftermath of World War II*. New York: St. Martins Press.

Lukas, Richard C. [1994] 2001. *Did the Children Cry? Hitler's War against Jewish and Polish Children, 1939–1945*. New York: Hippocrene Books.

Lukowski, Jerzy, and Hubert Zawadzki. 2001. *A Concise History of Poland*. Cambridge: Cambridge University Press.

Maleńczyk, Jerzy. 1994. *A Guide to Jewish Lodz*. Warsaw: Jewish Information and Tourist Bureau.

Margolis-Edelman, Alina. 1994. *Ala z elementarza*. London: Aneks.

———. 1998. Ala from the Primer. In *Focusing on Aspects and Experiences of Religion*, Polin: Studies in Polish Jewry, Vol. 11, ed. Antony Polonsky, pp. 94–111. London: Littman Library of Jewish Civilization.

Mazanek-Wilczyńska, Monika, Paweł Skubisz, and Henryk Walczak, eds. 2011. *Polskie Oddziały Wartownicze przy Armii Amerykańskiej w latach 1945–1989* [*Polish Guard Companies of the U.S. Army, 1945–1989*]. Szczecin: Institut Pamięci Narodowej.

Mazya, Fredka, and Avihu Ronen. 1990. Eastern Upper Silesia. In *Encyclopedia of the Holocaust*, Israel Gutman, editor-in-chief, pp. 1351–55. New York: Macmillan.

McCormack, James E. 1954. The Problem of the Foreign Physician. *Journal of the American Medical Association* 155(9):818–23.

McIntyre, J. E. 1939. Citizenship and Medical Licensure. *Journal of the American Medical Association* 112(11):1075–77.

Meed, Vladka. 1993. *On Both Sides of the Wall: Memoirs from the Warsaw Ghetto*. New York: Schocken Books.

Megargee, Geoffrey P., ed. 2009. *United States Holocaust Memorial Museum Encyclopedia of Camps and Ghettos, 1933–1945. Vol.1. Early Camps, Youth Camps, and Concentration Camps and Subcamps under the SS-Business Administration Main Office (WVHA)*. Bloomington: Indiana University Press.

Melzer, Emanuel. 1997. *No Way Out: The Politics of Polish Jewry, 1935–1939*. Cincinnati: Hebrew Union College Press.

Michalczyk, John J., ed. 1994. *Medicine, Ethics, and the Third Reich: Historical and Contemporary Issues*. Kansas City: Sheed & Ward.

Michlic, Joanna Beata. 2006. *Poland's Threatening Other: The Image of the Jew from 1880 to the Present*. Lincoln: University of Nebraska Press.

Michowicz, Janina. 1969. Więzienie przy ul. Gdańskiej (1939–1945 r.) w świetle relacji byłych więźniarek [The prison on Gdańska Street, 1939–1945 according to recollections by former prisoners]. *Rocznik Łódzki* 13(16):147–52.

Milton, Sybil. 1979. *The Stroop Report*. Trans. Sybil Milton. New York: Pantheon Books.

———. 1990. Non-Jewish Children in the Camps. In *Mosaic of Victims: Non-Jews Persecuted and Murdered by the Nazis*, ed. Michael Berenbaum, pp. 150–60. New York: New York University Press.

Miłosz, Czesław. 2001. *Milosz's ABC's*. New York: Farrar, Straus and Giroux.

Mnichowski, Przemysław. 1987. *Miejsca pamięci narodowej województwa zielonogórskiego: Nowa Sól*. Nowa Sól: Nowosolska Fabryka Nici "Odra."

Morrison, Jack G. 2000. *Ravensbrück: Everyday Life in a Women's Concentration Camp, 1939–1945*. Princeton: Markus Weiner Publishers.

Mostowicz, Arnold. 2005. *With a Yellow Star and a Red Cross: A Doctor in the Łódź Ghetto*. Trans. Henia and Nochem Reinhartz. London: Vallentine Mitchell.

Murray-Brown, Jeremy. 1992. A Footnote to Yalta. Available at www.bu.edu/jeremymb/papers/paper-y1.htm, accessed July 10, 2010.

Myerhoff, Barbara. 1992. *Remembered Lives: The Work of Ritual, Storytelling, and Growing Older*. Ann Arbor: University of Michigan Press.

Nance, Agnieszka. 2006. *Literary and Cultural Images of a Nation without a State*. New York: Peter Lang Publishing.

Nicosia, Francis R., and Jonathan Huener, eds. 2002. *Medicine and Medical Ethics in Nazi Germany: Origins, Practices, Legacies*. New York: Berghahn Books.

Nossack, Hans Erich. 2004. *The End: Hamburg, 1943*. Trans. Joel Agee. Chicago: University of Chicago Press.

Nyiszli, Miklos. [1960] 1993. *Auschwitz: A Doctor's Eyewitness Account*. Trans. Tibère Kremer and Richard Seaver. New York: Arcade Publishing.

Ofer, Dalia, and Lenore J. Weitzman, eds. 1998. *Women in the Holocaust*. New Haven: Yale University Press.

Office of the Chief Historian European Command. 1947a. *Disarmament and Disbandment of the German Armed Forces*. Occupation Forces in Europe Series, 1945–1946. Frankfurt-am-Main, Germany: Office of the Chief Historian European Command.

———. 1947b. *The Second Year of the Occupation*. Occupation Forces in Europe Series, 1946–47. Frankfurt-am-Main, Germany: Office of the Chief Historian European Command.

———. [1947] 1953. *The First Year of the Occupation*. Occupation Forces of Europe Series, 1945–46. Frankfurt-am-Main, Germany: Office of the Chief Historian European Command. Available at http://cgsc.contentdm.oclc.org/utils/getfile/collection/p4013coll8/id/2970/filename/2950.pdf, accessed January 25, 2013.

Paulsson, Gunnar S. 2002. *Secret City: The Hidden Jews of Warsaw, 1940–1945.* New Haven: Yale University Press.

Perl, Gisella. [1948] 1998. *I Was a Doctor in Auschwitz.* Repr. Salem, N.H.: Ayer Co.

Podolska, Joanna. 2009. *Spacerownik, Łódź żydowska* [*Walking guide to Jewish Łódź*]. Łódź: Agora SA and Biblioteka Gazety Wyborczej.

Polonsky, Antony, ed. [1991] 2005. *Jews in Łódź: 1820–1939.* Polin, Studies in Polish Jewry. Vol. 6. Portland, Ore.: Littman Library of Jewish Civilization.

Polonsky, Antony, and Joanna B. Michlic. 2004. *The Neighbors Respond: The Controversy over the Jedwabne Massacre in Poland.* Princeton: Princeton University Press.

Posłuszna, Małgorzata. 2004. Edukacja zdrowotna wobec cywilizacyjnych plag i chorób społecznych II Rzeczypospolitej w perspektywie początku XXI wieku. In *Edukacja dla bezpieczeństwa: Wybrane perspektywy,* ed. Dariusz Kowalski, Michał Kwiatkowski, and Andrzej Zduniak, pp. 271–81. Lublin: O'CHIKARA.

Proctor, Robert. 1988. *Racial Hygiene: Medicine under the Nazis.* Cambridge, Mass.: Harvard University Press.

Pula, James S., ed. 2010. *The Polish American Encyclopedia.* Jefferson, N.C.: McFarland.

Radzialowski, Thaddeus. 1974. A View from a Polish Ghetto: Some Observations on the First One Hundred Years in Detroit. *Ethnicity* 1(2):125–50.

Rahe, Thomas. 2009. Bergen-Belsen Main Camp. Trans. Stephen Pallavicini. In *United States Holocaust Memorial Museum Encyclopedia of Camps and Ghettos, 1933–1945,* Vol. 1, ed. Geoffrey P. Megargee, pp. 278–81. Bloomington: Indiana University Press.

Rittner, Carol, and John K. Roth, eds. 1993. *Different Voices: Women and the Holocaust.* St. Paul, Minn.: Paragon House.

Ritvo, Roger A., and Diane M. Plotkin. 1998. *Sisters in Sorrow: Voices of Care in the Holocaust.* College Station: Texas A&M University Press.

Robinson, Bernard, with Amalie Mary Reichmann-Robinson. 1998. Some Consequences of the Schmelt Organization as Experienced by Affected Individuals. Unpublished manuscript available at Yad Vashem Library, Jerusalem, call number 98-3151F.

Roemer, Milton I., and Ruth Roemer. 1978. *Health Manpower in the Socialist Health Care System of Poland.* DHEW Publication (HRA) 78–85. Washington, D.C.: U.S. Department of Health, Education, and Welfare.

Roland, Charles G. 1992. *Courage under Siege: Starvation, Disease, and Death in the Warsaw Ghetto.* New York: Oxford University Press.

Rossino, Alexander B. 2003. *Hitler Strikes Poland: Blitzkrieg, Ideology, and Atrocity.* Lawrence: University Press of Kansas.

Rotem, Simha. 1994. *Kazik: Memoirs of a Warsaw Ghetto Fighter.* New Haven: Yale University Press.

Rothberg, Michael. 2009. *Multidirectional Memory: Remembering the Holocaust in the Age of Decolonization.* Stanford: Stanford University Press.

Rudnicki, Szymon. 1993. From "Numerus Clausus" to "Numerus Nullus." In *From Shtetl to Socialism. Studies from Polin*, ed. Antony Polonsky, pp. 359–81. London: Littman Library of Jewish Civilization.

———. 2005. Anti-Jewish Legislation in Interwar Poland. In *Antisemitism and Its Opponents in Modern Poland*, ed. Robert Blobaum, pp. 148–70. Ithaca: Cornell University Press.

Ryłko, Władysław. 1929. *Zarys historji wojennej 7-go Pułku Artylerji Polowej 1918-1920*. Warsaw: Wojskowe Biuro Historyczne.

Rylko-Bauer, Barbara. 1980. Rethinking Ethnicity: A Study of Ethnic Change and Variation among the Polish-Americans of Metropolitan Detroit. Master's Thesis, University of Kentucky.

———. 2005a. Introduction: Bringing the Past into the Present: Family Narratives of Holocaust, Exile, and Diaspora. *Anthropological Quarterly* 78(1):7–10.

———. 2005b. Lessons about Humanity and Survival from My Mother and from the Holocaust. *Anthropological Quarterly* 78(1):11–41.

———. 2009. Medicine in the Political Economy of Brutality: Reflections from the Holocaust and Beyond. In *Global Health in Times of Violence*, ed. Barbara Rylko-Bauer, Linda Whiteford, and Paul Farmer, pp. 201–22. Santa Fe: School for Advanced Research Press.

Sadowska, Jolanta. 2005. Sytuacja sanitarno-epidemiologiczna przemysłowej aglomeracji łódzkiej w okresie niewoli narodowej i w II Rzeczypospolitej. *Przegląd Epidemiologiczny* 59:163–71.

Saidel, Rochelle G. 2000. Women's Experiences during the Holocaust—New Books in Print. *Yad Vashem Studies* 28:363–78.

———. 2004. *The Jewish Women of Ravensbrück Concentration Camp*. Madison: University of Wisconsin Press.

Schafft, Gretchen E. 2004. *From Racism to Genocide: Anthropology in the Third Reich*. Urbana: University of Illinois Press.

———. 2005. Nazi Anthropology and Public Health in Second World War Poland: The Case of Herbert Grohmann. *Anthropology in Action* 12(3):1–11.

Schafft, Gretchen E., and Gerhard Zeidler. 2011. *Commemorating Hell: The Public Memory of Mittelbau-Dora*. Urbana: University of Illinois Press.

Scheper-Hughes, Nancy, and Philippe Bourgois. 2004. Introduction: Making Sense of Violence. In *Violence in War and Peace: An Anthology*, ed. Nancy Scheper-Hughes and Philippe Bourgois, pp. 1–31. Malden, Mass.: Blackwell Publishing.

Schmidt, Ulf. 2008. 'The Scars of Ravensbrück': Medical Experiments and British War Crimes Policy, 1945–1950. In *Atrocities on Trial: Historical Perspectives on the Policies of Prosecuting War Crimes*, ed. Patricia Heberer and Jürgen Matthäus, pp. 123–58. Lincoln: University of Nebraska Press.

Sebald, W. G. 2003. *On the Natural History of Destruction*. Trans. Anthea Bell. New York: Random House.

Sidel, Victor W. 1968. Feldshers and "Feldsherism": The Role and Training of the Feldsher in the USSR. *New England Journal of Medicine* 278(17):934–39 and 278(18):987–92.

Siemiński, Henryk. 2005. *A Book of Łódź Martyrdom: A Guide to Radogoszcz and Sites of National Remembrance*. Łódź: Museum of Independence Traditions in Łódź.

Siemon, Bruce H., and Roland E. Wagberg. 1968. *The Employment of Local Nationals by the U.S. Army in Europe (1945–1966)*. HQ, U.S. Army, Europe and Seventh Army, Office of the Deputy Chief of Staff, Operations, Military History Branch.

Simpson, Christopher. 1995. *Splendid Blond Beast: Money, Law, and Genocide in the Twentieth Century*. Monroe, Maine: Common Courage Press.

Snyder, Timothy. 2009. Holocaust: The Ignored Reality. *New York Review of Books*, July 16.

———. 2010. *Bloodlands: Europe between Hitler and Stalin*. New York: Basic Books.

———. 2012. Stalin and Hitler: Mass Murder by Starvation. *New York Review of Books*, June 21.

Spiegelman, Art. 1986. *Maus: A Survivor's Tale. Vol. 1, My Father Bleeds History*. New York: Pantheon Books.

Steinbacher, Sybille. 2000. In the Shadow of Auschwitz: The Murder of the Jews of East Upper Silesia. In *National Socialist Extermination Policies: Contemporary German Perspectives and Controversies*, ed. Ulrich Herbert, pp. 276–305. New York: Berghahn Books.

Steinlauf, Michael C. 1997. *Bondage to the Dead: Poland and the Memory of the Holocaust*. Syracuse, N.Y.: Syracuse University Press.

Stevens, Rosemary, and Joan Vermeulen. 1972. *Foreign Trained Physicians and American Medicine*. DHEW Publ. No. (NIH) 73-325. Washington, D.C.: U.S. Government Printing Office.

Stola, Dariusz. 2000. The Anti-Zionist Campaign in Poland, 1967–1968. Warszawa: Instytut Studiów Politycznych Polskiej Akademii Nauk. Available at http://web.ceu.hu/jewishstudies/pdf/02_stola.pdf, accessed February 2, 2013.

Strebel, Bernhard. 2009. Ravensbrück. Trans. Alfred Gutmann and Stephen Pallavicini. In *United States Holocaust Memorial Museum Encyclopedia of Camps and Ghettos, 1933–1945*, Vol. 1, ed. Geoffrey P. Megargee, pp. 1188–91. Bloomington: Indiana University Press.

Sztuka-Polińska, Urszula. 2002. Sytuacja epidemiologiczna niektórych ostrych chorób zakaźnych w Polsce w okresie międzywojennym XX wieku. *Przegląd Epidemiologiczny* 56:137–49.

Szulc, Tad. 1949. How the AMA Bars Refugee Doctors. *The New Leader* 32 [July] (31):6–7.

Szwarc, Halina. 1972. Kobiece więzienie Gestapo w Łodzi w ostatnim okresie okupacji [Women's Gestapo prison in Łódź during the final period of occupation]. *Przegląd Lekarski*, nr. 1, pp. 196–202.

———. 2008[1999]. *Wspomnienia z pracy w wywiadzie antyhitlerowskim ZWZ-AK* [*Memoir of anti-Nazi espionage with the ZWZ-AK*], 2nd edition. Warsaw: Neriton.

Szymborska, Wisława. 2001. *Miracle Fair: Selected Poems of Wisława Szymborska*. Trans. Joanna Trzeciak. New York: W. W. Norton & Co.

Ther, Philipp, and Ana Siljak, eds. 2001. *Redrawing Nations: Ethnic Cleansing in East-Central Europe, 1944–1948.* Lanham, Md: Rowman and Littlefield.

Thum, Gregor. 2011. *Uprooted: How Breslau Became Wrocław during the Century of Expulsions.* Trans. Tom Lampert and Allison Brown. Princeton: Princeton University Press.

Tillion, Germaine. 1975. *Ravensbrück.* Trans. Gerald Satterwhite. New York: Anchor Press.

Todorov, Tzvetan. 1996. *Facing the Extreme: Moral Life in the Concentration Camps.* Trans. Arthur Denner and Abigail Pollak. New York: Henry Holt & Co.

Trunk, Isaiah. 2006. *Łódź Ghetto: A History.* Trans. and ed. Robert Moses Shapiro. Bloomington: Indiana University Press.

Tuck, William Hallam. 1948a. IRO at Half-Way Mark. *United Nations Bulletin* 5(9):854–55.

———. 1948b. Why Europe's Refugee Problem is Still Unsolved. *United Nations Bulletin* 4(10):426.

United States District Court, Eastern District of New York. 2000a. Holocaust Victim Assets Litigation, Special Master's Proposal: Slave Labor Class I (Annex H). 11 September, Electronic document, www.swissbankclaims.com/PDFs_Eng/697499.pdf, accessed January 23, 2013.

———. 2000b. Holocaust Victim Assets Litigation, Special Master's Proposal: Slave Labor Class I List (Exhibit 1 to Annex H). Electronic document, www.readbag.com/dpcamps-slavecamplist, accessed January 23, 2013.

United States Holocaust Memorial Council. 1995. *1945: The Year of Liberation.* Washington, D.C.: United States Holocaust Memorial Museum.

USHMM (United States Holocaust Memorial Museum). 1996. *Historical Atlas of the Holocaust.* New York: Macmillan.

———. 2004. *Deadly Medicine: Creating the Master Race.* Washington, D.C.: United States Holocaust Memorial Museum.

———. 2007. *Nazi Ideology and the Holocaust.* Washington, D.C.: United States Holocaust Memorial Museum.

Vaisman, Sima. 2005. *A Jewish Doctor in Auschwitz: The Testimony of Sima Vaisman.* Trans. Charlotte Mandell. Hoboken, N.J.: Melville House Publishing.

Waterston, Alisse. 2005. The Story of My Story: An Anthropology of Violence, Dispossession, and Diaspora. *Anthropological Quarterly* 78(1):43–61.

———. 2014. *My Father's Wars: Migration, Memory, and the Violence of a Century.* New York: Routledge.

Waterston, Alisse, and Barbara Rylko-Bauer. 2006. Out of the Shadows of History and Memory: Personal Family Narratives in Ethnographies of Rediscovery. *American Ethnologist* 33(3):397–412.

———. 2007. Out of the Shadows of History and Memory: Personal Family Narratives as Intimate Ethnography. In *The Shadow Side of Fieldwork,* ed. Athena McLean and Annette Leibing, pp. 31–55. Malden, Mass.: Blackwell Publishing.

Weinerman, E. Richard, with Shirley B. Weinerman. 1969. *Social Medicine in Eastern Europe: The Organization of Health Services and the Education of Medical Personnel in Czechoslovakia, Hungary, and Poland.* Cambridge, Mass.: Harvard University Press.

Weisel, Mindy, ed. 2002. *Daughters of Absence: Transforming a Legacy of Loss.* Sterling, Va.: Capital Books.

Whiteman, Dorit Bader. 1993. *The Uprooted: A Hitler Legacy.* New York: Plenum Press.

Wiesen, S. Jonathan. 1999. German Industry and the Third Reich: Fifty Years of Forgetting and Remembering." *Dimensions: A Journal of Holocaust Studies* 13(2):3–8, at www.adl.org/Braun/dim_13_2_forgetting.asp, accessed May 10, 2010.

Wiland, Barbara Cygańska. Wspomnienia więźniarki Gestapo [Memoir of a Gestapo prisoner]. 2005. Unpublished manuscript, Wrocław, May 2005, Museum of Independence Traditions, Łódź.

Wrobel, Paul W. 1979. *Our Way: Family, Parish, and Neighborhood in a Polish-American Community.* Notre Dame, Ind.: University of Notre Dame Press.

Wyder, Grażyna, Tomasz Nodzyński, and Joachim Benyskiewicz. 1993. *Nowa Sól: Dzieje miasta.* Zielona Góra, Poland: Zielonogórskie Zakłady Graficzne.

Wyman, Mark. [1989] 1998. *DPs: Europe's Displaced Persons, 1945–1951.* Repr. Ithaca: Cornell University Press.

Young, James E. 1993. *The Texture of Memory: Holocaust Memorials and Meaning.* New Haven: Yale University Press.

Zamoyski, Adam. [1987] 2000. *The Polish Way: A Thousand-year History of the Poles and their Culture.* Repr. New York: Hippocrene Books.

Ziemke, Earl F. [1974] 1990. *The U.S. Army in the Occupation of Germany, 1944–1946.* Washington, D.C.: Center of Military History, United States Army. Available at www.globalsecurity.org/military/library/report/other/us-army_germany_1944–46_index.htm#contents, accessed June 2, 2010.

Zimmerman, Joshua D., ed. 2003. *Contested Memories: Poles and Jews During the Holocaust and Its Aftermath.* New Brunswick, N.J.: Rutgers University Press.

Index

🦢

References to illustrations are in italic type.

283; public opposition to, 272–73; quotas for, 272; requirements for, 273, 281, 282, 283, 364. *See also* Emigrants and emigration

Infectious diseases. *See* Diseases, infectious

Injuries: of J. Lenartowicz, 324; in Neusalz, 160, 188–89

Intern, J. Lenartowicz as, 43, 45, 47, 308

International Red Cross, 243

International Refugee Organization (IRO). *See* IRO

International Tracing Service (ITS), 120, 208, 243, 275, 276, 359

Interrogations, of J. Lenartowicz, 88, 107–108

Intimate ethnography, defined, 15

IRO (International Refugee Organization): and Camp Grohn, 283; and "embargo on brains," 271–72, 363; Embarkation Center of, 283; and J. Lenartowicz, 269–70, 273–74; and refugee physicians, 271–72, 303, 363–64; and refugees, 269, 272. *See also* Certificate of Professional Status; *Displaced Persons Professional Medical Register* (IRO); Resettlement, of Polish DPs

IRO Embarkation Center, 283. *See also* Bremen, Germany

Iron Curtain, 254, 363

ITS (International Tracing Service), 120, 208, 243, 275, 276, 359

Iwaniec, Michał, 217, 360

Jadzia, 5. *See also* Lenartowicz, Jadwiga Helena (Jadzia)

Jehovah's Witnesses, 126

Jews: badges worn by, 76, 126; as DPs, 236, 362; in Eastern Upper Silesia, 144, 145; in Echzell, 243; Ferencz on, 351; and Final Solution, 6, 9, 118, 146; and Germany, 75–76, 77–78, 243, 346; at Gruschwitz, 16, 159–61; and Harrison Report, 236; and Jewish Agency for Palestine, 243; and *Judenrein*, 75; in Łódź, 68, 75; Nazi targeting of, 6, 58, 65; in Neusalz, 159, 160, 166; in Poland, 8–9, 23, 24, 33–34, 83, 236,

346, 348; postwar violence against, 236; at Ravensbrück, 126; restrictions on, 75–76; in Silesia, 144–45; in Sosnowiec, 145, 354; at universities, 33–34, 343. *See also* Anti-Semitism; Death camps; Ghettos (Jewish); Holocaust; Neusalz (subcamp of Gross-Rosen); Organization Schmelt

Journal of the American Medical Association (JAMA), 301

Judenrein, defined, 75

July Manifesto (postwar Poland), 287–88

Käfertal, Germany (Civilian Guard Training and Replacement Center): Butkiewicz at, 256; as Camp Kosciuszko, 252; Gierzyński at, 256; health care at, 256–57; Krzeminskis at, 252, 258; J. Lenartowicz at, 252, 255–56, *258*–59, 265, 267; M. Lenartowicz at, 252; *New York Times* on, 252; Poles at, 257; purposes of, 257–58; W. Rylko at, 259, 261, 263; training of DPs at, 253, 257–59. *See also* Main Polish Liaison Section; OW (Oddziały Wartownicze); RAMPs (Recovered Allied Military Personnel)

Kałuża, Mrs., 69–70

Kaminsky, Marc, 342

Katyń (film), 344

Katyń Forest Massacre, 56–57, 344

Katz, Anna, 170–71, 180

Kielce, Poland, pogrom in, 236

Killing centers, 7. *See also* Concentration camps; Death camps

Kłąb, Halina (Szwarc), 63, 369

Korczak, Janusz, 327, 343

Kramár, Jenő, 269

Krogulski, Lusia (Ludmilla), 295, 321, 324

Krzeminski, Janek and Lola: in AK, 235, 246; at Avignon, 248; at Käfertal, 252, 258; and J. Lenartowicz, 234, 235, 237–39, 248–49, 251, 319; as teachers, 258

Kularska, Irka. *See* Bolinska, Irka

Kularski, Tolek, 94

Kuźwa, Mr., 289, 290

339; at Ludolf-Krehl Clinic, 268–
69; macular degeneration of, 333,
334, 336; as "maharajah," *36*, 37;
and Anna Margolis, 48; marriage
of, 264–65; at medical academy,
27–32, *29*, 35, 36, 40–42; at medical
academy ball, *31*; at Mehltheuer,
219–24, 225, 226–28, 233, 360;
Military and Displaced Persons
Camp Registration of, 241; and
Mogilnicki, 51; name day of, 279–
80; and NCWC, 289; at Neusalz,
156, 161–62, 164–66, 167–68, 169–
70, 171, 172–75, 176, 177–80, 181–
83, 184, 185–88, 189, 190–91, 196; as
nurse's aide, 304–306, 314, 322–23;
and OW, 255, 267, 277, 278, 279; as
pediatric resident, 47–50, 55, 66, 81;
photographs of, *2, 25, 35, 41, 240,
256, 258, 278, 279, 312, 318, 329*; as
physician in Łódź, 42, 43, 45, 47–50,
55, 66–68, 69, 70, 72–72, 86, 103;
as physician in postwar Germany,
233–34, 246, 251, 252, 255, 256–57,
258–59, 267, 268–70, 277–79, 281–
82, 300, 309–11, 339; and Piłsudski,
34; Poland visits of, 315–19, 321,
324, 325–26, 327–31; in Poznań, 26,
27, 28–29, 30–32, 33–34, 35–36, 37,
40–42; pregnancy of, 277, 280; and
Priester, 166, 178, 179, 196, 245; as
prisoner-doctor, 152, 153, 156, 161–
62, 164, 166, 167, 169–70, 177–80,
181–84, 185–88, 189, 196–97, 219,
220–21; and private patients, 73–74;
and Raburska, 130–31; and radios,
97, 98, 108; at Ravensbrück, 120–27,
129, 130–43, 276; as refugee, 227–
28; refusal of Volksliste by, 207–208;
retirement of, 324; and Rutkowski,
244; and W. Rylko, 259, 261–65,
264, 268, 276, 277, 279, 280, 305,
321; and Rylko-Bauer, 12, 280, *286,
318*, 321, 322, 325–26, 327, 331–
32, 334–35, 338; as social insurance
physician, 67–68; and SS, 125, 127,
143, 149–50, 151, 156, 161, 169–70,
182, 184, 218; and Stefanik, 281–82,

289, 300; and survival strategies,
138–39, 198, 200, 203, 204–205,
339; and Szajniuk, 220–21, 228, 231,
238; taping sessions with, 9–13; as
teacher, 258–59; and Tomaszewska,
49–50, 66; in Trautenau, 151–54;
and United States medical licensure,
300, 303, 304, 306–208, 309–10, 311;
on USNS *General W. C. Langfitt*,
285–89; vacations of, 34; verifying
imprisonment in Nazi camps, 120,
208, 243, 275–76; verifying medical
diploma, 306; in Warsaw, 89, 317; at
Weinheim, 251, 268; at YMCA, 268
Lenartowicz, Marysia (Maria), *25, 35,
125*; in AK, 85, 86, 87–88, 245–46,
349; arrest of, 88; in Auschwitz-
Birkenau, 89, 90–91, 124–25,
243–44; in Bergen-Belsen, 244;
childhood of, 22; in Darmstadt,
245–46; death of, 86; interrogations
of, 89; at Käfertal, 252; and J.
Lenartowicz, 30, 35, 36, 50, 64, 86,
90, 245–46, 248, 269, 313, 317–18,
243–44, 313; in postwar Poland, 251,
313, 317–18, 349; typhus of, 244; at
university, 27, 35, 36
Lenartowicz, Stanisław: and apartment
on Zawiszy Street, 47, 75, 76–77,
327–28; death of, 314; as feldsher,
21, 24, 25, 26–27, 45, 64; identity
pass of, *64*; and J. Lenartowicz, 36,
47, 67, 74, 173; marriage of, 21; in
World War I, 21, 22–23
Lenartowicz, Zosia, *25*; childhood of,
22; in Łódź, 317–18; in Romania,
55–56; at university, 27
Levi, Primo, 130, 183, 184–85, 357
Liberation: of concentration
camps, 195, 207, 213, 360; and J.
Lenartowicz, 221–24, 225, *240*; of
Łódź, 190; of Mehltheuer, 222–23,
224, 225, 226–27; of Oflag VIIA,
261; of Plauen, 224; of Poland, 287;
of prisoners of war, 225–26, 261; of
Warsaw, 349
Lice, 109, 112, 139, 202–203, 206, 210
Line of contact, *230*; defined, 232

Ober Altstadt (subcamp of Gross-Rosen), 152. *See also* Trautenau

Occupation of Germany. *See* Zones of occupation

Oddziały Wartownicze. *See* OW (Oddziały Wartownicze)

Oflag VIIA, *260*, 261, 277, 281. *See also* Murnau, Germany

Oflag VIIIA, 259–60

Operation Carrot, 250–51, 266

Operation Tannenberg, 57

Oranienburg, Germany, 117, 139–40, 141, 353

Organization Schmelt: and Auschwitz-Birkenau, 146; dismantling of, 145–46, 151, 160, 354, 355–56; and Gross-Rosen, 146, 160; and Grünberg, 150–51; and Himmler, 146, 354; and Jews, 144–45, 146, 150, 152, 159; living conditions under, 144; and Sosnowiec, 145; transport sent by, 159. *See also* Neusalz (subcamp of Gross-Rosen)

Ostatnie Wiadomości (OW newspaper), 263

OW (Oddziały Wartownicze): criticism of, 255; defined, 253; and DPs, 252, 254, 257; and industrial police, 267; Labor Service Companies as, 253; and J. Lenartowicz as physician with, 255, 267, 277, *278*, 279; and number of civilian guards, 252, 253, 267; *Ostatnie Wiadomości*, 263; and OW Welfare Fund (*Fundusz Społeczny*), 263; purposes of, 254; and K. Rylko, 276–77; and W. Rylko, 261, 268, 276–7, 280; support for, 255; and the United States Army, 253, 254, 255, 267, 276. *See also* Käfertal, Germany; Main Polish Liaison Section; United States Military Government, Germany

Palestine, 193, 195, 236, 244–45

Parczewska, Dr., 142, 148–49, 151

Parschnitz (subcamp of Gross-Rosen), 152. *See also* Trautenau

Physicians: Butkiewicz as, 256; Edelman as, 83; Frenkel as, 81–82; Gierzyński as, 256; J. Lenartowicz in Łódź as, 42, 43, 45, 47–50, 55, 66–68, 69, 70, 72–73, 86, 103; J. Lenartowicz in Nazi camps as, 152, 153, 156, 161–62, 164, 166, 167, 169–70, 177–80, 181–84, 185–88, 189, 196–97, 219, 220–21; J. Lenartowicz in postwar Germany as, 233–34, 246, 251, 252, 255, 256–57, 258–59, 267, 268–70, 277–79, 281–82, 300, 309–11, 339; Mandels as, 81, 82; Aleksander Margolis as, 82–83; Anna Margolis as, 48, 81, 82–83, 347; Alina Margolis-Edelman as, 83, 347; in Poland, 26–27, 44, 57, 67–68; as refugees, 269–70, 271–72, 301–302, 307–308, 363–64; 365–66; women in United States as, 307. *See also* House doctors; Medical licensure, United States; Prisoner-doctors

Piłsudski, Józef, 23, 24, 34, 101, 259

Plauen, Germany, *194*, 221–22, 223, 224, 360–61

Pogrom, 236

Poles and Poland: badges worn by, 59; *Blitzkrieg* against, 55; borders of, 20, 23, 250, 355; "cleansing" of, 58; Communist government of, 235, 245, 250, 255, 266, 287–88, 325–26, 348; education in, 28, 60; Endecja movement in, 24; ethnonationalism in, 23–24, 33–34; food rationing in, 69, 70–71, 74; and Generalgouvernement, 20, 57, 61, 94–95; German annexation of, 20, 57; Germanization of, 60–61, 62–63, 64–65, 91–92; German occupation of, 56, 57–58, 59–60, 61, 64–65, 71, 85, 91–92, 145–46, 235, 345, 348–49; and Germans and Germany, *20*, 23, 54, 56, 59; health care and public health, 23, 26–27, 43–44, 45, 61, 67–69; Himmler on, 60; Hitler on, 54, 59; Hoffman on, 9; illegal economy in, 70–72; invasion of, 54–55; and Jews, 8–9, 23, 24, 33, 34, 83, 236, 346, 348; Katyń Forest Massacre, 56–57, 344; London government-in-exile of, 250, 255, 348; maps of, *20*; martial law in, 325; medical schools in, 44; Miłosz on, 58; and Nazi racist ideology applied to, 58, 59, 60, 61, 91, 345; NKVD, 56; Operation Tannenberg, 57; partition of, 21, 22, 23, 57; physicians in, 44, 68; and Piłsudski, 23–24, 34, 101, 259; pluralism in, 23–24; and prohibition on radios, 3, 7, 60, 97; as "reservoir of labor," 59; resistance movement in, 85–87, 348–49;

Ribbentrop-Molotov Pact, 20, 54; rural areas in, 23, 43; and Russia and Russians, 21, 23; Sanacja regime in, 23; Second Polish Commonwealth, 20, 23, 24, 28, 56; Słonimski on, 8; and Soviet Union, 54, 56–57, 189–90, 250, 255, 287, 344, 349, 355; and United States, 292–93; Warsaw Ghetto Uprising, 145–46, 347–48; Warsaw Uprising, 235, 251, 349; women in, 28, 34; and World War I, 21–22, 23, 44; and World War II, 8–9, 20, 54–55, 56, 57–58, 59–62, 65, 75–76, 85, 87, 116, 189, 287, 343–45, 348–49; as World War II Allies, 253; and Yalta Conference, 235, 236, 250, 255, 355. *See also* AK (Armia Krajowa); Children, Polish; Łódź, Poland; OW (Oddziały Wartownicze); Polish American community; Polish postwar refugees; Volksdeutsche; *names of specific people*

Polish American community, 268, 291–93, 313–14, 364. *See also* Detroit, Michigan

Polish American Council (Rada Polonii Amerykánskiej), 260, 291–92

Polish-American Technical Society of Detroit, 296–97

Polish language, banning of, 60–61

Polish-Lithuanian Commonwealth, 21

Polish National Alliance, 292

Polish postwar refugees: as DPs, 249, 250, 266, 362; and Operation Carrot, 250–51; and Polonia, 268, 291, 292–93; repatriation of, 249, 250–51, 252, 254, 266, 362, 363; resettlement of 272, 363–64; at Wildflecken, 234. *See also* DPs; Käfertal, Germany; OW (Oddziały Wartownicze); Rylko, Władysław

Polish WAC PWX Camp ("Burg"), 245, 246, 247

Polonia. *See* Polish American community

Popiełuszko, Jerzy, 326

Potsdam Conference, 355

POWs. *See* Prisoners of war (POWs)

Priester, Hania: at Flossenbürg, 208; and J. Lenartowicz, 166, 178, 179, 196, 245; as prisoner-nurse at Neusalz, 162, 165, 179–80, 187

Priests. *See* Catholicism in Poland

Prisoner-dentists, 153, 162

Prisoner-doctors: Adamska as, 140–41, 353; dilemmas faced by, 183, 185, 338, 357; J. Lenartowicz as, 8, 146, 151, 152, 153, 156, 161, 164, 166, 167, 169–70, 177–80, 181–84, 185–88, 189, 196–97, 219, 220–21; purposes of, 147, 161; roles of, 140, 185, 357; Szajniuk as, 219–21

Prisoner numbers: of Adamska, 141, 353; in concentration camps, 126, 127, 135, 151, 160, 208, 218, 359; of J. Lenartowicz, 120, 121, 126–27, 151, 208, 219; of M. Lenartowicz, 124–25

Prisoner-nurses: dilemmas faced by, 183, 357; Priester as, 162, 165, 179–80, 187; purposes of, 357

Prisoners of Fear (Lingens-Reiner), 185

Prisoners of war (POWs): camps for former, in Germany, 234, 239, 245–46, 253, 261; at Flossenbürg, 217; in hospitals, 86–88, 259; in Neusalz, 157–58; W. Rylko as, 259–61, 274–75, 277, 281, 298; Stefanik as, 260, 261, 281; and U.S. Army, 229. *See also* Oflag VIIA; Oflag VIIIA; RAMPs

Prisons, 7, 58. *See also* Gdańska Street Prison, Łódź

"Promised Land," Łódź as, 43–44

Prontosil, 49, 181, 187, 357

Raburska, Janina: arrest of, 98–99; and J. Lenartowicz, 130–31; and radios, 97; at Ravensbrück, 113, 121

Race camp. *See* Rassenlager

RAD (Reichsarbeitsdienst), 158–59

Rada Polonii Amerykanskiej (Polish American Council), 260, 291–92

Radios: and Bartoszewska, 97; and Bukowiecki, 97; and Cudnowska, 97, 98, 107; and J. Lenartowicz, 7, 97, 107, 108; and Poles, 3, 7, 60, 97; prohibitions on, 60, 97; and Raburska, 97

RAF (Royal Air Force), 201

RAMPs (Recovered Allied Military Personnel), 253, 261

Rassenlager: defined, 91; in Łódź, 91, 92

Rationing, 69, 70–71, 74, 232, 363

Sosnowiec, Poland, 145, 354

Soviets and Soviet Union: dismantling of, 326; distrust of, 238–39, 250; and Katyń Forest Massacre, 56–57, 344; and Poland, 23, 54, 56–57, 189–90, 250, 255, 287, 344, 349, 355; and repatriation, 236, 237, 362; and Ribbentrop-Molotov Pact, 20, 54; tensions with the West, 254, 255, 363; as World War II Allies, 189–90, 207, 244; and Yalta Conference, 232, 237, 250; zone of occupation in Germany, 230, 232, 238. See also Russia and Russians

Special Committee on Displaced Physicians, 303

Sperrstundenausweis, defined, 64

SS (Schutzstaffel): as administrators of concentration camps, 126, 129, 136, 162, 163; defined, 117; and Flossenbürg, 214, 220; and German industry, 118–19, 157–58, 351, 353; and Gross-Rosen, 149–50; and Gruschwitz, 158, 159, 160; and J. Lenartowicz, 125, 127, 143, 149–50, 151, 156, 161, 169–70, 182, 184, 218; and Mehltheuer, 221, 222; and Neusalz, 160, 161, 162, 163, 164, 169, 191, 196, 197, 356; physicians, 136, 140, 352–53, 357; and Ravensbrück, 121, 125, 129, 134, 135–36, 137; and slave labor, 118, 119, 351, 353; and trains, 155; and Trautenau, 152, 153; treatment of prisoners by, 130; women as, 125. See also Concentration camps; Himmler, Heinrich; Organization Schmelt

SS women: Aufseherin, defined, 125; aufsjerka, defined, 133; Gersch as, 162, 171; in Neusalz, 162, 163–64, 169–70; in Ravensbrück, 125, 135–36; training center for, 125; treatment of prisoners by, 125, 127, 134, 135–36, 197, 356

Stalin, Joseph: and cold war, 254; and Poland, 250; and repatriation, 237; at Yalta Conference, 236

Stankiewicz, Halina, 37, 39

Stankiewicz, Jadwiga, 37, 39

State Board of Registration in Medicine, Michigan, 303–304

Stefanik, Władysław: death of, 261; in

Detroit, 260–61, 281–82, 289, 290, 291, 321; and J. Lenartowicz, 281–82, 289, 300; as POW, 260–61, 281; and W. Rylko, 260–61, 281–82, 289

Steinlauf, Michael, 236, 346

Stroop, Jürgen, 348

Subcamps of concentration camps, 116, 119, 142, 147, 207, 218, 353, 354, 356, 357, 359, 360. See also Grünberg; Mehltheuer; Neusalz; Ober Alstadt; Parschnitz; Trautenau

Sudetenland, 144, 151, 193

Suffrage, of women in Poland, 34

Suhren, Fritz, 119

Szajniuk, Wanda: at AK camp, 239; and Fischer, 222; and J. Lenartowicz, 220–21, 228, 231, 238; at Mehltheuer, 219–20, 221, 222, 224, 225; as physician, 233; as prisoner-doctor, 219–21; as refugee, 227, 228, 233

T4, defined, 62

Tattoos, 126, 127

Teichman, Maria, 63

Témoignages (Lecoq), 140

Testimonies. See Memoirs and testimonies

Textile industry: and forced labor, 144, 145, 146, 150, 158–59; in Grünberg, 150; in Łódź, 43; in Łódź ghetto, 77–78; in Neusalz, 157, 158; and slave labor camps, 146, 151, 152, 159, 160, 161. See also Gruschwitz; Neusalz (subcamp of Gross-Rosen)

Third voice (Myerhoff), 18, 342

347th Infantry Regiment of the 87th Infantry Division, 224, 225

Todorov, Tzvetan, 338, 358

Tomaszewska, Matylda: as chief of pediatric surgery, 49–50; as interim director of Anna Maria Hospital for Children, 52; replacement of, 65, 66

Tomaszewski, Antoni, 49–50, 66–67

Transports: to and from Auschwitz-Birkenau, 78, 145, 146, 244, 354, 356; to Bergen-Belsen, 212, 218, 360; to and from, Flossenbürg, 207, 212; from Gdańska Street Prison, 112–14; to Gruschwitz, 158–60; Hilberg on, 155;